Light Readings

Light Readings

A PHOTOGRAPHY CRITIC'S WRITINGS
1968-1978

A. D. COLEMAN

OXFORD UNIVERSITY PRESS
Oxford New York Toronto Melbourne

Oxford University Press

Oxford London Glasgow
New York Toronto Melbourne
Nairobi Dar es Salaam Cape Town
Kuala Lumpur Singapore Hong Kong Tokyo
Delhi Bombay Calcutta Madras Karachi

and associate companies in
Beirut Berlin Ibadan Mexico City

Library of Congress Cataloging in Publication Data

Coleman, Allan D
Light readings.
1. Photography, Artistic—History and criticism. I. Title.
TR642.C64 770'.8 78-11891 ISBN 0-19-502516-4
ISBN 0-19-503196-2 pbk.

Acknowledgment is made for permission to reprint the following:

Material reprinted by permission from California *Artforum*, Inc., 1976.

Material reprinted by permission from *Art in America*, September–October 1972.

Material reprinted by permission from *Camera 35*, 1974–77.

Material © 1970/71/72/73/74 by The New York Times Company.
Reprinted by permission.

Material courtesy *Popular Photography*,
© Ziff-Davis Publishing Co., 1970, 1973.

Material reprinted by permission of the *Village Voice*.
Copyright © The Village Voice, Inc., 1968–73.

Printing (last digit): 9 8 7 6 5 4 3 2 1

Printed in the United States of America

For Edward

Preface

In the spring of 1968 I became a full-time freelance writer specializing in photography criticism.

I began writing about photography because I was excited by photographs, curious about the medium, and fascinated—even frightened—by its impact on our culture. I still feel that way.

My first pieces appeared in the *Village Voice,* in a regular column called "Latent Image." Between 1968 and 1974, my primary forums were the *Voice, Popular Photography,* and the Arts and Leisure section of the Sunday *New York Times;* I was a regular columnist for all three simultaneously. Since 1974, I have written for a diverse group of periodicals, with *Camera* 35 my most frequent outlet. During this decade I wrote well over four hundred articles on various critical, historical, educational, and cultural aspects of photography. That volume astonishes me now; I do not think I could match it again.

The quantity of that output had much to do with the specific nature of my involvement with photography as I initially conceived and undertook it. I intended my work to be an interconnected running commentary on photographs and photography itself—a form of *journalism,* in the diaristic sense of the word, as well as a critical interaction with the medium.

When I started, photography was entering that state of evolution and redefinition which in the past few years has brought it increased critical attention and a much widened audience. Though I prophesied that eventuality, and proselytized for it, I think I never really expected it to happen. While I have my reservations about many of the side

effects, I'm glad that it came about; I believe the attention—and the audience—will be rewarded.

So much seemed to be happening in photography at that point, and my knowledge of and background in the medium were so scant, that I did not presume to function as an authority or an arbiter of taste. Those roles don't attract me; and my youth, inexperience, and lack of an overview made them impossible in any case. What I hoped to do was to exemplify the possibility of engaging on a personal level, emotionally and intellectually, with a wide range of photographic imagery in an articulate and meaningful fashion, thereby provoking others to do the same.

Because so much was going on, and so few were writing about it, I was leery of functioning as an intentional filter—that is, I was reluctant to exclude from my consideration anything that seemed even remotely pertinent. I wanted my function to be that of a *synapse* in the medium: a message center, a bridge between the origin of communication and its destination. So I embraced and tried to deal with almost everything that came my way or could be ferreted out, let it all pass through me and, as best I could, turned the experience into words. For a while it was possible to maintain at least the illusion that I was ingesting almost everything there was (on the East Coast, at any rate); but by the early 1970s that had become patently impossible, and my understanding of my task began to change. By late 1974 I had virtually ceased writing about exhibits and monographs. Partly that was due to the sudden lack of access to effective forums for such discussions, partly to shifts in my own attitudes.

This book is an attempt to reconstruct this evolution, in public, of a critical overview and vocabulary pertaining to the medium of photography. It is also a quite personal and surely idiosyncratic account of a crucial period in the medium's growth, somewhat limited by its geographical fix on New York but still more extensive an eyewitness chronicle than anything else of which I'm aware. And it is a collection of my favorite essays, judged from my standpoint as a writer.

Except for minor corrections and alterations, I have not rewritten these pieces; rewriting would have made this a different kind of book. The early pieces, by and large, are quick and tentative responses to the works with which they engage. But I see them now as necessary steps in the ongoing critical process of coming to terms with individual

bodies of work as they evolve, take shape, and are nurtured by their makers. That, in part, was the point of them originally, and is certainly part of my purpose in including them here. From an autobiographical standpoint, I wanted to indicate something of my own fallibility and naïveté, and to suggest by example that critical ideas can be thought of as exploratory and mutable—sometimes drastically so, as can be seen for example in my writings about Paul Strand. The pieces dating from 1973 through 1978 are generally more considered essays.

The book focuses on the work of younger, less-established photographers; that was the emphasis in the total body of writing from which these pieces have been selected. The few essays about better-known photographers that appear were included either because I felt the piece was a reconsideration which departed markedly from the established critical consensus, or because I felt the subjects hadn't received the attention their contributions merited.

Even within those parameters, however, there are glaring omissions —dozens of less established and/or younger photographers whose names should appear in any comprehensive survey of the past quarter-century's activity in photography. But this book is not intended to be such a survey. Many people whose work I find highly important are herein referred to only in passing, if at all—sometimes because my writing about them did not do justice to their work, or was otherwise ephemeral; sometimes because the occasion for writing about their work did not arise. Such absences therefore should not be taken as value judgments. Those represented here are only the tip of the iceberg.

Finally, I would like to note several professional stances which I feel have had distinct shaping effects upon my work. One was the decision to be and to remain a freelance writer, a status I retained even as a weekly contributor to the *Village Voice* and a bi-weekly contributor to the *New York Times*. This choice was made in order to leave myself ultimately accountable to no editorial policies save my own. I have never regretted it.

The other was the early decision to write only about publicly presented work: books, magazines, exhibitions, and other events which were open to everyone. I have not gone into the studio to examine work to which readers do not have access, nor have I asked image-makers to explain their creations to me and reported those explanations

as if they were my own. Nor have I written about work which my readers cannot experience for themselves. I consider such writing to be a form of speculative fiction. In such cases, the danger is run of the criticism supplanting the work. I have always kept in mind as an operating principle that the work is primary and the criticism secondary, regardless of the relative quality of the two. The main function of criticism, I believe, should be to provoke other personal dialogues with the primary works.

Yet, having said all that, I must also say that I have my own biases and predilections, as I'm sure will be apparent. A good question for members of any audience to keep in mind is, "What's being filtered out?" That question should always be asked when dealing with any form of human communication that's reached the audience through one or more intermediaries. An audience is entitled—and expected—to form its own opinions.

I hope this book will be of some interest and use to the general public, to students of photography and of contemporary communicative/creative media, and to photographers. If the general public can learn from this book something about what's behind the current ferment in the medium, and be encouraged to engage with it more actively as an audience; if students (and teachers) can find it effective in generating a more articulate responsiveness to the full diversity of photographic imagery; and if photographers of all stripes can encounter herein at least some of their attitudes, ideas, concerns, and intentions enunciated in ways with which they would not entirely disagree—I'll be more than happy.

Finally, I wish to give credit to four people whose writings about imagery, about photography, and about communicative media were highly influential on my own, particularly at the outset: William N. Ivins, Marshall McLuhan, Minor White, and Ralph Hattersley. Had I not encountered their work, I might never have started all this.

Staten Island, New York A. D. C.
July 1978

Acknowledgments

I owe more than I can pay back to a number of people, some of whom only passed through my life and some of whom are still in it. I would like to thank them all, wherever they may be, for what they've given me. I'd like to express my particular appreciation to the following individuals: my parents, Earl and Frances—who gave me a love of books, ideas, and freedom of thought—for their examples of inductive reasoning and commitment; my younger brother Dennis, for surviving me; three fine teachers, Leonard Albert and Mildred Kuner of Hunter College and Arthur Foff of San Francisco State College, from whom I learned much about language, literature, and writing; Charles Devlin, as close to a mentor as I ever had; and my son Edward, known to his friends as Butch, who is a constant and cherished inspiration to me.

I want also to pay my respects to the one artist of my generation whose work has been for me a major source of spiritual nourishment: Robert Zimmerman/Dylan, poet and musician.

No body of work such as the one this book represents is created in a vacuum; evolving a critical vision in public requires professional as well as private support and encouragement. Instrumental in providing backing of both kinds were: my former wife Alexandra, who bolstered my decision to become a freelance writer when I first set out on this venture; those editors with whom it's been my privilege to work—Diane Fisher, who gave me my start at the *Village Voice*, Jim Hughes (then at *Camera 35*), Renée Bruns at *Popular Photography*, Willard Clark (currently at *Camera 35*), and especially Seymour Peck, former editor of the Arts & Leisure section of the Sunday *New York Times*;

and those friends whose presence and energy in my life during the years in which this writing was done have become inextricable from it —Michael, Debbie, Richard, Neal, Robert, Rhett, Paul, Melissa, Les, Dianne, Lee, Bob, Sara, Bill, Mary J., Joel, Betty, Ralph, Tricia, Will, and Doug.

Finally, I am grateful to Stephanie Golden and James Raimes, for helping me to find the proper shape for this material.

A. D. C.

Contents

All action is a form of speech. Language is the shape life takes passing through us; it is how we pay homage to things and preserve them. . . . What one works toward is this: that there be no difference between the man, the life, the voice, that all become a way of standing in the world, a kind of witness.

PETER MARIN, *In a Man's Time*

Light Readings

1968

Latent Image

"Photography as a fad is well-nigh on its last legs, thanks principally to the bicycle craze," wrote Alfred Stieglitz in an 1897 manifesto. Time has proven his sardonic optimism wrong; however—and this at least would have pleased Stieglitz—the ranks of serious, dedicated photographers have also swelled slowly but surely (though hardly proportionately). Much of that·is attributable to the impetus given this new medium by Stieglitz and his apostles; certainly the acceptance of photography as a legitimate art form is directly traceable to his life-long battle on its behalf. Yet equally responsible, though often disclaimed, are the popular uses of photography—journalism, advertising, even family album snapshots. Aesthetically "impure" as these·may be, they served to educate an entire society to the value and uniqueness of photography as a medium for recording events, communicating ideas, and transmitting information; thus, paradoxically, the same "photography as a fad" despised by Stieglitz bred a generation for whom the camera is a natural and instinctive creative tool.

In its current manifestation, popular interest in photography is at best a mixed blessing. The very familiarity which results brings with it not only acceptance but, perhaps inevitably, a curious form of contempt. The importance of photography in our lives is so frequently acknowledged that we have become numb from repetition, while the increasing technical sophistication of modern cameras (coupled with our escape from formal visual inhibitions) has made it easier to take

Village Voice (hereafter *VV*), June 20, 1968.

good (though not great) pictures. Despite or because of all this, the significance of an original photograph—as a statement, a work of art, a *Ding an sich*—is usually overlooked, along with the intellectual and emotional factors involved in the process of making one.

Still prevalent among the public is the attitude that if you've seen a photograph once—in any form: reduced or enlarged, as a newspaper halftone or a gravure plate or an actual print from the negative—you've seen it all. An otherwise discerning audience, which would never dream of judging Ad Reinhardt's paintings by their reproductions in *Life* magazine, will unhesitatingly presume reproductions of Marie Cosindas's subtle color portraits (in the same publication, May 1968) to be identical to the originals.

Photography may be recognized as a valid art, and part of the public may be sensitive to the superficial differences between good and bad pictures, but, with the exception of a small band of devotees, the general level of interest—to say nothing of self-education—goes no further. Questions of technique and aesthetics are discussed only in the pages of photography magazines. Such perversely unhelpful shows as the Museum of Modern Art's recent "Photography as Printmaking" merely perpetuate the mystique that photographic methods involve arcane necromancy beyond the comprehension of the uninitiated. Collectors with modest budgets pay no attention to original photographs, though they are surely the best buy in our over-inflated art market. Photography exhibits (by which I do not mean the annual Coliseum extravaganzas) are notoriously ill-attended. The mortality rate for galleries specializing in photographs is staggering. Books of photographs—even the greatest, such as Weston's *My Camera on Point Lobos*—are too often remaindered. Somehow, photography always seems to get the short end of the stick.

This column will be a continuing attempt, on a small scale, to change that situation by giving to photography the serious critical consideration it merits. It will be (I hope) a means for turning a sizable potential audience on to photography as a creative medium, affirming the importance of original photographs as significant objects, and providing a dialogue between photographers and their public.

Paul Strand (I)

Paul Strand once suggested to Beaumont Newhall (now curator of the George Eastman House) that a retrospective exhibition Newhall was assembling for the Museum of Modern Art—"Photography 1839–1937"—should include the work of only four photographers: David Octavius Hill, Eugene Atget, Alfred Stieglitz, and Paul Strand. The photographer's inclusion of himself in this pantheon says much about his personality; the company he chose reveals much about his work. Hill and Stieglitz are Strand's heroes. Their names crop up time and again in his writing (see the four fascinating essays included in Nathan Lyons' *Photographers on Photography*), serving as constant examples of what Strand sees as photography's true path. As exponents of what might be termed classical photography, Hill and Stieglitz are Strand's artistic forebears—though they are no more than predecessors, Strand being too much his own man to be influenced by anyone for long—and Strand may well be the last of his line; there is no photographer today picking up where he leaves off.

In one of the essays mentioned above, Strand wrote, "The full potential power of every medium is dependent upon the purity of its use." Strand is an intransigent purist, opposed to any form of post-exposure manipulation of the image, insistent that the photographer must compose his picture in the viewfinder rather than in the darkroom. He has always lived up to the stringent demands of his approach. More than technically perfect, Strand has transcended technique as have few photographers; the resulting freedom, combined with what he terms "objectivity"—the complete perception of what is framed in the viewfinder, with each detail understood in relation to the whole—produces images in which nothing is ever extraneous. Every object, every line, every tone has been integrated functionally into the whole, and is intrinsic to the picture's purpose.

Strand's perfectionism carries over to his prints. He makes very few prints of his own work for sale; the resulting shortage has been compounded by changes in printing material—dissatisfied with available paper, he now makes even fewer prints than before. Consequently,

VV, August 1, 1968.

original Strand prints are scarcer than hen's teeth, rarely seen outside museums. Since his last show in New York was at MOMA in 1945, chances are you haven't seen much of his work unless you're on the far side of the generation gap.

Only one of Strand's books is currently in print in this country, but it is a masterpiece: *The Mexican Portfolio* (Da Capo Press, 1967). This series of twenty photographs, taken in Mexico during 1932–33, was originally issued in a limited edition of 250 copies in 1940. It immediately became a collector's item, and, like his original prints, is rarely seen outside museum collections. The Da Capo Press edition, produced for the publishers by *Aperture* magazine in conjunction with Strand, is limited to 1000 signed and numbered copies, and will certainly be a collector's item also within a few years.

Briefly, the portfolio consists of a superb suite of photographs, magnificently printed and sumptuously bound. These are gravure plates, not original photographs—but what reproductions! The plates have been printed by hand on handmade paper, then varnished by hand. (The original gravure plates, made for the first edition, have been used for this edition also.) Strand provided the formula for the ink used—a rich, dark, deep brown—and supervised the entire production. The prints, along with a letterpress foreword by Leo Hurwitz, a statement on Strand's art by the painter Siqueiros, and Strand's own note on the new edition, are enclosed in a Russell-Rutter slipcase and boxed.

This book has no equivalent in photographic publishing; it represents a quality of craftsmanship usually devoted only to limited editions of work by graphic artists. Its selection by the American Institute of Graphic Arts as one of the "Fifty Books of the Year" recently is a much-deserved honor.

The photographs are worth all the care which went into this printing. *The Mexican Portfolio* contains some of Strand's greatest work, and is, as a book, surely the finest he has ever produced. Strand has juxtaposed three aspects of Mexico—the Mexican people, their religious artifacts, and their environment—to form an intricate triple image of Mexican life.

Each picture stands on its own. To pick just a few, I would single out "Man, Tenancingo," "Plaza, State of Pueblo," and "Virgin, San Felipe" as examples of what Strand has accomplished. But selection is a difficult process when faced with these photographs, precisely be-

cause they are intended to be seen as a sequential visual essay. Having cut away everything unnecessary, Strand's vision is almost unbearably pure. Without sentimentality, with any aura of agitprop, the photographs present a total portrait of Mexico which seems inarguably true —not factual, but true, in an absolute sense. This, one cannot but believe, is the essence of how it was, distilled through the refining apparatus of Strand's mind and heart. Here is art without artifice, and it takes your breath away.

Jerry Uelsmann (I)

Though purists continue to howl, various techniques once lumped together disparagingly under the heading of "trick photography"— solarization, multiple exposure, negative sandwiching—are being accepted by photographers as valid approaches to their medium. Perhaps it's just the photographic version of the aesthetic eclecticism of our times—more likely, though, it's a sign of many photographers' desire to expand the boundaries of their medium as far as possible.

My own attitude toward such experiments—and these processes are still in the experimental stage—runs along the lines of "you can't argue with success." If an image works, it works. Against the argument that post-exposure manipulation is a cheap trick to minimize the risk of artistic failure, I would pose a statement made by Ornette Coleman several years ago. Under fire at that time from critics who claimed that his music was a fraud because, since it adhered to no established method, it avoided the danger of adverse criticism, Ornette made an important point. "It was when I found out that I could make mistakes," he responded, "that I knew I was onto something."

Mistakes are equally possible in manipulated photographic images— which means implicitly that artists exploring this area are onto something as well.

The manipulated image has been around in photography much longer than most purists care to admit—from the pictorial melodramas of Henry Peach Robinson to Stieglitz's solarized portrait of Georgia O'Keeffe's hands down to Harry Callahan and a host of others in be-

tween and after. All of them made mistakes; all of them had successes.

Of the younger photographers investigating the potential of these methods, the most consistently successful is Jerry Uelsmann, whose work occupies a major portion of the current issue (13:3) of *Aperture* magazine. A comprehensive selection of Uelsmann's photographs—covering almost a decade—is accompanied by a most strange article by William E. Parker, dean of the Parsons School of Design in New York. Parker's article is the first of its kind I've ever seen devoted to a photographer's work, but not all precedents are valid. Elaborately footnoted, replete with references to the Earth Mother, the Archetypal Feminine, the ritual hierosgamos, it reads like an essay from the same Bollingen Series Parker quotes so frequently. I'm not trying to put it down; Parker is serious, he makes a few interesting points, and I suppose that such an article indicates a widening acceptance of photography as a legitimate art form. All the same, most of Parker's exegesis strikes me as wildly irrelevant, and the old adage of one photograph being worth a thousand words certainly seems to apply.

Uelsmann's pictures, at their best, are disturbing symbols whose meaning, like a carrot dangled before a donkey, remains several steps ahead of the viewer, leading him ever onward. They remind me of nothing any other photographer has ever done (Magritte is the only artist whose "symbolic syntax"—as Parker puts it—has had an obvious influence on Uelsmann). I truly don't know how to describe them, but they stay in your head, haunting and perplexing. Their intent is specifically non-verbal—one of the reasons I find Parker's essay unnecessary; Uelsmann is not trying to "tell a story," as Henry P. Robinson did, but to portray and evoke moments of dream-trance—subconscious awareness through visual, not verbal, imagery. When he succeeds (which is often), I find myself unconcerned with questions of techniques and Is-this-photography, caught up instead by an elusive memory from my inner past. As I said, you can't argue with success.

1969

Christmas Gift: "Harlem On My Mind"

"Harlem On My Mind: Cultural Capital of Black America, 1900–1968," the mixed-media photo show which opened to the public Saturday at the Metropolitan Museum of Art, is such a ghastly mistake—on every conceivable level—that I am left awestruck at the monumentality of its failure.

In Museum Director Thomas P. F. Hoving's preface to the book version of the exhibit a number of amazing statements are made, the general thrust of which is that "Harlem On My Mind" will probably be attacked as too daring and too gutsy, but damn the torpedoes and full speed ahead. This self-laudatory paean reaches its pinnacle with Hoving's proclamation that " 'Harlem On My Mind' is Humanism." (Note that capital H.)

"Harlem On My Mind" may be Humanism to Hoving, but to me it's a staggering display of honky chutzpah. Blacks who have lived in Harlem are entitled—though assuredly not prone—to sentimentalize this ghetto. The white cultural establishment and its individual members—none of whom have lived there, and few of whom have even visited the area—are not. That hasn't stopped them from trying, though, nor has it prevented them from spending a quarter of a million dollars in the attempt.

A visual version of slumming, this show skims the surface of life in Harlem (at great length, it must be admitted) without ever probing to the horror beneath. To be sure, a previously uninformed viewer will emerge from the exhibit with the impression that life, recogniz-

able human life, goes on in Harlem pretty much as it does elsewhere, with the exception of a few details. Perhaps that is an accomplishment of sorts. But it is those details which are of the greatest importance. How come—in this entire exhibit, thirteen huge rooms of it—not a single photograph of a cockroach or a rat?

Now that would have been a radical achievement—a room devoted to the vermin of Harlem, with still photos, slides, and films of roaches, lice, and rats crawling over babies, adults, food, toothbrushes, to the accompaniment of a tape playing, over and over, the obscene scuttling noises of rodents in the walls. But that might be a little too strong, even for the Met's capital-H Humanists.

So, safe as milk, the show avoids those particular residents of the slums. Oh, you see poverty all right, but not much from the present day, mostly from the past (militancy is the theme of the present-day room; poverty comes two or three rooms earlier, implying that the poverty is no longer there). If I were that uninformed viewer mentioned above, I'd walk away from this show asking "What do these people want?" The show itself certainly gives no indication.

But I am making it sound as though "Harlem On My Mind" is a piece of deliberate, insidious propaganda. It isn't. It's the Met's Christmas gift to its sponsors' faithful retainers everywhere, a patronizing but well-meant handout. If the show had been intended as malicious propaganda, it might at least have been, like *Triumph of the Will*, intellectually challenging. However, the exhibit's obviously unconscious, off-handed racism—such as the title, taken from, of all sources, an Irving Berlin song—makes it merely dull.

Representatives of the black community are picketing the show, claiming (correctly) that it gives a totally false picture of Harlem. They should be joined in their protest by all the photographers whose work is included in the show, since, on purely aesthetic and technical grounds, "Harlem On My Mind" violates photography repeatedly.

There is evidence aplenty that Allon Schoener, coordinator of this exhibit, and his fellow workers have read Marshall McLuhan and really tried to do something original and avant-garde. There are photos all over—on towering columns, on walls, on ceilings, on TV screens, everywhere photographs, more than you can shake a stick at. But one can look at just so many photographs on any subject unaccompanied by informative text before they all begin to look the same. Here they

are lumped together, in no order save chronology, hung in clumps on the walls, grouped in fives and sixes for no apparent reason, certainly without any visual harmonies or correlations. What a waste of so many fine photographers—Aaron Siskind, Todd Webb, Gordon Parks, Ken Heyman, Lee Friedlander, and Bruce Davidson among them. Schoener's omnipresent lack of real imagination permits him to hide in a dim corner a Helen Levitt photograph which should have been the opening shot—a chalk-drawn picture of a push-button scrawled on a Harlem wall, with these words beside it: "Button to Secret Passage—Press." That same lack of imagination forces him to resort to fatuous, self-defeating gimmicks for impact. For instance, there is a huge (14 × 52-foot) photo-mural of the Reverend Adam Clayton Powell, Sr., with his Sunday school class, of which the Met's press releases are inordinately proud. The room in which this print is on exhibit, however, is so filled with other clutter—plywood pillars and constructions covered with photographs—that it is impossible to view the entire mural, or even an uninterrupted major portion of it, from any point in the room, which negates the purpose of the blow-up.

Examples of this pointless and rampant exhibitionism are plentiful. There is a brief film portrait/interview featuring Harlem's oldest living resident, shown via closed-circuit TV—but the sound track is inaudible (a recurrent problem throughout the exhibit). In one gallery—the next to last, covering the 1960s—two banks of slide projectors shoot images onto two long facing walls, four or five pictures per wall simultaneously, high above the audience's head, so greatly enlarged that no one can see more than one slide at a time—which destroys the effect of simultaneous projection. In the final room, dozens of full-face portraits are suspended overhead, parallel to the ceiling but just below it; what this is intended to accomplish, aside from giving those few people who notice them up there a collective crick in the neck, is anybody's guess.

For all its good intentions (" 'Harlem On My Mind' is a discussion. It is a confrontation. It is education. It is a dialogue," writes Hoving), "Harlem On My Mind" is so predictable and perfect a statement of the white-liberal attitude as to be a grotesquely funny (that's black humor, friend) self-parody. I'm sure that some of the Met's officials, looking out at the picket lines, will think to themselves, "What do these people want?" I really don't have any answer for them, except

to point out that at the press preview last Tuesday the bartenders were white, but the waiters who scurried around collecting empty glasses were black.

That's still where it's at, isn't it?

Richard Kirstel (I): "Pas de Deux"

Erotic art seems to evoke from critics—with a by now tedious inevitability—endless strings of rhetorical questions. What is pornography? Is the sexual act a fit subject for visual art? *Where do you draw the line?*

These supposedly burning questions are never answered outright, probably because only a fool would ask them. But they're bound to be asked repeatedly during the run of M. Richard Kirstel's new exhibition, "Pas de Deux," which opened Saturday at Exposure.

"Pas de Deux" consists of two related suites of photographs showing people making love. The first, made up of thirteen prints, portrays the heterosexual act of love; the second, fourteen prints long, is devoted to a lesbian couple.

Neither of these aspects of the same subject has been touched on at such length by any photographer—at least not in a public exhibition. Consequently, there's not much to which they can be compared. Emil J. Cadoo's artsy color photographs, James Lee's grotesque portfolio in *Evergreen Review* last year (an interracial lesbian couple—something for everybody—quite obviously posing for the camera), John Brook's lambent, somehow effete studies all come to mind, but they're not in the same league.

Kirstel's pictures are of major importance because in them, for the first time in such essays, sex is accepted implicitly as a natural act. Nothing is hidden, yet nothing is thrust forward out of defiance or rebellion; at no time is there the slightest hint of embarrassment, shame, or guilt. This in itself is a considerable, though refreshing, shock; it is rarely enough that one encounters a healthy mind. In the presence of one, the rhetorical questions do not have meaning.

The photographs are superb in many ways: as forceful yet gentle compositions, as masterful, almost virtuoso displays of the various uses of chiaroscuro techniques. But these virtues, though significant, are

nevertheless secondary, for these photographs were not made as studies in form or shadow, and to treat them as such is to shy away from their intent.

Inescapably, these are photographs of human beings engaged in the act of love. They are not suggestive, but outspoken. They are certainly capable of arousing your sexual passions—as well as your aesthetic ones. I can't say whether they're in "good" or "bad" taste (there are some people for whom cunnilingus—depicted in both sequences—will always be in bad taste), but they are intransigently honest.

In a wittily succinct note to the exhibition, Ralph M. Hattersley—a long-time friend and former teacher of Kirstel's—suggests that the photographs may disturb many people, either because they feel guilty about their sexuality or else because their own sex lives are not up to par. In a way, the show can serve as an informal Rorschach test, and I recommend tuning into your own emotional reactions as you go through it. Try to remember, as you do, just who is drawing the dirty pictures, should you see any.

"Pas de Deux" is, in the last analysis, a dispassionately passionate photographic celebration of physical love. Though I don't think either the photographer or the gallery owners set out to be heroes, it is also a courageous exhibition, one which may well be seen, some time from now, to have been a major breakthrough for both photographers and the public in the much-neglected area of freedom of vision.

Critique

In one of its rare but habitually patronizing nods to the medium which gave it birth, television has once again acknowledged the existence of still photography. The vehicle for this latest display of paradoxical paternalism was Channel 13's "Critique," which devoted its hour last Wednesday to "Light[7]," an exhibit assembled by Minor White.

The show consisted of a cursory sampling of the exhibit's wares (complete with the solemn intoning of snatches of White's Zen commentary), an interview with White accompanied by a small portfolio of his own work, and a panel discussion, moderated by Stanley Kauff-

mann, with Beaumont Newhall, W. Eugene Smith, and Andrew Sarris.

Given the paucity of TV's coverage of photography, I suppose we should be grateful for the largesse. Personally, I'm past that stage; I'd sooner starve than eat any more damn cake. I remember when, as a teenage jazz buff, I was delighted every time Timex dragged jazz up the river again—just the recognition of the medium, no matter how inanely presented, was enough for me then. Not any more.

Among the numerous irritants in the "Critique" program were the following: a wholly inadequate perusal of the exhibit, much too fast and truncated even to hint at what White was getting at; that maddening trick (which Sarris pointed out) of zooming in on some detail in a photograph, then zooming out to show the whole—a cinematographic gimmick which destroys the integrity of any still picture; and Stanley Kauffmann's infuriating habit of cutting his guests off just as they're on the verge of making an important point. But what angered me most was hearing Kauffmann—in that pseudo–devil's-advocate tone which always accompanies such queries—ask that hoary old question, "Aside from pushing a button, what does a photographer *do?*"

I can't imagine him having the gall to address variants of this question to artists and/or critics in any other medium. Try them out yourself. "Aside from (hacking away at a rock) (jumping around on the floor) (blowing air through a metal tube), what does a (sculptor) (ballet dancer) (French horn player) *do?*"

To my surprise and their credit, the panelists (with the partial exception of Sarris, who seems to harbor latent my-medium-can-lick-your-medium hostilities toward still photography) chose to treat Kauffmann's question as that of a benighted child, and, keeping their faces as straight as possible, gave him some good but generalized answers. Gratifying as it was to hear Gene Smith state that "pushing the button is a relatively unimportant part of the process," I was more appalled by the waste of time this question generated. Certainly only a small segment of the potential audience for this show is so naive as to need an explanation of the photographic process on that level; why go into it at all? And, as long as you've gone into it, why not attempt to answer it fully? Why not explain that, both prior to and following the act of "pushing the button," the photographer makes numerous major decisions? He must first pick his basic instrument, then a particular lens,

select filters if necessary, choose between black-and-white or color film, then take a specific film within those categories; he must also select a subject, single out what he feels are the essential elements of it, find the best angle from which to shoot it, cope with the vagaries of light, and only then push the button. After this, he must develop the film, edit his contact sheets to find the best pictures, pick a paper to print them on, determine the desired tonal range and print size, then make his print.

These are only a greatly oversimplified few of the technical processes involved, all of which have aesthetic and philosophical ramifications. Additionally, the photographer must train himself in other ways. He must learn the basic language of vision, and evolve his own dialect; he must develop an instinct for and instantaneous reaction to those rare moments in which things reveal their essences visually; he must discover who he is, and what he wants to say . . . That, in part, is what a photographer does. Now—aside from asking fatuous questions— just what does a moderator *do*?

1970

James Van DerZee

One of the few positive effects of "Harlem On My Mind" was that it brought to the attention of critics and public alike the work of James Van DerZee, a black photographer (now eighty-four years old) who for sixty years recorded life in Harlem. Van DerZee may well have been the only one to benefit by the Met's enormous mistake since—even though the show was a horror—it revealed to the world at large an unsuspected treasure trove of primary source material for black history in this century: Van DerZee's huge file of prints and negatives, somewhere between 30,000 and 50,000 of them.

The World of James Van DerZee: A Visual Record of Black Americans (Grove Press, 1969), the first extensive exploration of this archive, comes off as an attempt to capitalize on the recent flurry of publicity accorded Van DerZee. I don't think this is entirely intentional; Reginald McGhee, who edited the volume (and who served as director of photographic research for "Harlem On My Mind"), has great respect for Van DerZee's accomplishment, and his admiration for the photographer shines through his Introduction. Similarly, Candice Van Ellison's lengthy interview with Van DerZee—which is really the only text the book contains—is generally lucid and pertinent. But McGhee's selection of pictures fails to back up his own assessment of Van DerZee's significance; instead, it directs the reader along a false trail that leads away from, rather than toward, an understanding of the importance of Van DerZee's contribution. Additionally, McGhee's handling

VV, January 22, 1970.

of the pictures themselves nullifies what could have been this book's value.

Consider that, of the several hundred pictures reproduced therein, only a quarter are captioned in any way whatsoever, and even those are annotated less than adequately; how much research would it have taken to determine just which "one of the Mills Bros." is depicted in a photograph? Consider that the bulk of these photographs are individual and group portraits of unknown people, unidentified and (except in those cases where Van DerZee signed and dated the print or negative) undated. Consider that there is no real indication as to whether the order of the pictures is chronological. Consider that the only logical purpose of presenting 100 studio portraits of anonymous faces—aside from proving the photographer's talent for making same— is to provide a useful record of changes in style and fashion over the years, a record which can only be useful if arranged chronologically and with annotations. And so forth.

Why McGhee chose the pictures he did I have no idea, and I am even more bewildered by his careless, haphazard presentation of them, since that has created a book from which very little information can be gleaned. But I am most surprised that McGhee would use these images as a basis for suggesting that Van DerZee should be ranked with "those who have set the pace and continue to set the pace in this art called photography—people like Steichen, Stieglitz, Hine, Davidson, Hattersley, Bresson, Parks, Capa, Duncan, and Lang [sic]. . . ." (Note that Roy DeCarava's name is conspicuous by its absence.)

As a matter of fact, I don't think the comparison is entirely inapt, but McGhee's hyperbole clouds up the issue to no end. In the interview with Miss Van Ellison, Van DerZee makes it clear that, throughout his career, he was entirely unaware of what was happening in the medium, even of what was going on with black photographers; such names as Steichen, Stieglitz, Hine, and van Vechten rang no bells in his memory. From the photographs it is also apparent that—though he loved photography from the age of fourteen—he did very little exploring and experimenting in the medium, contenting himself simply with making straightforward posed portraits for a living. Van DerZee, then, is a naif artist, and one whose innocence did not lead him to any technical or aesthetic breakthroughs.

If he is not a genius, however, he is far from being a hack. A su-

perbly competent craftsman, he took excellent commercial portraits (which, if properly organized, could reveal much by themselves). In addition, he photographed the world around him: street scenes, parades, political rallies, sporting events, storefronts—almost the entire panoply of life in Harlem. "Harlem On My Mind" hinted at the extensiveness of his documentation; this book falls woefully short of displaying it properly. As the photographer himself says at one point, "With each new camera I would go out and shoot everything in sight." Had McGhee exploited this side of Van DerZee's work more intelligently, by emphasizing the photographer's uniqueness as a documentarian (Van DerZee is the only photographer I know of, black or white, who recorded Harlem throughout the first half of this century), the book might have established his claim to fame. As it is, McGhee's evaluation of Van DerZee is not supported by the evidence he offers—which is sad, because it could very well have been otherwise.

Since we are not likely to see another Van DerZee book soon it seems that the only possible way to gauge his true stature as an artist is through an exhibit—an extensive, carefully planned, accurately labeled showing of his own prints. I recommend this idea to the Metropolitan Museum of Art for consideration; it wouldn't be a bad way to begin atoning for past sins.

Roy DeCarava: "Thru Black Eyes"

Rising in a high, fluid arc of melody, the piercing cry of a soprano sax skirls and soars through the spacious gallery, echoing off the white, sun-warmed walls. An almost unbearable passion—more simultaneous ecstasy and anguish than most of us allow ourselves in a lifetime—surges through the horn, filling the room with its energy.

In one shadowed corner of the gallery, the creator of this music—John Coltrane, dead (so very much too soon) these three years—leans brooding against a wall between sets, hunches his huge form over his instruments, and then, drained utterly in the ugly pre-dawn city grayness, rests his head on a luncheonette table. These images are only photographs, of course; but in them, for anyone blessed with the memory of having seen him perform, Coltrane is alive. The music, as well as the man, can be felt in them.

Popular Photography, April 1970.

Other famous faces dot the walls: Lester Young, Billie Holiday, Langston Hughes. But unfamiliar faces outnumber them by far: children, young men and women, adults, the old, caught in all kinds of activity—laboring, playing, at home, on the streets. Just people, involved in the process of living, unusual only in that most of them are black and have been brilliantly photographed—as the exhibit's title makes explicit—"Thru Black Eyes."

Those three small words define the show perfectly. As they imply, the people portrayed therein have not been seen as specimens, symbols, or social phenomena, but as distinct, unique human beings—a rare and momentous achievement. And, as the title also suggests (through an apropos, probably intentional, pun), these images were made by an artist who has fought a long, punishing battle for creative survival—and who has, at great cost, won.

In a peculiarly American perversion, our society delights in taking credit for the success of artists who manage to overcome the endless obstacles we place in their path. It may be gratifying to think of ourselves as an aesthetic boot-camp, and in some instances not entirely inaccurate; most often, though, all that is accomplished by this enforced hurdling of nonsensical barriers is the dissipation of creative energy, the frustration of wasted time. For black artists, needless to say, these problems are so compounded that superhuman efforts are required merely to retain enough sanity to go on.

I state this deliberately and bluntly, to forestall anyone (myself, white as I am, included) from rationalizing himself into the mistaken belief that the triumph of this exhibit belongs to anyone save the man who made it—Roy DeCarava. This is his show, his alone; and, quiet as it may be kept, I do not think that Edward Spriggs—executive director of the Studio Museum in Harlem, where "Thru Black Eyes" was mounted—exaggerated too much when he called it "one of the most important photo shows of our time."

It's a three-flight walk up to the heavy metal door bearing the name DeCarava in thin, elegant letters. If the light is right in the dim hallway, you can just make out the word "photographer" beneath the name, painted over but still faintly visible. Inside the studio there is space, light, and order.

Row on row of carefully labeled boxes of prints line the shelves, along with books, magazines, and records. The furnishings are sparse:

a neatly made bed, several chairs. A saxophone rests on its stand, gleaming in the noon light which streams into the front room from windows which look out on Sixth Avenue in the upper thirties, near the heart of the garment district in midtown Manhattan.

The studio's tenant must be numbered among the eminent contemporary photographers. One of that handful of men who have been awarded Guggenheim Fellowships for photography, he is represented in the permanent collections of many institutions, including the Museum of Modern Art, the Chicago Art Institute, and the Metropolitan Museum of Art. He ran one of the first exclusively photographic galleries in the city, and organized a workshop which, though currently defunct, continues to be highly influential. He has participated in numerous important group exhibitions, including "The Photographer's Eye," "Always the Young Stranger," and Steichen's "Family of Man." (Steichen, incidentally, is a particular admirer of his.)

In collaboration with a renowned American writer, he produced a book that won two awards, received critical plaudits from the *New York Times Book Review,* and sold out its first edition. Additionally, as his superb one-man show proved, he is capable of sustaining an exhibit almost 200 prints long—which, in my book at least, places him in the ranks of the master photographers.

Yet Roy DeCarava is almost as unknown to the outside world as are the men who push racks of clothing through the streets below his windows. His name is hardly recommended for dropping; it rings no bells with most people. While it is tempting to call him a "photographer's photographer," that would be evading the issue, since only a small number of photographers are aware of his work.

Most of those who recognize his name do so with raised eyebrows and a strange expression—as though the photographic world were a frontier town, and they had just heard tell of some trouble-making lawman hellbent on a showdown with the local gunslingers. Not only do such words as "difficult" and "intransigent" crop up continually in the ensuing discussions; at times, incredibly, there is even a faint aura of danger, much like that which hangs over the marked man in a gangster flick.

All of which is curious indeed, because Roy DeCarava does little more than tell the truth as he sees it and insist on his rights as an artist and as a man. It would be even curiouser—incomprehensible, in fact—were he not black.

Though unacknowledged and unmentionable—photographers, after all, pride themselves on belonging to a hip, pace-setting profession— there is as much *de facto* segregation in the photographic field as in any other. Less blatant, perhaps, because it is less an act of commission (it's hard to stop a man from taking pictures) than of omission (it's easy to prevent him from making a living at it), discrimination is nevertheless common practice. Excepting Gordon Parks, the industry's carefully selected token Negro and the only one yet permitted to reach the top, the facts speak eloquently for themselves.

Aside from those employed by the black press, only a handful of black photographers have been able to earn a living as photojournalists. Despite the dramatic increase in coverage of black-oriented material and news events over the past decade, this situation has not noticeably improved. Ironically, the assignments for these stories have almost invariably gone to white photographers. Intent as we are on preserving our distorted vision of black reality, we have insured that it reaches us only after filtration through white eyes.

Similarly, blacks have been unable to break into fashion and/or advertising photography. Indeed, until a few years ago there was segregation on both ends of the lens: the models, as well as the photographers, were exclusively white. That could hardly have escaped the discerning eyes of the fashion and advertising photographers: but, though it was certainly within their power to do so, I don't recall the top men in the field banding together and refusing to shoot a racially unbalanced session. Nor, for that matter, have the leading models exerted any corresponding pressure for integration of the studios. A tacit form of racism is still, conveniently, being overlooked.

The same bias prevails in the area of creative photography. Not many "pure" photographers, black or white, are able to support themselves through their art, so the criteria are different. But the clues are there: the established galleries do not exhibit the prints of many non-whites, while museums have for the most part ignored them completely. Thus, the black artist is cut off from his potential public and from his peers, forced to work in a vacuum and go unnoticed.

Under these circumstances, it is little short of amazing that a black photographic aesthetic has evolved and that a black school of photographers can be identified. Both of these developments can be attributed directly to Roy DeCarava, who has bucked the system and worked toward these goals for over twenty years.

DeCarava's contribution to modern photography is twofold and both facets merit consideration in depth. First, he is—as photographer James Hinton wrote in the exhibit brochure—"the first black man who chose by intent to document the black and human experience in America, and he has never wavered from that commitment. He was the first to devote serious attention to the black aesthetic as it relates to photography and the black experience in America."

Consequently, DeCarava's body of work, taken as a whole, provides what is undoubtedly the most thorough and profound record we have of black life over the last two decades, invaluable precisely because it was made from within the black culture rather than from without. His unswerving dedication to this task has made him the spiritual father of all black photographers. To quote Hinton, "For those of us who knew his work at first hand, he set a unique example. His influence today extends throughout the field."

Much of that influence can be traced back to the Kamoinge Workshop, which DeCarava founded and ran from 1963 through 1966. Organized by him at the request of numerous black photographers, Kamoinge (the word, Kikuyu in origin, translates roughly as "group effort") was, according to DeCarava, "an attempt to develop a conscious awareness of being black, in order to say things about ourselves as black people that only we could say. A black man," he continues, "sees the world through black eyes, and it's this blackness that shapes his world. The black man—and, of course, this means the black photographer too—tends to see the world in a more truthful, realistic way; he must, to survive. And, because of the immediacy of the medium, this is very important."

He is not involved in the planned revival of Kamoinge. "It was a very fruitful experience for me," he explains, "but I've done what I could: I don't think there's anything I could add at this stage of my life." The workshop's impact has continued to be felt since its demise, not only directly—in the work of such former members as Lou Draper, Beuford Smith, and Ray Francis—but also at one remove from the group itself.

As James Hinton (another former member) pointed out in a telephone conversation, "The younger black photographers have been influenced by Roy without knowing it, through the few black photographers who do know his work. Black photographers—and black sub-

jects—used to be afraid to be black. Roy broke that down, and he was doing that in the late forties and early fifties—twenty years ahead of his time."

The second part of his contribution, inherent in his work, is an approach to the medium, to the act of photography, which makes his images extraordinarily compelling.

We are accustomed to defining maturity in a photographer as the ability to confront honestly and express clearly his own deepest feelings. This is a valid standard, as far as it goes (though there are precious few who meet it: too often, in its guise, we are offered pictures which, by pleasing the eye and titillating the intellect, camouflage their failure to affect the heart). Beyond the self-knowledge which introspection brings, however, there is an even higher level of photographic maturity: the ability to use that self-knowledge for the purpose of confronting honestly and expressing the deepest emotions of others.

For any photographer whose primary subject is people, this is treacherous ground to tread. Pitfalls abound: sentimentality is one, formlessness another—and, even if these are avoided, success is never guaranteed. Yet, eschewing sentiment, and without in the least sacrificing formal considerations, Roy DeCarava has charged all his images with the emotional *Gestalt* of the moment in which the camera seized them.

If this sounds somewhat reminiscent of the "decisive moment," that is not accidental: Cartier-Bresson was DeCarava's greatest initial influence (though, like many others, DeCarava finds in the French photographer's later work a decided falling-off in quality). But DeCarava does not share Cartier-Bresson's detachment: his personal involvement in the moment—best described as subjective objectivity—produces pictures in which self and subject are perfectly merged. Because it is purely visual, this effect is difficult to describe (though such words as love, soul, and compassion—especially compassion—come to mind), but it results in unutterably moving photographs.

Given all this, it is hardly surprising that DeCarava should have elected to work within the boundaries of the realistic tradition, unquestionably the ideal framework for his vision. However, it is not only surprising but grimly ironic to hear the curator of a leading photographic collection dismiss him—regretfully, it should be noted in all fairness—as being, "after all, rather old-fashioned." That DeCarava

has remained true to his vision, even at the price of being bypassed by the waves of fashion, is one of his greatest victories.

For, far from stagnating, his work has become richer and more passionate. Straightforward and ungimmicked as always, his style has acquired a flowing tenderness rare in any medium. His formal sense is sure but deceptively simple: only as an afterthought does the viewer realize the strength of his compositions. His prints, unusually sensitive to subtle tonal gradations, are never harsh or exaggerated, filled instead with the delicate interplay of dark and light.

One is conscious of him not as a photographer but as a perceiver, focusing himself on the world, forcing the viewer to experience it with him, up to the hilt. Discipline and freedom, eloquence and understatement, in exactly the right proportions—the hallmarks of the consummate artist.

> *You should be able to look at me and see my work. You should be able to look at my work and see me.*
>
> ROY DECARAVA

Portraits of him—even one he took himself—fail to capture the controlled intensity of his presence. In them, his eyes seem vaguely troubled, and there is a guarded quality, as though he did not entirely trust the instrument to which he has devoted his life. In person, what appears at first to be an impossibility—the absence of bitterness—is in fact something more dynamic, the presence of an internalized anger that must daily be reconquered.

"I am bitter," he said quietly, "but that's a safety valve, a self-indulgence. Either you believe that life in all its manifold horrors is basically and essentially good, or you don't." A pause. "What I try to say in my work is that I believe in life. I can't create out of bitterness. It undermines my creativity."

As we sat talking, at the tail end of September, "Thru Black Eyes" —his first one-man show in several years—was entering the third week of its run at the Studio Museum. It had taken him only three days to assemble: "I knew what I wanted to include," he told me, "and I had the prints on hand. I always make up several as I go along—I hate printing old negatives."

Attendance was high, resulting in part from DeCarava's reputation and in part from the unanimous critical acclaim accorded the exhibit.

While obviously pleased with the show and its reception, he was anxious that it be understood. "I wanted to show in the community," he said, explaining his acceptance of the Studio Museum's invitation (the Studio Museum, a non-profit gallery/showcase for black artists, is located just off 125th Street on Fifth Avenue in Harlem).

"This is not a retrospective," he also insisted. "I'm not nearly finished—I'm not even ready for a summation." To emphasize the exhibit's non-retrospective nature, none of the pictures from *The Sweet Flypaper of Life*—first published by Simon and Schuster in 1954—were included.

Unready for a summation he may be, but Roy DeCarava has been at it for a long time. Born in New York City in 1919, he was brought up in Harlem and began his creative life as a painter, studying at Cooper Union and elsewhere. "My mother always had a Brownie and took pictures all the time," he recalls, "but I never thought of it as a serious medium." However, like many other painters, he began taking pictures himself in lieu of making laborious sketches, and eventually gave up painting for good.

He gives two reasons for his switch to photography. First, "a black painter to be an artist had to join the white world or not function—had to accept the values of white culture, like emphasizing technique in painting rather than what the artist feels. Black people have a spiritualism, maybe because for so long they had nothing else." Second, he found himself devoting more and more time to photography.

He started to photograph seriously in the late forties, and received his Guggenheim—the first ever awarded to a black artist—in 1952. The pictures that he took on his Guggenheim—all studies of life in Harlem at that period—became *The Sweet Flypaper of Life*, to date the only collection of his work in book form. This slim volume (still available in a Hill and Wang 1967 reprint edition)—which Gilbert Millstein described in the *Times* as "a delicate and lovely fiction-document"—was the brainchild of Langston Hughes, author of the tender, lyrical text.

"Nobody wanted the pictures," DeCarava remembers, "so I took them to Langston. I never said a word to him about those photographs; I just handed them over to him." Hughes assembled DeCarava's images into a visual narrative, a counterpoint to the bittersweet story he wrote to accompany them.

As Millstein pointed out in his review, "Mr. DeCarava's photo-

graphs are peculiarly apposite, without being merely a collaborative effort. In this book, the story and the pictures are not so much dependent on each other as they are justifications of each other."

(Since then, the photographer has produced another book, *The Sound I Saw: Improvisations on a Jazz Theme,* but "nobody wanted that either. I did all the work—writing, editing, designing. . . . It's been to all the publishers, but they all turned it down. They say it's too pretentious. . . ." Much larger and more complex than his first book, *The Sound I Saw*—which contains many of the pictures in "Thru Black Eyes"—is an exciting attempt to capture the spirit of jazz and its close relationship to the black experience, interweaving photographs and a long poem in free verse.)

Until 1958 DeCarava supported himself and his family by working as a commercial artist, shooting in his spare time. Then he decided to try freelancing: his two children were of age, and he was financially free. But breaking into the field was next to impossible, because he was black. "It was a horrible experience. I had won a Guggenheim, I had published a book, I had run a gallery, but I couldn't get any assignments. It was a hand-to-mouth existence. Harry Belafonte gave me several jobs, and that helped to pull me through. . . ."

Even so, it is only recently that he has enjoyed any measure of financial security. He has been under contract to *Sports Illustrated* for the past three years; this provides a stable income, and he enjoys the job: "I wouldn't want to work for anyone else right now." He also teaches a course in photography—beginner-level, one class a week—at Cooper Union, his alma mater. Fame has, so far, eluded him—or vice-versa. Yet it is to be hoped that "Thru Black Eyes" will mark a turning point in his career, and engender a greater public awareness of his talent. A *tour de force* despite itself, the show only hinted at the breadth of DeCarava's accomplishments.

Though one would tend to assume that such a large collection of prints—roughly 180—must represent the absolute cream of his visual crop, this is not the case. Indeed, according to a photographer who knows DeCarava's work well, "Roy could have put together ten shows this size. Some of his strongest pictures are missing—things I kept expecting to see just never turned up. But that's the way Roy wanted it." Rather than a self-glorifying, virtuoso display, DeCarava chose instead to offer a carefully planned, thematically structured exploration of black life. Sections were devoted to such subjects as family

life, music, civil rights demonstrations, work, and the white world; the exhibit probed the ghetto's subsurface far more exhaustively than the Metropolitan Museum of Art's "Harlem On My Mind."

"Thru Black Eyes" more than justifies DeCarava's "intransigent" insistence on an entire room for himself as the price for his participation in the Met's fiasco. No one, black or white, has photographed New York's black ghetto more truthfully or in greater detail over the past two decades, so it hardly seems out of line for him to have asked for one room—which, not altogether coincidentally, is exactly the space "Thru Black Eyes" occupied.

But his conditions were not accepted, and—unlike Bruce Davidson, who at first made the same demand—DeCarava refused to compromise. Opening night of "Harlem On My Mind" found him on the picket line outside, dressed for the icy January weather and bearing an angry placard ("the foreigners reveal the real nitty-gritty"); no pictures of his graced the walls of the Met's galleries. Shortly thereafter, he stated the motives for his protest in these pages (May, 1969). His biting critique of the exhibit's technical flaws concluded with these words: "It is evident from the physical makeup of the show that Schoener and company have no respect for or understanding of photography, or, for that matter, any of the other media that they employed." Then, exercising considerable restraint, he added, "I would also say that they have no great love for or understanding of Harlem, black people, or history."

Obviously, this sort of frankness has not endeared him to the photographic establishment, and he has ended up in a semi-exile which is only partially self-imposed. During his membership in ASMP (the American Society of Magazine Photographers), for instance, he formed a committee to combat discrimination in the field. But, as he notes, "doing something fundamental was a different question entirely." At one meeting of the organization, he rose to inform the assembled members that "there are two societies—one white, one black." No one today would question that statement, but he was denounced as a racist and promptly resigned. "They give you a promise like a carrot on a stick—and you wind up without any balls, grinning. No, I'm not loved by the white photographic community," he says wryly, "but I *am* loved by the black photographic community, and that's what really matters to me."

He recounts these and countless similar incidents reluctantly,

though with calm objectivity; he would obviously much prefer to discuss his work. Yet his struggles are so intertwined with his imagery that it would be hypocritical of him to avoid mentioning them.

Always, though, he comes back to his art. "Photography is an intransigent medium," he believes, "and it's very hard to express yourself. After you get a certain technical facility—and from the very first I took 'good' pictures—you've got to get at what you feel." Describing his own approach, he says, "I want to reach people inside, way down—to give them a quiver in their stomach. I've reached a certain plateau at this point, where I can sense an even greater intensity in a situation than I'm able to get on film. That's what I've got to learn to capture, even if it takes the rest of my life."

It is little short of tragic that our prejudices should have deprived Roy DeCarava of the wide audience he deserves, and deprived that audience of an artist with so much to reveal that they desperately need to know. As Edward Spriggs commented, in soft indignation, "Roy was way overdue for something like *Thru Black Eyes*. He should have been exposed on this scale fifteen years ago. He's forty-nine, and this is the biggest show he's ever had."

It is high time for Roy DeCarava, black photographer, to begin receiving that recognition rightfully due him.

"Photography into Sculpture": Sheer Anarchy, or a Step Forward?

No microcosm better exemplifies Marshall McLuhan's concept of the "global village" than the world of art in our time. Assimilationism is rampant in every creative medium, and experimentation so prevalent that the avant- and derrière-gardes seem to have reversed roles, with the more tradition-oriented now in a definite, if defiant, minority. The arts have so overlapped that it is fast becoming impossible to tell precisely to which media (save for the catch-all "mixed") individual works belong without consulting wall labels, those esthetic equivalents of scorecards; and, with curators hot on the heels of each new breakthrough, even those are not always useful.

Boundary lines once thought to be inviolable—those between dance

New York Times (hereafter *NYT*), April 12, 1970.

and theater, for instance, or between painting and photography—have been entirely eradicated in certain areas, and it is only a matter of time before other, theoretically clearer distinctions—between dance and painting, say, or music and film—become equally arbitrary. Indeed, future generations may not be able to distinguish between their sculptors and their painters (assuming, one hopes incorrectly, that they'll share our own compulsion to pigeonhole) unless records are kept from birth indicating just which each artist touched first, finger paints or modeling clay.

Depending on one's philosophical bent, this phenomenon can be viewed as (1) the penultimate stage of decadence, with nowhere left to go save—horrors!—sheer anarchy; (2) the necessary prelude to a puristic renaissance which will restore our guidelines, values, and morals; (3) merely another swing of the eternal pendulum; or (4) the first step toward a needed redefinition of·art/creativity—namely, the elimination of inter-media competition and bigotry.

Leaning as I do in the direction of the third and fourth attitudes, I am generally undisturbed by the reverse fence-mending now current in the arts (though I sympathize enough with those who believe in the first two alternatives to share some of their angst and/or optimism). After all, if a sanitation engineer is happier engineering my sanitation than he was when, as a garbageman, he collected my garbage, who am I to say him nay? In other words, labels are critically meaningful—as opposed to utilitarian—only when they are applied by the artists themselves, and the difference between a graphic artist such as Robert Rauschenberg, who incorporates photographic images in his work, and a photographer such as Scott Hyde, who employs silk-screen techniques in producing his final picture, is one that I do not care to define.

Admittedly, this leaves me open to charges of begging the issue—but is there really an issue? Unless we are to assume that a work of art must, by definition, be something belonging to one medium and one only, and unless we are ready to certify that any combination—from painted Greek sculptures through Picasso's collages to Lyn Wells's "photosensitized contour-molded cloth sculptures"—is a bastardized creation whose illegitimacy precludes ascension to the throne of Art, there isn't. We can only fall back on a pragmatic approach: Does it

work? Does it affect us in some way, intellectual or emotional (or both), profoundly? Does it state its own terms and meet them? And, further, if a number of otherwise unrelated artists can be shown to be experimenting in the same vein, does this body of work seem to be exploring a fruitful creative territory?

Though I would answer all those questions affirmatively in dealing with most of the fifty works assembled by Peter Bunnell in the Museum of Modern Art's new exhibit, "Photography into Sculpture," the show is certain to arouse controversy, and not just in photography circles. For one thing, instead of constructing a pigeonhole it deliberately tears one down; and for another, it offers the public a chance to reassume the burden of making its own evaluations.

"Photography into Sculpture" brings together the work of twenty-four American and Canadian artists (some of whom call themselves photographers, others painters or sculptors) whose work has two things in common: three-dimensionality and the photographic process. Their involvement in the potential complexities of photography ranges from minimal (Theodosius Victoria's "View," a *camera obscura* device created with a desk magnifier and a sheet of translucent Plexiglas) to maximal (Joe Pirone's marvelously titled "Succubus III: She Comes and Goes Bump in the Night," a multi-layered series of images on transparent film, mounted in a box so that all are seen at once). Sculpturally, they run the gamut from Charles Roitz's "Triptych"—a Metzker-like central panel composed of many images in a time-sequence, flanked by two apposite end panels—to the Lyn Wells piece mentioned previously, a life-size figure of sensitized linen stuffed with urethane, on which the front and back portraits of a man have been printed.

Is this Photography? I happen to think so—but if it isn't, does it matter? If Dale Quarterman can create, out of styrofoam and photographic prints, an extraordinary object which serves as an illuminating visual metaphor for subtle relationships between the clothed and nude human form and the mental states of extroversion and introversion, must we be able to categorize it before we can appreciate it? (In fact, might not the very absence of easy categories force us to come to terms with "Marvella"—as this piece is called—rather than allowing us to file it away?)

Conversely, if Jerry McMillan's "Door No. 2"—an acrylic painting

in which certain portions, such as the floor, are scale photographs of those parts of the scene—amuses us only mildly with its trompe-l'œil effect, can't we write it off as one of his less significant works without putting a generic tag on its toe?

Most of the pieces in this show defy description, except of the most pedantic, curatorial, materials-and-processes sort. The methods are startlingly diverse, and the results are almost always stimulating, since they all force the viewer to examine his preconceptions about the relationships between the various media involved. Beyond that, they begin to weed themselves out qualitatively; but even the least of them—"BLT" by Robert Watts, for example, patently derived from Oldenburg's food sculptures—are of more than passing interest.

And the best transcend technical punning and gimmickry; the work of Quarterman, Pirone, Carl Cheng, Jerry McMillan (his "Bag" series is remarkable), Jack Dale, Ellen Brooks, Leslie Schneider, and Robert Heinecken—a founding father of sorts for this new school—is as demanding and rewarding as that being produced by their contemporaries in other branches of photography, and in other media as well. This, really, is the only criterion by which we can assess such investigations into new artistic territories. That such a direction as this may eventually prove to be a dead end is the risk taken by any artist who dares to explore one. As "Photography into Sculpture" demonstrates, however, there is much to be learned along the way by those who join the expedition; and at least some of the samples such pioneers bring back will prove to be more than mere souvenirs.

Inside the Museum, Infinity Goes Up on Trial

The alliance (uneasy at best) between the Metropolitan Museum of Art and the medium of photography is almost as old—and equally as perverse—as this strange century of ours. From the very outset it was obvious that no fiery pas de deux would be danced by these partners, but one might have expected something more than the palsied two-step they have been doing these many years. To date, the Metropolitan has played the blue-blooded but distinctly decrepit December to photography's youthful but merely red-blooded May; and like most

old men who wed across the generation gap, the Metropolitan has yet to realize what a ripe, sensual, passionate woman it has on its hands. The unfortunate result is that this *mariage de convenance* has still to achieve consummation.

The relationship began shortly after the turn of the century, when Alfred Stieglitz blackmailed the Metropolitan's then-director, General Luigi Palma de Cesnola, into promising to mount an exhibition of Photo-Secession work in the museum—Cesnola's half of a tit-for-tat arrangement. Convinced that such an exhibit in the hallowed halls of the nation's foremost art institution would end photography's long period of bastardy, and assured as well that such legitimization was of utmost importance (two assumptions which could, conceivably, have been entirely erroneous), Stieglitz was tremendously disappointed when Cesnola's death precluded fulfillment of his share of the bargain. His grief was justified, for it was not until two decades later that photographs were finally installed in the Metropolitan's galleries—and then only after Stieglitz had been blackmailed into providing, free of charge, a selection of his own work.

That was the beginning of the Metropolitan's photographic collection. It was considerably enriched in 1933, again through Stieglitz, who—so poor that he could no longer afford to store it—decided to donate to the museum his magnificent personal collection of work by Photo-Secession photographers (J. Craig Annan, A. L. Coburn, Frank Eugene, Frederick Evans, Edward Steichen, Clarence White, and a host of others) rather than destroy it as he was tempted to do. It would have seemed—at least at that time—that the Metropolitan was off to a flying start as a photographic archive.

Yet, despite the importance of these initial accessions—along with some material acquired thereafter through the foresight of two former curators of prints and drawings, A. Hyatt Mayor and William M. Ivins, Jr.—the Metropolitan has been unable to understand or come to grips with the medium of photography, and the consequent absence of anything resembling a consistent policy in this regard has had regrettable but inevitable results. The collection is almost entirely unknown to the public (though not exactly inaccessible: anyone interested may peruse all the material therein, at his or her leisure, by appointment only, in the Print Study Room), an ignorance attributable specifically to the museum's failure to explore its holdings systematically via regularly scheduled and intelligently planned exhibitions.

The collection is also riddled with awesome gaps and has cast aside even the pretense of balance; furthermore, the accompanying library is woefully inadequate. All in all, there are so many good reasons for the decline of the Metropolitan's reputation in the area of photography that it will take much, much more than the recent renaming of the department—from "Prints and Drawings" to "Prints and Photographs"—to restore it. (Considering that museums and other institutions across the country are opening their doors to photography on an unprecedented scale, the tokenism implicit in pinning a photographic tail on the graphic arts donkey is both belated and patronizing.)

The crux of the matter is that the Metropolitan Museum has never taken photography seriously; and thus photography—by which I mean photographers, critics, and the photographic public—has ceased in turn to take the museum seriously. For too many people today, photography at the Metropolitan means either the Photography in the Fine Arts fiascos or "Harlem On My Mind." (Since the latter exhibit did not originate in the department nominally in charge of the medium, that department can't be held accountable for the stupendous bungling which ensued. However, the fact that the department did not protest, long and loudly, over the abuse of the medium in that show is in itself significant.) If this quite correct but hardly favorable impression is to be altered, nothing short of a radical restructuring of the museum's attitude toward photography will be required.

John J. McKendry, curator of the Department of Prints and Photographs, has high hopes that the situation will improve in the near future; but his optimism is not necessarily warranted, for the difficulties facing him are of major proportions. First, there is the spottiness of the collection, which is too heavily weighted toward the nineteenth and early twentieth centuries. Even for that period there are holes—Brady, Jackson, Gardner, Atget, Hine and several others are among those missing. Of the post-Stieglitz generation, Weston is the sole photographer of major significance who is adequately represented; Barbara Morgan, Cartier-Bresson, Paul Strand, Robert Capa, the Farm Security Administration school (Dorothea Lange, Walker Evans, Arthur Rothstein, Ben Shahn . . .), Harry Callahan, Brassaï, W. Eugene Smith, Wynn Bullock, Minor White, Bill Brandt—the list of those represented by only one print or totally absent goes on and on. And there is virtually nothing from the past decade.

McKendry, whose lanky elegance matches his soft-spoken articu-

lateness, is well aware of this deficiency. "If someone came in and looked through everything we have," he admits candidly, "he wouldn't get a particularly accurate impression of the medium's development. There are many gaps in our collection—but none are irreparable." (As indeed they aren't—if the museum is willing to spend the time, trouble, and money to flesh out this skeleton in its closet.)

McKendry is more immediately concerned with the severe shortage of available space for the presentation of photography exhibits, a shortage which has been exacerbated by the current combination of extensive renovation and centennial exhibits. This scarcity accounts in part for the brevity and confusion of the museum's most recent show. "The Photograph: A Selection of Recent Acquisitions," a hodgepodge of fifty-two prints by twenty-eight photographers, was installed in the Prints and Drawings Galleries in mid-April for a mere two weeks and received no publicity whatsoever. "I knew on a Thursday that the gallery would be empty for two weeks, and the show went up on the following Tuesday," the curator explains. "It was thrown together, of course, but I'd rather do that than not show anything."

It is a plausible enough excuse; but, though the fault cannot be traced to McKendry alone, the fact remains that the only time and space devoted to photography in the past year was completely inadequate, and the exhibition which resulted followed a pattern—or a nonpattern—which the museum seems unwilling or unable to alter. (The preceding exhibit, "Thirty Photographers," was mounted in May of 1969; though it did receive sufficient publicity, it was a similarly haphazard grouping of prints.)

Within the next few years, McKendry predicts a number of positive changes: a more thoughtful acquisitions program, the creation of a permanent photography gallery, and a regular schedule of exhibits. "What bothers me most," he emphasizes, "is that we're not doing nearly enough shows. Having so few gives each one an inordinate weight. I'd like to do many more exhibits, small ones with a minimum of fanfare, and vary the work considerably. We shouldn't concentrate on the classics as much as we have; the audience should be faced with visual challenges from the past and the present."

The pace is being stepped up a bit. There will be another photography exhibit in June and July ("Six Documentary Photographers, 1890–1929," consisting of seventy-five prints by Percy Byron, Charles

Currier, Arnold Genthe, Lewis Hine, Frances B. Johnston, and Jacob Riis); a major Paul Strand retrospective is now in the first stages of preparation; and McKendry speaks of plans for integrating photography into other areas of the museum (through such devices as mounting prints by Charles Sheeler next to the sculptures and statuary he photographed as a member of the museum's staff). "Eventually," says McKendry, "I'd like to have at least one photographic exhibit, large or small, on view at all times."

Promising as all this sounds, it nevertheless may prove to be too little and too late. What is really at issue is the Metropolitan Museum's fundamental failure to recognize photography as a major creative medium. The institution's attitude has not changed perceptibly since Cesnola's day; yet, simply by virtue of what it possesses, the museum has a responsibility to the public and has failed to live up to that obligation for almost half a century.

The remedy is obvious. It begins with the acknowledgement of past errors and the establishment of a separate Department of Photography, complete with ample gallery space and a curator with extensive training in the history and aesthetics of photography (which McKendry, for all his obvious respect for the medium, lacks). It continues with the provision of funds sufficient for the purpose of maintaining and expanding a comprehensive collection of historical and contemporary photographs, along with an intelligently designed, ongoing series of exhibitions to bring those photographs before the public.

There is a difference between a repository and a safe-deposit box. For too long, the Metropolitan Museum has behaved like the latter in regard to photography, with the result that it has become so irrelevant and useless to the photography community that it is in imminent danger of becoming completely divorced from the living medium. Unless the museum decides to take immediate steps to rectify this, it might do well to consider the possibility of turning its holdings over to any one of several other institutions which would be capable of treating them with the respect they deserve—and proud to do so as well.

Holography: A Prophecy

Photography is hardly short of direction. Indeed, if it has any troubles along those lines, they relate to the multiplicity of directions in which it is heading.

One recent development which is bound to have enormous impact on the medium's future is the holograph, a photographic process which makes possible the creation of a three-dimensional image. Holography has been around, conceptually, since the late forties, but the discovery of the laser beam and the increased sophistication of laser technology have made it a reality.

Those of you who read *Stranger in a Strange Land* and remember Heinlein's "photo-pantogram" of a Rodin sculpture have some inkling of the implications of the process, but sixteen examples of the real thing are now on view at the Finch College Museum of Art. These were created by seven avant-garde artists—Lloyd G. Cross, Robert Indiana, E. N. Leith, Allyn Lite, Bruce Nauman, George Ortman, and Gerald Pethick—working in collaboration with trained laser technicians. The works, therefore, while extraordinary, are not specifically photographic (Bruce Nauman's self-portraits come closest, I suppose), though they do employ a process which is a ramification of photography.

The holographic plate is created by diffusing, splitting, and reflecting a beam of laser light so that light waves from several different vantage points are bounced off the subject and recorded on the plate. The image, or hologram, is then reconstructed by diffusing laser light and bouncing it off the plate; the consequent reflection, caught on another plate, is an image so three-dimensional as to be almost unbelievable. What it could create, in the hands of serious and imaginative photographers, I hesitate to guess, simply because such predictions would seem far-fetched at the moment and tame a decade hence. I have no doubt, however, that someday in the near future we will purchase holograms in the same fashion as we now purchase prints, for photographers will inevitably involve themselves more actively with the exploration of what the exhibit terms "N Dimensional Space" through the holographic process.

VV, May 14, 1970.

The Horrors of Hiroshima

Over the past century, photography has taught us much about ourselves. Through this medium, we have learned the mechanics of human locomotion, the complexities of our skeletal structure, the physiognomic subtleties of our personae—and the depth of our depravity.

Not that man's inhumanity to man is the exclusive province of photography, by any means. From the illustrations for medieval "books of martyrs" down through Goya to Picasso and Francis Bacon, we have had an abundance of visual metaphors for the monstrous, savage cruelties of which man is capable. The difference between such graphic representations of horror and their photographic equivalents is, fundamentally, the difference between photography and the other graphic media.

Although it can, and often does, lie, the photograph is the closest thing we have to an objective visual record; it is evidence, and not only in a legal sense. The photograph deals with literal fact on a level no other visual medium can approach. Quicken the conscience though they may, metaphors—even such overpowering ones as those Goya created in the *Disasters of War*—are remote and therefore safe. The people therein are figments, along with their agonies. This permits the spectator to enjoy a vicarious emotional/esthetic thrill of moral revulsion while protected by the symbolic nature of metaphorical creations. In a photograph, on the other hand, the suffering, the wounds, the reality of pain are undeniably present.

It is hardly coincidental that the romantic myth of the glory of war began to evaporate at the same time that photographic coverage of nineteenth-century warfare commenced; the evidence made a mockery of the illusion. Nor is it accident that our own age has seen the flowering of the literary genre known as "black humor"—a genre whose practitioners, a scant three decades ago, would have been classified as lunatics and dismissed (or incarcerated) forthwith. The evidence was not yet in and we were simply incapable of believing the worst about ourselves.

In other words, the credibility of Joseph Heller's *Catch-22* is in a very real sense dependent on the existence of photographs recording

NYT, June 7, 1970.

the mountains of corpses at Belsen and Auschwitz, and on the existence of another body of photographic evidence which we are only now—twenty-five years after the fact—able to confront. I am speaking of the sixty photographs in the "Hiroshima and Nagasaki" exhibit on view at the New York Cultural Center.

They are not particularly unusual or outstanding photographs, in a stylistic and technical sense. Indeed, they are typical news photographs which could have been taken by any of a horde of press photographers working for daily papers around the world. That they are so horrifying as to leave me weak-kneed and sleepless for several nights after seeing them has nothing at all to do with their artfulness or lack of it; it has everything to do with the fact that they are *photographs* of those two atomic explosions and their aftermath, since there is no escape from the reality they document.

There is no artifice to hide behind, no re-enactment to place the carnage at one remove from conscience. The keloid scars that run like mountain ranges across a woman's throat, the fetus burned black within its mother's womb, the carbonized bodies caught in a final spasm of convulsive frenzy—all are simply there, beyond question, beyond belief (and yet demanding belief with the photograph's inexorable insistency). The inclusion in the exhibit of such items as chunks of human bone embedded in melted tile and a human hand fused to a lump of glass is almost gratuitous; the photographs are proof enough of what we unleashed upon other human beings.

At the beginning of the exhibit catalogue there is the following proclamation: "Now for the first time since the dawning of the Atomic Age, twenty-five years ago, the people of a nuclear power can view a comprehensive exhibition of the actual effects of nuclear war. What more appropriate way to *observe* this quarter-century Anniversary than to *actually observe,* as closely as we can, the realities of such a catastrophe?"

It is imperative that this exhibit be widely seen, and it is regrettable that—though it has been on view in Japan for fifteen years—we are just now getting our first look at it. There are explanations, of course, for the delay: the "yellow-peril" racism which underpinned our choice of Japan as the initial target and the shock-waves created merely by news reports and non-fiction documents such as John Hersey's *Hiroshima* are only two. Devastating though it may be, however, this is

one truth that we badly need to know, before the Pentagon talks the president into permitting the use of small-scale nuclear weapons in Indochina or elsewhere. These photographs reveal man's almost infinite capacity for cruelty. It will take time for us to come to terms with that capacity, and even longer to diminish it. We had best start soon.

Roger Minick: *Delta West*

Even today, photography books make the American Institute of Graphic Arts' list of "Fifty Books of the Year" infrequently enough that any such award is noteworthy. When such a volume is not only a superbly designed, bound, printed, and reproduced object, but also a profoundly expressive creative work and a significant socio-historical document, such production-oriented encomiums can only hint at the book's real value.

Delta West by Roger Minick and Dave Bohn, published in 1969 by Scrimshaw Press in an edition of 3000 copies, has recently been so honored by the AIGA, and deserves it tenfold. It is a beautifully made book, an obvious labor of love for all involved in its preparation. More than that, though, it is a major addition to the mainstream of photographic literature, a piece of work so forceful that not even slipshod production could have dimmed its luster.

The subject of *Delta West* is, in the words of the subtitle, "the land and people of the Sacramento–San Joaquin Delta of California." This is a rural, agrarian region, relatively isolated from urban culture, with a fascinating history which stretches back to the Spanish conquistadores and beyond.

The story of the Delta, and the people who inhabit it, has much in common with the effects of the Depression on the South and Midwest: battling against the elements (floods, rather than droughts, being the enemy in this instance); the arrival and departure of various racial and ethnic groups; migrant labor—familiar themes out of *An American Exodus* and *Let Us Now Praise Famous Men*.

Delta West is virtually a continuation of those two books, and is yet another indication that the documentary tradition in photography, as

defined by the FSA photographers back in the thirties and forties, is a durable and timeless form. Its longevity and continued usefulness can be attributed principally to the fact that it is not so much a stylistic tradition as a procedural and attitudinal one. The juxtaposition of historical overview, notes from the field, transcriptions of conversations with the subjects, and photographs is a simple and highly effective method of recording an area and its population. It is also an easy one to botch, for its effectiveness is strictly dependent on the insight and sensitivity of the recorders; Minick and Bohn have mixed subjectivity and objectivity in just the right proportions, avoiding both pedantry and sentimentality.

The book begins with a lengthy essay by Bohn (himself a photographer) which digs deeply into the Delta's past and its slow evolution. Bohn's spare, lithe prose—which suggests the influence of Paul Metcalf in its interweaving of source material and descriptive/emotive text—establishes a mood which is ideal for Roger Minick's sixty-three images and the selections from interviews which accompany them.

Minick's photographs call to mind the work of a handful of other photographers: Dorothea Lange and Walker Evans, of course, as well as Weston and Strand. The similarities are not stylistic—except insofar as the absence of mannerisms is in itself a style. Minick's approach may echo theirs (through the use of classic compositional symmetry, subjects frequently posed against the weathered boards of their homes, and so forth), but his vision is so intense that his images are his own. He has the patience, the blend of selflessness and ego, which is the hallmark of the documentary school at its best, and his pictures sing a slow, mournful, loving song to the Delta's rhythm.

The comments he gathered from the residents are entirely in key with his photographs, and the combinations which result can be extraordinarily revelatory. Next to one image, a battered armchair in a field of corn with a path receding into the distance, appears the following:

I speak about where you get on certain things in life and things confuse you. And when you get confused, you don't know which way to go—and you take the wrong road in life, the space is narrowed to the coffin. It's definitely narrowed to the coffin. You just revert to this. You revert to the wandering shadows of shadows and the space is definitely narrowed to the coffin. And when the space gets narrowed to the coffin, well you know and

I know, there's no more space left for us. It's all over. It's all over right there. Now that's definitely right!

This book, the result of a three-year project, is a strong, subtle, and complex document by an unusually talented photographer. That it received such painstaking craftsmanlike treatment by the publisher is an added bonus; would that all publishers did such justice to photography.

Robert Heinecken: A Man for All Dimensions

It wasn't until I was halfway through my first meeting with Robert Heinecken, one of the pioneers in three-dimensional photography, that I realized it was my second encounter with him. Leafing through a copy of *Are You Rea*—a limited-edition portfolio of his work—I remembered that in the winter of 1965, I had spent an evening in San Francisco with several photographers who were experimenting with slide shows. Among them apparently was Heinecken, for of all the work I saw that dampish night, it was his which had remained in my mind.

At that stage in his evolution, Heinecken had come up with a simple method of creating complex image sequences. He would search through newspapers and magazines, selecting and snipping out small portions of images the size of a 35mm. transparency, which he would then glue into cardboard mounts, arrange into sequences, and project with a slide machine to the accompaniment of prepared tapes. These pieces of paper thus functioned as transparencies; since there was usually something printed on the other side of the page as well, he was able (without ever lifting a camera or entering a darkroom) to tap an almost limitless source of "found" multiple photographic images, ready-made negative sandwiches whose impact was heightened by the chance element inherent in the process.

The attitudes implicit in that approach to the medium of photography are typical of Heinecken's work today, and—though he strongly opposes any imposition of a "founding father" title upon himself—Heinecken epitomizes a new breed of visual artists who, though they

may define themselves or be defined by others as photographers, do not fit easily into that category. Most (though not all) of them know how to use a camera, and use it well, but they also know how to use the tools of other media and refuse to be bound by the arbitrary limitations imposed by purists.

Heinecken, for example, came to photography through the other graphic media, receiving an M.A. in Fine Arts from UCLA in 1960 (where he began teaching in the fall of that same year). His first photographic work was created in 1962. As his influences he cites no individual photographers or schools, but rather the Dada movement generally and Marcel Duchamp ("his attitudes, his writings") specifically, adding that "the idea of the ready-made represents a profound shift in our idea of art."

Indeed, Heinecken's own work—from those early slide shows on—employs "found" or ready-made material with great regularity. Many of the images he uses—especially those in the viewer-participation puzzles, constructions, and other three-dimensional pieces for which he is best known—are ones he created himself; but an equal proportion, most of which appear in his two-dimensional work, come from elsewhere. Recently, he has been devoting most of his energy to the latter. "I haven't taken any images of my own for over a year," he notes. "Everything that goes on in the mass media is idealized and false, which is what I'm interested in at present. To find those images in real life is virtually impossible."

One just-completed project, "14 or 15 Buffalo Ladies," is a case in point. This startling series of twenty hand-colored lithographs juxtaposes a group of unidentified turn-of-the-century portraits of women (taken from negatives found in a junk shop in Buffalo, N.Y.) with images selected from a batch of pornographic magazines purchased during the same visit to that city. The resulting contrast of the prim and the obscene is both amusing and disturbing, for the two visions of female sexuality they represent—neither of which is in the least erotic—have more in common than we may care to think.

Pornography of the hard-core variety has come to be a major theme, even an obsession, with Heinecken lately. It appears throughout his current explorations in many forms: a set of large positive black-and-white transparencies of pornographic material, which he mounts over TV screens as "filters" (a group of which caused quite a scandal this

spring at a Los Angeles museum); "magazines" created by alternating pages of pornographic publications with advertisements from large-circulation periodicals; copies of *Time,* quite normal except for the occasional appearance of pornographic images silk-screened across random pages; a series of large prints on photosensitized canvas incorporating many of the same overlapped images he utilized in making the "Buffalo Ladies" lithographs.

Yet Heinecken is, if anything, less a pornographer than an anti-pornographer. All these creations—some of which will be shown at a one-man exhibition this October at the Witkin Gallery in New York—are records of a search for the causal connection between the frustrated sexuality of pornography and the obscene society of which it is symptomatic. They are, of course, shocking to certain sensibilities: what is miraculous about them is that they are also tender, even lyrical, for Heinecken's vision transmogrifies them in such a way as to restore an honest eroticism to these manipulative masturbatory fantasies.

Though his work has been shown in more than forty one-man and group exhibitions, and though articles and pictures of his have appeared in some two dozen publications, Robert Heinecken was relatively unknown on the East Coast until the Museum of Modern Art included seven of his pieces in its "Photography into Sculpture" exhibit this spring. Of that show he says: "I feel that the sculptural approach is a natural extensional aspect of photography which was and is being developed, and 'Photography into Sculpture' intersected it. Peter [Peter Bunnell of MOMA, who assembled the exhibit] has the idea that *I* started something here—specifically, the volumetric or three-dimensional approach. Actually, it just happened."

It is true that the work of Heinecken's students—such as Darryl Curran and Ellen Brooks, to name only two—bears little direct resemblance to his own. Yet, even if sculptural photography did "just happen," the impact of Heinecken—a teacher with a far-ranging mind, a radical vision of society, and a deep commitment to his many-faceted role as artist, instructor, friend, and adviser—on many of the participants in "Photography into Sculpture" has much to do with that occurrence.

Though, by his own admission, he "stumbled into teaching," he enjoys it greatly, finding that "it reaffirms my belief in the ultimate survival of the individual." In his view, "the students are always the ones

who make major changes and advances, because they bring a collective intelligence to bear on any idea, tear it to pieces, and then reconstruct it."

He also enjoys living in Los Angeles, partly because his spacious home—where he lives with his wife, three children, and a gigantic but still rambunctiously puppyish dog—is perched on a hillside in one of L.A.'s strings of canyons, and partly because he finds that city, its plastic and neon notwithstanding, to be a gigantic test-tube for the American experiment.

"I have the feeling," he told me, "that L.A. is a kind of model (good and bad) for the country. All of the things which are happening in urban life are happening first or more intensely here . . . the crowds, the hustle, the sprawl, technological effects, industry . . . all tend to produce very free-wheeling attitudes and life-styles in people which are reflected in the art . . . the sort of attitudes that say 'Try it first, and prove it later.' I think it produces and develops a certain expectancy about new and different things. Things are changing so fast that objective standards or medians never have a chance to coagulate. All of this probably doesn't have a directly measurable effect, but it is a felt, assumed aspect of the environment."

His acceptance of what might be called the California *Zeitgeist* has, naturally, affected his work and his teaching. Of the latter, he states, "When one teaches ideas, individuality, expression, sensations, responses, ideological and experiential attitudes first, and media second, students will tend not to create objects which fit a particular traditional description. The concept of individual existence as art is relevant to this."

In describing his own work, he indicates several basic concerns—"the relationship and play between an unfamiliar picture-object content and the familiar photographic image . . . the various ways in which photographic images transcend their relationships to actuality . . . setting up *real* physical participation by the viewer in the work . . . relating the concept and content of each piece to the next, so as to be involved in the constant development of individual subjective work." He sees photography as a wide-open field—"the ideas behind it are experiential ones, so that no one's photographs really can be like anyone else's, because the experiences are unique."

It is somewhat ironic that Heinecken, who is now nearing forty, is

no better known here than his most promising former students. "Photography into Sculpture" hinted at the scope and significance of his work; the fall showing at the Witkin Gallery should help to make clear what is, and will continue to be, Heinecken's major contribution in expanding the limits of the photographic medium.

Bruce Davidson: *East-100th Street*

Bruce Davidson's "East 100th Street"—an exhibit of more than forty prints now on view at the Museum of Modern Art—is a selection taken from the just-published book by the same title (Harvard University Press, 1970). Both, in turn, were selected from a much larger body of work, created by Davidson over a two-year period, which was devoted almost exclusively to photographing one particular block in the East Harlem ghetto.

Davidson, whom historian Peter Pollack has described as "something of a romantic," took almost every conceivable precaution to invalidate charges that he was exploiting the subculture he recorded. It was not a quickie project, but a long-term study. Davidson decided against using a hand-held camera, and chose instead to work with a large view camera on a tripod—thus eliminating any hope of secrecy, or of shoot-and-run techniques, and forcing himself to be open, planted, and vulnerable. He gave away several thousand prints to the residents of the block, and made sure that they all got copies of the book when it was published. Members of the community were invited to and attended the show's opening. Davidson even has plans for using the book as a lever to get funds and other sorts of assistance for the neighborhood.

Davidson's intent, therefore, went far beyond mere profiteering off an oppressed subculture, and there is no questioning the sincerity of his motives or his commitment to his subjects. As he says in his brief preface to the book, "I entered a lifestyle and, like the people who live on the block, I love and hate it and I keep going back."

Yet, at the risk of being accused as I often am of "injecting politics into aesthetic criticism" (conjuring up images of myself as a mad doctor out of a Terry Southern novel, poised above the typewriter, cack-

ling maniacally and wielding a gigantic hypodermic), I must make clear my belief that "East 100th Street" cannot, by its very nature, be discussed as though its aesthetic import were completely divorced from its "political" significance, for the two are very much intertwined—inseparably so, in fact.

If this were not so, then Davidson would surely have felt no need to take those extensive precautions listed above—for, in a "nonpolitical" context, charges of ripping-off repressed subcultures are never made. Dorothea Lange did not have to placate anyone by giving away prints, nor Walker Evans, nor Lewis Hine. I am not saying that Davidson should not have done so; the situation obviously demanded it, and Davidson acknowledged the rightness of that obligation and fulfilled it. But that the demand was there, even if tacitly, even if only in Davidson's conscience, does prove that the situation has other than aesthetic ramifications.

This is because, in the context of East Harlem, Davidson is not only an outsider but an alien. He is neither black nor Puerto Rican, but white; he may, like the block's residents, "love and hate" this ghetto—but, unlike them, he has the option of leaving which is implicit in his impulse to "keep going back."

Does this mean that Davidson's work—or, for that matter, any white photographer's documentation of non-whites—is invalid? By no means. But it does imply that such work, no matter how good—and Davidson's is very good—is limited. Limited because, no matter how insightful a white photographer may be, and despite all precautions he may take, he remains white and therefore alien. Thus, even when there is mutual admiration and respect between photographer and subject, there is automatically a barrier, for they stand on different sides of the socio-cultural fence.

This is apparent in all of Davidson's images, noticeable as a guarded quality, a wariness on the part of both the photographer and his subjects. There is a thin line being trodden in these images, and it is something more than the already difficult process of making a portrait. Something is being kept back by the subjects, and while Davidson has recorded that keeping-back process superbly, he hasn't caught the something that was withheld.

Perhaps this is because, in a peculiar way, Davidson himself is withholding something—there is a caution in his eyes as well as in those of

his subjects. It expresses itself indirectly but nonetheless visibly, in the very fact that his images are, without exception, beautiful. Not grim, not ugly, not chilling—even the photograph of a rat scuttling across a garbage-strewn alley brings no shivers of revulsion.

In other words, Davidson has transmuted a truth which is not beautiful into an art which is. If the reality on which that beauty is based were transmuted at the same time, I would have no objections, but it is not; for those who live on East 100th Street, the garbage which provides Davidson with such strikingly forceful compositions will continue to stink and decompose, and may even endure longer than Davidson's superb prints.

This is one of the paradoxes of contemporary documentary photography, and Davidson is not to be faulted for coming up against it. (This same paradox is operative in the many projects, doubtless well-meant, whereby ghetto youths are trained in the use of the camera and turned loose in their neighborhoods: "You thought all that squalor and degradation was just squalor and degradation—but it's really the raw material for art. And now, instead of starving because you're oppressed, you can starve because you're an artist, and you know that artists are supposed to suffer . . .")

However, if photography is to help change (and not just record) such horrors as the conditions on East 100th Street, then photographers are going to have to abandon their concern with Art and Beauty and start making stark, grim, ugly, repulsive images—images so ghastly that none of us will be able to eat or sleep or go to museums until we know that such conditions no longer exist. We need images as strong, as simple, as "artless" as those of Hine and Riis, for anything less permits us the delusion that this brutalization of the human spirit serves some purpose, if only to provide photographers with ripe subject matter.

But even those photographs, if they come—as I pray they will, and soon—will not be enough if they are made exclusively by white photographers. If we are to come to terms with the situation, as a first step toward improving it, then we need to hear (and see) from the other side. We need, in short, exhibits by the best minority photographers—not held uptown, but hung in the same museums and galleries as those by whites. It is little short of scandalous that the Museum of Modern Art has never given a one-man show to a non-white photographer, for

there are many at least as talented as some of the photographers the museum has chosen to show over the years.

That such an exhibit—or, ideally, a series of exhibits—might seem a little, well, *forced,* is beside the point. So what? The situation at this point is critical, and rapidly deteriorating. If the Museum of Modern Art intends to wait until such an exhibit will not have "political" overtones, it runs the risk of becoming entrapped in what I hope is an inadvertent but nonetheless definitely racist policy. Given the museum's lack of concern over the political implications of Davidson's show—and there certainly are such implications in any exhibit of images made in a non-white community by a white photographer, mounted in a white museum where no non-white photographer has even had a show of equal size—such over-concern comes too close to hypocrisy to be credible.

This closed circuit—whereby, in museums, in galleries, and in publications, we see images of non-white subcultures taken exclusively by whites—must be broken. To do so at this tormented moment, not furtively but by conscious and announced decision, would be an act of courage, not cowardice. Out of the resulting contrasts might come a fuller and deeper understanding of what it means to be black (and white) in America today.

Until such a breakthrough comes—and the burden of it, for obvious reasons, must fall on the Museum of Modern Art—all photographs of non-whites made by whites (including Davidson's, despite his precautions and for all their virtues) will be suspect, for we ourselves, as audience, will continue to lack the knowledge and understanding necessary to gauge their true merits and flaws. Thus we are not only deprived of the view from one side, but are in fact being cheated out of both. And, caught as we are in the grips of a spiritual as well as a fiscal recession, we will not be able to afford that luxurious but debilitating blindness any longer.

Duane Michals (I): *Sequences*

More and more photographers are investigating the sequential approach to imagery. Sequences have a long and honorable tradition going back through Stieglitz to the old stereopticon slides and even fur-

ther into the past. But they seemed to die out for a while, perhaps overwhelmed by the trend toward "street" photography, with its emphasis on isolated images.

Discovering—as did Minor White—that the monumental single image can be a magnificent tombstone commemorating a limited, closed idea, photographers are rediscovering the sequence, with its inherent openendedness (which derives from what Richard Kirstel calls "interstitial reality"). Among the best of the new crop of sequential imagists is Duane Michals, whose exhibit "Stories" at the Museum of Modern Art coincides with the publication of a volume of his work titled *Sequences* (Doubleday Projections Book, 1970).

Michals' sequences are, on the surface at least, quite simple. The programmatic titles ("The Sad Farewell," "The Girl Is Hurt by a Letter"), the documentary technique applied to the staged events, and the strictly narrative approach Michals employs to tell his stories— all these lead us, as viewers conditioned to specific ways of reacting to set modes of communication, to a relatively literal, "factual" reading of each sequence. But that doesn't work, for while the events recorded by Michals' camera have the clarity of hallucinations and the factuality of dreams, they are, like all visions, so shot through with the sense of otherness that a literal reading does not even touch on their true meaning.

Michals is aware of this, and deliberately plays the literal style against the hallucinatory subject matter. In one sequence, "The Lost Shoe," a man drops a woman's shoe on the street and, in progressive shots, disappears in the distance. When he is gone, the shoe bursts into flames. In another, "The Illusions of the Photographer" (not in the book), he puns visually on his own method and on the act of photography, creating a metaphor for the camera's distortive intensification of reality. Though they all conclude, none of Michals' sequences resolve; excluded from each one are those elements which would specify a single meaning, thus forcing the viewer to supply his or her own. (In that sense Michals' work is certainly connected to "One-eyed Dicks," the exhibit of sequential stills taken by remote camera during bank robberies, which MOMA presented earlier this year.)

The book contains fifteen sequences, which range in length from five to eight images. The exhibit at MOMA includes thirteen of these, two additional sequences, excerpts from several others, and a

number of single images (almost all of which, such as "Self Portrait As If I Were Dead," have the same surreal quality as the sequences).

Back in 1968, when Michals showed several of these sequences at the Underground Gallery, I wrote that he was exploring a territory that fell somewhere between Jerry Uelsmann and Ray Metzker. It seems clear at this stage that the work of these two artists does not represent confining boundaries around Michals' turf, but merely defines what Michals' work is not. Michals has struck extremely fertile ground in these sequences.

Richard Kirstel (II): Is This the Scopes Trial of Photography?

> *I do believe that the college community would defend this right [the right to academic freedom] but, again, I raise the question of whether it should.*
>
> K. A. SHAW, DEAN OF FACULTY, TOWSON STATE COLLEGE

On that unusual reversal of the normal priorities—which comes from Dean Shaw's memorandum recommending that a scheduled exhibition of M. Richard Kirstel's "Pas de Deux," a photographic sequence whose subject is the act of love, be canceled—hangs a tale, the import of which is ominous enough to warrant widespread attention, and not only from the photographic community.

Richard Kirstel is a thirty-four-year-old photographer, writer, and teacher who is presently a member of the faculty of the Maryland Institute, College of Art in Baltimore. A former student of Ralph Hattersley, Minor White, Aaron Siskind, and Harry Callahan, he has published two books and numerous articles (in such periodicals as *U.S. Camera* and *Camera 35*); his pictures have appeared in the *Village Voice, Evergreen Review, Infinity,* and *Popular Photography's Woman Annual.*

"Pas de Deux," the sequence in question—actually composed of two suites, one devoted to heterosexual love, the other to lesbian—was first exhibited at Exposure, in New York City, early in 1969. This marked the first time that such explicitly erotic photographs had ever been

publicly shown in New York. Though the owners of the gallery were understandably nervous, there was no public outcry and, even more important, no attempt at censorship, a precedent which makes the show a landmark. Finally, though it was Kirstel's first one-man show in New York (he followed it up, less than a year later, with another, "Karen's Party," also a major sequence), and though it received relatively little publicity in the mass media, "Pas de Deux" attracted 7000 viewers during its six-week run—certainly a record for a one-man gallery show in this country. The show has been discussed in many magazines, here and abroad; excerpts from it have appeared in *Evergreen Review* and *Infinity* (which recently gave over half an issue to the pictures and commentary thereon). It has also received book publication in a sumptuous $25 edition put out by Grove Press in 1970 (since banned, predictably, in Boston) with an introduction by Nat Hentoff.

It may well be irrelevant to the issue to establish Kirstel's credentials, or those of his work. (It most certainly is in Kirstel's view: "Would it be all right," he asks, "if I were an unknown—even an unknown pornographer—and my work were censored?") But it does have some bearing on the case, if only to suggest a possible fallibility on Dean Shaw's part. For, though Shaw indicated in a telephone interview that he didn't "feel qualified to judge these photographs as to whether or not they are obscene," he certainly did feel qualified to state, in his memorandum, "I see nothing that suggests that ["Pas de Deux"] is a landmark effort . . . one that would put us on the map in the aesthetic sense."

The development of the Great Towson Debacle has a fascinating inexorability of its own, as though the event itself (and not just the participants) were aware that it symbolized a spirit newly loosed upon the land. Shortly after arriving in Baltimore to assume his position at the Maryland Institute, Kirstel was invited by the Exhibitions Committee at Towson to show "Pas de Deux" in the college's gallery. He accepted, and began making, mounting, and framing prints in preparation. The exhibit was scheduled to open on October 29. Then Stanley Pollack, chairman of the Art Department, saw the book version of the show and became disturbed by its contents. He went to Towson's president, Dr. James L. Fisher, who indicated to Pollack that this was a faculty matter which did not require his involvement. Turning next to Dean Shaw, Pollack reiterated his sense of disturbance; and, with

a representative from Shaw's office, called a meeting of the Art Department faculty on October 19.

At that meeting, attended by fourteen of the department's eighteen members, Pollack informed the faculty that, this being an election year, he didn't want to offend any state legislators. He then asked the faculty to vote on whether or not the Kirstel exhibit should be presented. A secret ballot was cast, which resulted in a 10–3 vote in favor of presenting the show as planned. (Those members of the department not present were subsequently polled, via telephone, openly and personally, by Pollack himself. Not surprisingly, they voted against holding the exhibit.)

However, even those members of the minority in favor of canceling the exhibit agreed to abide by the majority decision—with, apparently, one exception: Pollack himself, who, purporting to represent the members of his department, went to the administration and requested official sanction of the exhibit. This led to Dean Shaw's memorandum of October 22, previously cited, and to another, a few days later, from President Fisher's desk, upholding Shaw's recommendation. Fisher's memo, directed to Pollack and the Art Department faculty, is a classic study in self-contradiction which merits excerpting.

To my knowledge you have never asked the administration's sanction for exhibits you have shown. . . . In this case, however, the department asked for College sanction for an Art Department exhibit—you asked for censorship, a function which requires a yes or no answer; since you asked, either a negative or a positive decision on my part could be considered censorship.

I deplore anything that smacks of censorship in the academic community, and I recognize the essential importance of maintaining a free forum for the expression of any idea through any medium on our campus. Academic freedom is essential to our survival. . . .

Without belaboring a point on which I am the best judge because I am closest to it, I can assure you that our source of support would not stand for my decision to allow the Kirstel exhibit.

So, with the faculty over-ridden by their own chairman, the dean of faculty, and the president—all, presumably, intent on preserving the principle of academic freedom by insuring that it was not practiced—the "Pas de Deux" show was tacitly canceled.

Too tacitly, in fact. So tacitly that, though Kirstel had heard of all

these goings-on secondhand, he had received no official communication whatsoever from the administration of Towson—no letter or telegram informing him of the cancellation. Not even the courtesy of a phone call. Nothing releasing him from his side of the contract, and nothing indicating whether Towson would fulfill its obligation even minimally by paying the token fee he had been promised (which would barely have covered his expenses).

So Kirstel, outraged at what he considers to be "a blatant repression of academic freedom which should prove unacceptable to the college community and the public at large," decided to hang the show as scheduled. On October 29 he pulled up in front of Van Bokkelen Hall, which houses Towson's Art Gallery. A student protest demonstration against the cancellation was already under way. Kirstel, his arms loaded down with framed prints, was stopped by a campus security guard and told that he was trespassing. Kirstel replied that he had received no official notification that his show had been canceled, and that he intended to hang it. The guard left, conferred with President Fisher, and then returned to warn Kirstel that if he were not off the campus in ten minutes he would be arrested. Kirstel refused, and was taken into custody when the deadline expired.

At this point the anger of the student onlookers was on the verge of boiling over. "It was starting to look ugly," Kirstel recalls. So he made a speech to the assembled students, calling for a non-violent demonstration, permitting them to march with the photographs in lieu of signs, and carefully defusing an explosive situation. (The head of the campus security force later thanked him personally for cooling down a potential riot.)

Kirstel was then handed over to the local police, who took mug shots, fingerprinted him, and booked him on two counts of trespassing. He was out on $1000 bail a few hours later. The ACLU has taken the case, which comes up for a preliminary hearing on November 16. Kirstel and his attorneys intend to demand a jury trial and will be filing countersuits against Towson on a variety of charges. Local press and TV coverage was extensive, and the Great Towson Debacle may well become a regional, if not national, *cause célèbre*.

And what, one might ask, does all this have to do with photography? Quite a bit. It is obviously important for photographers, and members of the photography community generally, to know when

and where photographs are being censored, and why. It is vital that we all begin to recognize that photographs—even photographs on non-political subjects—can have political implications. President Fisher's letter makes that clear, even if one is not aware that there is a particularly bitter and venomous political battle going on in Maryland as of this writing, even if one does not know that Vice-President Agnew has injected himself into that struggle, even if one does not know that the suburb of Towson happens to be Agnew's home town and that Van Bokkelen Hall is one block off Agnew Drive, which runs through the campus.

Photography, too, represents a principle, one which the founding fathers did not foresee: freedom of vision, as important a right as freedom of speech. The repression engulfing us will not exempt photographers of any school: they had best be alert to the threats, and prepared to defend their freedom against those who would undermine it.

"I am astounded," Kirstel told me the night of his arrest, "at the immense power the photographic image has over the small minds of frightened people." This being the first time, to my knowledge, that a court case has centered around a photographer's right to freedom of vision (and the academic community's and general public's same right), it is perhaps not too presumptuous to speculate that the Kirstel case may turn into the Scopes trial of photography. It should be quite an event.*

* My coverage of the trial was published in the *Village Voice* ("Poetic Justice [1]," March 4, 1971, and "Poetic Justice [2]," March 11, 1971). Kirstel was convicted of the felony of trespassing, sentenced to sixty days in jail (suspended for two years of "unsupervised probation"), and fined $200 plus court costs. The Burger Supreme Court refused to hear the appeal, so the sentence was served.

Jerry Uelsmann (II):
He Captures Dreams, Visions, Hallucinations

It should be obvious by now that, no matter how controversial his work is (and will, no doubt, continue to be), Jerry Uelsmann is anything but a flash in the pan.

Signposts along the road to widespread acceptance of Uelsmann's art have been appearing at an increasing rate over the past few years. Aside from the pervasiveness of his influence—which, by itself, indicates that his approach is here to stay, like it or not—and the frequency with which his images are shown, published, and discussed, two of the most significant pieces of recent photographic criticism (William E. Parker's extended essay in *Aperture* 13:3 and John L. Ward's monograph *The Criticism of Photography as Art: The Photographs of Jerry Uelsmann*, published by the University of Florida Press in 1970) are either devoted to or based on Uelsmann's photographs. As a capper, the new portfolio published by the Friends of Photography includes one Uelsmann reproduction, indicating his acceptance by the photography establishment. (Ironically, in his introduction to that same portfolio, Wynn Bullock places the stamp of legitimacy on Uelsmann, only to tongue-lash those—photographers, critics, and curators—who would carry some of the implications contained in Uelsmann's work a step further.)

And, if all that is not enough to convince the skeptics, then the overwhelming Uelsmann retrospective which opened at the Philadel-

NYT, January 3, 1971.

phia Museum of Art on December 12 should certainly end the argument; for, in the almost 200 prints it contains, this exhibit presents a body of creative imagery as cogent, as consistent, and as durable as any being made today.

The crux of the argument over the validity of Uelsmann's photographs (and in some ways the most amazing aspect of his artistic success) is his concept of "post-visualization," which he himself defines as "the willingness on the part of the photographer to revisualize the final image at any point in the entire photographic process." For not only is this concept in direct contradiction to the Weston-Adams credo of "pre-visualization" (through which the photographer knows, theoretically at least, exactly what will appear in the final print at the moment of clicking the shutter), but it is founded on what is undoubtedly the most maligned and discredited chunk of the photographic tradition: the stilted, mannered, sentimental, gimmicky composite prints of O. G. Rejlander and Henry Peach Robinson. (The discrediting of a gimmick is, of course, merely part of a more profound accreditation, a purification ritual which is one portion of some succeeding generation's heritage; but that is another essay.)

Uelsmann's unique perception as to the work of those two early photographers was that their aesthetic failure (Rejlander's and Robinson's images are banal beyond belief, though they were immensely acclaimed and imitated in their day) had nothing at all to do with the techniques they employed—negative sandwiches, composite prints, *et al.*—but was due instead to their conceptual weakness, a sheer paucity of imagination. Imbued with the soggy *Zeitgeist* of the mid-nineteenth century, Rejlander and Robinson produced images whose literal, narrative content outdid the worst currently popular fiction, and whose compositional style imitated the worst in contemporary painting.

In reaction to this mushy pap, the purists—from Peter H. Emerson through Stieglitz and down past Weston to our own day—threw out the baby with the bathwater. Small wonder, as anyone who has seen a Rejlander or a Robinson will concur. But the technique was still there; and, since techniques neither die (unless by improvement beyond recognition) nor carry any internal rightness or wrongness, it simply waited—if I may, like Uelsmann, anthropomorphize—for an esthetic it would fit.

As it happens, this technique—along with the others Uelsmann

employs, including negative imagery—is eminently suited to the rendering of various states of consciousness (dreams, visions, hallucinations, memories), since it frees the photographer from the strictures of the "real" world. That world is, of course, filled with the absurd and surreal, but its subconscious symbols are neither dependably present nor, necessarily, the artist's own. If we permit Magritte (the only painter whose influence on Uelsmann's vision is apparent) to depict a boulder suspended in space without an objective correlative, we can hardly deny photographers the same privilege.

So it follows that, in an age when artists in all media and from all cultures are turning from outer realities to inner ones, photographers would attempt to explore the same areas; but it took Uelsmann's perseverance, and his willingness to battle an entrenched purism which can be at times almost rabid, to legitimize the techniques necessitated by this voyage inward.

It is safe to say that no photographer of lesser gifts could have done so. The first hint of gimmickry, the first lapse in content, the least soupçon of mawkishness, and the chorus of I-told-you-so's would have buried his method for another fifty years. But Uelsmann's work, from the very beginning, has maintained an abnormally high level, as though the photographer were aware of the do-or-die exigencies of his approach.

Not that the corpus of his work to date is without its failures, by any means; but they are few and far between, and their "defects" are those to which all great photographers are prone—a (rare) emotional inaccessibility, an occasional lack of metaphorical coherence. However, as the massive Philadelphia retrospective shows, Uelsmann's successes are too frequent and too dependable to be flukes.

They are strange images, to be sure, filled with such recurring symbols as peapods, floating trees, oriental icons, phallic and vaginal shapes. They are not there to be "understood" in any cognitive sense; they have no literal meaning, make no narrative sense, cannot be defined (though they have an awesome inexorable rightness peculiarly their own). One can interpret them in any number of ways; both Parker and Ward, in their studies, view Uelsmann's images in the light of Jung's theory of archetypes, but any of numerous other systems of symbolic interpretation could be applied with equal validity— and with equal fallibility.

For, finally, Uelsmann's images exist to be felt—to be experienced,

as Bob Dylan wrote, "with no attempt to shovel the glimpse into the ditch of what each one means." They form an intransigently personal record of one man's journey through his own inner landscape (indeed, in one room—where a dozen prints have been blown up to vast enlargements—they seem like stills from a film in progress). And their significance, their value, their bite, is their correspondence to the subconscious records of those who view them, records which we all keep but which only a handful of artists—Uelsmann among them—force us to open and scrutinize.

Les Krims:
Four Photographs That Drove a Man to Crime

Another first for the medium was established on Wednesday, March 24, when—in an incident which should demonstrate, to even the most obstinate opponents of the notion, that photographs have social and political import beyond their esthetic significance—an armed man entered the home of Dr. Richard E. Batey in Memphis, Tenn., and kidnapped his thirteen-year-old son. The ransom? Removal of four photographs from a group exhibit at the Memphis Academy of Arts.

According to the Associated Press release, the kidnapper (who is still at large and unidentified) forced his way into the home which Batey—a professor of biblical studies at Southwestern University in Memphis and a part-time humanities instructor at the gallery—shares with his wife, son and two daughters. Waving a .45-caliber pistol, this imaginative censor forced Richard Jr. to tape the hands of his father and sisters together, announced that he was making sure his children or grandchildren "won't see those pictures," cut the telephone wires, and informed Dr. Batey that his son would be released unharmed as soon as Batey broadcast a promise that the photographs would be removed.

After freeing himself and his daughters, Dr. Batey went on WHBQ-TV and WHBQ radio to announce that the photographs would be taken down. Less than an hour later, his son was set free in midtown Memphis.

Even more fascinating than the incident itself was the kidnapper's

NYT, April 11, 1971.

choice of photographs against which to direct his sense of outrage. The exhibit, assembled by Murray Riis, a photographer and instructor at a local college, was an invitational group show which included the work of twenty-two contemporary photographers, among them James Dow, Emmet Gowin, Betty Hahn, Scott Hyde, Leland Rice, Jerry Uelsmann, and Alice Wells. Many of their images have erotic overtones, and at least one participant in the exhibit—Robert Heinecken—actutually incorporates hard-core pornographic imagery into his works. Yet the photographs whose removal was set as ransom were anything but erotic in nature, though they all included nude subjects.

All were by the same photographer—Leslie Krims, who teaches at Buffalo State University in New York and who has exhibited widely both here and abroad. (Recently, he was paired with Wynn Bullock in a two-man show at the Witkin Gallery in New York City, and his second one-man show at Eastman House in Rochester will open in May.)

While many of Krims's images could not be reproduced in the *New York Times*, simply because his subjects are predominantly nude, few of them have any erotic content and none could be interpreted as having erotic intent. A Swiftian satirist who "stages" most of his images, Krims is a sardonic documentarian who is blending the snapshot and grotesque traditions into a unique vehicle for psychosocial commentary. In the introduction to a portfolio of his work published last year by Doubleday I wrote, "It is no small accomplishment to take pictures which could have come from the pages of a middle-class family album, yet which simultaneously reveal the hallucinatory absurdity of normalcy with such cheerful and merciless accuracy."

There could be no more direct confirmation of that accuracy than the indignation his images aroused in the kidnapper; apparently, they affronted the man morally to such an extent that he overlooked entirely the pornographic imagery contained in the Heinecken works. This suggests that Krims's work touches on fears and frustrations which go even deeper than the sexual perversity of our culture. Harmless though they seem on the surface, they are among the few photographs I know which consistently disturb and unsettle those who view them. Our unknown crusader's reaction to them, though certainly extreme, is merely an amplification of the emotions I have watched play across the faces of people looking at Krims's work for the first time.

In a telephone conversation a few days after the event, Krims indicated that he himself was just recovering from the fear for his personal safety which the incident had aroused. (For inexplicable reasons one Memphis newspaper had, in a remarkable display of journalistic zeal, gone so far as to include Krims's home address in its coverage of the case.) Krims, who does not enjoy talking about his work, initially disclaimed its impact by saying, "I'm not sure that this had anything to do with my pictures per se. I think any pictures might have set this guy off, though I would love to believe that it was specifically *my* imagery which had this effect . . ."

Pressed on this point, and reminded that the Heinecken pictures, among others, had not been mentioned by the kidnapper (nor by the local citizenry, which also found Krims's photographs so shocking that Mayor Henry Loeb was forced to appoint a committee to decide whether the display was obscene—it was not, in their opinion), Krims grudgingly admitted that "maybe they touch on a sort of societal crisis.

"My pictures," he continued, "relate very much to my own life—sometimes on a symbolic level, often on a quite literal one. There's certainly a sense of satire and irony in many of them, even a vengeful and aggressive tone; I don't like to admit that, but it's true. I react strongly to events in my life and in the world, and the pictures are meant to be as forceful as I can possibly make them."

About the four prints which led to the kidnapping, Krims noted, "I feel that those particular pictures are some of the strongest images I've ever made. But I can't intellectualize about my photographs. I must persist in making the pictures I feel obliged to make—what else would I do if I didn't?—but I don't really understand them on any level I could describe verbally."

Perhaps the kidnapper does; and, if he is ever apprehended, an attempt to interview him on that issue (and others) will be made. Until then, Les Krims, bolt your door and beware the friendly stranger.

Fundi: The Nuances of the Moment

Fundi (Billy Abernathy), whose exhibit of forty-three black-and-white prints you should definitely see at the Studio Museum before it closes, is one of the very, very few black photographers whose work is mature

and profound enough to merit comparison with that of Roy DeCarava. Take that with a grain of salt; not much photographic work from inside the black community gets exhibited, even uptown, and I suspect that much of what's happening with the medium within the black subculture is presently underground.

Fundi, however, has surfaced, at least long enough to reveal to anyone interested in getting up to the Studio Museum in Harlem that he has become a major contributor to the development of a black aesthetic in photography. I will go further and say that *In Our Terribleness*—the book from which the pictures on view were drawn, a collaboration between Fundi and Imamu Amiri Baraka (LeRoi Jones)—deserves to stand next to the DeCarava–Langston Hughes *Sweet Flypaper of Life* as a truly superb prose poem/photo essay on the black life-style in our time.

This is not to suggest that Fundi is a DeCarava imitator. But he does come out of a tradition which was essentially founded by DeCarava, and is working within an aesthetic which, in photography, is essentially based on DeCarava's principles. Like DeCarava, Fundi has eschewed a chic experimental approach—which offers easy entry into the basically white photography world—in favor of a straight "old-fashioned" documentary style. Similarly, he has opted against thematic eclecticism—another easy out—and for the intensive exploration of black life. Furthermore, like DeCarava, he works primarily (perhaps exclusively) in black and white.

None of these are arbitrary choices. They have deep philosophical implications, and are directly related to the emergence of a black photographic aesthetic. A verbal formulation of that aesthetic—especially one made by a honky critic like myself—would be suspect; even if it were not, it almost certainly would be premature, since there have not yet been enough major black photographers to define the aesthetic's boundaries clearly.

However, certain aspects of it are unmistakable. DeCarava, for example, has suggested that the dangers of being black build into the black photographer an attunement to the nuances of the moment which, to say the least, comes in handy in making images. This seems sensible, and ties in with the curious—and I don't think accidental—fact that DeCarava and Fundi (as well as a number of other black photographers) have been jazz musicians.

Jazz, as it happens, is the musical form whose philosophical basis is

most akin to photography's. (One could even argue that some of the struggles Edward Weston went through were the result of his analogizing his own medium with classical Western forms of music; the fundamental conceptual difference is enormous.) It is not by chance that jazz was born in a culture whose concern, on all levels of existence, is less the construction of static monuments than the development of an intensified awareness of the Now. In its rhythmic and harmonic attitudes, in its emphasis on intuition, spontaneity, and improvisation (which it shares with several other forms of music, particularly that of India), jazz is directly linked to the idea of creativity as process-consciousness, as *flow* in a Zen sense.

Its kinship with photography should therefore be obvious. Photography—especially documentary photography—is concerned with precisely that same flow. (If you're not familiar with DeCarava's work then think of Cartier-Bresson's within this context.) It demands the same introspection/extroversion on a moment-to-moment basis, the same intensified perception of the *Gestalt* present. I don't think it would be overstating the case to suggest that anyone who has grown up within black America and osmotically absorbed the cultural precepts which produced jazz has an almost instinctual affinity for—and an extensive if "unstructured" training in—what might be called the photographic attitude, to which an awareness of the rhythms of life, the flux of events, is indispensable.

To translate this back and relate it to DeCarava and Fundi as exponents of a still young and unformulated black photographic aesthetic, I would suggest that the work of these two photographers runs parallel and has much the same foundation. The difference between them, in a musical analogy, could be stated thus: DeCarava's sensibility, his territory, lies in the area between Lester Young and Coltrane; Fundi's runs from Coltrane to Pharoah Saunders. As I hope this indicates, there is some overlap, but the edginess, the wicked switchblade glint from which Fundi's vision begins, is at the outer limit of DeCarava's. Fundi is rarely able to get back to that mellowness which fills so many of DeCarava's pictures (though he does sometimes, as in "The Glory of Hip"), a very soft and tender melancholy; times change, as well as people, the rhythm of the culture to which both photographers have dedicated their lives is sharper and more angular, and this has had an inevitable effect on Fundi's work.

The book version of *In Our Terribleness* (Bobbs-Merrill, 1970), is simply beautiful. Designed with great but understated strength by Laini (Sylvia Abernathy, the photographer's wife), it contains all the pictures in the exhibit, adequately reproduced, and a long prose poem by Baraka, one of his most lyrical creations to date. It is a brilliant and complex statement which captures—as far as this outsider can determine—the totality of the present-day black experience as surely as Langston Hughes did in *Sweet Flypaper* twenty years back. It has the same direct, pungent, emotional honesty as does its predecessor (or companion piece), though the approach and language are much different; it also has—though Baraka's enemies in Newark would never in a million years believe it—the same message: as he writes in one segment, "Not just to love, but to be love, itself."

Fundi would not permit one of his photographs to appear with this column. His reason—which I've received second-hand—is that he feels *The Voice* does not reach the audience to which he speaks. There I disagree with him, and hope that the response to this column will prove him wrong. We simply must start seeing the work of more black photographers on the city-wide museum-gallery-library circuit; there must be someone around with the minimal "courage" necessary to break the ice and mount a series of such shows downtown.

I would especially recommend a visit to this show for any and all of the young street photographers who still believe that you can (and are entitled to) go cold into an unfamiliar community and come out with images which have any relationship to truth worth speaking of.

Peter Bunnell:
Money, Space, and Time, or the Curator as Juggler

During the informal discussion which closed the symposium on photography criticism held at George Eastman House last February, Peter Bunnell, curator of the Museum of Modern Art's Department of Photography, suggested that among the areas of inquiry not covered by this gathering was the role of the curator as critic. Unfortunately, there was insufficient time to permit elaboration of this concept, but the idea was obviously significant enough to pursue. So, in a recent

series of interviews on Bunnell's home ground at the museum, I questioned him about the critical function of curatorship and its specific applications to his own work.

Bunnell and John Szarkowski—director of the Department of Photography, and the man who invited Bunnell to join the department's staff in 1966—are co-pilot and captain, respectively, of the largest photographic archive/showplace in New York City, which in turn is the undisputed center of photographic activity in the country. Together, their influence on the world of creative photography is unparalleled; the power they wield jointly, and the ways in which they wield it, have inevitably created factions within the photography community. Both Bunnell and Szarkowski have their admirers and detractors— though Bunnell, because he has chosen to sponsor directly a body of radical, experimental, mixed-media work, has perhaps more than his share of the latter.

Certainly much of the criticism leveled at these two men (a goodly portion of which has come from these quarters) is merited, in that the rightness of their decisions and the wisdom of their judgments are often open to question. But—disregarding that hostility which springs more from personal antipathy than any other impulse—the majority of adverse comments on the department's policies are not so much undeserved as inevitable; the two men who guide it are holding down jobs which—like the mayoralty of New York City and the presidency of the nation—are almost untenable, for it is truly impossible to satisfy all, or even most, of the numerous segments which make up its public.

Bunnell is well aware of this, though his response to such an insurmountable problem is not resigning himself to brooding fitfully. Instead, he is determined not to let it sap his energies (which appear less exhaustible than his time). And he sees it as directly linked to his own critical role as a curator. "The main vehicle for bringing work from the artist to the 'public' critic, and thus to the public at large, is the museum," he explains. "By the process of selection with which he deals, then, the museum curator is automatically a critic."

I asked if, that being true, there was what might be called a MOMA aesthetic. "If there is," Bunnell replied; "I think it's a broad one, broad enough to allow us to work, as we did, on the Walker Evans retrospective, 'Photo Eye of the Twenties,' and 'Photography into Sculpture' simultaneously. There's no question that we are here

developing a critical stance and position, though I wouldn't care to define it at this point, for I believe it's very much in flux. This department has been molded by three quite different sets of values: those of 1937–46 [Beaumont Newhall's tenure], 1946–62 [Edward Steichen's], and, under John Szarkowski, from 1962 until now, with myself thrown in as an added factor since '66. Lately we've realized that we'd accepted a bias—which led from Atget through Stieglitz to Weston—and we're in the process of rethinking that and straightening it out.

"Some of the problems involved in running this department are just too complex for solution," he continued. "For example, there are always very difficult decisions to make as to what you acquire for the permanent collection, what you show without purchasing, and so forth. Normally you can set a balance of sorts, but right now we're in a financial bind—this is true of the whole museum. We may have to cut our exhibit schedule heavily, which will mean that each show we choose to mount will carry an even more exaggerated weight in critical terms. We may have to cut down on purchasing—and even if a curator doesn't wish to function as a critic insofar as showing or writing about a specific artist goes, he's morally obliged to preserve the work of those who have been judged significant by other critics. There's a thin line you walk in figuring out what to acquire, and that's based on your critical faculties. Shortage of funds will make the line that much thinner."

Though the museum is best known, in photographic terms, for its collection of twentieth-century artists, there are problems even there, according to Bunnell. "At the moment, we're deeply involved in cataloguing our entire holdings—first, to find out what we have, since there's much confusion in that area, and, second, to produce a catalogue for publication and distribution. As it happens, that's the task I was initially called in to perform, but there's just so much to do that my energies have been diverted elsewhere.

"Even at this stage, though, it's obvious to us that while we have a substantial collection for this century, we're deficient in work from the turn of the century through the 1920s, major figures like Coburn as well as minor ones. We have to fill in just below the landmark level; that came out in preparing the 'Photo Eye' show. As for the nineteenth century, that's a thorny issue; there we have to balance our educational function and our curatorial emphasis, but under no

circumstances can we hope to be anything more than representative in that area. On the whole, though, I feel we have a remarkable collection, given our dilemmas. . . ."

These dilemmas boil down to conflicts between three basic factors, which crop up over and over in Bunnell's conversation. "We have just so much space, so much money, and so much time. It becomes a juggling act. We're working on the cataloguing; we're working on exhibits [two will open in July; one is a traveling one-man show by Manuel Alvarez Bravo, the other an original exhibit of the work of Clarence H. White, which, with an accompanying monograph, is being prepared by Bunnell]; we travel and lecture and confer. We've got boxes in storage vaults and stacked around here which haven't been opened in ten years—we don't even know what's in them, and we need to find out.

."Acquisitions, publications, and exhibits take a lot of money, in addition to which the maintenance of the collection, simply to preserve it from the physical handling it gets in the Study Center, costs a lot. We can't figure out a plan to handle all this which makes us happy, let alone anyone else. But we must choose, we must make decisions which are in effect critical decisions based on these factors. We can either accept responsibility for that, or else do it haphazardly, but we can't get out of doing it." He uttered his sharp, barking laugh. "You have to be willing to live with your own fallibility to take on a job like this."

There are two accusations commonly leveled at the department (and, indeed, at museums generally). The first is that, by giving attention to a new trend—such as sculptural photography—the department may be tacitly directing artists to explore a certain area. Bunnell acknowledged this possibility, but insisted that "what you do you believe in, and you demand quality. I have a very distinct sense of the dangers involved—people think of us as czars—but I'm truly not interested in just throwing out red herrings. I am interested in enriching the quality of life. The pursuit of a direction, ideally, will serve to further that purpose. 'Photography into Sculpture' challenged my own aesthetic judgments as well. . . . Especially in this museum, exhibits originate with the curatorial staff; they are—as embodiments of critical attitudes—indicative of the personalities involved."

The other accusation often heard is of cliqueishness, and Bunnell

candidly admitted that "there are elements of truth there. There are people you come to know well over the years, and whose work you respect, so you're prone to say, when someone calls up to inquire about work in a certain area, 'Oh, yes, you should get in touch with X or Y.' There's a tremendous danger in that, so we try to be intensely aware of it and guard against it.

"At the same time," he went on, "much of the mistrust is really unfounded. I know that one of the cliques which is supposedly operative here is said to involve Lee Friedlander and Diane Arbus. But they've only been shown here once. If that's a clique, it sure doesn't throw much weight around. Nevertheless, familiarity is a risk, which is why I take traveling so seriously. It keeps me from becoming insulated, a tendency which comes with the job. I never go out of town to speak but what my real motive is to use their money to get there and see what the students are up to. I make it a policy never to stay at the home of a faculty member; I check into a hotel, make contact with the photography students, and tell them to come over after dinner. There'll be a couple of bottles of Scotch, and we can find out what's going on."

Of his own involvement in the medium, Bunnell recalls, "I was snookered into photography to begin with—captured by certain aspects of the medium—and it's simply been a matter of deciding what I could do within that context. The whole reason I'm in this [curatorship] is Beaumont." He was referring, of course, to Beaumont Newhall, who transmitted the historian/curator bug to Bunnell when the latter was an undergraduate at Rochester Institute of Technology, during a period which he refers to, with an old grad's nostalgia, as "the Golden Era." Minor White and Ralph Hattersley were on the faculty, and the student body included Jerry Uelsmann, Pete Turner, Carl Chiarenza, and Bruce Davidson. Bunnell worked for twelve summers under Newhall at Eastman House, meantime completing an M.F.A. at Ohio University and an M.A. at Yale (where he is now a Ph.D. candidate; his thesis, a study of Stieglitz's work between 1887 and 1917, is being held in abeyance—another bit of juggling).

Originally, Bunnell intended to be a photographer himself, but got caught up in the critical side of the medium, though he's been in numerous group shows and had three one-man exhibits. He now says, "I have a lot of fun with my own photography, but I wouldn't par-

ticipate professionally. Not only are there too many extraneous complicating factors, but I find my other work much more intellectually challenging. I'm not a particularly intuitive individual, and I can't deal with people who don't want to be movers and shakers in some way. So I'm inordinately happy here. I love the values dealt with by people working in photography—it has a much richer diversity of expressive materials than any other medium today. . . ."

Peter Bunnell is a difficult man to describe or define. I find it impossible to take at face value the pro and con arguments about his sapience, integrity, taste, and motivation; too many emotions tinge the multiple images of him held by the photography community. Some of the paradoxes have been suggested by Jerry Uelsmann in two portraits of Bunnell: one has him standing in a small, outhouse-like structure beneath a statue of Romulus and Remus suckling; the other depicts him prone on a beach, with a gigantic Prexy's burger—"the hamburger with a college education"—floating overhead.

Two moments come to mind, however, each time I meet or think of him. I see him at a housewarming party for his new apartment, spiffily casual in a dashiki, next to a refreshment table which holds both alcoholic potables and a gallon of organic apple juice; and I remember watching him hobble around on the ground floor of the museum two days before the opening of 'Photography into Sculpture,' leaning on a cane and ignoring the cast on his broken foot, opening packages full of strange objects with a combination of curatorial care and childlike glee. Suspect him I must, just as I would expect the public to suspect him, and myself, and anyone else functioning in a critical capacity in this elusive medium. But I also recognize that the task he performs, for better or for worse, is one which not even his most savage detractors envy him.

Jan Van Raay: The Crest of a Tidal Wave

In Jan Van Raay's "Artists in Revolution: A Document, and Other Photos" we have an excellent illustration of the nonsensicality of attempting to apply a single, inflexible critical method to all photographic imagery in every genre. Van Raay's work—with the exceptions

of some of the "Other Photos"—is straight documentary photojournalism; entirely consistent, dependable, and competent. It makes no attempts at stylistic, technical, or procedural breakthrough. Her prints are acceptable but hardly, how shall we say, archival. Her subject matter is concrete (though it—not she—does hint at abstractions, even if on a less than cosmic scale), and may eventually appear, in the perspective of history, ephemeral.

But.

What makes Van Raay's photographs not only significant but invaluable is not the *how* of them, which is commonplace, but the *what* —and, indirectly, the *why*. For what we are offered, in the more than 100 prints which comprise the "Artists in Revolution" segment, is a record of the moral/political/aesthetic upheavals which have shaken the New York art world over the past three years—a record so thorough (exhaustive is perhaps the better term) that I doubt anyone, even *The Voice's* own peripatetic Fred McDarrah, can match it. Van Raay appears to have been everywhere: not just at the major and minor demonstrations, but also at the small street-corner petition-gatherings, the interminable loft meetings and planning sessions. While the causes for which the artists in question have crusaded— pro-abortion, anti-war, anti-racism—are topical, the attitudes inherent in the reawakening of political activism among the avant-garde are directly linked to fundamental alterations in our definitions of what art and artists are, tied to such developments as the emergence of conceptual and/or process art, the pricking of the valuable-object mystique's balloon, and so on. Thus these images of Van Raay's—and, if the negative numbers on the backs of her prints are to be believed, the vastly larger file from which they're drawn—become a vital record of what is almost certainly a major transitional stage in art history. I suspect that any scholar, historian, or curator who chooses to explore this phenomenon will have to turn to Van Raay's work, just as those who subsequently investigated the "happenings" of the sixties found much of their source material in the files of photographers whose genius lay not in style or methodology but in their recognition that something was happening here and even if they didn't know what it was, a straight, artless record of it was called for, which they provided to our great benefit.

This leads me to speculate along the following lines. Peter Bunnell

said recently that "it's time to stop talking about specific photographers and talk about images instead." He was not referring to anonymity of the individual artist. Nor am I. But it is high time—even if only temporarily—to think about photography in more McLuhanesque terms, to recognize that the photography community (in which I would include anyone who makes, takes, edits, writes about, looks at, or in any other way incorporates photographic imagery into his/her existence) can in fact be viewed as an entity, an organism. No matter how amorphous and inchoate that organism may appear, no matter how random its activity may seem from such a perspective, we can safely say that it is engaged in nothing less than the creation/ingestion/digestion/excretion/re-creation of as much of interior and exterior reality as it can gulp down.

If this is the function and purpose of the photography community as an organism (albeit unrecognized by the individual cells, and possibly only one of countless functions on a higher plane), then it is obviously inane to continue thinking about specific cells—individual photographers—as isolated and self-sufficient, just as it's ridiculous to persist in rating the various organs—or schools—in terms of which is higher or lower in ultimate value, since you are thereby forced into talking biological apples and oranges. Which is more important to the body's functioning, the brain cells or the marrow? Without Roger Fenton and Mathew Brady you don't get a Jacob Riis or a Lewis Hine; without Hine and Riis you don't get the omnipresence of photographic reportage in newspapers; without that you don't get Weegee, and without Weegee you don't get Friedlander, and so on.

If we can get away from the brain-stultifying ego trip endemic to photographers and critics and the audience—that continually pressing urge to be/find the one who sums up a particular subject for all time, the one who has the *final say,* as if that were desirable as well as possible—we might come to the conclusion that the ultimate negative Stieglitz envisioned is perhaps legitimate as a personal symbol but (though it's pretty to think otherwise) meaningless on this larger scale. There's more that needs to be said about peppers than Weston could say, insofar as the proverbial man from Mars needs a photograph showing that the pepper is a vegetable, another showing its normally humble function, and another showing people dancing, before he can fully appreciate that Weston found the forms of people dancing in a salad adornment.

All photographs, then, are in many ways interdependent with all other photographs, filling in a total photographic image of which the individual photographer cannot be aware. Why haven't we seen a picture of the whole picture yet, you ask? Because this total, ongoing image can, obviously, never be finalized; but the fragments—meaning the bodies of work of everyone involved with the photographic image —are inextricably linked. To use the case in point as an example, I'd say that within the continuing process, in its recording of the New York art scene, we'd have to have the following to provide even an approximation of complete photographic documentation: portraits of the major and minor luminaries; photojournalistic accounts of their political activities (such as Van Raay's); documentary/interpretative explorations of the artists' works and shows to indicate the attitudinal connections; intensely personal images revealing, on the part of some photographers, the ways in which the work of these artists has affected the photographers' own ways of seeing; and, finally, photographs which show how all the preceding varieties of photographic imagery end up affecting the artists themselves. This would provide us with at least a skeletal framework on which to base our own synthesis of the situation.

Incredibly, even at this primitive stage of the organism's growth, that's probably what we'll get, though it may take us time to perceive the whole picture. The organism does function *de facto* in this way, although its "separate" parts are not yet willing to recognize that we need Gene Smith bleeding all over the place alongside Walker Evans with his inbuilt styptic pencil—in short, that the creation of the fullest possible document necessitates the simultaneous functioning of a dozen major approaches and numerous variations thereon. To encourage the premature atrophying of any of these by engendering a factionalism based on the limitations of one's personal taste is, in a critic, contemptible power-mongering and, in an artist, a debilitating waste of energy. If there is such a thing as evil, it may only be definable as that which deliberately seeks to limit man's vision. Let the heliotropic beast grow and slouch toward its own equivalent of Bethlehem.

If we can minimize the willful parochialism which is now prevalent, we may even begin to perceive just how closely tied to other areas of the art scene is contemporary photography. Not only is the photographic image now crossbred with virtually all other media, not only is it intrinsic to such supposedly alien forms as earthworks, but such

issues as social responsibility/politics/valuable-object manufacturing are raising their heads in sectors of the photography community as well. While it leads (and has led for decades) the other arts in most areas, photography has remained a few years behind them in confronting such questions. We still talk somewhat daintily of the "concerned" photographer, not the angry one, and the mere suggestion that these issues are relevant to photography still affronts and outrages many sensibilities within the community. But they will arrive, inexorably; they are, indeed, at the gates right now. If I suggest that what the more tremulous view as the Mongol horde is simply a band of young Turks come to shake us from our too-prolonged somnolence, it is less to assuage the fears of the old ladies among us than to reaffirm my faith in the ultimate rightness of the cycle. And if I recommend a visit to Van Raay's show (at the Hudson Park Branch Library), I do so not as a certification that there you will find and bask in the cheery glow of Art, but rather as an indication that in her images there is an abundance of information about the tidal wave which is about to strike our tight little island. Whether it will drown us or rejoin us to the mainland Van Raay does not reveal. Nor can I.

But. There it is.

Photography and Conceptual Art

If anyone out there still doubts the growing dependency of contemporary art on the photographic image and process, Shunk-Kender's documentation of Willoughby Sharp's "Pier 18," part of the Museum of Modern Art's "Projects" series, demonstrates it neatly. The dilemma is clear: if you create a conceptual event/work, and want to extend its sphere of influence beyond those who witness it in person, you must make some kind of record of it for others to see; and that record, necessarily a tangible physical object of some sort, automatically assumes a permanence, a financial value, and a share of the *objet d'art* mystique which the work itself attempts to deny. Coming smack up against this paradox, artists tend to take an illusorily easy way out by documenting their works with photographs, to which they attribute a theoretical but entirely incorrect valuelessness and impermanence.

What a game. There's a lot of philosophical chickening-out going on in this area. This is not to say that any photographic document of a conceptual work/event is illegitimate. I don't think Shunk and Kender's records are invalid, or that there was anything wrong in Sharp's permitting their documents to be made. On the other hand, though, I would look askance at photographs documenting works by any artist claiming to be in total revolt against museum/gallery/critic-imposed attitudes concerning permanence, financial value, and object fetishism. Internal contradictions.

Those working in this area without such dogmatic absolutism have another problem: they're obliged to come to a fuller understanding of the metaphysics of the medium once they incorporate it into their work, even if that incorporation only extends to taking a Polaroid snapshot of a trench in the desert. Because what we're dealing with in photography—and, as a rationalist, I come to this conclusion with considerable difficulty—is nothing more nor less than magic, in any and all senses of the word, and this magic endures beyond all the explanations of the physics and chemistry of the process and the machines which make it possible. He who says there is no magic in being able to hold in your hands a sheet of paper containing a sliver of time is blind. Such a sliver is present in every photograph ever made; such a sliver is lost with every discarded image. Most conceptual artists using the photograph as a documentary method are relating to the medium on the level of parlor prestidigitators, pulling out of the photographic hat the rabbits they've planted there. Diverting and harmless. But soon they're bound to start pulling out the rabbits they didn't plant, and they'd do well to bone up on the care and feeding of those creatures, because it's hard as hell to put them back when you haven't the faintest notion where they came from. Photography may make sorcerer's apprentices of them all.

Harvey Stromberg: The Sneakiest Show in Town

It is 10:30 in the muggy night of July 15. We are crowded around the TV set in a SoHo loft, waiting for the 11 o'clock news on Channel 4. Richard Nixon is telling us that he will go to Peking. I am fan-

tasizing him running on a peace ticket in the upcoming election. Harvey Stromberg is saying, "I'm perfect for this kind of thing."

Harvey Stromberg is a photographer. Or a media manipulator. Or a self-made chance factor. Or an impresario. Or a guerrilla activist. Or a fraud. All of the above. None of the above.

Harvey Stromberg employs photographic images in his work. Some people may have encountered them last winter, when he strewed Central Park with photographic reproductions of autumn leaves in "A Last Tribute to Fall." Stromberg's notoriety rests primarily, though, on his creation of the longest-running (two years to date, and still ongoing) one-man photography exhibit the Museum of Modern Art has ever housed. The museum is not altogether happy with the part it has played in setting this record, particularly since Stromberg has been showing there unofficially and without sanction. MOMA's problem, however, as Stromberg succinctly puts it, is that "there's no way of stopping me."

Stromberg's method of showing at the museum is admirably simple. He makes exact-to-scale, *trompe-l'œil* black-and-white photographs of such museum features as keyholes, alarm buzzers, light switches, electrical outlets, bricks, cracks in the walls, and air vents. These neatly cropped images are then backed with double-faced masking tape and hung, surreptitiously, at appropriate spots around the building. Sometimes they are discovered and removed (though Stromberg claims that a number of them, particularly those in the sculpture garden, have been up since the beginning); but they are easy to replace. And, as Stromberg points out, even if he himself were barred from the museum, he could simply send someone else in to carry on the project.

Apparently, the perfection of his "crime" was such that Stromberg felt obliged to throw a monkey wrench into his own works, just to see what would happen. So he decided that, the show having run for two years, it was time for an official opening. With Barbara Malarek of *New York* magazine acting as press agent, the affair was set for 8 P.M. on July 15, outside the museum. Formal invitations were sent out, the media were alerted, and the MOMA Litmus Test was under way.

It really was a beautifully laid trap, since it had to catch something. If the museum treated the event with benign neglect, then a significant precedent would be set. If MOMA took a hard line, and Stromberg got himself arrested, then the museum would be busting a

conceptual work very similar to many it had shown under its own auspices, and how do you argue that in court without looking a bit ridiculous?

We were still waiting for the news. I was running the evening again in my head, beginning with the press conference held at a friend's studio on East Fifty-third Street just before the opening. Stromberg is grilled extensively by a reporter from a Newark paper, who asks about his relationship with his father: did he have a happy childhood?—psychiatric esthetics. Stromberg is more interested in talking about his latest venture, Kumquat Galleries, under whose auspices any artist in any medium will be able to exhibit whatever, whenever, and however he/she wants. It's simple, Stromberg explains. Anyone who wants a show writes to him at his studio and tells him what the show will consist of. Stromberg then writes back, authorizing the show as being sponsored by the gallery, and includes it in a regular mailing listing what is currently being shown under the Kumquat aegis. No overhead, and therefore no commissions or hanging fees.

"Imagine," Stromberg says, "Kumquat could have five hundred, even a thousand shows a month, across the country, around the world . . . anybody who wants a gallery show can apply, no one will be turned down. . . ." His eyes go wide and dreamy at the thought. The Newark reporter is still hunting down causal traumas. "Are you a starving artist?" he queries. "Hell, no," Stromberg replies, "I'm not even an angry young man."

Then off to the opening, a small but highly disorganized group trailing westward, Stromberg proclaiming that he's "decentralizing the museum" and hinting that the Modern is only the beginning. He is evasive when asked where he will strike next.

The crowd outside MOMA is small, but grows as the lights go on and the cameras start to roll and click. Stromberg passes around the guest book, which will subsequently be sent to the museum, and hands out photographs of champagne glasses to add sparkle to the festivities. After much posing and many questions, Lew Wood of Channel 4 suggests action pictures. Out comes Stromberg's looseleaf binder, and with three deliberate but rapid motions he is gone, leaving behind a drain pipe, a light switch and a keyhole. As the crowd ebbs after him, a security guard steps outside and rips down the drain and

the switch, then opens the door again—missing the keyhole, pasted on the edge of the door at eye level, completely—and ducks back inside.

I follow this guard, in my official capacity. Will he identify himself? No. Can he tell me if these photographs he's seized are to be included in the museum's permanent collection? He can't say—I'll have to see someone in Public Relations. I go back outside. Stromberg is re-staging his bit, on the other side of the entrance, for a different network. Zip-slap, zip-slap, zip-slap—light switch, alarm buzzer, door knob, all incongruous on the marble facade. Stromberg hands out half a dozen works to eager volunteers, then follows them into the museum.

Upstairs, into the galleries, whip 'em out and stick 'em on, guards milling, shooting dirty looks, angrily peeling off the ones they spot and crumpling them up, hurling them to the floor, opening little phone boxes to call the Head of Security, but we are gone, downstairs and out, in no more than ten minutes all told. A neat operation. The guard who ripped down the first set pasted up outside casts a last suspicious look as we leave. (The next week, at the Clarence White opening, he recognized me, pulled me aside, and said, "That was child's play, man—just par for the course, that's all.") I ask Stromberg if he considers the opening to have been a success. "Don't you?"

(Several days later I questioned Peter Bunnell about the Department of Photography's attitude toward this event. "I'm sorry I couldn't attend," Bunnell said, "I was looking forward to it. I'm familiar with Stromberg's work, but I thought his autumn leaves thing was more interesting conceptually." Are any of the seized Strombergs in the museum's collection? "Not unless he pasted them in somehow. To the best of my knowledge, the Custodial Department has them. I have one myself, which I found down in the lobby. It's on my desk now.")

Richard Nixon's decision to go to Peking has been analyzed. So have various national and local news stories, and assorted sports events. The weather is being wrapped up. On comes Lew Wood, and there it is, edited and trimmed and juggled and real and unreal at the same time. Harvey Stromberg is right; he really is perfect for this kind of thing. It's a great two-minute news item.

As Wood's face fades from the screen, I am left with two questions. The first is this: Stromberg claims to have been extensively influenced by Andy Warhol, and Warhol has said that in the future everyone

will get to be a star for five minutes, so has Harvey Stromberg already had his turn? The second is this: what are the moral, legal, and aesthetic implications of the photographic facsimile of my signature which is neatly pasted into Harvey Stromberg's guest book?

Diane Arbus (I): The Mirror Is Broken

"A photograph is a secret about a secret. The more it tells you the less you know." Diane Arbus said that last April Fool's Day. The same statement holds true for the act of suicide. Diane Arbus took her own life last week.

It has always seemed ghoulish to me to speculate as to the motives behind a suicide, particularly so in attempts to correlate the act with an output of major creative work. Suicide can be either a confession of defeat or a hymn of triumph, an admission of one's inability to confront the pitilessness of life or a defiant refusal to tolerate it, a self-erasure or a self-definition, but it is always a private act, a final *Mind-your-own-damn-business* hurled into the teeth of the universe, and anyone who takes that irrevocable step has earned his or her privacy.

Diane Arbus slashed her wrist and bled to death in her Westbeth apartment—sometime late Monday or early Tuesday, since her diary contained an entry dated Monday, July 26. Hers was the third suicide at Westbeth, the second by a photographer. Her body was discovered by her close friend Marvin Israel, on Wednesday, July 28. Funeral services were held at Campbell's on Madison Avenue. She was forty-eight years old.

Diane Arbus studied with Lisette Model and earned her living as a commercial photographer, but her concern as an artist—I should say concerns, as twinned as the children in one of her most famous images—were the freakishness of normalcy and the normalcy of freakishness. She called freaks "the quiet minorities," and defined her special field of interest in photography as "a sort of contemporary anthropology," much reminiscent of August Sander, with whose work her own had considerable affinity.

In a 1967 interview for *Newsweek,* she said about freaks, "There's a quality of legend about them. They've passed their test in life.

Most people go through life dreading they'll have a traumatic experience. Freaks were born with their trauma. They've already passed it. They're aristocrats."

And, about herself, in a more recent statement: "Once I dreamed I was on a gorgeous ocean liner, all pale, gilded, cupid-encrusted, rococo as a wedding cake. There was smoke in the air, people were drinking and gambling. I knew the ship was on fire and we were sinking, slowly. They knew it too but they were very gay, dancing and singing and kissing, a little delirious. There was no hope. I was terribly elated. I could photograph anything I wanted to.

"Nothing is ever the same as they said it was. It's what I've never seen before that I recognize. . . .

"Nothing is ever alike. The best thing is the difference. I get to keep what nobody needs."

Of her death, Richard Avedon, who knew her well, said, "Nothing about her life, her photographs, or her death was accidental or ordinary. They were mysterious and decisive and unimaginable, except to her. Which is the way it is with genius."

Diane Arbus's photography was Stendhal's "mirror held up alongside a highway." That mirror is broken, by her own hand, but the mirror-with-a-memory which is the camera has allowed us to retain a few of the pieces. Perhaps someday we may even come to understand them. And thus ourselves, and her.

"I Have a Blind Spot About Color Photographs"

CAMERA/infinity, a photographers' cooperative, has been holding its annual exhibit at Lever House. Today is its last day. The group has gotten considerably smaller over the past two years—where once there were well over a dozen photographers whose work was included, there are now only half as many.

I am going to disqualify myself from commenting on a large portion of the show by acknowledging a personal blind spot—specifically, color photographs in general. Of all the color photographs I see—and that's a lot, if you include reproductions as well as original prints— very few achieve anything for me beyond a momentary gratification of the retinal synapses. Since I'm not a photographer myself, this is

not a result of some personal prejudice related to my own work, but I have yet to settle in my mind the cause behind it. Three possible ones keep circling around in my thinking.

The first is simply that not many photographers are really doing much with color aside from making pretty pictures. The second is that the psychological/emotional/aesthetic factors involved in color imagery in general are so complex, and so hard to control in photography (where any number of factors can create a huge gap between the exact shade the photographer sees and what ends up appearing on his print) that, when combined with what is still our basic ignorance about the effects of color on perception, it's astonishing that anyone at all manages to push through and make a coherent, articulate color photograph. And the third is that the abstraction inherent in black-and-white photography (which is actually not an abstraction at all, since we perceive in tones and not in colors, but we sense it as such) makes possible layers of meaning which are beyond the reach of color photography—or, in other words, color photography is too damn "realistic" for its own good.

The fact that I have been genuinely moved by a (small) number of color photographs tells me the situation is not hopeless. And I am aware that there are strong counter-arguments to which this column is open, for anyone who wants to engage in what could be a provocative and productive debate. But until I resolve my own uncertainty in this area, I will refrain from talking about exhibits of color work unless they seem either egregious by any standard or transcendent. For me, those in the CAMERA/infinity show fit neither category, so I pass.

Larry Clark: *Tulsa*

Ralph Gibson's Lustrum Press is rapidly building an absolutely first-rate line of photography books, to such an extent that if the output and quality levels are maintained Lustrum will soon have to be considered one of the major photography publishers. In addition to Gibson's own *The Somnambulist* (1970), Lustrum has now (1971) issued books by Neal Slavin, Larry Clark, and Danny Seymour.

Larry Clark's *Tulsa* is staggering, a poignant, raw, compassionate,

and utterly honest sequence on the speed scene in Oklahoma, of which Clark was a part for a long time. (In his succinct introductory note, he writes, "i was born in tulsa oklahoma in 1943. when i was sixteen i started shooting amphetamine. i shot with my friends everyday for three years and then left town but i've gone back through the years. once the needle goes in it never comes out.")

Tulsa is a major work, almost too good (coming from a young and relatively unknown photographer) to be true. Its significance is not as a sociological documentation of the drug subculture, although it can serve as such (and it is head and shoulders above anything previously done in that area). What matters about *Tulsa* is that it is not only a felt piece of work but that it makes you feel also. It is an intense, visceral, wrenching statement whose life-giving quality results from its mirroring of the paradox inherent in the drug subculture, that frustration with the inadequacies of life which creates the need to intensify it through the use of poisons, the conscious risking of death in order to enhance life.

Minor White has used the terms "nourishing" and "poisonous" to distinguish between different kinds of photographs (on a personal level; i.e., one man's meat, or vegetable, is another man's poison). Those terms have rarely struck me as more specifically applicable than they are to *Tulsa,* in which both qualities function simultaneously. Clark is preaching neither an anti- nor a pro-speed sermon, but rather showing what it is like from the inside. In passing, I might add, he gives the lie to the persistent nonsense about "objectivity" as the foundation of meaningful documentary photography. *Tulsa* has the extraordinary power that it does because Clark was willing to trust his honest subjectivity, his instincts and heart and guts, and ride with them. His commitment to his own perceptions through the camera is so obvious and so strong that it forces an equivalent involvement from anyone viewing the images. Thus the existence of the book, as an affirmation of life in itself, has a multiplied impact, coming from one who obviously has been deeply into and emerged from this manifestation of life/death conflicts. Parker Tyler once wrote somewhat derogatorily about what he saw as the sophistry of the scene in Gelber's *The Connection* where the musicians talk one of the photographers into shooting scag so that he'll know what it's all about, but in point of fact Gelber was right in many ways. One must be not only committed

to but knowledgeable about and experienced in one's subject matter as well as one's medium, as a general principle. A while back, there was a cartoon by Lorenz in the *New Yorker* showing a camera bug in Hell taking snapshots of the devil. Lorenz was making one point, but there's another implicit there; you don't (can't) make pictures of Hell from the outside.

Tulsa is, in conception and sequencing, a blend of the cinematic and novelistic. It begins by introducing its "cast of characters," major and minor, and is then divided into three sections, "1963," "1968," and "1971," each of which is a sort of slice-of-life episode climaxed by or revolving around a death. Each segment has its own specific mood. Thus the first, when most of the participants are in their teens or early twenties, has an aura of youthful bravado and Midwestern innocence, even a joy, to it, before it is shattered by the death of a girl. The second, made up entirely of film strips (except for the *in memoriam* image of Billy Mann), is more obscure, harsher, and grimmer, and concludes with the death of one of the major characters. The last is full of violence: guns everywhere, as playthings; an accidental bullet wound; girls with their eyes blacked; the beating up of a police informer; and the funeral of a baby—the child of two of the characters— as the finale, with a postlude in which a number of new, younger faces appear to indicate that the cycle will continue.

Yet even in the midst of all this death the characters are in life; and harrowing and painful though Clark's images are, the very involvement they create and the intense emotionality they extract from anyone who encounters them are affirmations of the viewer's own life urge. This book, in other words, is for those who are willing to commit themselves to it.

Danny Seymour: *A Loud Song*

Danny Seymour's *A Loud Song* (Lustrum Press, 1971) is an unusual photographic book, which, though it does contain a number of photographs by its author, is nothing like a monograph and thus can't be considered as such.

A Loud Song is probably best described as Danny Seymour's family

album, a preliminary sketch toward some future autobiography. It contains pictures of Seymour as a kid, pictures of (and by) his father, Maurice Seymour, pictures of his sister Rosa, a letter from Allen Tate, a note from Robert Frank (with whom Seymour has worked frequently)—in short, a lot of memorabilia, most of it photographic, tied together by Seymour's handwritten text.

It is a very personal work, yet at the same time entirely open and accessible. Seymour has put it together well; every word and every image is made to count. Within a brief space he conveys a real and deep sense of his family and friends, and evokes the texture of his own life remarkably well and, so far as I can judge, with almost complete honesty. The images, both Seymour's own and those by others, are intrinsic to the work, and I think that to approach them as separate art works, in a critical sense, would violate their spirit. They function with the text in a symbiotic relationship similar to that established by Wright Morris in *God's Country and My People,* and *A Loud Song* as a whole falls roughly into the photo-fiction category. It is a book full of life and energy, and it offers a lot more than it demands in return.*

* Danny Seymour disappeared from his sailboat while en route from Colombia to the United States in December 1972. He had just helped Robert Frank complete the filming of his Rolling Stones tour film, *Cocksucker Blues.*

Michael Abramson: *Palante*

I have written frequently about the pervasive stagnation afflicting contemporary photojournalism, an ineffectuality bred of blind devotion to the false god Objectivity and exclusive concentration on situations reflecting the multiple stalemates in current societal crises, rather than the solutions thereto.

Most photojournalists have consistently avoided going beyond the professionally fashionable form of image-making, which permits only two basic kinds of photographs and their variants. The first includes photographs of the victims of warped cultural systems, a genre represented at its nadir by Davidson's *East 100th Street* and at its peak by Herb Goro's *The Block.* These two versions of the same theme are il-

lustrative, insofar as they demonstrate that there can be marked quali-tative differences in works created on the basis of this approach; within its strictures, therefore, there exists the possibility of success as well as failure. That possibility, along with what I feel is an impera-tive need for sociological data and accounts of individual sufferings, for the record, validates the approach despite its limitations.

Similarly, one can justify—on basically the same grounds—the omni-present photographic coverage of demonstrations and confrontations which is the second fashionable approach. Theoretically, at least, we do need these images—or, rather, will need them at some point in the future distant enough that we can consider these crises as history and deal with them on those terms.

Nevertheless, while we can rationalize a legitimacy to encompass such images, our defense of them is inevitably based on intellectual, even scholarly grounds, and the attitude implicit in that defense is so remote in its scientific detachment as to be not only pedantic but in-human. Considered in terms of real lives in a very real present (as opposed to the hypothetical value of full data and extensive archives in an increasingly uncertain future), it is clear that neither David-son's book nor Goro's accomplished any tangible alleviation of suffer-ing for either their specific subjects or others in the same situation. Whatever their purpose, then, and no matter what intentions lie be-hind them, photographs of the victims function for the photographers themselves and for their audience more to confirm their generalized sympathy for those whose lives have been undermined by injustice than as stimuli to action. For the victims themselves they serve no positive purpose whatsoever, and may actually do them harm by merging their personal agonies into an endlessly swelling documenta-tion of suffering so overwhelming as to paralyze anyone who might otherwise be prone to act against it. Such images are testimonies to the bleeding hearts of the photographers who make them, and the bandaid stockpiles of their viewers, and little else.

By the same token, the now-standard confrontation images neither deal with the people involved in demonstrations, on either side, as in-dividuals, nor make any attempt to go beyond the impasse such dem-onstrations represent to seek out solutions. Abiding by the law of objectivity, they depersonalize their subjects and further rigidify at-titudes; they close minds and confirm prejudices, never the opposite.

Yet, incomprehensibly, they are permitted to serve as evidence that the photographers who make them are open-minded and unbiased, that they are somehow epitomizing for us visually the Great American Credo that not only are there two sides to every question, but that both sides are necessarily right.

Charitably inclined as I am, I have heretofore ascribed this misfunctioning of photojournalism to lack of insight and example, rather than to its more probable sources—a lack of real moral commitment to either side of any major question and a fear that if, as a photojournalist, one takes sides, one may prove to be not only wrong but unfashionable. But my charity has been depleted considerably over the past several years, and the appearance of a brilliant example of what the new photojournalism can be—Michael Abramson's *Palante: Young Lords Party*—indicates that it should no longer be necessary.

Abramson has been working with the Young Lords since 1969. In the course of his experience with them, he came to a philosophical conclusion about photojournalism which runs parallel to some of the questions I've been raising in this column. In his afterword to *Palante* (McGraw-Hill, 1971) he writes, "It is time for photographers to stop photographing the victims of America and begin to record the struggle of those who fight against that victimization. Alternatively, it is of equal importance to examine those who perpetuate and are responsible for this victimization. . . . It is my hope that this book will enable people to understand what it means, in deep personal terms, to be a revolutionary in this society."

Clearly, Abramson is—or, to be more precise, has become—fully committed to the Lords both as individuals and as an organization; he has thus relinquished any claim to pure objectivity. Yet I think it would be instructive for other photojournalists—particularly those concerned with preserving their technical objectivity at all costs—to read *Palante* and to compare it with some classics in the genre, for it is certainly no less objective than *The Block,* or *An American Exodus,* or *How the Other Half Lives,* or *Death in the Making,* to cite just a few. The text—which, with the exception of Abramson's note and a few official manifestos, is made up of transcriptions of conversations with the Lords—is refreshingly free of cant, dogma, and sloganeering. Along the way, the Lords discuss almost all their activities and recount the major events in their history as an organization, and Abram-

son's powerfully simple images cover the same ground, so that the book, aside from being a solid and persuasive argument for the Lords, is also a thorough document of their past and present.

Stylistically, then, *Palante* could be described as traditional. The difference which makes it a true breakthrough in the gray room is that Abramson chose to commit his energies as a photographer to a group of people who not only are aware of what is wrong in their lives but have clear and cogent ideas about how to change it. Such a high-profile approach to the issues is certainly dangerous, and no doubt will create a lack of credibility for Abramson in certain circles—the same circles which insist that if you're going to do a story on prison conditions in New York City, you're obliged to let Prison Commissioner and apologist George McGrath have his say in obeisance to the equal-time rules. Abramson may not be "objective" but neither he nor the Lords—who share credit for the book—are propagandists either. In fact, what makes the book not only a moving document of a significant struggle but a tool for change in itself is that it is a series of personal testaments and hard-won insights into America, not a phrase-mongering diatribe.

Palante sets a high standard for activist photojournalism, and shows the way. It will take courageous, committed photographers to follow Abramson's lead, but the challenge implicit in its existence is one which we have every right to insist be met from now on.

More on Color: Readers Speak Out

If the letters in response to my column of August 29 are any indication, that article—in which I enumerated my reservations about most contemporary color photography—touched a sore spot. A number of letters ardently pro and con color came in, and, while I want to get to the significant portions of these responses, I'd first like to clear up a few misconceptions of my own attitude toward color which seem somehow to have crept into the argument.

Let me make one thing perfectly clear. I have nothing whatever against color photography as a medium of expression and, in fact, believe it has great—though relatively unexplored—potential along those

lines. The correspondent who cited what he believed to be my "old and prejudiced black & white sensibility" couldn't be more wrong in that regard. One of the first photographic books I came to love, long before I began writing about the medium, was Eliot Porter's *In Wildness Is the Preservation of the World*.

I still enjoy Porter's work, as well as color imagery by a diverse, if small, group of photographers. My tastes along those lines run from Len Gittleman's color photograms to the more classic styles of Porter, Charles Pratt, Dorothea Kehaya, and Wynn Bullock. They also include a lot of colored photographic imagery, as distinct from color photographs (by which I mean works in the mixed-media vein).

Moreover, as a non-photographer, my attitude toward color photographs is not predicated on personal stylistic predilections or working methods. Rather, it is simply the reaction of one observer, whose tastes are quite eclectic, to the sizable amount of color photography to which he's been exposed.

Since I've already had my say on this subject (though not my final say, I am sure), I've decided not to exercise the columnist's prerogative of having the last word and arguing *ex post facto* with the opinions below. Instead, in order to further the debate, I've selected from a half-dozen letters sections which struck me as significant to my own continuing consideration of the color issue. A few buttress my own beliefs; most disagree. And some deal with pertinent questions which I did not touch on.

From Peter Clagdon: "It seems the only tradition we have in color photography is commercial. The commercial photographer was forced into color. He shot transparencies which he sent out to be processed. The darkroom was forgotten when it came to color. The only 'post-visualizations' possible were obvious techniques such as sandwiching transparencies. The few photographers that became involved in the darkroom (such as Rene Groebli's dye transfers) got into techniques that emphasized only the color. This seems to be changing slowly. One has to accept a color photograph, first, as a photograph. The hordes of home shutterbugs never question the validity of color. They want a photograph of their family, house, swimming pool, or dog. When color film became available they used it. *Now we have millions of color images that document a way of life. This giant body of work*

constitutes a valid tradition in photography. [Italics mine.] The home-picture-taker is the first to accept color photography as, simply, photography."

From Marvin W. Schwartz: "You can shoot a Buddhist monk burning to death in color and it's almost a pretty picture; in black & white it's horrifying . . . here lies the difference: *you can hide in color* but not in black & white; the austerity implicit in the absence of color enriches by revealing the picture itself. Yet art directors—especially clients—love color. The payment for shooting color is hundreds of dollars higher per day when it should be at the very least equal. Color has brainwashed us—color, color, color—we're living in such an unnatural life style, is it any wonder nobody wants to see things as they are?"

From Susan Trentacoste: "Basically, we perceive a subject by one or more of the following elements: shape (that is, the two-dimensional quality of the subject), form (three-dimensional), texture and color. All these elements give us information about the subject. A photographer can choose to use one or more of these elements in his photograph . . . there are instances where deletion of color negates the message of the picture entirely. . . . In my own experience I have found I much prefer color for its subliminal, emotional impact. . . . There is one last thought (and here I admit I am out on a limb): there are, undoubtedly, more male photographers and male critics than there are women in these fields. Could it be that the more rational, cerebral male becomes bewildered when confronted with emotional color? Women have been known to be more aware of colors (as in studies showing that more women than men remember having dreams in color) and also are reputed to be more emotional and subjective than their counterparts."

From Robert Worth (one of the photographers in the exhibit which touched off my statement about color photography): "No doubt your prejudice is well founded. You stated the case against color well: (a) Too many pretty pictures. (b) Color photography too realistic. (c) Emphasis on color for color's sake. And I can add another: Too many unresolved 'experiments' published before fruition. Your mention of the technical, emotional, aesthetic complexity of color is important, but it's not a reason for rejection. It only requires that we put ourselves out a little more in our attempt to understand. . . . It's

my feeling that color must be evaluated in the same terms as black & white. What does the picture say? What does it leave to the imagination? Is it provocative or evocative? Does it communicate? What is the photographer's involvement with his subject and does he involve us? Does the photograph celebrate life? Does it relate to nature or is it just an imitation? Is it an intellectual exercise or a gut response to an experience? Is it creative or is it manufactured?"

And, lastly, "some possible notes" from Lee DeJasu: "(1) Color concerns a correspondence between the molecular coding of a given presence and its interplay with visual light. (2) Color in actual life seems to stay elusively at some radiant in-between; tied to its objecthood, yet one looks past and through color at texture, line and shape. (3) Color photography has been more keenly tied to painterly solutions and conventions, whereas black & white was freer sooner. (4) The transience of surface and therefore visual reality may be most agreeably accessible thru color. This pointing toward the tenuous and mortal aspects of our lives. (5) I believe as far as we may know, color is a very human condition. (6) Lastly, the need and eventual success-necessity of working in color is apparent, 'simply because it is there.' "

I would certainly add my own heartfelt Amen to DeJasu's last point. Perhaps talking about these issues affecting color photography—and continuing this debate, which is still open—may stimulate all our thinking on this subject and eventually generate some solutions to the multiple problems of color photography as a creative vehicle.

A Manifesto for Photography Education

"The illiterate of the future will be ignorant of the use of camera and pen alike." That was Moholy-Nagy's prophecy in 1932, and what is startling about it is not only its accuracy but our persistent unwillingness to take heed of its implications despite four more decades of accumulated evidence demonstrating inarguably that photography is the most profound and energizing innovation in communication since the printing press.

First published in the "Photography in Baltimore" issue of The Paper, October 23–November 4, 1971. Subsequently reprinted in NYT, November 21, 1971.

In little over a century, photography has come to pervade Western culture (and much of its Eastern counterpart) to such an extent that if, by some chance, all materials and techniques directly or indirectly connected to photography were to vanish overnight without a trace, our society would be paralyzed. So thoroughly interwoven is photography into the fabric of our culture—the threads run through communications techniques, of course, but also through nuclear physics, biochemistry, medicine, all branches of industry, and virtually every other field—that the warp of our culture and the loom of history are absolutely dependent on it for stability.

We should realize, then, that in any consideration of methods for alleviating the widespread photographic illiteracy of our time we are dealing with a phenomenon vastly larger than the mere appearance of a new graphic medium with expressive/creative potential. *Of course* photography is an art form, and *of course* the teaching of it as such demands a radical re-evaluation of our established methods for teaching, instilling, and nurturing creativity. That reassessment has been long overdue in the arts anyway.

However, to suggest that this should be the main thrust of photography education in our time is as constricted an attitude as that which says photography's real struggle within our culture should be toward its acceptance as an art form. Heated though these skirmishes may be—and they are both still raging—any overview shows clearly that these are false issues, red herrings, delaying tactics subconsciously evolved by the culture to divert energies and slow down the photographic juggernaut. Both these fights—for acceptance of the photograph as art, and for new methods of teaching it as such—are legitimate and important, as are many others. The battle is everywhere. But the front is elsewhere.

The problem created by the emphasis on these two questions in photography education is that it forces us to view the situation through what McLuhan called "the rear-view mirror," to pit ourselves against the most benighted attitudes, rather than test ourselves against the most enlightened ones. There will always be someone to argue that you can't make Art with a machine, and someone else to say that if you can it'll only be by imitating "proven" esthetic attitudes from other media. Unfortunately, photographers—and virtually everyone involved in photography education is a photographer—take these ar-

guments personally, and thus get sucked into trying to break through this chain of circular reasoning. That is why, just as war is too important to leave to the generals, photography education is too important to leave to the photographers.

This is not merely a facile analogy. Both the military and photographic experts make an identical and fundamental mistake by assuming that the population of the world can be divided readily into two groups. In the case of the military, these are soldiers as opposed to civilians; in photography, "serious photographers" as opposed to amateurs and non-photographers.

In both cases, this artificial and inaccurate distinction serves only to create a hermetically sealed world within whose confines experts and their acolytes speak only to each other, oblivious to their dependence on and interaction with those who fall outside these arbitrary parameters. For just as there are no more civilians in contemporary warfare, so there are no more non-photographers in our culture.

If we tear ourselves away from the rear-view mirror long enough to take a long hard look at the role of photography in our culture, it becomes apparent that a radical redefinition of our concept of the photography community is necessary. For too long we have assumed that it included only "serious" or "artist" photographers, curators, critics, and that small public specifically interested in viewing, purchasing, and reading the works of these three groups.

In light of the omnipresence of photographic imagery and the medium's manifold offshoots in our culture today, the elitist parochialism of this concept is painfully obvious. Even if we exclude photography's effects in other areas and concentrate solely on the communications media—film, TV, books, magazines, newspapers—we are forced to conclude that we, as a culture, are now receiving as much of our information from the photographic image as we are from the written word, which in turn means that roughly 50 per cent of our decisions (collective and individual) are in some way based on photography. To exclude from the concept of the photography community anyone who derives half his data input from the photograph is a bit ludicrous.

Let us, therefore, posit a new definition of the photography community; one more appropriate for our own time. Let us include in it—with no insistence on ranking those we include according to the aesthetic quality of their work or their awareness of their involvement

with the photographic image—anyone who makes, uses, edits, views, assesses, incorporates, studies, learns from, or teaches with the photographic image in any of its forms on a regular basis.

That is, I hope, all-inclusive. It suggests, I also hope, that virtually everyone in this society, and in the world, is part of the photography community. Viewing this vast community as an organism with extraordinary potential for growth—a potential based on the demonstrated capacity of the photographic image, which is the organism's source of nourishment, to deepen the organism's understanding of itself and intensify its perception of the universe it inhabits—we must necessarily rethink our attitudes toward photography education.

To begin with, we must take Moholy's prophecy to heart in this new light and recognize how imperative it is that everyone in this larger photography community (and not just those who eventually decide to make photography their vocation or avocation) be educated in the functions of the photographic image. Such instruction is as vital as that in reading and writing; it should begin in childhood, and be an integral part of the school curriculum at all levels. It would be a good start for every college in the country to offer a basic course in the history of the medium (such courses presently being scarce even in colleges with photography departments). But that is really just a drop in the bucket, and in a sense begs the issue.

That issue is this: if we are to come to grips with the phenomenal power of the photographic image in our culture and its potential as an evolutionary (as well as revolutionary) tool, we must recognize that photography has multiple functions in this society, and that many of these functions have little or nothing to do with the aesthetics and goals of "serious" photography. It has already been demonstrated, over the past century, that photography is an art form; but to teach it only as such—that is, to teach only the craft, the history, and the aesthetics—is woefully, if not willfully, short-sighted.

What we need, instead, is an educational approach to photography which does not relegate it to the tail end of Fine Arts departments, but integrates it with virtually every discipline. Unless we are so gullible as to believe that our ability to see ourselves, our relatives, and our friends at various times in the past simply by leafing through a family album has no effect on us, we must face the fact that our perceptions of ourselves and those we know have been drastically altered

by the photographic image. Where, then, is the school whose psychology and photography departments are jointly exploring this?

Unless we are willing to believe that the concept of war as a romantic, glorious experience simply died out, we must admit that it was irreparably shattered by photographs of war, from the early ones by Mathew Brady to the last ones of Larry Burrows. Where is the college whose history and photography departments are working on this question?

Similar questions could be asked of every discipline—sociology, medicine, literature—but the answers would all be identical: there are no such projects, there are not even many small independent studies being carried out along these lines.

To say that we need such researches and investigations would be minimizing the urgency. We need them desperately. But we will begin to get them only when everyone concerned with photography education is willing to look beyond the limited purview of the craft/aesthetics approach and begin to apply pressure throughout the educational system for an interdisciplinary approach to photography education, an approach which will bring together the photographers, photography historians, photography curators, and photography critics of the future with present and future social scientists, poets, psychologists, doctors, dancers, musicians, mathematicians, physicists, and sculptors, in order to stimulate an interchange and correlation of ideas and a cross-fertilization of perception.

The age of specialization may turn into a permanent cultural status quo, but that is scant excuse for continuing to teach photography as though it were entirely unrelated to the culture(s) in which it exists, or for teaching other subjects as though they related to a non-photographic culture. We must face the fact that we are now—and will be for centuries at least, if we survive—living in a social system utterly dependent on the printed word and the photographic image.

The time for the change this recognition makes imperative is now. We are the "illiterates of the future" Moholy warned us about; and our children will be the illiterates of an even more hopeless future unless we transcend our current fantasies about photography education and align them at last with the higher realities of our time and place.

Danny Lyon and Geoff Winningham: Barred Doors, Bared Mats

Coincidence brings us, at pretty much the same time, two books of documentary photographs from Texas, both utilizing a traditional approach—photographs blended with transcribed conversations and other documents—and both presented in the same oblong format. The first is Danny Lyon's long-awaited and much-heralded *Conversations with the Dead* (Holt, Rinehart & Winston, 1971), a study of convict life in assorted Texas prisons. The other is Geoff Winningham's *Friday Night in the Coliseum* (Allison Press, 1971), a close look at the wrestling subculture in Houston, Texas.

Aside from similarities in approach and format, both these volumes deal with relatively little-known subcultures; and (I can hear the groans already) I feel obliged to say that Winningham—though not nearly as distinctive a stylist—has done more justice to his subject than Lyon has to prison life. This is not to say that Lyon's book is worthless. I've enjoyed reading and viewing it several times now—it has a wistful, slightly woeful tone which is very easy to swallow, and strikes a melancholy chord which is aesthetically harmonious and, indeed, actually pleasant. I am entirely in accordance with the jacket blurb's comparison to *You Have Seen Their Faces* and *Let Us Now Praise Famous Men;* like the former, it is the product of a sensibility from a different era, and like the latter its indignation is subsumed into a subconscious recognition that the suffering it records makes

good grist for the mill of Art, thus surrendering from the outset all hope of effectiveness as an instrument of change.

I am personally outraged by current conditions in this country's penal systems, and even more deeply offended by most of the basic premises on which they are founded. There are no more than two images in this book which serve as metaphors for those feelings, or as emblems of them, and nothing else within the volume makes up for that deficiency—not even the naif drawings and diary excerpts by convict Billy McCune, who castrated himself in prison after conviction on a rape charge which Lyon, in his foreword, intimates was spurious but to which McCune confesses fully on the last page, thus nullifying his central role in the book as the epitome of the creative misfit victimized by a cruel society.

In fact, I simply cannot understand how a photographer with Lyon's supposed commitment, given permission to photograph without restrictions the entire penal system of a state over a fourteen-month period, could end up creating a book which fails to render the texture of prison life either generally or specifically (I ended up knowing little more about McCune at the conclusion than I did at the outset); which does not touch even obliquely on such aspects of prison life as homosexuality, brutality, and segregation; and whose only indication of the constant humiliation of prison life is a series of photographs of convicts stripping for routine searches after work. Is that all there is? Aside from that, the grim stolidity of a few mounted guards, the barred doors and windows, and the different cut of the uniforms, you couldn't tell these men from a regiment of troops in boot camp—and you know that no matter how bad army life may be, jail is a thousand times worse.

Consequently, interesting and affecting as this book frequently is, it seems to be entirely remote from the actual agonies of the men whose lives it purports to document, and I can't imagine it stimulating one single alteration in the prison system (since it fails to indicate anything specific that demands alteration). Somewhere along the line, Lyon seems to have confused Lewis Hine's credo: instead of showing us those things which had to be changed and those to be appreciated, he has made something appreciable of that which needs change.

Winningham, by contrast, is only out to change our lack of appre-

ciation of a fascinating subculture, and he succeeds marvelously. I haven't had as much sheer, uncomplicated, unmitigated fun with a book for a long time. Anyone whose only experience with wrestling has been the late and unlamented television bouts in New York is in for a surprise with this book. Unlike the hammy, often entirely faked fiascos which emanated from New York, wrestling Texas-style is an all-out, life-and-death struggle in which the presence of a demanding (but not especially bloodthirsty) audience goads the wrestlers on, and in which the wrestlers function less as entertainers in a spoof than as archetypes established and embattled for audience identification. These bouts, as is evident from Winningham's images, are no-holds-barred assaults whose occasional melodramatics are not the *raison d'être* of the spectacle but the icing on it, the tangential manifestations of the wrestlers' personalities and styles.

This becomes increasingly obvious as one goes through the book—it can be seen in the photographs time and again, and is echoed by the text which Winningham has transcribed from conversations with wrestlers and fans. Anyone in doubt is advised to turn to the climactic final sequence on a Russian Chain Fight (in which wrestlers are chained to each other by the wrist): there is no questioning the blood streaming down Wahoo McDaniel's face from a chain slash. They play for keeps.

Among the aspects of *Friday Night* which excite me are the thoroughness of it—one finishes it feeling that one knows pretty much what the wrestlers' attitudes are, what the audience is seeking and finding, and what it's like to be there when it's happening—and, additionally, Winningham's avoidance of easy stereotypes and other preconceptions. This is not a satire of a crew of Southwestern klutzes indulging their tastelessness at some grotesque spectacle; it is a study of committed performers and a committed audience coming together for the enactment of a meaningful ritual which is nourishing to all of them. Certainly one of Winningham's accomplishments with this book has been leaving himself open to experience fully something which a great many people sneer at and deride, and because he did so this book serves, in a very humanizing and loving way, as a bridge back for anyone else open enough to cross it.

Both the design and the reproduction quality of this book are excellent; all in all, I recommend it highly.

Paul Strand (II)

What right—if any—do we have to ask an artist to "grow"?

This question is a loaded one, especially within our culture; most suspect, in fact, because we have come to demand novelty to satiate our artificial "need" for it, and rarely pause to discriminate between that which is new and that which is meaningful. Above and beyond that neurosis, however, is there any legitimacy in asking of those who present us with their visions that, over the course of time, they change, evolve, progress?

In my own thinking, this question has particular pertinence to the work of Paul Strand. This being Strand's year, he is on my mind frequently, as he has been in the past. I have avoided going to his retrospective in Philadelphia (opting to wait till it hits New York in early '73), and have not yet received a review copy of his new monograph, but even his current and comparatively small exhibit at Light raises these persistent issues.

Strand is unusual in this regard because—like only a few other photographers, such as Callahan—he came to his own personal vision early in his career and has stuck to it with admirable consistency over the past half-century. The images which appeared in the last two issues of *Camera Work*—which Stieglitz dedicated entirely to Strand's work—were Strand's public debut, and yet they defined his concerns and his approach as clearly as anything he has produced since. What a shock they must have given to other photographers and to the audience for photography, after years of nudes with glass bubbles, soft-focus portraits, lyrical landscapes. They linked the then-young tradition of "art photography" back with the social concern of Jacob Riis and Lewis Hine (whom Stieglitz and his coterie had snobblishly dismissed); suggested, for the first time in art photography, that the city was an ugly and brutalizing environment; made of an unsentimentalized common man a legitimate subject; revealed the strength and diversity possible within a clean, hard, uncluttered approach to photographic images; and not only posited but actually achieved a successful merger of abstract seeing with documentary concerns, formu-

VV, February 17, 1972.

lating in the process a new aesthetic which depended on realism without becoming banal.

This was a monumental and radicalizing achievement, basis enough for the myth which was to grow up around it. Followed, as those early images were, by a consistent body of work (culminating, in more ways than one, with *The Mexican Portfolio* in the early thirties), they founded a new tradition whose influence permeated all schools of photography for more than three decades. The issue at stake, then, in any discussion of Strand, is hardly whether or not he deserves to be taken seriously or merits his acclaim. Without question, he has been a giant among photographers. There is no doubt that he has demonstrated sufficient "growth" to validate his niche in the medium's pantheon. The real issue, simply, is whether or not this giant has continued to develop and expand his vision.

The answer to that, I feel, is no. I have found myself overwhelmed, time and again, by small doses of Strand—any of the books, for example, or a small show such as this (diversified, including some *Camera Work* gravures, *The Mexican Portfolio* in its entirety, and new prints of many old and recent images). His total body of work, however, begins to bore me after *The Mexican Portfolio,* since what can legitimately be viewed as the continuation of a pure and unaffected style becomes, for me, repetitive to such an extent that the stylelessness seems more and more mannered. Taken singly, I find each of his books photographically superb; taken together, they become interchangeable sets of images of peasants and workmen posed against rough stone/ wood walls, the differences between them being more of bone structure, skin tone, and clothing style than of culture and/or personality. In short (and with what is probably unforgivable glibness), they strike me as *The Mexican Portfolio Goes to Italy, Son of the Mexican Portfolio in Egypt,* and so on.

There is, to be sure, a certain egalitarianism to this visual one-worldism, and it's possible that if I felt it was intentional my response might be slightly different. But, as Gene Thornton pointed out in the *Times* a month ago, there is now a definite romanticism attached to the reverence for workers and peasants (since they themselves are, in most cases, anxious to become anything but), and the romanticism of that dated vision of mankind is in conflict with the unromantic clarity and harshness of Strand's approach to photography itself. This should

not diminish our esteem for his work through the early thirties; it does, however, legitimize at least my own doubts as to how much I've gained from Strand's subsequent work, which has not noticeably raised my high regard for him but has merely perpetuated it at the same level and which is rapidly approaching the point of diminishing returns.

Bernadette Mayer: "Memory"

If I were asked for an explanation of the snapshot aesthetic, I think I'd simply send the asker to see Bernadette Mayer's show "Memory," which does not by any means define the snapshot aesthetic (I don't think that's quite ready for formulation yet) but which certainly exemplifies it.

"Memory" was presented in a loft at 98 Greene Street and will be on view at Mayer's own studio in the near future. It consists of 1116 color photographs (processed by Kodak) and six hours of taped narration. Mayer shot one roll of 35mm. color film every day for the month of July. The pictures were then mounted side by side in row after row along a long wall, each line to be read from left to right. All the images made each day were included, presumably in sequence. Accompanying this visual document was a thirty-one-section tape, which, according to Mayer, "uses the pictures as points of focus, one by one, and as taking-off points for digression, filling in the spaces between."

What resulted from this combination of methods and media was a unique and deeply exciting document whose ultimate ambiguity derived specifically from its enormous accumulation of data. In a very direct way, "Memory" gets to the heart of the persistent magic of photographic imagery, a magic which has very little to do with art or style (though it can be enhanced by both) and everything to do with the phenomenology of the medium itself.

These snapshots—and that, literally, is what they are, not simply utilizations of aspects of the snapshot by an experienced photographer—are astonishing. Their significance is not in the presence of an excerptable number of strong individual images (though those are

there, more frequently than I would have expected—Mayer has a good eye, but that's as much beside the point as is the presence of a number of visually uninspired images). The aesthetics of her images—in terms of composition, subject matter, and print quality—exist on a basis as close to chance as one can come with a human eye and hand behind the lens. Within that framework, this show only demonstrated the (not insignificant) truth that anyone who bangs away and takes a thousand images will come up with several hundred interesting ones.

The real significance of "Memory" is that it comes to grips with the question of what photographs tell us about our experience and what they don't tell us, contrasts experience through images and experience through words, and hints throughout at the probably unverbalizable difference between what we remember, what we think we remember, and reality with a capital R. Listening to the tapes—which add a significant dimension to the work—one finds that one's own understanding of each image is inevitably different from the narrator's, that the visually insignificant is often emotionally monumental, and that the reality of any experience is at best evanescent and possibly nonexistent.

"Memory" is an important work precisely because it explores photography not as an art but as a tool which has extended our vision in ways we have yet to comprehend. If there is any way of turning this work into a book—and I am sure that is possible—it should be done; it takes up where Danny Seymour's *A Loud Song* ends off by investigating in greater depth a more limited period of time, and it touches on a number of intrinsic, extra-aesthetic aspects of photography which are no less significant to our understanding of life for falling outside the boundaries of what is generally considered to be photographic art.

Thomas Barrow and Charles Gatewood

The differences in the work of Thomas Barrow and that of Charles Gatewood—both presently on view at Light Gallery—boil down to a distinction between the literary and vernacular modes in photography. Barrow's imagery is rooted firmly in the relatively new but rap-

idly growing tradition of academic photography. This tradition has much in common with the academic novel and academic poetry: deliberately and consistently experimental, it is highly (often overly) intellectualized, scholarly in its concerns, and chock full of references to (as well as puns on) the work of other artists within and without the medium of photography. Titles, in this genre, tend to be significant clues to the work's intent (no stone left unturned) and images tend to be grouped serially if not sequentially.

Barrow's own work, insofar as this exhibit represents it, is neatly bisected. One portion, a series called "Product News," consists of Verifax prints—archivally processed—of collages incorporating both words and images. These prints, with their odd, flat tones of gray and green, combine the use of a technological process—the Verifax system—which is essentially photographic but puristically unacceptable, with a subject matter which refers more to Dadaist experiments than to photography.

The other portion is composed of two series of pink-toned prints, titled "Pink Stuff" and "Pink Dualities," in which each individual print contains two images side by side, sometimes variants on the same scene and sometimes quite disparate. The distinctive pink tone of these works manages to be simultaneously garish and subtle; the subject matter is often intentionally banal, and the format mocks the stereoscope card in echoing it distortedly.

While I find Barrow's work sometimes engaging on an abstractly conceptual level, its over-all lack of emotive content—which seems to me unsuccessfully disguised by a veneer of pedantic impersonality—leaves the work devoid of affect and makes of it a cold if occasionally rigorous exercise in analytical deduction. One cannot make love by following a textbook—not, for that matter, by merely violating its instructions.

Charles Gatewood's photographs stand at the opposite pole. To be sure, they can be placed within a definite photographic tradition—one which begins, perhaps, with a horde of unsung news photographers; reaches its first culmination point in Weegee and its second in Robert Frank, Lee Friedlander, and Diane Arbus; and is currently being expanded by such younger photographers as Geoff Winningham, Paul Diamond, Les Krims, Gatewood's cohort George Gardner, and Gatewood himself. But that tradition is not itself the subject.

The subject matter of all these photographers is people; their concern is the social landscape, specifically that of America, and their approach is simply to seek out the most extreme manifestations of our cultural consciousness—those places and events where we let it all hang out—and record it. Their art is Stendhal's: "A mirror held up along the highway." And they may, in fact, represent the only form of "pure" photography still vital today.

While all these photographers are excellent craftsmen, their involvement with the print is not directed toward creation of a precious object but toward amplification of the content. It is not accidental that several of them prefer to make enormous prints, nor that most have gravitated toward such vehicles for reproduction and dissemination as posters, books, and—in the case of Krims—small portfolios produced on a mass scale. The image, not the print, is the message.

This is not to say that the work all looks the same; it doesn't. Gatewood's coverage of Mardi Gras, for example, is quite different from George Gardner's, though they have worked as a team on this subject for several years. Many of the images in this exhibit are from that document (which surely deserves publication), and it serves well as a central metaphor for Gatewood—an event in which the rules are suspended and people are free to act out their personal realities, which may be anything from drunken costumed bliss in the streets to a transvestite mooning the camera in a bar. Gatewood's world is freakish, earthy, blunt, erotic—most of all, terribly and beautifully alive. I am sure there are those who are (or will be) appalled by his vision; I would only remind them, as in the old joke, just who it is who's drawing the dirty pictures.

Duane Michals (II):
The Journey of the Spirit After Death

Duane Michals' new book, *The Journey of the Spirit after Death* (Winter House, 1972), is a fine if indirect explanation of why so many photographers are turning to book form for the presentation of their imagery and to the sequence as a primary format. I do not think

it demeaning to Michals' work to say that many (but not all) of his images are relatively insignificant when isolated, or that his prints, as objects, are not especially noteworthy examples of craftsmanship. These failings—if you wish to consider them as such—are actually intrinsic to his approach, leading as they do away from the original-print mystique and the decorative-composition fallacy toward the conveyance of complex ideas in an extended form.

In fact, at least a third of the twenty-seven images in this book would seem not only trivial but virtually meaningless outside their sequential context. That within this context those same images are charged with philosophical meaning is a tribute to Michals' mastery of sequential form and to the potent conceptual power of the sequence itself.

This sequence—the most extensive and ambitious Michals has created to date—is a further exploration of one of the photographer's main preoccupations, death and transfiguration. Though he writes, in his preface, of the effects of Catholicism on his feelings about death, this sequence is a strangely non-sectarian blend of Western religious beliefs and Eastern ones, owing many of its underlying concepts— most specifically, that of the clear light—to such philosophies as those expressed in the *Tibetan Book of the Dead.*

Out of the simplest of materials—a group of not very difficult images—Michals. has constructed an intricate cyclical metaphor which cosmically extends such briefer previous works as "The Spirit Leaves the Body," "The Human Condition," and "Death Comes to the Old Lady." Though this sequence is perhaps even more narrative in structure than the earlier ones—it includes, for the first time, written as well as visual clues to its story line—it does not function literally but rather allegorically. Michals' grasp of visual syntax has never seemed firmer; the structuring of this sequence is flawless.

Getting back to what I said earlier, there is obviously no better way to present such a work than book form. For one thing, it is necessary to experience the images in a sequential format rather than individually; for another, the work demands re-experiencing since the metaphor grows in scope with each new viewing. Neither of these would be practicable in any format except that of a book, and so this thin volume represents, in its own quiet way, one of the triumphs of conceptual integrity over precious-object fetishism.

Who Will Be the Replacements?

The almost simultaneous departure of two major figures from the country's two largest photographic museums is a remarkable occurrence, and one which will have significant repercussions throughout the photographic community.

Peter Bunnell's acceptance of the newly created David Hunter McAlpin Professorship of the History of Photography and Modern Art at Princeton University—a custom-fitted chair funded with a million-dollar endowment—is a history-making event in itself. The establishment of this chair—the first devoted to the study of photography—is a breakthrough in academic recognition of the medium as a serious art form meriting scholarly attention. It will make Princeton a new center of photographic activity, since the university simultaneously acquired McAlpin's private collection and announced its intention to devote energy to exhibitions and publications as well as research.

Beyond that, however, it promises to produce a new breed of photographic scholars, critics, and curators working (and thinking) out of a highly academic tradition. While there are some (myself among them) who view that eventuality as a mixed blessing, there is no doubt that such a development is not only inevitable but long overdue.

However, Bunnell's resignation from the curatorship of the Department of Photography at the Museum of Modern Art leaves a large hole in the department's aesthetic, and it appears that hole will not be filled. MOMA does not intend to replace Bunnell, which means that what gets shown from now on at that influential institution will depend almost entirely on the vision of one man, director John Szarkowski.

This is a dangerous situation for the medium, since Szarkowski's overriding interest has always been the documentary tradition (centering on the Farm Security Administration crew, extending backward in time to various precursors of Walker Evans and forward to new exponents of the tradition). His sympathies for more experimental approaches to the medium—be it mixed-media or technically straight but conceptually freakish imagery—have proved notably scant.

Bunnell's aesthetic, too, has limits, but at least they are different

NYT, May 7, 1972.

from Szarkowski's, so that while they worked together they supplemented each other well, if not perfectly. Bunnell's curatorial swan song at MOMA—the current Barbara Morgan show, a failure on many counts—hardly typifies his vision: "Photography as Printmaking" and "Photography into Sculpture" were more accurate representations of Bunnell's feeling for the medium, and despite the frivolity (even triviality) of much of the work in those exhibits, both of them were influential in expanding the public's awareness of the medium's potential.

MOMA seems to be retrenching heavily at the moment on all fronts, and the fiscal squeeze responsible is affecting the Department of Photography noticeably. There's already been a marked decrease in exhibitions and publications (and, I presume, in acquisitions as well). It may, therefore, be financially unfeasible for Bunnell to be replaced. I can only hope, though, that Szarkowski will see fit to supplement his own aesthetic regularly, through either curatorial internships or guest curators. There's too much power centralized in MOMA as it is, without it being controlled exclusively by any one man; that can only threaten the health of the department and the medium.

The George Eastman House—now known as the International Museum of Photography at George Eastman House—has been retrenching for a long time now, ever since the forced resignation of Nathan Lyons several years ago. (As the name change suggests, that institution is also trying gradually—though none too successfully—to wean itself from the Eastman Kodak teat). Lyons' departure—the lever for which is rumored to have been an incident involving witchcraft—took place, essentially, because his activist approach to the practice of running a museum was making the House's powers-that-be too nervous. Lyons believed in doing a lot of exhibiting, acquiring, and publishing, emphasizing and even sponsoring new and qualitatively questionable work by younger, living photographers over impeccably credentialed work by dead masters.

Last winter, when Beaumont Newhall resigned as director of Eastman House, the institution could have chosen to renew its support of living photographers by appointing a lively, unacademically oriented replacement. Instead, the House's well-earned reputation as a hotbed of academicism was reinforced by the selection of Van Deren Coke, an academic's academic capable of writing (in his new book, *The*

Painter and the Photograph), "Although [Joseph Cornell] never formally studied art he has made collages that are powerfully evocative."

But Coke has now left Eastman House, voluntarily, in order to return to his teaching position at the University of New Mexico. In a recent interview Coke suggested that the directorship of Eastman House was equivalent to "running a national park," and cited as one of his major problems the difficulty of overcoming the local attitude that the House was more "a provincial monument to George Eastman, a sort of country club for the socially elite, than an internationally celebrated photographic museum." His resignation, effective August 31, leaves the International Museum faced once again with the problem of self-definition.

It is surely to be hoped that the committee searching for his successor will specifically attempt to seek out someone who can revitalize the museum's attitude toward the medium. Once again, the International Museum of Photography can choose between being a showplace for the most adventurous contemporary work or a mausoleum stockpiling photography's Golden Oldies. The latter stance is easily defensible, but at this juncture we have a much greater need for a courageous institution willing to travel in the other direction.

Bea Nettles

Bea Nettles' work, currently on view at Light, has all the ingredients necessary for avant-garde stature except affect, for which effect is too often substituted. Stitching, sensitized plastics and fabrics, dry and liquid extra-photographic materials; the panoply of the photo-media approach is visible here, and the very profuseness of effect is in itself engrossing, at least up to the point at which it becomes a mere distraction.

In Nettles' work these devices do not function exactly as gimmicks, but rather as ways of disguising sensibility. It is undeniably amusing to see hair, dried fish, Kool Aid, feathers, and assorted other things incorporated into photographic works, and I am in full agreement with Joyce that the pun is the highest form of language. However, Nettles' visual puns exhaust themselves a bit too quickly and are too

often predictable; the numerous devices she employs do not amplify the meaning of the images, they merely sidetrack one from the realization that these works have no center—nothing much to say about life, about their maker, or even about themselves.

A few of the works do achieve some notable effects. In "Veiled Tunnel" a small strip of fabric adds considerable depth and mystery to the image; stitching creates a definite three-dimensionality in "Georgia and Three Swans," and "Florida Pharmacy Fantasy" is a successful multi-leveled pun on Uelsmann's "Slaughter of the Innocents."

The only two which seemed to me to actually integrate their techniques into a large statement are "Shingled Scene"—which consists of two overlapping images, stitched together, showing a life-size cutout of the photographer curled up on a bed—and "Umbrella Portrait," a cyanotype on canvas, one of the simplest images in the show but also one of the most unified.

I feel compelled to add that while I don't respond strongly to most of Nettles' experiments, I am delighted that there's a gallery in the city with courage enough to show such work regularly and give us all a chance to experience it and sort out our own responses. See it, by all means.

Judy Dater

The first one-woman show in New York by Judy Dater, a Bay Area photographer, is a strong debut. Though her work is probably familiar to the East Coast audience through various publications and group exhibits, her show at the Witkin Gallery is the first presentation here of a large body of imagery, and specifically of her series of portraits of women.

Working out of the tradition of straight photography, Dater is—in terms of style—an inventive but essentially conventional image-maker. Her images are carefully composed, her prints expertly made, and her over-all technique entirely straightforward. This standard approach is not at all detrimental to the pictures, but somehow intrinsic to them. It is worth noting that when Dater digresses from it to achieve a more

graphic-oriented effect—as in the several solarizations—the mood changes drastically and the impact is lessened.

The emotional intensity of the portraits of women is generated by a combination of qualities. One of these is their energy; these images tremble with life. Another is the sexual tension registered within them, which is not at all subliminal but always operative at or near the surface. And a third—probably the most crucial—is the fierceness of their self-assertion; each of these images seems to be a mutually agreed-upon statement, the revelation of a previously hushed secret known only to the photographer and her subjects and now announced as the seal on a pact of blood.

To say that they are records of distinctly feminine sensibilities—the photographer's among them—is only a half-truth, for they explore a side of those sensibilities which the world has rarely seen and for which it may not be ready. These are among the strongest studies of women as individuals which have been made in recent years; they put to shame such trivia as fills the pages of *Popular Photography*'s *Woman* annuals.

Beuford Smith:
He Records the Texture of Black Life

For all intents and purposes, the tradition of black photography begins with Roy DeCarava. DeCarava is not the first black photographer (though he was the first one to be awarded a Guggenheim); the history of black photography stretches back more than a century. Nor is he the best known; Gordon Parks is closer to a household word than DeCarava, and even James Van DerZee—rediscovered recently during the making of the Met's "Harlem on My Mind"—has received more public attention. DeCarava has never had a one-man show at any major museum (his largest exhibit to date, a solo retrospective which was hardly a swan song, having been presented by the Studio Museum in Harlem several years ago). And, considering the extent and importance of the remarkable body of work he has created over the last three decades, he has been vastly under-published; only one slim volume of his images, *The Sweet Flypaper of Life* (with text by

NYT, July 2, 1972.

Langston Hughes), has ever been issued, and that one is almost twenty years old, though miraculously still in print.

Despite that, DeCarava's influence, as another black photographer has stated, "extends throughout the field." There are few black photographers today who have not been affected by DeCarava, whether they know it or not. To some he has served primarily as a symbol of intransigent honesty; to others he has been a mentor, either directly or second-hand, through his organization of the still-active Kamoinge Workshop of black photographers. And the impact of *The Sweet Flypaper of Life* can be felt, attitudinally and conceptually, in the work of almost all black photographers, so that virtually every show by a young black photographer is a form of homage to DeCarava.

Beuford Smith makes his debt to DeCarava explicit in the biographical data accompanying his current show at the Studio Museum, indicating that it was *The Sweet Flypaper of Life* which made him turn to photography in the first place. The show itself—"Time," a selection of over sixty of Smith's black-and-white prints—reveals that Smith has absorbed DeCarava's influence without becoming enslaved by it, and has evolved a distinctive and charged vision which is based on the black experience but extends far beyond it.

The similarities between Smith and his mentor are readily seen. There is the same adherence to a head-on, gimmick-free documentary style, a concentration on urban black life as the central theme, and a consistent confrontation of human emotion. There is also a resemblance in their printing which strikes me as noteworthy, though I do not yet know how to interpret it, nor even how to say it without it sounding peculiar as hell. Most black photographers whose work I've seen—DeCarava, Smith, and Fundi, in particular—evince not only a fearlessness of, but a love for, deep, rich black (and lots of it) in their prints. I am not speaking of dark prints as opposed to light ones, but absolute black as a tonal equivalent of space and an emotional metaphor for the void. There are some white photographers—W. Eugene Smith being a prime example—who use black similarly, but they seem to be proportionately fewer; many white photographers tend to turn skittish at the sight (or even the thought) of what one once referred to as "large masses of undifferentiated black." I have no explanation for this phenomenon, but I think it merits some consideration. Smith's "Sliding Board" is just one of many instances in this show.

While one can find traces of DeCarava in various aspects of Beuford Smith's work—the poignancy of "Man with Roses," for instance, is worthy of DeCarava though wholly Smith's own—the differences are significant. Though, like DeCarava, he records the texture of black life (in such pictures as "Cadillac" and "Garment Worker"), as well as the music which is woven into it, his exuberance—witness "Woman Bathing," a rooftop nude—is more overt and his anger more explicit.

Through Smith's eyes we are forced into an awareness of the constant indignity of racist graffiti, whether directed at blacks, as in "No Niggers," or at Puerto Ricans, as in the tragic triptych "Ruben Moved." The increasingly ugly symbolism of the American flag—whether decaled to a police-car windshield, held by a too-young white child at a parade, or toted by a particularly vicious-looking man—is explored in images which have specific political implications but remain unpolemical by virtue of their pity. And the anger contained within the two-panel series of images made the day after Martin Luther King's assassination is tempered, but not muted, with sorrow.

Smith also demonstrates, in this exhibit, an unusually deep concern with old age, which runs as a sub-theme throughout. The photographer attributes this partly to the experience of being raised by his grandmother and partly to his feeling that "old women are the mothers of us all. You see lots of pictures of young black women with their Afros," he adds, "but not so many of the women who brought them up." Whatever their source, these images—"Old Woman in Window" with its mourning wreath like the seal of death; "Hop Scotch," with its hint of a tombstone; "Canes," "Old Woman with Crutch," the tender "Saturday," the pathetic "Woman Carrying Doll," and many others—speak with a precocious empathy of some of the horrors of age and isolation. That a number of the remaining images deal directly with death thus comes as no surprise, and Smith's rage against the reaper makes itself felt in "Coat," "Doll #5," and the purgatorial "Rope," as well as in the torn posters of "Death Mask."

It seems paradoxical to say that gentleness and joy are also contained in Smith's work, even at its fiercest, but the truth of that is perhaps his greatest accomplishment and the firmest possible foundation for the major body of work he has just begun—and, indeed, at this stage can hardly avoid—creating.

Not Seeing Atget for the Trees

When, late in 1969, I suggested—on the occasion of the Museum of Modern Art's first show of some prints from its then recently acquired Atget collection—that MOMA should undertake to present a series of exhibits exploring various facets of Atget's work, I did not suspect that the first show in such a series would be one for which I would be reluctant to take credit even if (as is certainly not the case) it were due me. "Atget's Trees" is a show which only a curator could love. It has very little to do with Atget's own sensibility—it is, in fact, considerably misleading in that regard. Instead, it is a definition of the sensibility responsible for assembling it, and an illuminating example of the tacit critical power exercised by those who choose what the public is to see—the power exercised in this case by John Szarkowski.

The selection of images on view is in itself remarkable—with only a few exceptions, this is the most unenjoyable group of Atget photographs I have ever seen, apparently picked in total defiance of the lyrical yet robust romanticism which is the hallmark of Atget's vision. Even the prints themselves are, for the most part, badly faded and washed out, as if to refuse the viewer the small solace of Atget's mellow tonalities. Since this is so untypical of Atget's imagery, it can only be taken as a manifestation of the puritan, ascetic aesthetic behind the show: thou shalt get no joy from Art.

Proving that Atget's work is capital-A Art seems to be the purpose of this exhibit. Capital-A Art, as defined in Szarkowski's peculiar wall label, is neither accidental nor intuitive in origin; it is exclusively a process of conscious problem-solving, the problems in question being purely intellectual and aesthetic. Such problems, according to this definition, are formal issues posed by the artist. Hence Szarkowski's unimpeachable-since-unverifiable claim that "Atget's decisions were apparently based not only on intuition but on a conscious analysis of his own earlier work." We are, blessedly, spared the normal accompanying thesis, that when an artist's work refers to anything but itself it refers only to the work of other artists; in Atget's case, there is too much evidence showing him to be unaware of the work of others to support that.

VV, July 27, 1972.

I am unalterably opposed to the prevalent misconception that the ideal end result of creative struggle should be a self-contained and sealed system referring only to itself, communicating only with its maker, and permitting no dialogue with its audience. In creative terms that is an elaborate definition of failure, not of success. Art is not about itself, any more than a ladder is. A ladder is about climbing; art is about living.

Yet Szarkowski is out to prove, in this show, that Atget's work is about itself—not about Paris, or Atget's life, or being enchanted by reality and trying to preserve some slice of it. Szarkowski would seem to have much in common with William Jenkins, who wrote in a recent issue of *Image*, "It seems to me that the time when the artist could enjoy the luxury of being innocently, or at least privately, influenced by an art not his own or a variety of other experiential forces is long past." In its semantic assumptions and manipulations, this sentence sums up a brand of perverse academicism which is coming to afflict photography as well as the other arts. The real question is not how one can "enjoy the luxury" of extra-aesthetic influences, but whether it is possible to escape the painful but necessary presence of "other experiential forces" which is at the core of the creative process, since that core can only come from the heart of life.

This reductivist attitude—that art is about itself—is certainly applicable to some contemporary artists (and photographers) who are purposely making work to fit this thesis. The thesis itself has obvious appeal for curators (and critics), since it reinforces their delusion that their training in the history of art and the formal problems confronted by artists—which are a part, but only a part, of the creative act—gives them the power of ultimate insight into the nature of any creative work. This labor-union mentality, one of the unfortunate by-products of an age of specialization, results in assumptions as ludicrous as a master plumber asserting that the skyscraper whose construction he is supervising was created as a statement about indoor plumbing.

Ostensibly, the purpose of this show is to refute Edward Weston's statement (made in 1938) that "Atget was a great documentary photographer but is misclassed as anything else," and Man Ray's suggestion that Atget worked in an essentially intuitive manner. The counter-argument basis of the show, however, is quite specious, since Weston's statement has little or no current acceptance among either

photographers or the public, and since the only way to contradict
Man Ray, in the last analysis, is to produce writings from Atget's own
hand or testimony from those to whom he spoke about his work; any-
thing else, after all, is nothing more than intuition no matter how you
slice it.

So here we have a group of photographs by one of the major fig-
ures in the medium's history, which have very little to offer; so little,
in fact, that anyone unfamiliar with Atget's work would be forced to
turn in bewilderment to the wall label for some explanation of such
mediocrity—only to be told that these photographs hold the key to
Atget's genius for the discerning few. Anyone at all familiar with At-
get, however, will detect their unrepresentativeness; Atget made hun-
dreds of stunning images of trees, only a handful of which are in-
cluded here. Surely, when she sold her huge collection of Atget
prints and negatives to the museum, Berenice Abbott could not have
intended that the exploration of this treasure trove should begin in
the bottom drawer.

Robert Frank: *The Lines of My Hand*

Robert Frank's new book, *The Lines of My Hand* (Lustrum Press,
1972), is in its structure an unusual instance of an artist influencing
himself at second hand. Autobiographic rather than monographic in
intent, chronologically ordered but otherwise formally loose, dotted
with memorabilia as well as "serious" images, *The Lines of My Hand*
clearly is a response to Danny Seymour's *A Loud Song* as well as a
personal chronicle in its own right.

Frank's book is larger than that of his spiritual offspring, of course,
for his life has been longer, and because his influence on photography
has been so vast, this book, for all its informality, is a sort of history of
contemporary photography and for that matter of the past two dec-
ades as well. Although *The Americans*, which revolutionized docu-
mentary photography and distilled a new American essence, is only
hinted at here, represented by a mere handful of images, its presence
is intensified by its absence, and *The Lines of My Hand* seems in-
tended as a simultaneously larger and smaller statement into which

The Americans is to be fitted by those who know Frank's work. It is a larger statement because it shows what preceded *The Americans* and what followed it, right up to the "Ten Bus Photographs" and the transition into films; and, at the same time, it is smaller because it is more personal, centered around Frank's life rather than American culture.

These two levels are intercut throughout the book. A portrait of Jack Kerouac, part of an in-memoriam collage of deceased friends, speaks of personal loss, but also relates back to Kerouac's foreword to *The Americans* and ties Frank to the Beat movement. The faces of Eisenhower and Nixon, which appear in several older images, are as related to the seventies as to the fifties. Kline and de Kooning, Mailer and Ginsberg are here; so are Frank's children, growing up during the book's duration. The effect is of being caught up in a time warp, able to go back into the past without losing awareness of the present. In the minds of many—even though the thought was never accurately verbalized—Robert Frank "took away our children's roots." In *The Lines of My Hand* he gives them back again, transformed but recognizable, so that the reader, like Frank himself at the end, finds himself home at last.

Frank's images are like the bricks on Dylan's Grand Street: "They all lie there so perfectly, they all seem so well timed." This book is full of photographic miracles, like the magical dog leaping in the snow, but in the long run it is about photography as an adjunct to life. "Isn't it wonderful just to be alive," Frank concludes, and if his aliveness—as well as our own—was somehow at stake during the period covered by this book, the book tells us in some mysterious way that we have all come through.

Ed Ruscha (I): "My Books End Up in the Trash"

Los Angeles—"After a book leaves here, it's for whatever anyone wants to use it for. I'd love to have the facts on where my books are . . . I had a daydream once not long ago about an imaginary person known as the Information Man, and I wrote it down. Let me read it to you.

NYT, August 27, 1972.

"The Information Man is someone who comes up to you and begins telling you stories and related facts about a particular subject in your life. He came up to me and said, 'Of all the books of yours that are out in the public, only 171 are placed face up with nothing covering them; 2026 are in vertical positions in libraries, and 2715 are under books in stacks. The most weight on a single book is 68 pounds, and that is in the city of Cologne, Germany, in a bookstore. Fifty-eight have been lost; 14 have been totally destroyed by water or fire; 216 books could be considered badly worn. Three hundred and nineteen books are in positions between 40 and 50 degrees. Eighteen of the books have been deliberately thrown away or destroyed. Fifty-three books have never been opened, most of these being newly purchased and put aside momentarily.

" 'Of the approximately 5000 books of Ed Ruscha that have been purchased, only 32 have been used in a directly functional manner. Thirteen of these have been used as weights for paper or other small things, 7 have been used as swatters to kill small insects such as flies and mosquitoes, 2 were used as a device to nudge open a door, 6 have been used to transport foods like peanuts to a coffee table, and 4 have been used to nudge wall pictures to their correct levels. Two hundred and twenty-one people have smelled pages of the books. Three of the books have been in continual motion since their purchase; all three of these are on a boat near Seattle, Washington.'

"Now wouldn't it be nice to know these things?"

It is early afternoon and we are in the bright, spacious, white-walled studio of Ed Ruscha (pronounced Rew-Shey, as his business card indicates) on North Western Avenue. A punching bag hangs on one wall; a motorcycle sits in another room; there are paintings on the wall, and a framed photo of Bela Lugosi with cigar. Several cowboy hats hang from the edge of an unframed mirror resting on an easel. From the radio comes a mixture of rock, jazz, and cowboy yodeling.

Ruscha, a transplanted Oklahoman who has already established a hefty reputation as a painter, is also the creator and publisher of a unique series of photography books. The first of these, *Twentysix Gasoline Stations,* was issued in 1962; it has been followed by thirteen more, making a sizable set of works altogether.

In addition to *Twentysix Gasoline Stations,* the entire canon con-

sists of: *Various Small Fires*, 1964; *Some Los Angeles Apartments*, 1965; *Every Building on the Sunset Strip*, 1966; *Thirtyfour Parking Lots*, 1967; *Royal Road Test*, 1967; *Business Cards*, 1968; *Nine Swimming Pools and a Broken Glass*, 1968; *Crackers*, 1969; *Real Estate Opportunities*, 1970; *Babycakes*, 1970 (part of a set of multiples and not for sale separately); *A Few Palm Trees*, 1971; *Records*, 1971; and *Dutch Details*, 1971.

For the most part, they are simple little volumes which show exactly what the titles indicate. *Thirtyfour Parking Lots* is a set of aerial photographs of same; *Nine Swimming Pools*—the only one which employs color—includes photographs of nine swimming pools and a broken glass. A few are more elaborate in format: *Sunset Strip* consists of two sets of "continuous motorized photos" printed on an accordion fold which expands to twenty-seven feet in length; *Dutch Details* is made up of foldouts. All in all, they form an impressive, cryptic, and funny collection of photographic works by an artist who does not even consider himself to be a photographer.

Many of the photographs in the books, in fact, were not even made by Ruscha himself, but by such collaborators as Joe Goode, Patrick Blackwell, Art Alanis (the aerial photos of the parking lots), and Jerry McMillan. "It's not really important who takes the photographs," asserts Ruscha. "I don't even look at it as photography; they're just images to fill a book."

Are they equivalent to drawings then?

"No, no, because the drawing gives a touch of the hand to it that I didn't want at all. The camera is used simply as a documentary device, the closest documentary device; that's what it's all about . . . Drawings would never express the idea—I like facts, facts, facts are in these books. The closest representation to an apartment house in *Some Los Angeles Apartments* is a photograph, nothing else, not a drawing, because that becomes somebody else's vision of what it is, and this is the camera's eye, the closest delineation of that subject."

Asked if he has been influenced by the work of other photographers, Ruscha replies, "None. I have no interest in photography as a medium. I mean, I like to look at photographs, I really find them intriguing, especially when they have a documentary sense to them. I like Mathew Brady, just because I get to look at all those soldiers and look at the way life was back then; and At-get—how do you pro-

nounce it? Atget?—I love his work just because it's like going on a lit-
tle trip, a little storybook trip, and that's what I like about it."

If, as Henry T. Hopkins has written, Ruscha's creation of these
books "undoubtedly stems from some deep-seated hoarding instinct
developed in childhood," Ruscha has sublimated such motivation be-
yond recognition. "I know," he says, "that my books are not thought
of in the same way as my paintings are. People take a painting and
they put it back in a vault somewhere, but these books they'll just
throw on a shelf and that amuses me, the fact that it just turns over
and it affects people, people get the pictures and look at the pictures
and they put it away and eventually somehow it just kind of ends up
in the trash, which is OKAY—that's all right with me, it doesn't
bother me that much, that they might decompose, or not be thought
of as 'objects of art,' because they're definitely *not*.

"I've shown them, I had a show in Germany of these, in Munich.
I went to the gallery, and we had a lot of frames there, and I couldn't
think of a better way of displaying them than just putting them in
these little pop-in frames and putting them up on the wall. But then I
also put a table there and put books out, for people to sit down in
chairs and look at them, too. So I was just showing the covers of
them; but people would come in and say [*sotto voce*] 'Psst—how much
is that?' and I'd say, 'Psst—three dollars . . .'" He laughs.

Ed Ruscha (II): "I'm Not Really a Photographer"

"It's a playground, is all it is," says Ed Ruscha. "Photography's just a
playground for me. I'm not a photographer at all."

Despite this disclaimer, Ruscha's fourteen small books of photo-
graphs have found much of their audience among people interested
in contemporary photography. They were among the first of the new
wave of privately published photography books; they also pioneered
in the use of photography as a basic tool of conceptual art. Quite
aside from their historical significance, these books have a consistency
and a charmingly mystifying ambiguity which results from their very
literalness. They seem—at this admittedly early stage—to be remark-

NYT, September 10, 1972.

ably durable works, Ruscha's fear of their eventual "quaintness" not-withstanding.

Ruscha indicates that he began working with photographs out of "a combination of desires. One was to, first of all, make a book. I wanted to make a book of some kind. And at the same time, I—my whole attitude about everything came out in this one phrase that I made up for myself, which was 'twenty-six gasoline stations.' I worked on that in my mind for a long time and I knew that title before the book had even come about. And then, paradoxically, the idea of the photographs of the gas stations came around, so it's an idea first—and then I kind of worked it down. It went hand in hand with what I felt about traveling . . .

"I just barely got my feet wet with gas stations," he continues. "Then I just had a lot of other things come out. Fires have been a part of my work before too, I've painted pictures of fire, and there've been little things about fire in my life—not as experience, not in a negative way, there's been no catastrophe as far as fire goes, but the image of fire has always been strong in my work and so it just culmi-nated in this little book here [*Various Small Fires*, which contains six-teen images—burning pipes, cigars, cigarettes, a flare, a cigarette lighter aflame]. It's probably one of the strangest books—it kind of stands apart, a lot of people have even mentioned that to me about how it stands apart from the others because it's more introverted, I guess; in-troverted, less appealing, probably more *meaningless* than any of the other books, if you know what I mean."

I mention finding, in a Fourth Avenue used-book store, a copy of a catalogue from one of his exhibitions, the cover of which was charred by fire. "Charred by fire?" Ruscha laughs. "Everything gets its due, right? Bruce Nauman took a copy of *Various Small Fires* and burned it ceremoniously, took a picture of each page, and made a big book out of it, which is an extension of that. I think he liked *Various Small Fires*.

"Some of them look like *capers*," Ruscha adds. "Like *Business Cards* looks like a caper, which it *is* . . ." Or *Crackers*? "*Crackers* is a caper; *Sunset Strip* is a *visual* caper; *Royal Road Test*, yeah . . ." This is a significant distinction, especially in light of the slight note of dissatisfaction which Ruscha applies to the term "caper." All four of these books hinge on something other than the images themselves,

being thus more specific and conceptually limited (though also, perhaps, more accessible) than the rest. *Sunset Strip* depends on its accordion-fold format and the inclusion of every building on the Strip; the other three are tied to staged events.

Royal Road Test documents the results of heaving a Royal typewriter out the window of a 1963 Buick Le Sabre traveling at ninety miles an hour; it stars Ruscha himself as Driver and singer-songwriter-humorist Mason Williams as Thrower. Williams wrote the story on which *Crackers*—an improbable and somewhat misogynistic narrative in stills—is based. (Ruscha, working on a Guggenheim Fellowship, recently turned this into a movie titled *Premium*.) And *Business Cards* records a business card exchange between Ruscha and Billy Al Bengston and a presentation dinner in celebration thereof.

The latter book is also one of the two signed editions Ruscha has published, a practice from which he has since veered away. "I decided I don't want anything like that, I just want to get the book out. And the books will compete with any other books on the paperback market, they'll just be my style of books, you know? . . . Most of my books should be of unlimited quantity. I don't want people to come up to me and say, 'Boy, I'm going to save this because some day it's going to be a work of art. That's not it—you missed it . . .'"

Ruscha, who feels that he's "just scratching the surface" with his books so far, indicates that "it's not only photography that interests me, it's the whole production of the books . . . I just use that thing [the camera—he works with a Yashica, by the way], I just pick it up like an axe when I've got to chop down a tree, I pick up a camera and go out and shoot the pictures that I have to shoot. I never take pictures just for the taking of pictures; I'm not interested in that at all. I'm not intrigued *that* much with the medium . . . I want the end product; that's what I'm really interested in. It's strictly a medium to use or to not use, and I use it only when I have to. I use it to do a job, which is to make a book. I could never go through all my photographs I've taken of different things and make a book out of it." Do you mean, I ask, that you can't conceive of a *Greatest Hits of Ed Ruscha,* with two parking lots and one swimming pool and three palm trees? "Well, no, I wouldn't say that . . ." He laughs.

Having run out of questions and tape, we begin to pack up. Ruscha answers a knock at his door and admits Billy Al Bengston, resplendent

in a bright red hat, looking—somewhat studiedly—like a refugee from an Al Capp panel. Ruscha gives Bengston a box of trout flies, a belated Christmas gift. Then he inquires as to whether I like anchovies and, upon receiving an affirmative response, gives me two tubes of anchovy paste and two cans of rolled filets of anchovy with capers. He explains that he hates anchovies, and had used a number of these same tins and tubes to surround a present for his wife, who despises them equally.

I accept the anchovies and ask Bengston if *he* considers Ruscha to be a photographer. "Oh, sure," Bengston replies. "He's a fine photographer. Ed's made pictures that don't look like anyone else's I've ever seen." He flashes an evil grin, and chortles.

Of those anchovies, one tube of paste has been sent to Van Deren Coke, author of *The Painter and the Photograph*, for his collection; one can of rolled filets has been sent to Peter Bunnell as a contribution to the collection of Princeton University. The second can of filets has been reserved for personal consumption at some future date, and the second tube is in the brown paper bag Ruscha offered them in, sitting in a cabinet outside my workroom, marked "Gift of Ed Ruscha."

Now isn't it nice to know these things?

Van Deren Coke: *The Painter and the Photograph*

One cannot fault a book for living up to its own intention, unless that intention is too modest. Van Deren Coke's *The Painter and the Photograph: From Delacroix to Warhol* (University of New Mexico Press, 1972) announces its goal early on: "The present volume is . . . essentially a history, pictorial and verbal, of various ways in which artists of many countries have used photographs directly or indirectly in their work since the perfection of photography in 1837." On one level, at least, this book—a revised and enlarged version of the catalogue for an exhibition on this theme created by Coke in 1964— achieves that goal; it is a volume full of evidence that photographic imagery (and photographic vision) has had direct and undeniable influence on the work of painters over the last century and more. As such, it will certainly prove to be an invaluable source of information

Art in America, September–October 1972.

for any future studies of the cross-fertilization which has occurred in the arts.

It is also—as the jacket blurb's hyperbole would have it—"a tremendous feat of artistic detection." The author has unearthed scores of little-known photographs and matched them to paintings for which they quite obviously served as models. For this spadework alone, historians of the future will owe him a considerable debt. One wishes that some accounts of such sleuthing had been included in the text, because the book's main flaw is that it is deathly dull.

This dullness, though not intentional, is virtually built into the book. Like its first version, *The Painter and the Photograph* is essentially a catalogue, a listing of instances: here is the painting, here is the photograph it is based on, these are the transferred elements. What little continuity there is to grasp is more chronological than conceptual; each chapter deals with a specific variety of painting (portrait, genre, landscape, etc.) and cites examples along the historical trail between 1837 and today. Only the most perfunctory attempts are made to link these discrete phenomena to one another, and no unifying overview—the equivalent, in such a study, to the story line in a novel—is developed. The reader is left without any conceptual framework into which to fit the profusion of data collated here. While this laundry-ticket organization is acceptable in a necessarily brief exhibition catalogue, it is hardly a way to create a readable and deeply informative book.

To be sure, much of the data the author has brought together is inherently fascinating; it is exciting to see how Munch, Derain, Gorky, Rivers, and a host of other painters transmogrify photographic images and/or incorporate them into their work. But such uses by painters of a new medium are more than feathers in the cap of photography (which is how they are treated here). They are tacit—and often possibly unconscious—acknowledgments of the arrival of a revolutionary method of communication which brought with it not only a drastic alteration in cultural ways of seeing and of acquiring information, but also certain historical imperatives inherent in the new medium itself.

Not only did photography encroach on and gradually usurp areas which had hitherto been the exclusive domain of painting (such as the portrait), but it forced painters into a more ontological examination of their medium. Photography also served to redefine and expand

the then-prevailing concepts of acceptable subject matter, directing painting toward such themes as current politics, popular culture, and private life, suggesting by its nature that one function of art is to deal with the themes and events of its own time as well as those of the past. Photography's documentation of the bizarre world around us gave credence as well as impetus to more grotesque and fantastic painterly visions (and may, in fact, eventually force a total redefinition of the concept of the grotesque as an aesthetic category). Finally, photography created a more visually sophisticated audience than painting had ever previously had. That painters have used photographs does not legitimatize photography; on the contrary, such cross-pollination has primarily helped *painting* remain a vital and effective medium.

The author, though obviously aware of such ideas, becomes somewhat skittish in their presence, as though they were unwanted intruders into his text rather than invitees. On page 95, for example, Coke quotes André Derain: "It was the era of photography. This may have influenced us, and played a part in our reaction against anything resembling a snapshot of life." Coke then adds, "This may indicate that the reaction against photography was a much more important factor in shaping the history of art than has been considered." Having thus merely repeated Derain's statement in somewhat different words, he drops this provocative notion like a hot spud, never to pick it up again. (One of the book's shortcomings, in truth, is that the ideas it implies and hints at are rarely elaborated and are occasionally left entirely unbuttressed. On page 105, for instance, Coke asserts, "In ways not often considered, [W. R.] Leigh's paintings are related to those of the Easterner, Ben Shahn." But, since he goes no further and fails to indicate the rarely considered ways in which these two artists are related, he only compounds the oversight he seems to decry.)

A few ideas and attitudes do manifest themselves recurrently; these add up to a highly—and, in my view, overly—academic view of the creative process. In his preface, Coke chides Emily Genauer for her failure to "grasp the simple fact that throughout the history of art it has been art itself—in all its forms—that has inspired art," as though art were exclusively about art rather than the experience of life. Further on, he writes of Joseph Cornell, "Although he never formally studied art he has made collages that are powerfully evocative," the operative word being *although*. And in his concluding sentence—"To-

day's photographs are so geared to life that one can learn more from them than from life itself"—he appears to be suggesting that photography has actually *replaced* life.

It is not contradictory to say that, despite all this, *The Painter and the Photograph* is an important work which merits a place in any collection of reference books on the history of art and/or photography, since the literature on this topic is notably scant. It is thoroughly researched, amply illustrated, and well edited (though if the dates for illustrations 521 and 522, on page 269, are correct, it would seem that Lucien Clergue's photograph was based on Cocteau's fresco, not vice versa). Its limitations are for the most part self-imposed. In his preface Coke writes, "It is my hope that with this amount of information available further investigation of the subject will be stimulated." I can only agree and wonder why, having done all the necessary research for that more challenging book, Coke chose not to write it himself.

Ansel Adams:
Let Me Make One Thing Perfectly Clear

What can you say about a seventy-year-old photographer who is not only at the peak of health but is also photography's one active household word and the medium's best-selling printmaker to boot?

Whatever the answer may be, there is at least the partial relief of knowing that nothing a critic can say can hamper the future of a man who has wrapped his landscapes around Hills Bros. coffee cans, hidden them on the inner sleeves of record albums, sold four 16 x 20s of his "Moonrise" at $200 a clip in just the first week of his show at the Witkin Gallery—and who, on some channel of some TV set somewhere even as I write this, is tramping through Yosemite trying to persuade someone that the planting of a tree more than compensates for the pollution generated by test-driving a Datsun. Even one who has not, as I have, seen (however briefly) the fog creeping up the Pacific coast to cocoon the windswept evergreens outside the twenty-foot-high windows on the west side of his living room might encoun-

ter difficulty in determining just exactly what he had to say about the photographs of this Mr. Natural prototype.

Some of us have taken that problem on as an occupation (not infrequently to our regret), and we tend to be of the type what takes our job serious. One of our number, John Szarkowski, has provided a most seductive interpretation of Ansel Adams' *œuvre*. Known in Lit. Crit. circles as the Melville Gambit, it derives its name from the prolonged (if not inexplicable) public misconception that *Moby Dick* was nothing more than a book about whaling. In the Szarkowski Variation on the Melville Gambit, we are told that Adams has not been making perfectly printed oversized picture postcards, but mordant studies of a grim and implacable natural universe—that he is the Lee Friedlander of the High Sierras, in short, the Garry Winogrand of the view camera. Resisting the temptation of this theory is indeed difficult—it's only human to want to welcome that one sheep back into your fold. A cup of some fine Hills Bros. brew helps to straighten you out, though. The recommended parry is the presentation of a copy of *Michael and Anne in the Yosemite Valley* (Studio Publications, 1941), accompanied by a request that the theory be reconciled with the practice or else discarded.

I am willing to accept the proposition that Adams' work makes perfect sense in the environment which it records with such fidelity; and I have no desire or compulsion to denigrate his superbly crafted product—the price of which will rise, at the end of the current Witkin show, from $150 for anything up to an 11 x 14 and $200 for a 16 x 20 to $200 and $250, respectively. His prints are the supreme examples in photography of the result of one-track technical perfectionism, and they exist in limited enough numbers that their value cannot help but rise. Emotionally and intellectually, they fall in the same plane as the works of Rockwell Kent and Andrew Wyeth; they are almost aggressively accessible, demanding very little and returning more than they demand. I have never had a bad time in an Adams print. Even a clunky variant on Wynn Bullock's "The Emptying Wave"—Adams' "Log and Surf, No. California"—is beautifully enough made to be forgiven. Adams has learned well some key lessons from Strand, from Weston, and from Stieglitz, and has created a body of work which I must respect for its phenomenal extent and consistently rigorous standards of craftsmanship, but I am obliged to state also that it is a

body of work to which, in the normal course of events, I never turn for solace, exaltation, insight, inspiration, or even argument's sake.

Robert D'Alessandro: New York's Funky Epiphanies

Robert D'Alessandro—along with such others of his generation as Winningham, Krims, and Clark—is the inheritor of a mixed bag of influences. The development of the medium over the past three decades has been—as usual—convulsive, but in an unusually accelerated fashion. The best of the younger generation of photographers have made their peace with and choice from their multiple heritages, but it's all happened so suddenly that the results are often jarring, garish, customized, full of rejuvenated anachronisms. This is not unexpected, when you consider that photography is a medium in which an early inventor like Auguste Lumière could die in the same year as Robert Capa, who in terms of the medium's progress must be considered at least a tenth-generation descendant. Nevertheless, the images are uncomfortable to be with; they make you edgy (but alert) with their ungainly energy, their gawky strength . . . their adolescence, in a sense, with all that that implies, for they are truly the eyes of the first rock 'n' roll generation, and they too have gone from Bill Haley to Alice Cooper in just half their lifetimes.

The heritage D'Alessandro has chosen for himself is one of attitude rather than style. From the FSA comes a meet-the-people, press-the-flesh approach generally absent in these days of grab-shot street photography; D'Alessandro's subjects are contacted, touched by the image-making process, and by it made real. From Weegee comes his sense of the photographer as performer, and also his love for the city, a love only thinly disguised by the smartass street-punk tone of the wall label D'Alessandro provides for his current show at the Floating Foundation of Photography, "The Life Fantastic." And, from paterfamilias Robert Frank (not to mention Paul Simon), he has accepted the concept of America as a shifting state of mind rather than a fixed and recordable surface.

VV, October 19, 1972.

Stylistically, the influences are even broader, embracing Walt Disney, R. Crumb, pop art, TV commercials, and such. The techniques D'Alessandro employs are never present simply for their own sakes. The wide-angle lens is used not for catchy design purposes but because it's the only way to get everything necessary into the picture. The prints are large not for the sake of virtuosity but because that way the viewer is sucked into the event, grabbed by the collar and shaken awake by what is taking place within the image.

And just what is taking place in D'Alessandro's images? Well, New York—his exclusive subject in this show—is collapsing into a semblance of a bombed-out European city at the tail end of the big war; the people just get uglier, and you have no sense of time. The city becomes the setting for a series of peculiarly funky epiphanies, with dog skeletons moldering in front of tenements and inhabitants covering their faces to keep from being photographed. There is no avoiding these visions; they leer at you from the walls. These are not fantasies, by the way, merely slices from the life one lives walking around the city. We have all seen that affronted old man standing before the window full of Pampers, we have seen the other crazies and uglies who populate these images. D'Alessandro, though, has met them, his photographs are introductions; in an uncanny way, his images break through the boundaries New Yorkers set up around themselves and force the viewer to acknowledge the decrepit bluesy madness of urban America right now. There is life here—warped, trapped, and inappropriately set, but squirming, fecund, hot to the touch. "The Life Fantastic" is one of the most fertile statements in town, a match for the city that gave it birth.

Diane Arbus (II):
Her Portraits Are Self-Portraits

In some rare cases a body of creative work is not primarily a statement of esthetic sensibility or an intellectual feat of strength or a sermon or anything abstractable and removed, but rather the naked manifesta-

tion of the artist's own moral code in action. There are ethical decisions involved in all forms of creative work, of course, but they are perhaps closest to the surface in still photography. A photographic image is a transformation of reality; when selected with consciousness and an intention beyond the recording of surface, it is inevitably a remaking of an event into the photographer's own image, and thus an assumption of godhead.

The ethical issues inherent in the photographic medium are most fully exposed in the act of portraiture, by which I refer specifically to portraits of other people. (It is, of course, possible to make a portrait of a tree—another life form—or even of a rock; it is also possible to exploit these two non-human subjects, and all others as well. But that is another discussion, and less pertinent to ourselves.) There are no hard and fast rules for ethical portraiture. Most photographers, no matter what their subject, take photographs; a few, to use Minor White's distinction, *make* photographs; fewer still (as Robert Leverant puts it) *give* photographs.

Diane Arbus *gave* portraits—an astonishing number of them, as can be seen in the retrospective exhibit opening on November 7 at the Museum of Modern Art, and in the accompanying monograph on her work. She was able to do so by virtue of her absolute and intransigent insistence on documenting what I can only term the truth concerning an interaction which demanded her own self-revelation as the price for the self-revelation of her subject. This process is by necessity intuitive, for it cannot be systematized, dependent as it is on the constantly fluctuating state of one's finally secret soul.

John Szarkowski, who directed the retrospective, indicates that her work "challenged the basic assumptions on which most documentary photography of the period had been predicated" by being "concerned primarily with psychological rather than visual coherence, with private rather than social realities, with the prototypical and mythic rather than the topical and temporal. Her true subject was no less than the interior life of those she photographed." And, he might have added, of herself as well, for her portraits are self-portraits.

She gravitated to subjects we group under the label "freaks"—midgets, giants, hermaphrodites, twins, lesbians—not out of any decadent search for the outré but because she saw them as heroes who had already passed their individual trials by fire while most people stood

around pleading for theirs to be postponed. It is not surprising that her work was often misunderstood—though that should be more infrequent now that a large body of it, most of which has never been shown before, is readily available—nor that it had its greatest impact on a generation which followed Bob Dylan into the same territory.

Without disagreeing with the impeccable distinctions made by Szarkowski in the statement quoted above, I would like to point to one specific area of current cultural consciousness and change to which her work is particularly relevant, prophetically though not intentionally so. Like the German photographer August Sander—to whom her work is linked but not beholden—Arbus explored her subjects' roles. But where Sander concerned himself principally with the roles imposed by class and occupation, Arbus dealt with those imposed by body and gender.

As Marvin Israel has commented, she made no nudes, "only pictures of naked people." They are all freaks—as are we all, equal in our differentness. Some happen to be physically abnormal while others are more average, some happen to be male and some female. Her images are never concerned with how these individuals appear, only with their relationship to their physical and sexual selves—what they've done with what they were given. Look at such images as "Hermaphrodite and dog," "Girl sitting on her bed with her shirt off," "Woman with veil on Fifth Avenue," "Two friends at home," and "A naked man being a woman"—especially the last one . . .

There is more, much more, to talk about; her humor, for example, and her tenderness—in which regard the untitled series made in a home for the retarded merits a lengthy discussion all to itself. There is time for analysis later; right now while it is still fresh and uncategorized is our last opportunity to stand before her work and try to match its nakedness. Let us not permit ourselves to assume—pretty as it may be to think so—that when she committed suicide over a year ago she had no idea of how important her work already was to so many and would become to so many more. Consider instead the possibility that she did know—and that such knowledge was not enough. Diane Arbus once said, "Somebody else's tragedy is not the same as your own." Janis Joplin once said, "I'm going to write a song about making love to 25,000 people in a concert and then going back to my room alone."

Bob Adelman and Susan Hall: *Down Home*

In *Down Home* (Prairie House/McGraw-Hill, 1972) Bob Adelman and Susan Hall have created a work which—like *Tulsa, The Bikeriders, Palante, Friday Night in the Coliseum*—is a most valuable contribution to the growing literature of a genre I am coming to define as the new photojournalism: extended, probing explorations of cultural microcosms. Like all the above works—partially excepting *Tulsa*—*Down Home* is not simply a set of images, but a more complexly structured work involving a lucid combination of words and images to present the texture of present-day life in a small Alabama town. The images are Adelman's; the text consists of the thoughts and feelings of the subjects, taped and edited brilliantly by Hall—each statement, no matter what its length, seems a perfect summation of identity.

What is made rapidly, abundantly, and horrifyingly clear by this collection of portraits/self-portraits is that the mentality operating in the white power structure of Camden, Alabama, is the same as that which Caldwell and Bourke-White registered in *You Have Seen Their Faces*, which Marion Palfi dissected in a gripping, unpublished work ("There Is No More Time"), and which has in fact been found and documented by every single photojournalist who has ever worked in the South. To hear, at this late date, the mad litany of happy-go-lucky nigras and trouble stirred up by outside agitators is to achieve immediate empathy with virtually any action taken to escape the torture of domination by such mental ossification.

But the pervasive, endless racism is not always blatant, though it is almost never absent—indeed, in one of the few cases where it seems at least to be waning, the speaker has perforce remained anonymous. Every white person, no matter how liberal on the surface, has the seeds of the rot sprouting within, and Hall has chosen these portions of her interviews with an ear for the often almost imperceptible moments when the rot manifests itself. This is not to say that the white subjects of this book are entirely monstrous and insensitive, for they are not. Lev Sheffield makes a not inconsequential point about work and wages when he states, "A man's worth whatever he can get from his eyes up. That's where his senses are. From his eyes down, he's

worth 75 cents." There are other, perceptive comments on a variety of topics, and it is to the credit of Adelman and Hall that what might be termed "the wit and wisdom of Wilcox County" is explored with scrupulous fairness.

Yet the worm of bigotry has apparently riddled the entire white community, and seeing it appearing in one person after another is an increasingly ghastly experience, ultimately resembling some hellish nightmare in which all one's paranoia is amply justified. It is not, I think, presumptuous to suggest that this book is capable of conveying some modicum of what blacks in this country must experience on a continual basis: an endless process of waiting for the other shoe to drop and the worm to show its head.

If there is a counterbalance to this grimness, it comes from the contrast between a fossilized, decaying white power structure and an increasingly unified, organized, activism-oriented black community. The grotesqueness of Pat Nettles and Hollis Curl—the reappearance of whose picture, in much enlarged size, is positively scarifying in a cinematic way—is disappearing by attrition. As the Reverend Thomas Threadgill puts it so pithily, "A few funerals, and one or two other elections, and we're going to have a good county."

There are any number of fine moments which I could pluck out of this book, but that would be to treat it as a collection of disjunct images with an incidental text, rather than as what it is—a visual and verbal matrix of the South today. If you want to sample what Adelman and Hall are capable of achieving, go to a bookstore and look at the photo and text on pages 92 and 93. The text—a Sunday sermon at a Baptist church—generates a keen understanding of the church as a broadcast center for coded messages to and from freedom fighters (disguised as sermons). In combination with this text, Adelman's group portrait of the congregation takes on stunning double meanings, since it is also the study of a long and patiently evolved revolutionary cadre. No mean feat for a mere two pages. However, the book deserves your sitting down and reading/looking through it from beginning to end.

Robert Delford Brown: An Introduction

While the recognition is finally dawning on us all that photographs can (and usually do) lie at least as much as they tell the truth, they nevertheless remain the most factual fictions, the most credible prevarications available within the parameters of graphic communication. Indeed, excepting film and videotape—wherein sound and motion create the illusion of even greater realism (and thus permit even more outrageous fabrications)—we have come to use photographs as our primary visual means of transmitting information. This is true to such an extent that the method immediately preceding it in our cultural history and outdated by only half a century—those sketches and drawings which illustrated newspapers up through the 1920s—seems laughably anachronistic and hopelessly unreliable on those rare occasions (such as significant court trials) when, as a last resource, they are employed for informational purposes.

So the photograph, though highly untrustworthy, is—as a form of visual evidence—the only game in town. In our culture we utilize it most frequently on this basic level, with no aesthetic concerns other than those implicit in such acts. We use the photograph to prove things: that certain presumably significant private events (confirmations, bar mitzvahs, erections, travels, weddings, injuries) and even the most obviously insignificant public ones, actually occurred; that certain items, both man-made (new cars, the Taj Mahal, children)

Introduction to *First-Class Portraits* by Robert Delford Brown, edited with an introduction by A. D. Coleman (First National Church of the Exquisite Panic Press, 1973).

and natural (the Gobi Desert, the Grand Canyon, the sunset) actually exist. Our purpose in doing this is to set up the basis (utterly fallacious, needless to say) for a process of inductive reasoning whereby we hope to demonstrate to each other's satisfaction that the presence of our two-dimensional reflections within these accumulations of silver particles on paper is proof positive that we ourselves can be said to occur and sometimes even to exist.

The number of such photographs produced within our culture, which runs into billions annually, suggests that our need for such reassurance is desperate and insatiable. This profound uncertainty about our very existence has resulted in the creation of the most voluminous visual archive—that cumulative document implicit in countless family snapshot albums—which the species has ever left behind. That same doubt also explains our instinctual complicity in the photographic deception; as Dylan has said, "You can be in my dream if I can be in yours." So we take photographs of each other and ourselves within our overlapping dreams, holding them as talismans against those ubiquitous demons—we have all met them—who threaten constantly to "disappear" us.

Thus, to say that photographs—particularly photographs of people, and even more particularly those of people whom we know—are important to us all would be a vast understatement. We not only cherish our family albums and snapshots, we virtually venerate them. Scoff though we may at "savage superstitions" which depict the camera as a thief of souls, we nonetheless acknowledge the reality of those same intuitions in our behavior before the lens. We all primp and preen in some fashion for our portraits, which are formal presentations of our masks and, on rare occasions, of ourselves. We all object, sometimes quite violently, to photographs which we feel distort our public visual personae (such images, naturally, being those which have come closest to our inner truths). We have all known the difficulty of fully unfolding before the camera's eye and looking squarely into it, which is no doubt why we tend to make photographic records of each other and ourselves at moments of triumph, when we sense our personae to be most cunningly molded and strong enough to reflect the implacable light without melting in its heat.

The ultimate testimonials to the mystic significance we attach to our photographs are these: the ferocity with which we force others to

verify them, the heroism we muster to preserve them (people have fought flood and fire to salvage these tokens of the past), and the anguish we feel at their destruction or loss.

In a course I once taught I attempted to illustrate for my students a few of those precritical responses to photographs which we all share by asking how many of them were carrying with them snapshots of themselves, their family and their friends. Most of the students reached immediately for their purses and/or wallets, which was illuminating in itself. The greater revelation came when I warned them not to take their photographs out unless they were willing to incinerate them on the spot. Some prohibition (by now close to instinct, if not yet near to definition) so strong went into effect that not a single photograph came forth.

This incident speaks to another pertinent point: the photograph as a process and a product permits us to carry around on our very persons a matrix of illusions to which we all encourage each other to give credence, a matrix which is a symbolic "genuine imitation" of the fabric of our past. In a quite touching display of technological and scientific faith we assure ourselves that if we only believe in it hard enough (and most of us do), we can make it real and—as we did with Tinker Bell—keep it alive purely by virtue of our faith in a blatant and transparent fiction.

This means that, as members of a photographic culture, we lug around a lot of psychic and emotional baggage: the past is always with us, in the form of our photographs, which we tell as we might a rosary, wearing them smooth with the fingerings of our eyes. Photographs are small and weightless objects in comparison with our larger possessions, but unlike cars and TV sets and other material goods we cannot trade our photographs in and break our attachments to them without considerable pain. It is no coincidence that one cardinal rule in brainwashing is to remove from the victim all photographs of himself and people he has known . . .

In this group of "First-Class Portraits," Robert Delford Brown delves into this mass photographic subconscious, somehow managing to reinforce, warp, and undermine our primary assumptions regarding photography all at one and the same time. As can readily be seen, the images in this book are reproductions of photographs, which means that they all have—or at least had in the instant before their making—

the potential of functioning as evidence, as proof. Furthermore, as can be determined easily in all but a few of these images, they are without exception photographs of people. Thus they must immediately be classed with the most important kind of photographic evidence, since they automatically contain that distinctive if inexplicable substance referred to in the vernacular as "human interest."

Beyond that, however, it is difficult if not impossible to learn anything from these photographs. Evidence they may be, if only by virtue of their photographic origin, but evidence of what? None of them offers any tangible data in support of Delford Brown's assertions as to the identities of their subjects, which means that in the last analysis we are forced to make a pact with the artist, to trust him (a difficult and dangerous thing to do nowadays), before we can accept these images as portraits of those whom they purport to represent, and thus as proof.

Even if we do so, though, we do not thereby resolve the question of what they prove. As evidence, they demonstrate only that a Polaroid camera containing light-sensitive materials was operated in the presence (and often by the hand) of these beings. Few of us could identify them from their pictures here, and most of us would question the sanity of anyone who claimed otherwise.

If there were any facts here, I might add, they would only be facts about the past, not about the present, since the shutter's guillotining of the moment severs it from the stream of time. As one of the subjects, I am in a position to testify that I am not now as I was when my presence was recorded, not by any stretch of the imagination. The same holds true for all of Delford Brown's other subjects, none of whom are as they were, and one of whom—Joseph Cornell—in fact and within the construct of Western ontology no longer *is*.

I would also like to point out that the hand of the artist has manifested itself in these images in two ways, both of them uncommon to other graphic media and both actually antithetical to the most commonly observed procedures of so-called serious photography. The first of these manual forays into ostensibly mechanical territory is quite literal, clearly observable in the thumb- and fingerprints which appear in many of these images. Paradoxically, it is only on this level, concerning the artist's exercise of control over the image, that we receive anything which could be termed evidence, convincing enough

to establish an *a priori* case but useless because it does not apply to any punishable crime.

The second is in Delford Brown's decision to allow all these images to deteriorate to varying degrees and for varying lengths of time. The Polaroid image, as it comes from the camera (at least in the older model Delford Brown employs), is not permanent; like the very first photographic images ever made, it fades upon exposure to light. This decay can only be halted by applying a coating which fixes the image and makes it permanent. Since such fading represents a sort of death, there is a divinity inherent in toying with it, and it is worth noting that Delford Brown here achieves another of those paradoxes which are his forte; he takes a hand in these images precisely to the extent to which he does not take a hand to them.

Having said all this, I can think of nothing more to append to my comments save my own considered opinion that these images do indeed meet the basic definition of photographic portrait: they are all records on light-sensitive material of the presence of their subjects and their interactions with the camera and the artist. As for their being "First-Class" portraits, Delford Brown explains that "everything I do is first-class." He concludes, "I don't know the meaning of second-class," and that's a fact. You can take my word for it.

Life May Have Died, But Photography Lives On

Against the somewhat premature burial accorded to still photography by Gene Thornton in this space several weeks ago ("The End of a Great Era," Dec. 24, 1972), I feel compelled to counterpoise a different interpretation of the recent passing of *Life* magazine, if only to indicate the possibility of widely differing critical approaches within this column. My colleague's stance is summed up quite succinctly in his concluding sentence: "When *Life* died, only thirty-six years after its birth, photography's great era came to an end, and all one can now say is, 'Gee, it was great while it lasted.'" This position is buttressed by the twin theses that photography's status as an art and, indeed, its very existence as a significant mode of communication were both predicated on the continued survival of *Life*.

NYT, January 14 and February 11, 1973.

When *Life* folded, an era may be said to have ended, but the ending was a symbolic and belated one, for the influence of that publication on the development of photography has, for more than a decade, been negligible at best. With the sole exception of the late Larry Burrows, everyone on Thornton's roster of "photographers who owe their careers to *Life* or reached their largest public through it" made his or her major innovative contributions to the medium prior to 1960. For the vast majority of the photography community *Life* has been dead from the neck up for years; all of the photographers with whom I've talked recently were delighted to see that dinosaur collapse under its own weight.

This response was as widespread among photographers working in the area roughly definable as photojournalism as among those operating outside those parameters. (And, it should be pointed out, it was only a photojournalistic era which terminated along with *Life,* no matter when one chooses to fix the actual time of death.) Though this may seem paradoxical, it is not. Increasingly, over the last two decades, the reality of major events was, as Thornton himself notes, "transformed by the art of *Life*'s editors into something better, more entertaining and more affirmative than . . . it usually is." A generation whose credo John Lennon quite rightly reduced to "just gimme some truth" understandably looked askance at that editorial "art" which, through the influence of Madison Avenue, became more and more a process of packaging the news for maximum sales impact.

Many young photojournalists and documentarians, therefore, never expected their work to appear in *Life* nor held that possibility up as a desirable goal for their futures. It has been a long time since *Life* got down to the real nitty-gritty of anything at all, and so people like Michael Abramson and Alwyn Scott Turner and Larry Clark and a flock of others simply realized that, if they wanted to tell the truth as they saw it in photo-essay form and exercise some control over the ultimate use of their work, then books were the only viable solution.

It is easy to denigrate the book form as a vehicle for photojournalism by contrasting the circulation statistics of books with those of *Life,* but the ephemerality of a magazine reduces its effectiveness considerably. People keep books and throw magazines away. I know no one, offhand, who has a copy of the *Life* issue with Gene Smith's "Nurse Midwife" essay in it around the house, but I know dozens

who own his *Aperture* monograph and return to it regularly in order to re-experience that same essay. Which, then, has proved to be the vehicle with the most endurance and impact?

Photojournalists today are not, of course, restricted to book format. Scott Turner found a magazine willing to give over an entire issue to one of his essays (*Avant-Garde,* published by Ralph Ginzburg)—admittedly a rare occurrence at best, but one which would never have happened at *Life.* On a more practical and widespread level, others have turned to the hundreds of smaller, limited-market magazines and newspapers whose audience may not be as wide as *Life*'s but which do not demand so total a dilution of original intent as did *Life*'s editors in practicing their questionable "art."

Photographers have always published elsewhere, of course, since *Life* only skimmed a certain variety of cream off the top of photojournalism. But in recent years the appearance of anything in *Life*—even photographs—actually undermined its credibility with the younger generation because it had become obvious that the magazine which once spoke to (almost) all Americans had evolved into a complacent house organ for the middle and upper management of corporate America.

Furthermore, it was principally *Life* magazine—aided and abetted by *Look* and a few other, moldier corpses—which created the counter-productive Star System in photojournalism whose ultimate manifestation in our day is the David Hemmings character satirized by Antonioni in *Blow-Up.* At a time when, culturally, we were vastly more naive—up through, say, the end of the Korean War—this Star System was not so destructive; but then the event being covered became subservient to the photographer covering it, a process especially encouraged at *Life.*

There is, consequently, a grim irony in Thornton's assertion that TV is replacing still photography just as still photography replaced painting, since the only area in which this analogy holds water is in the very rapid transformation of TV news coverage from its original informational function to its current entertainment-based cult-of-personality status. Otherwise, in point of fact, still photography has hardly been supplanted by television. Not only is it used more and more by a constantly growing number of books and periodicals, but it has become a basic cultural tool, so thoroughly enmeshed in the con-

text of our daily lives that we are hard put to observe all the myriad daily manifestations of its presence. It is beginning to be utilized as the basic educational device it has always had the potential of being. It is being employed professionally by a wide variety of creative thinkers for whom neither *Life* nor the museum-gallery circuit was ever an ideal outlet—people like Les Krims and Emmet Gowin and Ralph Gibson and Fundi and so many others who use the camera to explore their world and themselves in personal, intimate ways which might well be vitiated by slickly packaged presentation to a mass audience.

Some work needs time to spread its ripples through the depths of our cultural waters. Edward Weston, Eugene Atget, J. H. Lartigue, and André Kertesz never did color covers for *Life,* but (directly or indirectly) they have all affected the way we use our eyes—more so, I dare say, than Gordon Parks or Carl Mydans or even Larry Burrows. *Life* magazine is dead, and deserves some eulogizing for its early contributions to photojournalism, but to bury the entirety of photography with it is to throw out the negative with the hypo. Like the reports of Mark Twain's death, those of photography's demise have been greatly exaggerated.

* * *

If you'll all settle down for just a minute, I'd like this opportunity to bestow, belatedly, the 1972 "Let 'Em Eat Hills Bros. Coffee" Award on Ansel Adams for the following credo, issued during his November visit to Funk City and quoted in the January issue of the *Photo Reporter:* "Whenever I see a picture of a garbage dump I am not the least bit moved. I have a garbage dump; I could take a photograph of my ash can that can be just as revolting as anything you can get here in Harlem."

Ralph Gibson: *Deja-Vu*

Ralph Gibson's mounting importance as a publisher over the past two years has somewhat obscured his significance as a photographer. The success of Gibson's Lustrum Press—which David Vestal justly compared to the Salon des Indépendants—is unprecedented, and has brought with it such a string of top-notch books that Gibson's own,

NYT, February 25, 1973.

The Somnambulist (1971; the first volume to bear the Lustrum imprint) seems far away indeed.

As Gibson has stated on numerous occasions, one of the reasons he founded Lustrum was to put into practice his belief that serious photographic work—particularly when sequential in nature—is best presented in book form, so that it can be experienced repeatedly and thus reveal itself most fully. This has been borne out by all the books he has published to date, but by none more than his own. Of all the Lustrum books, only Larry Clark's *Tulsa* approaches the specifically sequential complexity of *The Somnambulist,* the structuring of which is so intricate that I find myself still uncovering layers of meaning two years after first seeing it. *Deja-Vu* (1973), Gibson's latest book, is an extension of Gibson's understanding of sequence form. Like *The Somnambulist,* it demands to be returned to and therefore requires book form, proving Gibson's thesis more than adequately.

I am hesitant to define the narrative prematurely, but it seems to read eventfully and, I presume, autobiographically. Like *The Somnambulist,* it concerns a voyage, but not a cyclical one. In the emotional shock—murderous in its intensity—which follows upon the loss of a lover, the protagonist moves through two versions of limbo. The first is dominated by images of the business world and the banalities of urban existence, the second by the world of wealth. Escaping, the protagonist undergoes a sea change—several, in fact—and is eventually cast up on a beach resonant with that rightness beyond morality which fills the works of Magritte. The epilogue, a single image on the back cover, both affirms and denies the autobiographical nature of the narrative: it shows us Gibson himself, in a magician's top hat and a pair of bathing trunks, performing a handstand on the beach in front of his own camera, a virtuosic capper to the performance within and a reference back to the handstand image in *The Somnambulist.*

This is only one of several possible readings, but it seems to me less important to attempt an absolute definition of the narrative (which, in the last analysis, will be constructed by each viewer in quite personal fashion utilizing the outline Gibson has provided) than to point up some of the book's many other features.

First, I feel impelled to say that Gibson is a masterful maker of images—that even if his works had no sequential meaning his single images would nevertheless remain absolutely distinctive and unmistak-

ably his. Gibson's kinship with a few other photographers—most notably André Kertesz—has so few overtones of influence that it is difficult to see where he comes from; he seems to have arrived full-fledged, tapping his roots more into post-cubist art and the *nouveau roman* than into the photographic tradition *per se*. His images are small fragments and moments rendered monumental and timeless, made to cohere individually and serially by three prime factors.

One of these is his style, which is compounded of odd elements. Gibson's compositional sense derives equally from post-cubist art (particularly surrealism) and post-1950s graphics, taking the spatial complexity of the former and merging it with the presentational impact of the latter. This unifies the images on the surface, or two-dimensional level; while his choice of format and print quality—particularly his use of large areas of pure, deep black, brilliantly reproduced here by Rapoport Printing—defines a personalized, three-dimensional, uniquely photographic spatial sense which functions as a corollary constant.

Another factor is the consistent integrity of his images, which always contain just enough to be symbolically complete yet still ambiguous, providing tacit evidence of a coherent sensibility encompassing these visions without explicating them, a process always left to the viewer.

The last factor is Gibson's sequential intuition, brilliantly demonstrated in *The Somnambulist* and amplified in *Deja-Vu*. The images in the new book are sequenced not only individually but in pairs; almost without exception, the images on facing pages in *Deja-Vu* are halves of a unit, linked in a multiplicity of ways which are in themselves illuminating examples of the sequencing process. At times the links are compositional, graphic; in others they are narrative, and in still others symbolic. (The fifth and sixth, of a hand-held pistol and a man's bare back, are good examples.)

Individually, the images are not interdependent—they do not need each other; nor are the second images ever predictable. They are, however, inevitable; the correspondences are such that to have seen the first image is to have unconsciously anticipated (or at least to have been prepared for) the second, and to be unable subsequently to separate them. This, of course, is the meaning of *déjà vu* that synaptic confusion which leaves us feeling we have seen something before. As a title it applies not only to the overall work Gibson has given

us but also to the connections he has created within it. His ability to do this certainly entitled him to his magician's hat, and his exuberant handstand. For the second time in a row, he has given us a major photographic sequence which amplifies not only his own personal vision but the potency of book format as a medium in itself.

Minor White: *Octave of Prayer* (I)

I had a good week all in all, enjoying Larry Fink's family album at the Diana Gallery (brash, upfront portraits which were quintessentially New York Jewish) and being bored stiff by the "Landscape and Discovery" exhibit at Hofstra. While the latter show's premise—that photographers in the twentieth century have gradually turned from external to internal documentation of all subjects, including the landscape—is correct, it has been self-evident at least since the days of Weston and can even be traced back to Stieglitz, a pivotal figure in this regard whose omission from the show is glaring. There is at least one inconsistency in the show's makeup, though, which disturbed me. All the nineteenth-century figures—Frith, Jackson, O'Sullivan, Muybridge, *et al.*—were essentially commercial photographers, in that they made their living by selling their prints, whereas most of the twentieth-century photographers—partially excepting Ansel Adams—are or profess to be disinterested in the process of marketing imagery. The nineteenth-century work was inevitably affected by this mercantilism (though not necessarily to its detriment), while the later work achieves its privacy by withdrawing from the marketplace (not neces-

This was the last "Latent Image" column to appear in the *Village Voice* (March 15, 1973). It's the first half of a two-part critique of the exhibition and catalogue *Octave of Prayer*, which was edited and written by Minor White.

At the time I drafted it, I knew that this piece would be controversial within the photography community. What I did not foresee was that, after the first part had appeared in print, the second part would so distress a substitute editor at the *Voice* that he would refuse to run it without major alterations and changes in tone. This led to my backing up the piece as written with a conditional resignation, which the *Voice* management eventually accepted. Both parts were finally run, intact, in the November 1973 issue of *Camera 35*, for which I'd like to thank Jim Hughes, who was then that magazine's editor.

Camera 35 billed it as a "Great Debate!!!" and ran a rebuttal from Minor in the same issue. Along with my resignation from the *Voice* and the accompanying uproar, all that made it hard to put the piece in its proper perspective. Indeed, I'm still not sure what that is; but here, at least, is the piece as it was written.

sarily to its advantage). To contrast them as aspects of a single unbranching tradition is not entirely cricket; the true inheritors of Jackson, O'Sullivan, and the others are the present-day commercial landscape photographers, those whose images appear on posters and postcards and illustrate travel books and who attempt as did their spiritual predecessors the difficult task of satisfactorily balancing aesthetics and finance. Compromised their work may be by this involvement with money, but at least they spare us the fatuousness of Gary Hallman's pretentious enlargements of insignificant snapshots and William Dane's inane postcards.

I didn't give the show too much thought because I was preoccupied with *Octave of Prayer,* the book version of Minor White's latest anthology/sequence of other people's images, published by *Aperture* (1973). I realize now that it was wrong of me to poke fun last week at the letter White wrote soliciting submissions (I use the word advisedly) for his next show, "Celebrations," because in combination with *Octave of Prayer* that letter indicates beyond any doubt that White has given up functioning as a photographer and teacher in order to elevate himself to the priesthood of a peculiar new religion. Compounded of a visual banality so adolescently puerile as to be offensive and an intellectual Jesuitry so arrogant and anti-creative as to be proto-totalitarian, this religion—the Cult of Camera—is reminiscent of nothing so much as those arcane Southern California sects that believe orange juice is the one true sacrament.

I believe that *Octave of Prayer* is an insidious insult to all photographers, not only to those whose work is included therein but also to anyone trying to sculpt an idea in silver. I consider it such an arrant abuse of power that I am going to give it a full exegesis—the images this week, the text next—in an attempt to counter its harmful potential at least partially.

Let me preface my remarks on the imagery by saying that I have little sympathy with the photographers whose work is abused by this show. Not only were they given fair warning—in *Light*[7]—that White is capable of going off the deep end when it comes to the Cult of Camera, but they relinquished their right to beef at White's use of their images when they submitted them for his approval and for incorporation into his sequence. This exegesis is more in the nature of a class action suit.

Nothing is inherently wrong with the notion of thematic group

shows; not only can they serve useful informational purposes, when associated with a clearly defined social issue or event, but they can even function as weathervanes indicating the overall direction of the culture's thinking on more generalized concepts—the "family of man," say, in the exhibit of the same name. By sampling numerous visions focused on a common theme, some sort of picture can emerge to indicate trends of thought and attitude.

However, this presupposes that the work is being selected on the bases of quality and applicability to the theme, not on its support of one particular interpretation of that theme nor on its suitability for the role of cog in someone else's intellectual machine. Once this presupposition is invalidated—as is the case with the conceptual construct behind *Octave of Prayer*—the inevitable result is not the strengthening of strong individual voices by juxtaposing them (democracy in action) but the weakening of individual statements (or the selection of initially weak ones) and the subsumption of them into a collective voice capable only of repeating the ideas of whoever collected them. This, of course, is a basic totalitarian tenet—ask not what your country or Minor White can do for you, ask rather what you can do for it or him.

So, sad to say, only six photographers manage to retain their identity within this sequence, and five of them achieve this mainly through immediately identifiable styles which function as bench marks: Edward Weston, Barbara Morgan, Jerry Uelsmann, Paul Strand, and Ansel Adams (a distinctly ugly image, by the way). Only one, Chris Enos, stands out—and apart—from this show's claptrap by virtue of her images' content, which is so sardonic and satirical of just exactly the wispy mysticism and puffy religiosity of the sequence that it is obvious White failed utterly to understand them. With their hideous, garish Magic Marker tonalities and their mordant humor, they stick out like sore thumbs and mock the sappily reverential hush of the entire show.

Enos' work, breath of fresh/foetid air that it is, hardly compensates for the vacuousness of the remaining images. There are images in this book that I would be ashamed of if I were a photographer, images so corny in spirit and mediocre in concept as to be embarrassing—or, if you are on the viewing end, offensive. The face of Buddha superimposed on a leaf, for example. A hand, in a foreground, out-

stretched over the sunrise (let there be Light). Lots of beautiful clouds and waterfalls. Lots of intense-eyed young men with long dark hair, beards, and moustaches, which to White are evidently manifestations of saintliness. A little girl in sackcloth staring up at the heavens. Even a fucking seagull, believe it or not, though whether it's really J. L. in the flesh is difficult for me to say.

However, I know that—in the context of the larger bodies of work from which they have been untimely ripped—many of these images are nowhere near as gushy as they seem here. Brought together into this new context, however, they form an expanded Hallmark Gift Book, needing only appropriate excerpts from *The Prophet* and suchlike to make it (minus the Enos images) into a best-selling item at better newsstands and candy stores everywhere.

The wisdom of Merle Miller's epigram, "Never trust a man who does his praying in public" (from *A Gay and Melancholy Sound*), has rarely had a better photographic demonstration. The images are saccharine, cloying examples of the creeping-Jesus sensibility, both as a group and, in far too many cases, separately as well. They are, nevertheless, only the velvet glove. The iron fist is in the text, which we'll get to in the next issue.

Minor White: *Octave of Prayer* (II)

Last week I dealt at length with the photographs in *Octave of Prayer*, which show that Minor White has attained the enviable position of not even having to make his own photographs any more. All he now has to do is tell other people how to do it and then sequence the results in order to walk off with the lion's share of the credit. Many of the images in the book were quite obviously made to please White, for, despite his protestations anent the openness of his mind, White asks for—and, of course, receives—specific kinds of images.

He also generates a slavishly imitative brand of mystical pablum in prose. This is exemplified, in *Octave of Prayer*, by a most remarkable statement submitted by Ruth Breil to accompany her photograph of Yevgeny Yevtushenko, the Russian poet: "It struck me suddenly, as I was crouching down at Yevtushenko's feet—the stage above my gaze

. . . that the most beautiful, the most holy poem of all . . . the most sacred sound in the stillness around me . . . was the sudden anxious hiss of shutters clicking softly.

"I felt my tension ebb as I clicked this one and only image."

Now, language is a somewhat older and more symbolic medium of communication than photography, and poetry—the simultaneous distillation of experience and language—goes back a bit further than 1839. A human being standing alone before a huge crowd of strangers, offering them that essence of self which is poetry, attempting thus to communicate with a full understanding of the ultimate insufficiency and fragility of words, is committing an act of staggering heroism. If anything transpiring at that reading deserved to be called "sacred" or "holy," it was what Yevtushenko represented, by himself on that stage, trying to touch people with words. It surely was not *more* sacred or holy for numerous photographers to devote less than their full attention to those words in order to snatch images which cannot hope to capture even a whiff of the courage of that lonely act. For Breil to suggest that her and her colleagues' intrusion into Yevtushenko's music with their machine noises was devotionally superior to the work of the poet himself is inexcusably ignorant and insufferably arrogant.

The remainder of the text is mostly White's own writing. It occasionally reaches that pinnacle of inscrutability previously scaled by White ("because it was there . . .") in *Light*[7], a work whose incomprehensibility rendered it comparatively harmless. In *Octave of Prayer,* though, White is dangerously understandable.

Consider, for instance, the tortuous illogicality of the following. "The history of conscious prayer in photography goes back to the beginning of the century. In fact, to 1902, when the quarterly of the Photo-Secessionists, *Camerawork* [sic], was first published under the guidance of Alfred Stieglitz. Though Stieglitz meant art more than prayer, this exhibition is one more proclamation of the option of prayer in photography. The best name for that option is camerawork."

Roughly translated, what White says above is this: The tradition of conscious prayer in photography goes back to Alfred Stieglitz and *Camera Work*. Of course, Stieglitz (and the tradition he represents) was concerned with art, not prayer. Nevertheless, this exhibition is a

continuation of the tradition Stieglitz didn't found. And anyhow, we're going to rip off the name.

One might wonder about a man capable of such semantic gymnastics, engaged in for the sole purpose of aligning himself *post mortem* with a thinker who would have disdained the sanctimony with which this book is awash.

One might wonder, too, about a man capable of quoting at length one "Father MacNamara, Director of the Spiritual Life Institute of America," without identifying this organization any further or even giving MacNamara's first name. One might wonder about a photographer who laboriously describes eight levels of prayer and tells us authoritatively that poetry can only reach the second level but photographs can reach the third.

Having thus indicated to the faithful just where they stand on the scale of things, this self-appointed high priest gets into gear. "When a man experientially 'Sees' or discovers God in himself, with his mind, heart and gut, he grasps the joy of camera and man working in the service of the divine. *In the lawful relation of Man to God, he ceases to needlessly rebel*. The fallen Lucifer returns to his birthright." (Italics mine.) Stepping into a convenient darkroom, meek, mild-mannered Art Photography assumes his true identity—Jesus Freak!

Like all true believers, White would have one think that he and his acolytes are selfless. "Though some of those who leave the medium behind spend the rest of their lives in orison, meditation, and mystic prayer far from camerawork, a few return. Again they pick up the option of camerawork as meditative prayer and potential catalyst to the contemplative. The reason may be hard to believe [you betcha!] because it seems so non-egotistical. They realize that they have a natural talent for camera, that the medium is a part of their responsibility; so they keep their photography-as-prayer alive, but they do this just to strengthen or *magnetize others* of like mind, heart or soul, not for themselves!" In other words, boys and girls, that ain't *Aperture* you're holding, it's a copy of *The Watchtower*, intended to make converts willing to follow a man who can simultaneously assert his own "natural talent for camera" and lack of egotism, who can claim, in so many words, that he and his followers are God's gift to photography.

White subsequently goes on to tell anyone who cares to listen just how and where to go about making equivalents. "The major source

of equivalent and metaphoric images in photography," he writes, "are the great forces of erosion that shape and reshape the world. Camera has a positive genius for turning the effects of weathering into beauty and equivalence: wood, stone, faces, ice. It grandly celebrates the forces themselves: light, snow, wind, space, water, fire, earthquake, bulldozer, dynamite. In turn, man's artifacts on reverting to nature provide the photographer with many expressive abstract equivalents. Auto graveyards, crumbling buildings, rusting machinery, peeling paint offer camera rich, ambiguous, ambivalent images that may help the photographer evoke the sense of prayer. With a sudden shift of a mental Gestalt, images may allow us to recover even the ambience of historical personages and their halos, a Thomas or a John, a Judas or Peter." (Indeed, an example of the latter is even included—Carl Chiarenza's image, on page 44). Having thus, like one of Texas Guinan's satisfied clients, told 'em where he got it and how easy it was, White can nonetheless assert, in his letter calling for contributions for an exhibit extending this theme, that he has no idea at all what the work submitted will look like. He has dictated locale, style, and subject matter in the above paragraph; in the letter he dictates style even further, as well as size and even the precise tonal range of prints according to the Zone System. His threshold for surprise must be abnormally low.

White next compliments himself on the exhibit: "Considering the *medium* of camerawork, this exhibition is practically complete: some images are beautiful and thus art in both the profane and the religious sense, other images are symbolic and retrieve from storage hidden data in ourselves. Some images snap to the surface of the mind and can be talked about, others are 'dark to the mind,' reach us intuitively and so are 'radiant to the heart' (Evelyn Underhill)." Note White's equation of beauty and art, an outdated and indeed fatuous equation which explains his refusal, in the letter about "Celebrations," to consider images of sickness or depression.

"Included," he rambles on, "are images that occupy the mind, images that reach for the heart, those that satisfy the sense-loving body, and especially images that may be grasped intuitively by heart, head, and body simultaneously." Here White indicates that psychic intuition was the basis for the selection and sequencing of the images in the show. " 'Radiant to the heart' became the basic criterion for the

selection for *Octave of Prayer*. *As a criterion, 'radiant to the heart' re-
duces the terrors of connoisseurship by removing evaluation from the
head and putting it in the physical and psychic heart. This criterion
makes the whole of photography available to cameraworker, viewer,
and critic alike. When seen in depth, the radiant heart sees that all
subjects are equally important.*" (Italics mine.)

Note the value judgments in this paragraph masquerading as defini-
tions. "The terrors of connoisseurship" would seem to be those neces-
sary intellectual risks taken in venturing a verbal interpretation of an
image. "Removing evaluation from the head" is a more overt state-
ment of this anti-mind attitude, also revealed in the previous line
about "ceasing to needlessly rebel." "Placing it [evaluation] in the
physical and psychic heart" is a remarkable critical construct which
implies that the way to tell if it's a meaningful image is if it makes
your heart beat faster. And the statement that "all subjects are equally
important" is a rephrasing of that most intellectually debilitating of
all religious panaceas, "Is not all one?" The less thinking anyone does,
according to White, the better off we'll all be, floating around in that
famous peace that passeth understanding. No doubt it was that same
mindlessness which allowed White to write, further along, "Before
man existed, natural symbolism was." Symbol-making is a peculiarly
human function; no other creature invests things with symbolic mean-
ing, and thus before man existed, natural symbolism *was not*.

It is in the section of text headed "New Photographers" that these
anti-intellectual and self-aggrandizing themes manifest themselves
most frighteningly. "Today," White says, "we have come to that im-
passe of visual overproduction where *breakthroughs are an idle fantasy
and revitalization of the old is the task of artists and cameraworkers.
Whenever a revitalization, a rejuvenation, a resurrection, or a regen-
eration occurs, that image is a glowing contribution to one of the al-
ready established traditions.*" (Italics mine.) There is no point in
trying to find your own path, to do something new and original, he
claims. Your task as photographers is to repeat—with variations—the
breakthroughs that past gods (among whom White tacitly includes
himself) have made. And do not think that you will be able to take
credit even for excellent imitation; any time you succeed, your pictures
will be considered only as homage to the gods.

The vanity of this self-serving claptrap is almost too blatant to be

believed, and White obviously hasn't the faintest idea of just how in-
sulting he is being to the intelligence of every young photographer by
arrogating to his greater glory not only those photographs turned over
to him for exhibitions but every effective image to be made from
here on in.

The next three paragraphs, whose inanity is mind-boggling, merit
quotation in their entirety.

While I was embroiled with the contributions of over four hundred
photographers, a realization crystallized regarding a demand by new
photographers. ("Free, twenty-one, and owns a camera.") The new photog-
rapher is not crushed when I tell him his image has been done a thousand
times before and better. He says to me, "This is my experience of Isabelle,
or a Teton, this is my experience of union with a dead baby in the rubble,
this is my experience of a cloud, or a boss I despise. And the favor I ask
of you is this: please have the perception and sensitivity to evaluate the
depth of my experience.

"I know you have the capacity to evaluate the photograph along some
certain lines, aesthetic, social, documentary, symbolic, whatever your spe-
cialty; but can you evaluate *my experience?* My union with something is
to me a form of reality; and I have felt it in my head, in my heart, in my
body. My photograph may not be as strong as Stieglitz's pictures, as
Strand's pictures, Uelsmann's or Caponigro's, but here it is! Do *you* have
the capacity to measure my personal contact and union?"

Whether I or any other critic or teacher has the capacity to judge the
depths and breadths and heights of the new photographer's rapport, he
looks to us for affirmation on the dark road of his Way. He may want
photographs to promise stature, or love, or to be told he is headed for star-
dom. But the unexpected jolt is this: what matters to him more than fame
is the depth and validity of his experience. Depth of experience is hard to
judge in ourselves, let alone in others, so his question is one that most of us
would rather sidestep.

There is, of course, no such thing as an invalid *experience;* one's
response to and interpretation of one's experiences may be sound or
not, but the experiences themselves are neither valid nor invalid. And
there is absolutely no way of gauging the depth of anyone else's ex-
perience, either. As a critic, I do not consider either of these qualities
to be among my concerns. All one can learn from a photograph is how
the photographer sees, thinks, and communicates. Most photographers
become adept at only the first of these. White has removed from the

shoulders of young photographers the obligation to acquire the other two skills—thinking and communicating—and has replaced them with the nebulous non-skill of "feeling" or "experiencing," which everyone practices from birth. For his following, then, White is specifically calling forth those who do not want their work dealt with critically on any level other than the mystical.

The reason for this is made appallingly clear in the next few sentences. "While we will probably continue to evaluate still photography according to the going exhibition standards or the criteria of social comment, today we are begged to supplant those standards with our psychic perception of the depth, breadth, and heights of the photographer's experience of union.

"The spiritual crisis of the times demands that we should heed him. *The healing capacity of the process of creative work is desperately needed, now!* Let 'greatness' appear when it will, we do not need that ego trip. Best of all is the using of art and camerawork consciously for healing *no matter for how few* the psychological wounds caused by a society destroying itself." The italics are White's, and so are the implications: The culture is collapsing around our ears. If we few tender souls choose not to engage ourselves with it, either to repair it or build a new one, but decide instead to retreat to our monasteries and ivory towers and soothe our poor bruised little psyches with pretty, irrelevant imagery, who's to stop us?

It is not entirely startling that a man capable of such elitism and disengagement from the actions and passions of his time is also capable of saying, in response to adverse criticism of Bruce Davidson's *East 100th Street*, "Well, that's *Bruce's* ghetto."

Octave of Prayer is obviously intended to serve as the catechism for converts to an effete aestheticism remote from its own age. It tells young photographers that the best they can hope for out of their work is the imitation of past masters in the medium. It tells them that their minds are not only useless but actually antagonistic to the making of images.

Octave of Prayer represents a man, once a respected and vital teacher and philosopher in photography, coming to believe his own legend and making himself into an institution. This auto-deification is a sad and dangerous turn of events. There was a time when I thought the inferior, derivative imitations of White so often produced

by his former students were merely the unfortunate by-products of his teaching methods. It is apparent from *Octave of Prayer* that White does not regret his acolytes, but encourages them. I can think of nothing more useless to the medium, or to the world, than the photographic attitudes outlined in such proselytizing fashion within the pages of this book. Its egotism, abuse of power, and irresponsibility are monumental. It seems the time has come for White to be folded up neatly and carefully put away before he gets a chance to hurt himself or anybody else.

Michael Lesy (I): *Wisconsin Death Trip*

Having written on numerous occasions about the importance of preserving those segments of our culture's visual archives which molder forgotten in warehouses and attics across the land, and having advocated for some time the interdisciplinary study of photography and such other fields as history and sociology, I am gratified to find a work which exemplifies the potential of these practices.

The book is titled *Wisconsin Death Trip* (Pantheon, 1973). Originally presented at Rutgers as the thesis of its author, Michael Lesy, the book documents a fifteen-year period, 1885–1900, in the life of a town called Black River Falls, located in Jackson County, Wisconsin. It consists primarily of clippings from the county newspaper, the *Badger State Banner*—"only state, county, and town news items," as the author notes—along with photographs by the town photographer, Charles Van Schaick.

This primary source material is amplified with fragments from the records of the state insane asylum and carefully chosen sections from the fiction of such regional chroniclers as Hamlin Garland and Glenway Wescott. Additionally, and contrary to the traditional rules of historiography, the author has elaborated aspects of his material in anti-scholarly ways. He has entered into the body of the text behind two personae, that of the "Town Gossip" and that of the town historian, in order to present material not contained in his primary textual source. Not only his voice but also his eye is repeatedly manifest, for

he has collaged and montaged a number of Van Schaick's images to clarify and emphasize certain visual points as well.

Lesy's methodology bears no small resemblance to what is widely referred to as the "new journalism," that personalized and openly subjective reportorial/critical style which has dramatically changed our ways of apprehending our culture and thus altered the culture itself. Perhaps even more pertinently, Lesy's cognitive tactics are directly analogous to those of Carlos Castaneda in the latter's researches into the "separate reality" of a Yaqui sorcerer.

Castaneda challenged the supposed "objectivity" of the detached observational procedures common to field anthropology, on the grounds that they represented little more than a pseudo-scientific cultural chauvinism. Similarly, Lesy in his book posits an approach to historiography which attempts to go beyond the dry analysis of data to a reconstruction of the actual experience—the mood, the feel, the spirit—of an era. His intent is the creation of an emotional as well as intellectual shock of recognition. Because he so largely achieves this goal, it seems likely that Lesy's *Wisconsin Death Trip* will have an impact on his field no less violent than Castaneda's on anthropology. Just as Castaneda was willing to suspend his belief in the rightness of his culture's set on reality, so is Lesy. But Lesy's subject is our view of ourselves as Americans during a certain stage of our history—specifically, the myth of rural bliss and *fin-de-siècle* innocence which is the stock-in-trade of the nostalgia boom and the back-to-the-land movement.

What Lesy culled from the pages of the *Badger State Banner,* and found deep resonance for in Van Schaick's images, is a chronicle of disaster and doom so unrelenting and yet so commonplace as to be terrifying even at a distance of more than seventy years. For like any good hometown paper, the *Banner* reported all the events in its territory, large and small. Beneath what must have been the surface—international and national news, regional politics, anniversaries and other celebrations, and the like—there runs a constant current of madness and despair, a litany of horror. Suicide is a commonplace in these news items; so is arson. Insanity, death by epidemic, crimes of violence, and financial ruin are constants. Mortality is ever-present; disaster in one form or another nips at the heels of everyone.

Whatever the highlights of the era may have been in Jackson

County, this was its general texture—and there is more than enough reiteration of evidence to prove that this was truly the fabric of life and not just Lesy's pessimistically chosen thread. Impotence is the keynote, as can be seen from the list above. Insanity—at least in most of the endless instances cited here—was a declaration of impotence in combatting such forces as financial machination and contagious disease, both beyond the control of rural residents.

Even arson—the most frequently cited crime against others in these accounts—is peculiarly appropriate as the least preventable in a rural community. Suicide, in such a context, becomes a final desperate attempt to assert control, as Lesy points out. This is especially understandable since, as Lesy underscores in his introductory and concluding statements, the high statistical probability of infant mortality represented the devastating threat of failure to propagate one's line—a form of impotence symbolically charged and agonizingly close to the bone.

Thus it is certainly no accident that the images which begin the book are, first, an ungelded palomino and, second, a darker gelding. (The reference to Alfred Stieglitz's "Spiritual America"—a study of a gelded horse—seems clear.) If that pampered palomino represents the American Dream of fecundity and expansionism, of pioneering adventure and the fertility of the earth, then the gelded workhorse represents the more nightmarish reality which rural America faced when the dream was over.

The grim, numb-eyed visages which stare out from Van Schaick's portraits have seen their hopes lopped off like prairie oysters. The newpaper stories slip over them, stiffly; like mourning clothes bought off the rack, these tales of woe fit everyone passably and no one exactly. It is not the particular agony which any one of them suffered, but the cumulative "death trip" they all took, which is the core of this book. I doubt that anyone will ever again be able to look at turn-of-the-century photographs and consider them documents of a happier, less troubled time after paging through this family album of the damned.

Must They "Progress" So Fast?

San Francisco—The coinciding of various experiences—a number of exhibits I saw on the East Coast this past spring, several recent conversations with young photographers out here, and a poignant article by Peter Schjeldahl in these pages a few months back—has turned my attention to an increasingly pressing problem in photography: the tyranny of premature recognition. Schjeldahl's piece, epitomizing this very problem in another field, was a spirited defense of Frank Stella against the disfavor into which that painter has, apparently, lately fallen. The thrust of Schjeldahl's argument was that Stella should not be considered washed up, that he might still make a further contribution to his medium and so should not be written off as a has-been. Stella turned thirty-seven last May.

The poignancy of which I speak was neither articulated nor, I think, intended by the author. Rather, it resided—at least for me—in a fleeting vision of what it must have felt like to be that painter on that particular Sunday morning, opening his paper and confronting that apologia for himself along with all the assumptions which made it necessary in the first place. Stella's plight is a chilling demonstration of the result of current attitudes in the art world. Yet tacitly accepted—and thereby legitimatized—in Schjeldahl's discussion was a critical/curatorial/creative *status quo* which encourages and to some extent engenders such ghastly manifestations of this culture's hunger for stars.

Not unpredictably, in order to feed this insatiable appetite the culture tries to breed into young artists a drive to become famous as early as possible. "Immortality Now!" would be an appropriate slogan for this trend in the arts. And its central, academy-originated credo—that artistic endeavor is a calculated affirmation of the territorial imperative, a process of "staking out territory"—is quintessentially American: a depiction of creativity as some competitive, get-there-first Oklahoma Land Rush of the spirit.

Inevitably (though, as always, a bit late and out of breath), this art-world attitude has filtered into photography. Increasingly over the past year, I have had students from schools on and between both coasts

NYT, August 26, 1973.

ask me pointed questions, not about supporting themselves with their craft (a perfectly legitimate though widely disdained area of inquiry), but about Making It with their Art. What kind of work, they want to know, is being shown and published and collected? What is the coming thing? Even—most blatantly—what areas do I think are being overlooked?

It is becoming more and more difficult to explain to young photographers the absolute irrelevance of these questions, and to convince them of Edward Weston's wisdom in asserting that "Art is the outward manifestation of inner growth." Photography education continues to emphasize technique and sidestep any consistent consideration of content on the grounds that it is either too subjective a matter to be discussed or else irrelevant to the new fashion for "subjectless photography." Production—a large output, even if ultimately edited down—is widely held to be a virtue in itself, and since photography lends itself to prolificity it is easy for students to delude themselves into thinking that because they're making lots of Art they must be manifesting all kinds of spiritual growth.

Those few who manage to get out of school with some real commitment to the medium and all their f-a-c-u-l-t-i-e-s intact have only survived the first stage of this cultural gauntlet. Photography is a hot medium, perhaps the hottest of all the graphic arts, and the heat is on young photographers to pre-empt their conceptual acreage and make names for themselves quickly. The most rapid way to achieve cultural identifiability or stardom is by latching on to some instantly recognizable style or subject matter—preferably both—to call your own. (At the moment, for example, I can virtually guarantee immediate acclaim to the first photographer producing a necrophiliac sequence within the snapshot modality.) This is a tactical challenge which involves psyching out the culture, determining what it will want to see, and then creating a body of work to fit.

This process—generated by the culturally instilled urge toward public acclaim—is quite unrelated to the creative process, whose egotism is much more fundamental and nowhere so dependent on the approval, or even the recognition, of others. Seductive it surely is, though, especially when weighed against the slow, patient, painful unraveling of oneself and one's relationship to others and to the world —the foundation and cornerstone of that more arduous process which

a poet of my acquaintance calls "building a poetry of one's own." Such unraveling is necessarily a private, introspective act, poorly suited to the public-performer requirements of Making It and rarely reflected in the work of artists fresh out of school because it demands as its premises an experiencing of self in the world from which the womb of higher education has protected them and a maturity they have not had time to acquire.

Yet more and more, lately, I've seen shows—not just in galleries, but even in museums—by young photographers hot off the press whose bodies of work have little to say and lack any distinction beyond their statistically unique amalgamations of facets of their mentors and other influences. In their early or middle twenties, they already have lists of exhibition and publication credits as long as your arm. Many of them have already been academically recycled and are actually teaching, thus perpetuating this syndrome.

Museums and galleries and magazines—and critics—too often function as star-makers, intentionally or not. Seeking certification for the significance of one's work from these sources—rather than "building a poetry of one's own" whose significance needs no external verification—has the effect of addicting the artist to the support of others and locking him or her into whatever style or subject matter has gained this approval. When a twenty-five-year-old photographer has had a one-man or -woman show at the Museum of Modern Art and enjoyed all the fringe benefits thereof, the psychological odds against being able to turn away from such support are high indeed.

The result, in too many cases, is a young artist trapped into repeating previous successes and terrified of exploring any territory whose perimeters cannot be safely defined. Photography has produced a bumper crop of these recently. We should beware of applauding their meteoric rises (and of booing their meteoric falls). We should also beware of letting their flashiness blind us to those others who hide their lights under bushel baskets and don't open their mouths until they have something important to say.

Shouldn't We Be More Concerned?

While it appears we won't have Dick Nixon to kick around much longer, his benighted attitudes will be with us for years to come, embodied in the present Supreme Court of the United States. This avenging legacy to the American people may disown its maker in his last-ditch struggle, but the Burger Court's regressive philosophy has been expressed clearly in numerous decisions. Nowhere has this occurred more insidiously than in its rulings on obscenity last June 21.

To date, I have seen little discussion of the ramifications of this decision insofar as the visual arts are concerned. I have seen absolutely no concern over this issue within the photographic press. This is not altogether surprising, considering the general hardware-consumerist orientation of most photographic publications. Combined with the vows of apoliticality required by most of the photographic orders, such gadget fixation effectively precludes even enlightened self-interest.

Photographers have long grappled to themselves the notion that whatever is visual is non-political; indeed, they have done so with a fervor matched only in their renunciation of the original sin of literacy. It is a stance out of the gray flannel 1950s, that same era which the new obscenity rulings seek to restore, and as such contributes heavily to the climate which has made such a restoration possible. Artists generally, and photographers in particular, have failed to learn the lesson of the epoch: that censorship is cyclical and so—nature abhorring a vacuum—whenever artists forswear the moral imperatives of their calling, censors rush in to fill the void.

I could argue inductively that the politicality of art is manifest in the correlation between totalitarianism and censorship, but I believe it possible to be even more specific. Within the context of contemporary Western culture, the act of becoming an artist represents such intense individuation as to be fundamentally anti-social. This is even openly acknowledged by the culture, in its stereotype of the role. In a healthy and fluid society, the anarchic impulse inherent in creative activity is accepted as a perquisite for the desirable goal of organic evolution. In a corrupt, decaying society, creativity is inherently threatening to the *status quo*—i.e., revolutionary—and therefore increasingly suppressed.

NYT, November 18, 1973.

As a process of change and growth, art is an explosive force within our culture. To defuse it, the culture has evolved a variety of mechanisms, most notably the museum. The preservative function of the museum disguises its self-protective function, which is to certify that whatever is housed within its walls is acceptable and safe—and, thus, no longer art in the most meaningful sense of the word, merely artifact. The art object, after all, is only the embodiment of an idea. Once the idea of any work enters the bloodstream of a culture, its vehicle becomes a corpse—exquisite, perhaps, but a corpse nonetheless. The calling of the artist is not simply to be a manufacturer of objects, a craftsman, but to be a progenitor of new myths, new truths, new definitions.

Shelley was not being romantic when he wrote, "Poets are the unacknowledged legislators of the world." He was stating for his time what Stokely Carmichael stated for ours: "He who controls the definitions controls the structure of society." Anyone who doubts this needs only to look at the Watergate debacle for proof. That crisis is clearly a struggle for control of the definitions, and the Senate hearings are a televised linguistic battle royal. The *Realpolitik* from which Watergate sprang is also the source of the Burger Court's obscenity ruling.

As a creative medium, photography has not faced many censorship disputes, and consequently there has been little acknowledgment of the pertinence of this ruling to the medium. I think it is time for the photography community to re-examine the issue, since the chickens are coming home to roost. To wit: a number of "men's magazines" of the soft-core variety are being harassed and prosecuted in various states across the country. The offensive material, in almost all cases, is the photographic imagery they contain. Despite the extensiveness of the market for these images—many of the magazines have circulations in six and seven figures—the vague gauge of "community standards" apparently excludes them from constitutional protection.

The fear of such prosecution (which can lead to heavy legal expenses, stiff fines, and—as it did with Ralph Ginzburg—even jail sentences) inevitably breeds self-censorship, not only among publishers of erotically oriented periodicals but among publishers of serious photography books. Already, as of this writing, there are at least two photographers whose publishers have pressured them into removing from forthcoming books images which it was feared might be found

offensive to someone's "community standards." One of these publishers was an independent, the other a large, established house.

My purpose is not to point an accusatory finger at these two cases. There are inarguably pragmatic justifications for such protective measures on the part of a publisher, and it is hard to fault a photographer for deciding to sacrifice two images in order to save the rest. Until the photography community fights for its right to freedom of vision, however, such comstockery will continue; photographs will continue to be fair game, and there will be no way of telling when a photographer's statement has been bowdlerized to avoid trouble.

The situation is becoming increasingly urgent. Accordingly to an article in the September issue of the *Art Workers News,* the deputy chief of the appeals bureau of the Manhattan District Attorney's office, Lewis Friedman, "conceded that serious photographers of nude subjects might be affected by the anti-smut campaign because it is difficult for law enforcement officials to distinguish between photographs made for artistic or pornographic purposes."

It will be especially difficult for Harry Snyder, duly appointed head of the new *ad hoc* censorship committee in Clarkstown, New York, and originator of the memorable slogan: "You don't need to be an expert to know what is smutty." It will be especially difficult for Mr. Snyder because—as reported by this newspaper on October 22—he is blind.

"Photography: Recent Acquisitions"

Museum shows of recent acquisitions tend to be taken for granted. They are usually presented sometime during the cultural slack season —at the end of the spring schedule, in the middle of the summer doldrums, or in the fall before things get rolling. These are times when they're not likely to draw much critical attention, since critics then are often off on vacation. (Museums being cool and airy places, though, there's usually a large audience for shows during this period.) Because they are group shows, samplings of what's come in, they explore no single artist's work in depth—another reason no one pays them too much mind.

Popular Photography, December 1973.

But recent-acquisitions exhibits are very revealing, worthy of the most careful scrutiny. They indicate quite specifically what sort of work a museum is buying and accepting for its collection. They are guidelines to a curator's criteria, tastes, and biases. From them one can deduce what directions a curator thinks are important. And, if one is a young artist, one can try to use such shows to figure out how to go about making work that will appeal to the curator in question. In an art world grown increasingly hermetic and self-contained, with artists more and more often tailoring work to fit specific curatorial and critical aesthetics, the recent-acquisitions show is nothing less than a political act—a statement of what is of interest to the institution sponsoring it, and a call for more of the same.

Because it is one of the most influential museums in the photography world, such a show at the Museum of Modern Art always bears looking into, for just those reasons. This latest one was no exception. The departure of Peter Bunnell from MOMA to Princeton University has left the museum's department of photography in the hands of one man, John Szarkowski. This show, therefore, represents his vision of photography.

Unfortunately, as reflected in this show (and his recent book, *Looking at Photographs*), Szarkowski's aesthetic is an exceedingly narrow and limited one. It is restricted almost entirely to the documentary genre, centered around Walker Evans as the first conscious articulator thereof. It comes forward in time to the work of Lee Friedlander and Garry Winogrand, and traces itself backward to Eugene Atget. It incorporates the currently fashionable snapshot and the essentially academic concern with "photographs about photography."

What it does not include are: straight color prints or prints which include applied color; images subjected to visible handwork or post-exposure manipulation; mixed-media work; images concerned with specific human interactions; and images which demand a visceral rather than an intellectual response.

Very few of the images in this show contained people, and only three of fifty confronted the viewer with specific human beings. These were George Platt Lynes's formal portraits of Auden, Tanguy, and Cocteau. (John Schott's unimaginative photographs of three Philadelphia mummers were records of unusual costumes, not explorations of character.)

The work which fell into the new documentary vein included a Robert Adams urbanscape; six prints from Lewis Baltz's "Tract House" series, Joseph Dankowski's six photographs of manhole covers; Tod Papageorge's expert imitations of Garry Winogrand; Schott's trio; a Henry Wessel, Jr.; one print from Geoff Winningham's study of wrestling in Houston, *Friday Night in the Coliseum*, and Joseph Koudelka's two ersatz Bressons.

That which fell into the snapshot aesthetic/subjectless photography category included Bill Arnold's four Itek enlargements of dull images of somebody's dog; Ken Josephson's three photographs about photography; and several images from the previous paragraph.

Even the older images in the show seemed to have been selected for that same astringent, emotionless quality. There were typical landscapes by Francis Bedford, Francis Frith, and William Henry Jackson; a typically calligraphic wallscape by Aaron Siskind; two abstract compositions by Florence Henri; and only a few stray images like the Harry Callahan beach scene and John Paul Edwards' "The Web, Brooklyn Bridge" to suggest that feeling and voluntary communication might have a legitimate place in photography.

It was, most of all, an unbearably boring show, devoid of the juices of life and of any but the most oblique connection between photography and human lives. It represented a dessicated, sadly limited, and considerably dated vision of what photography is and what it can be. As a directional signal it is, of course, a self-fulfilling prophecy: Szarkowski has indicated to young photographers what kind of work he likes, and it should not surprise anyone that he continues to get it. What is regrettable is that the power and influence wielded by the Museum of Modern Art in the realm of photography should be held exclusively by a man who does not even recognize or compensate for his blind spots.

Clarence John Laughlin

Clarence John Laughlin is an obsessed romantic. A Southerner to the marrow, he makes photographs which exude that peculiarly southern aura: nostalgia amplified to the level of metaphor, guilt as a fetish

NYT, December 16, 1973.

object, decay as a perfume. There may be such a thing as a New
South, but that is not Laughlin's concern. His focus is strictly on the
Old South, that "country in the mind" of Faulkner, Davis Grubb,
Flannery O'Connor: a spiritual territory where rank, decrepit mythol-
ogies still live on in hope of resurrection.

Many of Laughlin's images might appear at first glance to be archi-
tectural studies—and, on a practical level, can certainly serve as such.
But the crumbling old mansions of the South are a central metaphor
in Laughlin's imagery, emblematic of the disintegrating glories of the
past. They are photographed with an alertness to form and an atten-
tion to detail sufficient to satisfy any historian; yet they go further, to
display a directorial concern with the *mise en scène*.

Laughlin is a dramatist at heart, and though he does not present
his work in sequential formats it nevertheless functions as a sort of
play—or, perhaps more accurately, as what used to be called a "the-
atrical," with all the magic, mystery, and melodrama that term implies.
From the collapsing plantation homes, which are tombs for the dreams
of the past, Laughlin moves to untended cemeteries, and the tombs of
the dreamers. These are the parameters within which his drama is
played out. At times he scrutinizes them from a distance, at times he
comes in close to examine a fragment and transform it into a paradigm:
a cobwebbed clock, a stuffed bird rotting in a tombstone decoration
("Bird of the Death Dream"), a demonic incrustation of mold on a
wall ("It Capers in Darkness," a title perhaps intended to evoke
Manuel Alvarez Bravo's "And by Night It Moaned"). These are all
haunting visions, and their power is intensified by the meaning with
which their connection to Laughlin's central myth invests them.

At the core of this myth is an enigmatic female figure, dressed in
black, her face almost always veiled and sometimes invisible. She
appears in image after image, sometimes—in combination prints from
sandwiched negatives—as a ghostly, insubstantial presence, more often
as a cryptic, ominous reality. She walks the cemeteries and inhabits
the houses; such parables as "The Elder Worship," "The Repulsive
Bed," "The Bat," "The Disease of Pride," and "The Secret of the
House" enunciate her symbolic ramifications: mourning, secretiveness,
the fantasy of southern womanhood, death-in-life. From her, as a
southern Gothic quintessence, Laughlin's work draws its coherence
and its power.

Laughlin himself has lived and worked outside the mainstream of photography, with the result that his work is not widely known even among his contemporaries. Yet he was employing such now-common methods and approaches as multiple printing, staged imagery, negative reversals, and collage in the 1940s and early 1950s, long before they became fashionable. This is not his prime significance—except, perhaps, to a historian. More noteworthy, from my standpoint, is that Laughlin is one of a very small handful of expressive photographers who have not only articulated their obsessions but have been able to create encompassing and unified mythologies which structure and give meaning to their visions. Laughlin's current shows—one at the Philadelphia Museum of Art, the other at the Neikrug Galleries—should serve to direct attention to his unique and important body of work.

Bill Dane

A tendency on the part of many artists to tailor their work to the tastes of curators has been noticeable in American creative life for quite some time now. Photography has certainly not been exempt from this trend, the apparent premise of which is that the customer is always right. Since the artist-curator symbiosis has been increasingly obvious for the past several years, it should come as no surprise that someone has found a way to eliminate the middleman—i.e., the audience—entirely, by addressing his work, literally and figuratively, directly to the curators.

The person in question is William Dane, whose work is currently being presented by the Museum of Modern Art's Department of Photography. The work, which is being shown in slide form, is titled "Unfamiliar Places: A Message from Bill Dane."

Dane is an artist who, some five or six years ago according to his bio, turned his attention to photography. His contribution to the medium so far consists in having made a series of black-and-white snapshots during his travels. These snapshots he has converted into limited-edition postcards, which he has sent to a select mailing list. All the examples of these which I have seen—including those in this show at MOMA—have been addressed to museum curators (in this case, to

MOMA's John Szarkowski and Dennis Longwell, with a glancing reference in one to William Burback, a former MOMA curatorial assistant). Szarkowski is the second curator in the New York area to have elected to show Dane's work. The way to a curator's aesthetic, it seems, is through his/her ego. This year Dane was awarded a Guggenheim Fellowship to continue his work.

Now, if I were a photographer myself, I would be deeply insulted by this show. I would be insulted that an institution so prestigious and powerful as the Museum of Modern Art would present, as photographically exemplary, a collection of random snapshots by someone who has not even established enough craft competence to make his disregard of craft standards a significant aesthetic choice.

I would be insulted at the presentation's implication that the work of an artist who diddles around in photography awhile has greater significance than the work of any of hundreds of photographers who have been serious and committed workers in their medium for a decade and more but who have never had even a single print in a MOMA show. And I would be insulted by the Department of Photography's sponsorship of an artist who writes, "It's been said that I'm documenting almost nothing sans technique. I've always been uneasy near compliments." Because, in the last analysis, it's the snottiness that gets to you.

But I'm not a photographer—a fact for which I have frequent occasion to be grateful. I am, as one photographer put it, a "word man," and so I cannot say that this exhibit insulted my craft, my art, or my profession. It only insulted my intelligence.

Emmet Gowin

Like that of many of his contemporaries, the work of Emmet Gowin involves itself with the cultural history of the snapshot. The snapshot is a vernacular form of photography, a democratization of the medium; as such, it is unique in the history of graphic communication. It would also seem to be particularly Western, in that the act of taking a snapshot is an interruption of the flow of events and of time, an interruption whose purpose is to preserve rather than observe. For all

its smallness, fragility and evanescence, a snapshot is not just a memento but a monument.

Since most snapshots are made by people without any formalized or structured understanding of visual communication, what they transmit to the viewer is dependent to a large extent on accident. Typically, a snapshot of someone's relative at Grant's Tomb will show the relative too far from the camera to be identifiable and Grant's Tomb too close to be recognizable. Such images convey little about the subject, the setting, or the event. The "information" they pass on to anyone outside the family circle concerns the need of the snapshooter to immortalize a significant moment in his/her life. Their charm and poignancy derives specifically from their *failure* to communicate—from their epitomization of what Eliot meant when he wrote, "Between the idea/And the reality/Between the motion/And the act/Falls the Shadow."

The deliberate creation of such inarticulate imagery is hardly fit work for a grown artist; and the inherent hypocrisy of claiming professional status while retaining the protection of one's amateur standing is self-evident. This results inevitably in the kind of distasteful snobbism which permeates Thomas Consilvio's *Snapshooters* (A Mouse Press, 1973). In this collection of three dozen black-and-white snapshots of people taking pictures almost all the "snapshooters" are depicted in ways which make them look somewhat foolish: positioned awkwardly, face squinched up, etc. While Consilvio has included himself among these "snapshooters"—*noblesse oblige,* after all—it is surely not altogether coincidental that this is the only image with a romantic fuzziness to it, that Consilvio's reflection in a shop window shows him nonchalantly and gracefully taking his snap one-handed, and that the words "Alma Foto" ("alma" referring to soul or love) appear right by his head.

Most photographers working within the snapshot aesthetic have gone the way of intentional incoherence, and have adopted the arrogance necessary to defend this posture. Emmet Gowin is one of the few who have accepted articulate communication as the obligation of the artist, and he has taken from the snapshot those qualities which increase the accessibility of his message rather than those which obfuscate it. His subject matter is traditional to the vernacular snapshot: his wife and children, their relatives, family occasions, travels, their house and its surroundings, friends and neighbors. Gowin rarely strays

beyond these parameters, and when he does the images inevitably link up in other ways to his clearly enunciated central concerns.

In its formal structure, Gowin's work is nothing more nor less than a family album. But there is more to the family album than meets the eye. Regardless of the quality of the images therein, such an artifact is a recent and unique aspect of Western culture: an ongoing description of the passage through time of one's forebears, one's descendants, and oneself. It is the closest we can come to concretizing the intangible experiences which compose the matrices of our lives. It makes us painfully aware of the physical changes in ourselves and others, reminds us of the brevity of our lives. On the familial level, it implies stability and continuity; on the individual level, it increases awareness of the inevitability of death.

When the images in a family album are not just of the private, inarticulate, "You had to be there" variety—when they bring you there instead—then the body of work constructed by their careful accumulation can become a metaphor for the lives of others, a paradigm of the human condition. Gowin's work has begun to function in such a fashion, as his current exhibit at Light indicates. These are recent images, with only a few exceptions made between 1972 and the present. Their mood is mournful, elegiac. Thornton Wilder's *Our Town* comes to mind, because these images lie somewhere between the last glimpses of a dying man and the intensified fragments seen by a ghost allowed to return for a day.

This sense of impending mortality is amplified by a simple device which also has its roots in the snapshot. George Eastman's first snapshot camera—the "you push the button, we do the rest" original—produced circular images on square negatives; millions of snapshots were made in this format. Gowin echoes this aspect of snapshot tradition by working with a lens from a 4 × 5 camera on an 8 × 10 body, which creates the same effect.

But it achieves more than that, for this is not merely a stylistic gimmick. The corners of Gowin's prints are usually black, an encroaching darkness which threatens even the most cheerful image. It creates, psychologically, a form of "tunnel vision," the gradual but inexorable shrinking of peripheral visual perception which accompanies old age and accelerates toward the end—that "dying of the light" against which Dylan Thomas urged his father's rage.

Death is thus omnipresent in Gowin's imagery, more so now than

ever before, and with increasing explicitness. A skinned rabbit, a butchered steer's carcass, the skeleton of a fish, and the corpse of Rennie Booher appear here as emblems. From anyone who has encountered Gowin's work before, the sight of Rennie—who has been seen in a number of his previous images—lying in her coffin may evoke the same pang of personal loss it wrenched from me. I measure Gowin's accomplishment as an artist and as a human being by the extent to which he made me care about an old woman whom I knew only through his photographs.

Julio Mitchel

At first, Julio Mitchel's current exhibit at the Midtown Y Gallery, "Two Wards," appears to consist of separate and unrelated essays. The first of these deals with crowds on New York City streets, while the second explores the texture of life at Goldwater Memorial Hospital, which specializes in chronic diseases.

The street series is the more peculiar of the two, its oddness emanating from a disjunction between form and function. Insofar as its style and format are concerned, this set of three dozen images locates itself within the territory generally referred to as "documentary" photography. That is, on the surface its intent seems to be the presentation of significant new information about a situation external to the photographer.

On that level, however, it rapidly becomes clear that this body of imagery is a self-fulfilling prophecy. Mitchel made these images by standing facing the flow of pedestrian traffic on Fifth Avenue during rush hour. It could not have come as a surprise to him—and should not come as such to us—that the result of confronting a crowd of strangers with a camera in a business district would be imagery reflecting wariness, hostility, and alienation on the part of those photographed.

The use of a wide-angle lens under such circumstances adds an element of grotesque distortion and amplifies the sensation of people streaming past the camera like cattle. And the harsh sharpness of the

NYT, February 24, 1974.

prints, which are not sensually pleasant to look at, intensifies this edginess even further.

But these results are so predictable—and, in terms of "documentary" photography, such old news—that it is obvious their area of concern is not an external but an internal situation. Clearly, they reflect a deep depression on the part of the photographer; he stands among his fellows as anomalous as a blind or legless beggar, and is passed by without notice, without contact, without touch, granted no more identity than the dismembered mannequins in the windows of the shops. It is on this level of the personal and emotional function of the imagery that relationships between Mitchel's two series crystallize.

For the essay ostensibly about hospital life is in fact a statement about touch. To be sure, there are other elements in the microcosm Mitchel describes—loneliness, physical pain, helplessness, and the omnipresence of death—but touch is the central metaphor, recurring in one image after another. Patients touch each other, reach for and are held by doctors and nurses, relate physically to animals and to themselves. It is as though (shades of Thomas Mann's *The Magic Mountain*) sickness were a necessary prerequisite of health.

The physical vulnerability which placed the patients there, Mitchel seems to suggest, generates or gives permission for an emotional vulnerability as well. The contrast between the world outside the hospital, where the physically well cannot find relief from emotional pain, and the world inside the second of Mitchel's "Two Wards," is the photographer's major point. It emerges from neither of these two essays separately; it is created by their combination.

And it is surely more than coincidental that in both "wards" Mitchel's position is that of an outsider. The dominant irony is that the photographer's physical health places him beyond the hospital's parameters of solace, while his psychic pain—manifested in his futile search for communication on Fifth Avenue—makes him an untouchable outside its doors. Whatever autobiographical conclusions one might draw from this evidence, "Two Wards" does demonstrate the need for a more precise term than "documentary" to denote such intensely subjective responses to personal experience as this one.

W. Eugene Smith: "Minamata"

The timely demise of *Life* magazine generated endless predictions of the inevitable disappearance of photojournalism as a mode of communication. In fact, however, the genre has merely entered a transitional stage, and the problem facing its practitioners—not an insoluble one, by any means—involves the fundamental rethinking of direction, styles of presentation, and suitable vehicles for integrated image-text statements.

The publication of "Minamata, Japan," a new essay by W. Eugene Smith, could hardly have occurred at a more opportune time, for Smith has functioned prophetically within photojournalism for the past three decades. His continued insistence on the necessity for committed advocacy as a photojournalistic stance went most unfashionably against the grain of the ostensibly "impartial" reportage of the repressive 1950s; and it was Smith who resigned from *Life* in a battle for the photojournalist's right to retain editorial control over text, captions, cropping, and layout, on the basis that individual moral accountability was the necessary premise for meaningful dialogue.

Smith's contradiction of the credo of "objective" photojournalism was taken to undermine his credibility, particularly when the passage of time generated inevitable revaluations of some of the positions to which Smith had committed himself in his work. And his lonely struggle with *Life* was held to be not merely idealistic but indeed quixotic; thus defined as a form of personal obsession, however laudable, it was considered safely devoid of any moral imperative requiring support from his peers.

As it turned out, Smith was right from a practical as well as an ethical standpoint. By the mid-sixties there were few established photojournalists who enjoyed even a modicum of spokesmanship among the current audience. Generally, they had entirely abandoned—or never joined—the fight for editorial control, retaining only the right to *ex post facto* lamentation over the abuse of their work by others. They had further undercut themselves as responsible full-fledged communicators by excluding writing or any active relationship thereto from their sphere of influence, thus limiting their role to that of salaried

NYT, March 10, 1974.

or freelance image-mongers. And *Life,* along with the other large-circulation glossies, killed itself off by turning photojournalism into a corporate process naturally lacking individuality and guts.

Small wonder, then, that Gene Smith's name is the only one which comes up consistently when members of a new generation of photojournalists are asked to trace the ethical and philosophical foundations of their work. His latest essay, created in collaboration with his wife Aileen, has been several years in the making. Though brief, image-dominated excerpts from it have appeared in *Life* and *Popular Photography,* and though it will be presented in expanded book and exhibit form in the near future, the version of "Minamata, Japan" which appears in the April issue of *Camera 35* merits attention in its own right.

One reason for this is that the magazine's editor, Jim Hughes, has established an important precedent with this issue by turning over twenty-six full pages to Smith and granting him complete control over photographs, layout, and text. I can think of few other journals—and no other photo magazines—which take their responsibilities to their readership and to photography with such seriousness. Another reason is that, as an example of what can be achieved by an articulate photojournalist in full control of his/her work from start to finish, the Minamata essay entirely justifies not only the space devoted to it but the effort expended by Smith over the past two decades to achieve that very control.

However, if publication of this essay merely certified Hughes's courage as an editor and vindicated Smith's professional capabilities, it would be only an historical artifact, a glorious collector's item. Its importance is not just in its demonstration that integrity and impact are interdependent, but in the events it describes and the issues it opens.

Minamata is a farming and fishing village and also, in Smith's words, "a factory town, dominated by Chisso—a chemical company." From 1907 on, Chisso dumped chemical waste into the waters around Minamata. Damage to the ecosystem was recognized as early as 1925. During the 1950s a mysterious, progressive disease spread among the inhabitants of Minamata; it was ultimately recognized as mercury-methyl poisoning, a form of slow death made more gruesome by the fact that mercury "can accumulate in the placenta, even in apparently healthy mothers," and cause the birth of deformed children.

Yet despite evidence of its responsibility, and though the number of victims in this case alone may reach 10,000, the Chisso company took only token safeguards, devoting its full energies instead to legal maneuvers intended to minimize its own culpability. When some of the victims finally organized to sue for compensation, the company tried everything from collusion with government officials to physical violence to break the movement. (Smith himself was beaten during the making of this essay, so severely that permanent damage to his right arm, and to his eyesight, was feared for months.)

The tale seems typical—except that the battle was not only fought but won. In an unprecedented legal decision with international implications, the Japanese court held that even though Chisso had met the minimum legal standards, "the Defendant cannot escape from the liability of negligence." The ramifications of this decision are vast, not merely in the area of ecological pollution but in regard to the larger issue of corporate responsibility to the human community.

Smith was the only Western photojournalist to devote himself full-time to this story. The essay which resulted is dense, as complex as the situation it seeks to unravel and explain; its viewpoint shifts widely, from the personal to the historical. It has its flaws, such as Smith's gratuitous declaration of love for one of the victims. And I certainly question Hughes's decision to use a cover which glorifies Smith at the expense of his message and reduces its potential audience drastically.

But the essay provides information, understandings, and warnings with clarity and power. It seeks to be, and succeeds in becoming, not a product but a process, a tool for change. As such it challenges photojournalists to redefine themselves as moral and political forces in a world which is shaped in part by photojournalism's description of it.

Michael Martone: *Dark Light*

The title of Michael Martone's first book, *Dark Light* (Lustrum Press, 1974), contains multiple meanings. Polarity, for one; opposition and tension. Chiaroscuro also, "pictorial representation in terms of light and shade," the basis of the photographer's craft. And a specific mood or quality of light—brooding, ominous—is suggested as well. It is the latter implication which is emphasized in the book's only text, a

fragmentary prelude: "It needed in the first instance / a bright light
to expose / and a dark light to expose . . ." The images themselves,
full of a deep and luminous blackness, amplify that sense of fore-
boding.

In their consistency of style, these photographs represent a dramatic
shift in Martone's work. His exhibitions in New York over the past
five years have consisted entirely of unique prints, one-of-a-kind works
created through extensive chemical manipulation of the print and/or
the use of unusual surfaces such as textured plastics as the vehicles
for imagery. By contrast, the photographs in *Dark Light* are straight,
unmanipulated, and stylistically uniform. They are also deliberately
sequential, another departure from Martone's previous work and one
no doubt generated by book form as a mode of presentation.

The first section of the book is constructed as a narrative. It opens
with an image of a violin case in a corner, suggesting some mute,
trapped voice. From there the camera, as protagonist, moves down a
staircase toward a mirror, but the image is made before its maker is
reflected therein. Then, as if at the bottom of the stairs, we see a
stereotype of marital bliss—a ceramic bride and groom from a wedding
cake, photographed from behind, seemingly about to pass from light
into a blackness which is their own shadow. The next image takes us
within that blackness. The bride has turned around; her face, covered
with white make-up, is mask-like, grim, forbidding.

The pairing of a stained brassiere display with a rigid nude on the
next two pages seems to speak of a disparity between fantasy and
reality, evoking a sexual coldness which is perhaps linked to the iconic
child who appears in duplicate in the following picture. Facing this
child, as if symbolizing a revelation, is a lamp. We are looking up
under its shade. The bulb is obviously on. The image, paradoxically,
is dark.

We return to the nude woman, who has turned to face the wall,
hiding her eyes from the light. She is juxtaposed to a moribund potted
plant. Subsequently, she turns, hands over her eyes. Two light bulbs
confront her, and she departs. Now, for the first time, we see the
protagonist, represented by a delicately carved wooden doll's head.
He sits on a window sill, in a spatial construct whose odd angularity
recalls de Chirico.

His expression is despairing, his eyes are rolled back in his head.

The implications are suicidal. The unfulfilled hungers at the root of this despair are summarized in the next image by three scrawny, glistening, almost turd-like dried fish in the bottom of a pan. Across the page from them we are shown a light bulb. It is naked. It is not on.

So far as I can tell, the narrative section ends here. It is followed by a suite of images which sometimes function singly, sometimes are joined in pairs, and occasionally are clustered in larger groups. They appear to be fragments of dreams, nightmares, and memories brought together by free association as a means of amplifying the themes of the first section.

For example, the sense of trappedness evoked by the very first image in the book is extended in one of these clusters. Two photographs— one of nineteenth-century flowerprints caught behind glass in a shop window, the other of a caged heap of turtles—indicate the imprisonment of living things other than the photographer. The following pair speaks of his own spiritual incarceration through the symbols of impenetrable, sharp-pointed metal bars and a threatening, mythic, two-headed black guard dog.

In a grouping centered around experiences of childhood, the macabre apparition of a row of different-sized but otherwise identical dolls' heads precedes a study of a photo-restorer's window display. The inevitable fictionality of this restorer's "translation" of a photograph of a woman and child is emblematic of the ultimate futility of trying to preserve a relationship with photographic images; even the ethnic identity of the subjects has eroded somewhere between "before" and "after."

From there we move to an image of an older child: a sculpture of a neatly dressed boy sitting on a stool, apparently an advertising device for the adjacent shoe store. His eyes are closed; his hands rest on a book as if he were reading Braille. The image conjures up that peculiar helplessness, that sense of being acted upon, that children experience in shoe stores. (Is that just my childhood, or everyone's?) And then the photographer studies his own foot, lying in the sand, encased in a tattered, dirty sneaker . . .

These are not cheerful photographs. They are direct and specific metaphors for what would seem to be a profound and prolonged suffering which encompasses impotence, fear, deprivation, and loss. Their power resides in the preciseness with which they describe not

merely what the eye has seen but what their maker has experienced. Devoid of emotional obscurantism, self-evidently autobiographical, they bespeak a painful vulnerability; yet, in doing so, they gain an eloquence whose foundation is honesty.

The final three images seem intended to indicate that, given such openness, "perseverance furthers," to borrow a phrase from the *I Ching*. In the first of these, the once-despairing male doll's head, now less distraught and somewhat resigned, has sprouted a flower in a Chaplinesque gesture. The penultimate picture shows a camera, the author's instrument, lying on its back in harsh sunlight. And then, miraculously, in the last image we seem to enter the camera. The bright light is without; the dark light is within.

New Japanese Photography

Much as I might wish it were otherwise, in considering the Museum of Modern Art's latest photography exhibit and catalogue, *New Japanese Photography*, it proves impossible to discuss the photographs themselves without simultaneously analyzing the show and book.

These latter two are, essentially, samplers. Of the fifteen photographers showcased therein, only two are given enough space to allow the evolution of their work to be traced clearly. (These are Shomei Tomatsu, with thirty-nine prints, and the younger Daidoh Moriyama with twenty-six.) The rest are restricted to roughly a dozen images each, the merest tips of their respective icebergs, especially since many of these photographers work with serial imagery. The development, structure, and thematic concerns of these separate bodies of work must be inferred from these fragments selected by others. Inasmuch as those selections limit and shape our inferences, they become inseparable from the work; the degree to which this is true is amplified drastically when the inferences also include correlations between different image-makers and even larger generic considerations.

For example: New Japanese photography is exclusively black and white, entirely unconcerned with the investigation of straight color, manipulated color, applied color, and the technology of modern color-press printing. New Japanese photography is only glancingly involved

NYT, April 7, 1974.

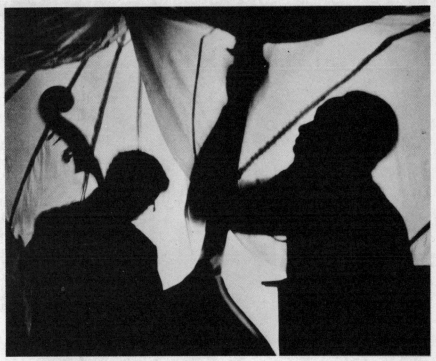

Beuford Smith, "Musicians #II"
Beuford Smith/Césaire Photos

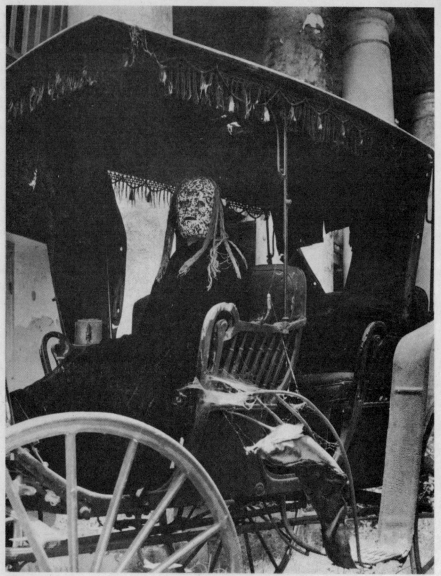

Clarence John Laughlin, "The Disease of Pride, 1949"

From *Group I: Satires*

"The model here is wearing a special mask made for this picture—and photo is one of several made to deal with certain psychological conditions in the South which helped to make the Civil War inevitable. The coupling of the figure and the background is for the purpose of conveying the concept that the stiff-necked pride which made it impossible for the Southern leaders to realize that social change *had* to occur—became, finally, like a disease . . ." (C.J.L.). 1949 © C. J. Laughlin

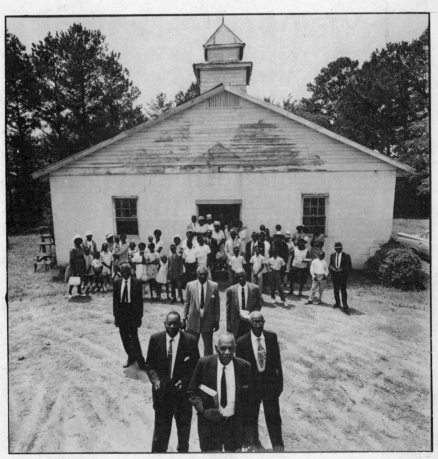

Bob Adelman, "Baptist Church, Camden, 1970"
From *Down Home*

Wright Morris, untitled

Ralph Gibson
From *The Somnambulist*

Charles Gatewood
From *Sidetripping*

Michael Abramson, "Rally in support
of prison rebellions, September, 1970"
From *Palante*

Edward Ruscha, "Texaco, Vega, Texas"
From 26 *Gasoline Stations*

Harvey (Hank) Stromberg, "Placing photo of brick in M.O.M.A. Sculpture Garden"

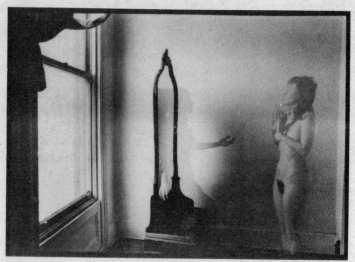

Duane Michals, "Persona"

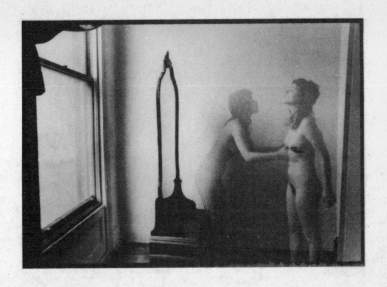

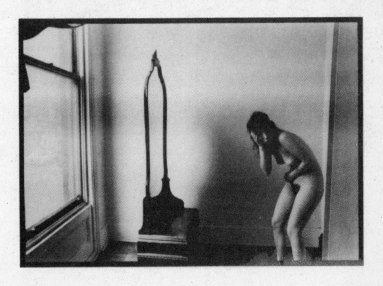

Geoff Winningham, "Tag team action"
From *Friday Night in the Coliseum*

Larry Clark, "First Hit"
From *Tulsa*

Emmet Gowin, "Edith, Danville, Virginia, 1971"

Abigail Heyman
From *Growing Up Female*

Robert D'Alessandro, untitled

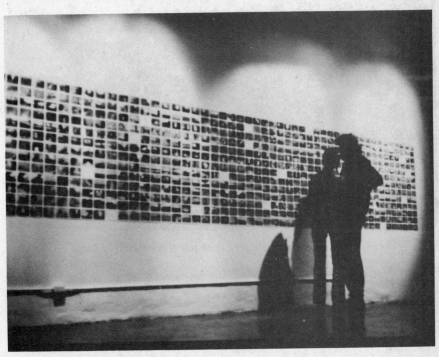

Bernadette Mayer, installation of "Memory"

Robert Delford Brown, "Self-portrait of Joseph Cornell"

Paul Diamond, "Irma, 1971, Brooklyn"

Julio Mitchel
From "Two Wards"

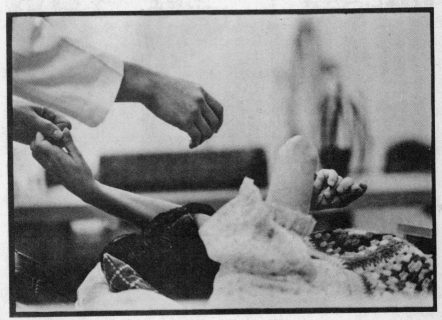

Julio Mitchel
From "Two Wards"

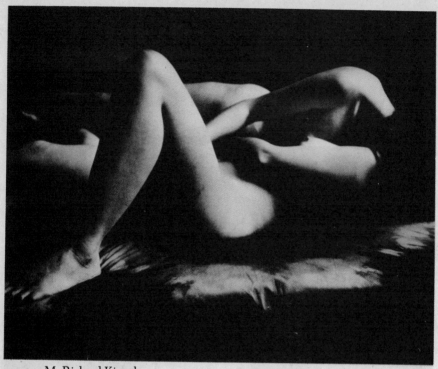

M. Richard Kirstel
From Sequence II, *Pas de Deux*

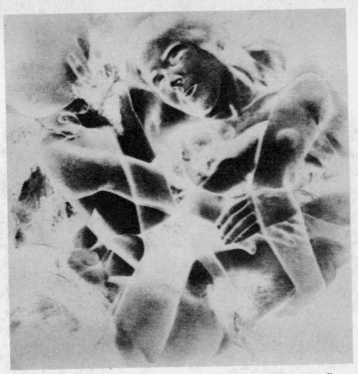

Robert Heinecken, "Erogenous Zone System Exercise #3, 1970"

Lucas Samaras, "Photo-Transformation 7/15/76"

Michael Martone, "Untitled, 1972"
From *Dark Light*

W. Eugene Smith, "Tomoko in her bath"
From *Minamata;* courtesy of the Witkin Gallery

Roy DeCarava, "Two Women, Mannequin's Hand"

Manuel Alvarez Bravo, "Striking Worker, Assassinated," 1934
Courtesy of the Witkin Gallery

Manuel Alvarez Bravo, "The Dreamer, Mexico," 1931
Courtesy of the Witkin Gallery

Danny Seymour
From *A Loud Song*

Jerry N. Uelsmann, "Forgotten Heritage," 1969.

Leslie Krims, "Aerosol Fiction, 1969".
One of the photographs involved in the kidnapping incident reported on p. 58.

with the nude and with the explicitly erotic; it is rarely concerned with any exploration of the staged event. Multiple imagery, mixed-media imagery, collage, and other photographic techniques are not a part of new Japanese photography. Though it sometimes refers, quite painfully, to World War II and the atomic holocaust, new Japanese photography is never anti-Western and certainly never directly political in intent. New Japanese photography is restricted almost exclusively to the boundaries of that territory we loosely label "documentary." Moreover, by remarkable coincidence, New Japanese photography looks almost exactly like the photography which has been exhibited at the Museum of Modern Art for the past ten years.

All these, I believe, are logical inferences drawn from the exhibit and its accompanying catalogue. All these are also inaccurate at best and in most cases entirely false. This would be immediately apparent to anyone even superficially familiar with the Japanese magazines and photography annuals, the books which come from Japan, and the portfolios by Japanese photographers which have been published in European and American magazines. But this material has not been disseminated widely even among American photographers, much less among the general public. Thus it may not be easily visible at first glance that this show has been cut along the specific bias of a severely tailored curatorial aesthetic.

Just where the show's co-editor, Shoji Yamagichi of *Camera Mainichi*, a Japanese photography magazine, stands in this progression is hard to say. His introduction is at least less pontifical than that of John Szarkowski, MOMA's curator, and raises one significant difference between Japanese and American photography. For a variety of reasons (primarily a lack of museum/collector interest in original photographic prints and a shortage of private darkrooms), Japanese photographers have gravitated to book form as their main mode of presentation. This has affected their work in several ways. Inevitably, it has directed them toward serial imagery and/or essay form. It has also generated a conceptualization of the original print as an intermediary stage, with a resulting interest in printing (i.e., mechanical reproduction) as a full step in the process of creating imagery.

Unfortunately, that is not clarified by this show. Nor is the intriguing fact that while occidental photographers (and Western artists in general) tend toward monogamy in their relationship to per-

sonal style, Japanese photographers appear to feel free to change styles drastically, not only from essay to essay but often within a single piece of work.

But that's another discussion in itself. What we really have in this show is an anthology of post-war Japanese documentary/straight photography. It begins with part of a series by Ken Domon which combines the landscape with carefully studied details of religious statuary in a classical style reminiscent of Edward Weston and Paul Strand. This is followed by selections from another essay completed in the middle 1950s, Yasuhiro Ishimoto's "Katsura," studies of stepping-stones in a palace in Kyoto. These images work in two ways: as records of architectural details emblematic of their culture's stress on harmony and surprise, and also as independent equivalents.

Shomei Tomatsu is the central figure in the show, and for good reason: he seems to have functioned in Japanese photography as a vortex into which most of the major shaping forces of international post-war documentary/straight photography were sucked and out of which were flung the seeds of a uniquely Japanese photographic tradition. In his work from the late fifties and early sixties one can detect the influence of Minor White and Cartier-Bresson, but what he took from them—the contemplative construct from the former, the attention to flow of the latter—was relevant to his own culture and seems to have led naturally to the gestural-drawing quality of the "Oh Shinjuku!" series and other works. Certainly, too, his shift from traditional to contemporary Japanese culture, his direct confrontation of The Bomb as a subject, and his repeated reference to the American presence in Japan must have been vastly liberating to his contemporaries and to those who came after.

His effect can certainly be seen throughout the rest of the show, though of the remaining photographers those who are best served are those who are represented by extensive selections from single bodies of work. Kikuji Kawada's "The Map" is a poignant suite of metaphors for the war, which is also referred to in images by Tetsuya Ichimura and Hiromi Tsuchida, but the portfolios of the latter two are so diversified as to be less than illuminating. The same, unfortunately, holds true for Daidoh Moriyama's segment, even though it is double the length. And the selection of Eikoh Hosoe's prints hints at his scope but does not sufficiently probe his involvement with myth-making.

A sizable enough segment of Masatoshi Naitoh's horrific "Hags Burst Out!" is presented to render its nightmarish quality. Ken Ohara's *One*—some 500 close-up studies of faces, identical in size and technique—could hardly be adequately shown, but is available at the museum's bookstore. (Recommended, too, though with a caveat; after fifty pages, you realize you can't tell what sex people are from their features.) Ohara and Shigeru Tamura (who photographed a landscape from a fixed vantage point over a year's time) are working in an area which overlaps conceptual art, but are using photography more pertinently and intelligently than most within those purviews.

I cannot conclude without taking exception to a statement of Szarkowski's in his introduction to the catalogue. In pooh-poohing a concern with photography as a language, he writes, "To speak of it as a language is to ignore the fact that its meanings (unlike those of Greek, or algebra, for example) cannot be translated with any acceptable degree of precision into other languages." That is specious. Translatability is not intrinsic to the definition of language.

Paul Diamond

The current exhibit by Paul Diamond at the Floating Foundation of Photography consists almost entirely of photographs whose source of energy is the conscious interaction between the photographer and his human subjects. They are, all but three of them, images involving people, people who are obviously aware of being photographed. Excepting some crowd scenes and group images, the images have been made at distances ranging from "intimate" (18 inches or less) through "personal" (1½ to 4 feet) to the close phase of "social" distance (4 to 7 feet).

These terms are from anthropologist Edward Hall's *The Hidden Dimension*, a study of spatial relationships in modern society. Within this range, according to Hall, the presence of another person cannot be ignored. Diamond's prints are sixteen inches square, excluding the vertical borders, and the heads of his subjects often fill the frame. This, in combination with the FFP's narrow passageways, forces

the viewer into an eyeball-to-eyeball confrontation with Diamond's subjects.

It is discomfiting to be thrust that close to strangers, especially strangers as strange as those Diamond presents. They pop out at you from blackness in abrupt clarity, rather like funhouse phantoms or members of a Grand Guignol troupe. One man holds a sharp, gleaming dagger in front of his face. Another, an Oriental, crouches in a kung fu stance. A third—Lee Witkin, as it happens—presses his nose against the window of a Chinese restaurant. Double exposure twists one face into a snarling grotesque, and the head of a woman wearing a look of bland, benign idiocy floats against a window.

This is a theatrical mode of presentation, and though the images are not sequenced the exhibit is a series of dramatic (and often melodramatic) events staged by the photographer, not merely described. Whereas Lee Friedlander employs strobe light as a graphic device in his party pictures to wash out detail and two-dimensionalize human figures and faces, Diamond uses it to pull faces and figures out of the surrounding blackness and create a three-dimensional illusion by retaining enough detail so that even in the lightest sections of the images you can count the subject's pores.

There are similarities in technique here to the work of Diane Arbus, though Diamond's intent (and sensibility) are far from hers. His imagery has to do with fantasy, caricature, and spectacle. His manner is directorial and aggressive; his humor is broad but decidedly black.

Abigail Heyman and Imogen Cunningham

One of many ideas which underwent modification to the point of metamorphosis during Susan Sontag's recent tripartite skirmish with photography in the *New York Review of Books* was her startling announcement that, "Strictly speaking, it is doubtful that a photograph can help us to understand anything." Sontag's reconsideration of this stance was implicit in her subsequent evaluations of the politics and ethics of various modes of photographic image-making. "All possibility of understanding," as she pointed out, "is rooted in the ability to

say no," and once she began saying no to numerous bodies of photo-graphic work some stringent revision became necessary.

Had Sontag not drastically altered that position, a book such as Abigail Heyman's *Growing Up Female: A Personal Photojournal* (Holt, Rinehart and Winston, 1974) would have been an easy and effective counter-argument. *Growing Up Female* is a coherent essay composed of precise, articulate images. It is accompanied by a text which adds a specifically autobiographical undercurrent; its presenta-tion in hand-lettered form personalizes the words. But, having seen a large selection of these images before their publication in book form, I can attest that the photographs' communicative effectiveness is inde-pendent of the writing. These images embody ideas, and the best way to approach them is perhaps to examine some of those ideas and agree or disagree with the understandings they convey.

Heyman is a self-professed "feminist" who says of herself, "I looked at people and events long before I owned a camera, more as a silent observer than a participant, sensing this was a woman's place. It is no longer my place as a woman, but it remains my style as a photogra-pher." The last unresolved dichotomy notwithstanding, both Hey-man's feminism and her reserve can be clearly discerned in her pho-tographs. Her feminism pervades the intensely subjective world she creates, a world in which men generally treat women badly—at best as possessions, at worst as meat—but in which women never mistreat each other or men. Her "silent observer" posture is apparent from the infrequency with which she comes physically close to her subjects or engages with them transactionally. As a rule, she maintains a social distance between herself and those she photographs. (My use of the term "social distance" is intended proxemically, to indicate a range from four to twelve feet, not socio-economically.)

The book's first two images are of a dressed-alike mother and daughter and of a young bridesmaid nervously gnawing the strap of her purse. They are about childhood experiences of tradition, role, and ritual in relation to gender. The closing image is of a woman seated on the low wall against which her bike is propped, looking out to sea; it metaphorizes individuation and search. The images in be-tween are recognitions along the path which Heyman sees as linking them.

The eighth image in the book, for example, is a head and shoulders

portrait of a young girl. Apparently she is a Native American, for she wears a beaded headpiece and hair decorations and several necklaces. This is ceremonial jewelry, intended to idealize and beautify her. The metal decorations on her teeth seem part and parcel of this outfit; it takes a moment to realize that those metal decorations are orthodontic braces, our own primitive culture's ritual artifacts for making maidens more attractive.

Further on there is a photograph of a man and woman sitting facing each other but yards apart on a porch. Some profound alienation seems implicit, some deep inability to make contact. Yet in fact there is not a shred of evidence to indicate that these people even know each other. The presumption of meaning is contextually derived, not implicit. The same holds true for a beach image which shows two women, fully dressed except for their shoes, standing at the water's edge while five men disport themselves in the water. (Perhaps it's my own naiveté, but I know of no cultural dictum which prohibits women from swimming in the ocean.)

One of the book's grimmer images—autobiographical, as the camera's viewpoint makes clear—shows the featureless, impersonal form of a gauze-masked doctor standing behind the V of a woman's spread legs. With a pair of forceps he holds something unidentifiable; traces of liquid glisten on her upper thighs. The caption reads, "Nothing ever made me feel more like a sex object than going through an abortion alone." This does not quite jibe with statements elsewhere in the book about taking full responsibility for one's body and one's actions, and seems to cast the physician as the villain in the image, which makes little sense even though he is male.

The sexism rampant in the medical profession is symbolized lucidly in a later photograph showing four small boys and two girls dressed in what appear to be official hospital uniforms: the boys are equipped as doctors, while the girls are garbed as nurses. Heyman's point there is concisely made and inarguable. But would the experience of the abortion have been significantly improved had the operating physician been a featureless, impersonal, gauze-masked woman instead?

Another image with which I find myself quarrelling shows a man eating alone at a table in the background while a woman in the foreground holds and plays with three young children. The setting is a

living room. The theme, once again, is alienation. Assuming, as Heyman intends us to, that these people are a nuclear family, the picture directs our sympathies toward the mother and her children. It is they who are placed in the foreground, relating to each other, touching and holding; it is the father (who might in truth be the uncle, or the brother-in-law) who sits isolated and remote in the background, relating to one one, touching and holding no one, feeding his face.

By its structure, this image is intended to convey that specific understanding, and does so effectively. The understanding, however, is shallow and unsatisfying, for it includes no channel of sympathy for a man who goes out and does whatever work his society requires of him in order to provide his family with the wall-to-wall carpeting on which they romp, whose job apparently brings him home past normal dinner time, and who is not thereupon surrounded by his wife and children but excluded from the circle of their warmth and left to eat by himself like a servant.

That is an equally viable interpretation of the situation, though certainly not one to which Heyman's image directs the viewer. There is much in this book that is oversimplified, polemical, propagandistic. There is also much that is intelligent, illuminating, and pertinent. Heyman is a highly accomplished photographer, even if the clarity of the thinking does not always match the clarity of the image-making.

Just how personal Heyman's vision is can be gauged by the contrast between her book and *Imogen! Imogen Cunningham: Photographs 1910–1973* (University of Washington Press, 1974). This quirky, provocative retrospective monograph, containing "rediscovered" images by someone who also grew up female, chronicles more than six decades of professional and creative activity by a photographer who scandalized Seattle with a series of nude studies of her husband back in 1915 and hasn't stopped making waves—or images—since. In addition to a private life involving family and children, Cunningham has made important contributions in the areas of portraiture and still life (among others) and today, in her nineties, continues to teach, make images, exhibit, and publish. That, apparently, is what she sensed was a woman's place.

"From Today, Painting Is Dead": A Requiem

Sometime within the last five years, photography devoured the art world.

The precise date on which this consummation began is difficult to determine, dependent as it is on variable interpretations of history. Some would trace it back centuries, to the development of the *camera obscura,* that sketching device which is the optical forebear of the camera as we know it. Others would pinpoint it at that decade in the mid-nineteenth century during which the various devices and processes which we call "photography" first coalesced.

Certainly, no one would deny that it was under way by the late nineteenth century, for two direct manifestations of its presence can be discerned by then. The first of these is the dissemination through photographs of art works in various media: architecture, painting, sculpture, graphics, and more. Up until the invention of photography, art history and art criticism were forms of imaginative fiction—analytical and even morphological evaluations of works which most members of the audience and many of the historians and critics themselves had never experienced directly. (Typically, Michaelangelo's *David* would be discussed extensively on the basis of a professional engraver's interpretation of a draftsman's copy of an artist's freehand sketch of the sculpture . . .) By providing a more reasonable facsimile thereof, the photograph became—and remains today—the form in which most people encounter works of art.

Not only did the photograph shape our critical and historical understanding of art, it also began to directly shape the art itself. Increasing numbers of artists began to employ photographs for a variety of purposes: as *aides-mémoires,* as anatomical reference works (i.e., Muybridge's *Animal Locomotion*), and as direct sources of inspiration and imagery. (This has been thoroughly documented by Van Deren Coke in his source-book *The Painter and the Photograph.*) Thus, the tradition of painting from the photograph extends back at least 100 years.

Inevitably, too, the photograph began to find its way into the works of art themselves. Beginning with Dada collages and Bauhaus graph-

Camera 35, July 1974.

ics, the photographic image was incorporated into the making of art works to such an extent that there are now many major bodies of individual creative accomplishment that cannot be considered in depth without attention to their photographic elements. Those of Romare Bearden and Robert Rauschenberg come to mind, though only as examples.

But those works, however photographic their origins, were not exactly *photographs*. They couldn't afford to be. The photograph, after all, has historically been treated as the bastard stepchild of high art, an image-making process whose mechanistic origin rendered it aesthetically suspect and whose reproducibility left it financially worthless. Art had for so long been tied to the concept of the precious object that any definition of art which included the photograph *per se* was threateningly revolutionary. Such a definition would reverse all the priorities: process would take precedence over product, image over object, duplicability over rarity. Goodbye the Bugatti.

By the mid-1960s, though, the definitions had begun to change anyhow. A number of radical theorists began to emulsify the art community and blur the boundary lines between categories. For instance, sculptors operating from a reductivist definition of their medium as the "volumetric articulation of space" began to dig trenches in the desert and otherwise modify the landscape. They documented their work *in situ* with photographs, which were subsequently shown in museums and galleries.

Other, less categorizable workers—who might previously have termed themselves dancers or poets or actors—came to define artistic activity more broadly as "extraordinary behavior." They involved themselves in various sorts of unusual performances—happenings, street pieces, and other events of a transient nature. These they preserved for posterity with photographs. And still others, taking their cue from Marcel Duchamp perhaps, came to think of art as life and dedicated themselves to the presentation of autobiographical information. Inevitably, various forms of photographic imagery, from the snapshot through the formal studio portrait, began to appear in their work.

So by 1970 it was no longer uncommon to come across photographs in an art gallery, though the art world still hung on to its distinctions. In a representative maneuver, for example, the art critic for the *Vil-*

lage Voice, John Perrault, declared that not all photographs were photography; some (those by people he certified to be artists) were Art. In the meantime, during the late 1960s photography as a medium in itself had developed a much-widened museum/gallery circuit and a vastly expanded audience. It had come to be at least marginally accepted as a legitimate art form, and a collectible one at that. A market began to emerge. There was gold in them thar silver hills.

And, all of a sudden, when you opened your paper to the art pages, there was photography all over the map. The photograph as document of "earthwork," "conceptual piece," or "event." The photograph as an element in works by Warhol, Kitaj, and divers others. Even, wonder of wonders, the photograph as an art object in itself. Such major New York City museums and art galleries as the Whitney, O. K. Harris, Hundred Acres, and Sonnabend were exhibiting photographs by Lucas Samaras, August Sander, Lewis Baltz, and Cecil Beaton. They were holding shows of such genres as group portraiture and nineteenth-century European landscape photography. One reputable art gallery even presented a sampling of the same snapshot-dominated "social landscape" photography which had preceded and engendered the hottest new school of painting: Photo-Realism.

Though it often goes under a different name, or at least a different prefix—Super-Realism, New Realism, Sharp-Focus Realism—this school represents the completion of a historical cycle within which painting, having been freed from the representational imperative by the advent of the photograph, has returned to the photographic image for sustenance. The irony of this bemused me considerably when I saw my first Photo-Realist paintings (though the term was not then in use) in an exhibit at the Riverside Museum sometime around the beginning of this decade.

Equally intriguing was the startling shift in the art world's stance concerning the link between painting and photography. This alteration of "party line" was as earth-shattering within its own microcosm as, say, the Stalin-Hitler pact had been to the Old Left. From the very beginning of photography, the art world had considered the act of painting from photographs as something shameful, to be committed furtively and admitted only under duress. Now, in a dramatic reversal, painters were openly confessing their involvement with the photographic image and making it explicit in their works. A number

were scurrying around trying to establish priority—i.e., who had been fashionably unfashionable first. And the critics and historians, who had consistently disregarded or discounted the significance of the involvement of major painters with the photographic image, were falling all over each other to drag out every precedent from Charles Sheeler to Thomas Eakins.

The rapidity with which the art world bedecked this former skeleton in its closet with the raiments of aesthetic respectability quite took my breath away. It was in this state of amazed hyper-ventilation that I went to view an exhibit which sought to epitomize the current state of the art, "Photo-Realism 1973: The Stuart M. Speiser Collection," at the Louis K. Meisel Gallery in New York City last October.

This collection was assembled by Meisel, one of the foremost Photo-Realist dealers, for Speiser, an aviation attorney and airplane pilot who collects things aeronautical. The twenty-two paintings, all but one in oils, were commissioned and purchased in advance, with the artists receiving "more than they were ever paid before," according to Meisel. The only catch was that every painting had to relate in some way to aviation.

That requirement, however, was apparently presented and interpreted quite loosely. The references range from the wooden toy airplane in Richard McLean's canvas and the sign reading "Fly TWA" in Noel Mahaffey's to actual images of real airplanes. Still, the collection is coherent and thus instructive in several ways, for it functions as a paradigm of the Photo-Realist movement. Brought together here are "major works" (a "major work," according to Meisel, "means oil on canvas") by many of the leading Photo-Realists (with a few notable exceptions, particularly Chuck Close and Joseph Raffael), all created during the same period and all centering around a common theme.

It is, of course, quite an experience to enter a room full of what appear at first to be gigantic enlargements of color snapshots. (Jerry Ott's is the biggest in the bunch, measuring in at 78 x 96 inches.) And, once that shock wears off and one recalls that these are, after all, fake photographs, it is interesting for a while to compare the various ways in which their makers have elected to forge the photographic illusion. The differences between tonal palettes—Arne Besser's cool, Audrey Flack's vibrant; the variations in approach to surface, from

Ott's almost textureless airbrush style to the heavier pigment layering of Richard Estes . . .

But these choices have more to do with craft than art. I wanted to know what creative elements differentiated these paintings from large photographic blowups of the images from which they were copied. One of the painters represented in the exhibit, Ralph Goings, happened to be in the gallery at the time. Goings had been described to me by Meisel as "one of the top three Photo-Realists," and though this raised the issue of who the other two were, I decided to pose my question to him. Goings' considered reply was, "The main difference is canvas and oil."

Well, now. If the images are virtually identical, then any difference must reside in their nature as objects. And as there is no innate reason why one should value an object in oils over an object in silver or aniline dyes, that difference must be extrinsic. It was summed up concisely by Meisel, who said simply, "The painting has more respect."

Within the context of Photo-Realism, however, that respect is not based on any of those qualities we normally associate with creativity: interpretation, selectivity, intellectual originality, emotional force. These, in fact, are rejected by the movement. According to Laurence Dreiband, "The photograph helps equalize the surface and objectify reality. It has to do with a common desire to avoid interpretations about the relative value of the things depicted." Thomas Albright is even more specific: "According to New Realist doctrine, the basic function of the camera is to put emotional distance between the artist and his work, and unselectively record visual 'information' which can then be translated more or less mechanically into paint on canvas."

Curiously, though, there are a great many paintings which fit this definition precisely but are not even considered as precedents, much less as legitimate Photo-Realist works. Countless individuals and mail-order houses make oil paintings from photographic portraits, and have done so for decades. Billboard painters, using a grid system closely akin to that of Close, Malcolm Morley, and other Realists, have long been creating even larger blowups of photographs in oil.

None of those were acceptable to either Meisel or Goings as analogs to Photo-Realism, because the makers were not "serious artists." In other words, the imitation of a photographic image in oils is a sig-

nificant creative act, but only when performed by someone who has been certified as an artist.

Here we approach the crux of the matter. Photo-Realism obviously seeks to re-establish the primacy of handmade objects in an art world grown increasingly event- and image-oriented. This in itself is not without legitimacy. I do not argue against the sometime necessity of embodying a creative statement in a one-of-a-kind object. But, in its homage to the painter's "more or less mechanical" translation of a photograph into a painting, Photo-Realism equates craft with art. It venerates the painter not as a creator or image-maker, but as a crafts-man whose manufacture of an oil version of an extant image is val-orized in itself. This display of mere craft competence is also held to imbue the oil version with a preciousness which is overtly aesthetic but covertly financial.

That a capitalistic impulse is at the core of this object-fetishism should by now be clear. Photo-Realism is emblematic of the jealously guarded power of "serious artists" to convert a financially valueless image into a financially valuable object. The distinction between the photograph and the painting which Photo-Realism promulgates is grounded in a reactionary, antiquated elitism which holds that the painting's uniqueness as an object and consequent monetary value make it aesthetically superior to a photograph. Conversely, photogra-phy is an inherently democratic medium whose images can be so ex-actly repeatable as to have relatively minimal financial value. Conse-quently, as a means of creative expression photography emphasizes image over object, process over product.

Since photography is currently dominating the art world and threatening many of the premises underlying contemporary paint-ing, it is natural that painters would unconsciously seek some sort of alliance with this new source of power. All that they can bring to such an alliance, however, is their ability to legitimize the photo-graphic image as Art among the collectors of precious objects. Thus Photo-Realism is predicated on perpetuating the ignorance of those who won't buy a photograph at any price or even consider it seri-ously, because it's "not art," but will pick up the vastly inflated tab for a painted copy of the same image because the manual labor of a certified "serious artist" is contained therein.

In fact, then, Photo-Realism, as a formal movement, can be seen as

a last-ditch attempt by the painting establishment and its merchandisers to co-opt the photograph as a precious-object prototype, rather than to treat it as a precious object in its own right or, even more appropriately, as an image and an idea—duplicable, inexpensive, and thus free of the corrupting allegiance between artistic activity and wealthy patronage.

Many people have thought that Paul Delaroche was wrong when he declared in 1839, after seeing an early daguerreotype, "From today, painting is dead." But, if Photo-Realism is any indicator, it appears he may simply have been off by a century and a quarter.

Art Critics: Our Weakest Link

One of the most serious shortcomings of art criticism during the past century has been its continuing failure to engage meaningfully with the most diversified and revolutionary image-making medium to evolve during that period. The art establishment's initial reaction to photography blended equal parts of hysteria and disdain, which gradually mellowed into a casual but virtually total disregard. Inevitably, this led to an ignorance so widespread and profound that there is hardly an art critic today competent to discuss photography as a branch of print-making, much less as a creative graphic medium with a unique and distinctive field of ideas.

Understandably, such ignorance proves embarrassing at this juncture. Art criticism itself is heavily dependent on the photographic image, since many critics (and much of the art audience) experience painting and sculpture not in the flesh, so to speak, but through its photographic representation. Painters have drawn heavily on photographic imagery from the very inception of the photographic medium, a long-suppressed though now much-touted fact. Photography has increasingly been woven into the fabric of twentieth-century art of all sorts, beginning with Dadaist and surrealist collages and continuing through the current work of Warhol, Rauschenberg, and a host of others. And, of course, a great many contemporary artists' creations—performances, conceptual pieces, earthworks, and the like—live on only in the form of photographs.

NYT, October 6, 1974.

If this ignorance affected no one but the art critics themselves, it would be only regrettable. Critics, however, are part of an informational circuit on which the evolutionary process of art is based. As a group, the critics in any given field inform the audience what the artists are up to, serve as a sounding board for the artists, and inform the artists themselves as to what their often widely dispersed co-workers are about. In such a circuit, ignorance begets ignorance. The lack of knowledgeability of the art critics in regard to photography does not stop with them; it is transmitted to both the audience and the artists. Such a situation is not merely regrettable, but damaging to all concerned.

For example, one direct result is the recent spate of veneration of Paul Strand, Ansel Adams, and Edward Weston by art critics around the nation, in conjunction with the appearance of an assortment of monographs and retrospectives. These three appear to be the photographers with whose work art critics feel most comfortable. The reasons for this are not entirely clear to me (though all three do share a devotion to the original print as a precious object). Insofar as ideation is concerned, however, their contributions to their medium were concluded decades ago.

There has been no change and little growth in Strand's image-making since the original publication of *The Mexican Portfolio* in 1933, and his continued romanticization of the noble peasant seems increasingly mawkish and patronizing.

Adams provided photography with an invaluable codification of craft principles (now largely outdated, according to a number of teachers), helped establish and maintain much-needed craft standards for photography as a form of print-making, and built up a body of work important in its description of America's Western parklands; but there has been little creative risk-taking in his photography as a whole, and a scarcity of original ideas and provocative theories in his published writings. (Wynn Bullock's inquiries into the photograph as a space-time matrix and Minor White's investigations of sequential imagery and the reading of photographs have a lot more philosophical heft to them.)

Edward Weston, of course, is fifteen years dead, and his work is a decreasingly active influence on young photographers even in his home territory, as several recent regional exhibits on the West Coast

have demonstrated. The "purism" he advocated is creatively inhibit-
ing and so closely linked to a particular subject matter, style, and
camera format as to negate large segments of the photographic vocab-
ulary and eliminate broad areas of experience from the photogra-
pher's imagistic concerns.

Weston's approach inherently restricts itself (as is apparent from
his own body of work) to formal portraiture, landscape, still life, and
the nude—the traditional subject matter of painting, it should be
noted. Within those tight parameters, he created a major *œuvre,* big
enough that its limitations are not immediately apparent nor finally
self-defeating. Yet, though his body of work is, for me, more resonant
by far than those of Strand or Adams, it is my belief that he will
eventually be seen as an awesome, monumental boulder in the path
of the evolution of photography in the twentieth century. For the
theory which accompanied his work is both a summation and a source
of the central misunderstanding of photographic communication: the
confusion between the being, object, or event in front of the lens and
the image which is made thereof.

These are not one and the same thing. The photograph is its
maker's subjective description of his/her experience, in silver particles
on paper. It is not, as Weston would have it, the "essential form" of
"the thing itself." To insist otherwise is to demand a leap of faith,
rather than to state a demonstrable fact. (There is an image by Todd
Walker which sums this up neatly. It is a silkscreen of a photograph
of a leaf, over which are superimposed these words: "A photograph of
a leaf is not the leaf. It may not be a photograph.")

As it happens, the illusionism of photography is seductive enough
that we are generally willing to ignore this crucial distinction and
make that leap without peeping. This does not validate the jump; it
merely affirms our own credulity and the effectiveness of the photo-
graphic deception. As Paul Byers has written, "Cameras don't take
pictures."

The dominance of the Westonian thesis (which has its corollary in
"documentary" photography also) in mid-century American photog-
raphy is a historical fact. That does not make it true, for the thesis
fails to resolve the profoundly equivocal relationship between the pho-
tographic image and "the thing itself." It is also a historical fact that
there exist alternative approaches to photography, approaches which

embrace the full range of available means within the medium, which acknowledge its subjectivity and which consciously confront its illusionism. (Examples would include work by Man Ray, Moholy-Nagy, Edmund Teske, Harry Callahan, Bill Brandt, Robert Frank, Jerry Uelsmann, and others too numerous to cite.)

The affirmation and valorization of the Westonian thesis—to which Strand and Adams are basically bound—is a matter of legitimate critical choice, if undertaken in recognition of that thesis's cyclical necessity, its inherent limitations, its present moribundity, and the flourishing extant alternatives. If based only on whim—or on the equally irresponsible premise that photography plays an increasingly prominent role in current art activity and so one must, after all, say something about it to prove one is in the swim—such affirmation is not merely meaningless and supercilious. It also seriously misleads the larger art community, and denies to photography's diverse practitioners the richness of their own heritage and the credit due many of them for pioneering expeditions into territories which—as a direct result of the wholesale critical oversight of the accounts these adventurers sent back—are still believed by artists and public alike to remain entirely unexplored.

This discussion will be continued, and a number of specific examples presented, in my next column.

Reinventing Photography

The late Alexander King used to recount the poignant story of a man he had met—somewhere in northern Europe, as I recall—during his travels as a youth. This man invited King to his home to see with his own eyes the machine he had been working on for twenty years. The machine, which he felt to be on the verge of perfection, was to be a great boon to mankind. King observed the man as he placed a piece of paper into the prototype and pressed a number of buttons. But it was not until he had watched the device attack and mangle the paper for several minutes that he realized the man was reinventing the typewriter.

Some time ago, a curator whose main concern is the Polaroid im-

age showed me with similar enthusiasm a recent Polaroid photograph by Brigit Polk. Polk has been experimenting with and exhibiting one-of-a-kind color Polaroids for about five years, and it has been interesting to watch her progress from a state of technical naiveté, during which her imagery incorporated a great deal of accident, to a more sophisticated craftsmanship and a more formal, controlled way of seeing.

The image I was shown by this curator (who handled it like a treasure and waxed more than enthusiastic over it) involved a mannequin in a shop window and a variety of reflections. Insofar as Polk's work up to that time was concerned, the image had significance as one of the first signs of her awareness and conscious use of light itself and the spatial illusions it generates. However, there is an extensive tradition of mannequins-and-their-reflections-in-shop-windows imagery in photography (works by Atget, Kertesz, and Friedlander come immediately to mind), and in juxtaposition to these Polk's image could not help but seem both ideationally hackneyed and imagistically mediocre. My curator acquaintance appeared considerably distressed when I opined that all this image represented, in effect, was Polk's reinvention of the typewriter.

Typewriters get reinvented out of ignorance. The art world is currently reinventing photography, also out of ignorance. In this instance, the ignorance stems from two sources: the critics and the artists themselves. The ignorance of the critics results from their failure to come to terms with the breadth of photographic history, as well as their inability to grapple with post-war American photography. They continue to venerate Edward Weston's devotion to the "perfect print" as a precious object and his belief in the photograph as the embodiment of the spirit of "the thing itself." As I have noted previously, Westonian purism is a decreasingly influential stance; its overemphasis by under-informed criticism has proved to be profoundly misleading to artists everywhere. This ignorance on the part of critics has generated, and become coupled with, a scarifying corollary on the part of artists: the belief that if they approach photography in ignorance they cannot be held accountable to its traditions and precedents.

Polk is only one of a number of artists who make photographs but carefully avoid any commitment to the medium they employ. In this they are aided and abetted by critics like John Perrault, who an-

nounced that "some photographs are not photography, they are Art," a semantic maneuver whose audacity is soon outstripped by its ludicrousness. Taking such statements seriously results inevitably in the sort of art-world contortions reported in these pages recently by Roy Bongartz in his article on conceptual art (August 11).

"The Gibson Gallery," Bongartz wrote, "shows photographs by Roger Cutforth, for example, that are not to be looked at as photographs, but as graphic representations of ideas or 'sculptures,' a term that has been extended to include conceptual art. There is a snapshot of a hand holding a snapshot, for instance, and it is to be bought and judged not as photography but as a transcendental form." ·

Bypassing the obviously foolish implication that photography by photographers excludes "transcendental form" and "the graphic representation of ideas," does the fact that Cutforth is labeled *artist* rather than *photographer* mean that he is not responsible for the unoriginality of his "transcendental form"? For most of the past decade, Ken Josephson has been creating—and exhibiting and publishing—an extended series of photographs involving hands holding snapshots and picture postcards. Are these not "transcendental forms" also? Is Cutforth's image not to be gauged alongside this series? And is Cutforth's dealer not to be chastised for an apparent incompetence which has kept this artist and the gallery customers unaware of the existence of a large body of work that is obviously similar to Cutforth's and that not only precedes it in time and goes far beyond it in scope but is also no doubt considerably cheaper?

In the same article, Bongartz reports that a new school of "narrative art" includes works which "consist of little stories or scenarios either typed on paper, tape-recorded by voice or shown in photographs." In discussing such works, are art critics to be excused from an obligation to consider them alongside such fictional photographic sequences from the past decade as those by Eikoh Hosoe, Ralph Gibson, Les Krims, Duane Michals, Ralph Eugene Meatyard, and Richard Kirstel—"narrative art" which has been published and exhibited widely, in most cases internationally? If so, on what rational basis?

Unless photographers are to be excluded *de facto* from the ranks of artists, no such rational basis exists. It is hard to believe that anyone in his or her right mind would argue that the craft expertise of photographers invalidates their imagery as "art" whereas the technical in-

eptitude of artists certifies the aesthetic legitimacy of their photographic experiments. Such an argument is patently ridiculous.

Yet it is being made, tacitly, by the art world at present. Many contemporary artists appear to believe that photography is a virgin territory without a history (beyond Westonism, at least), free from relevant precedents and prior accomplishments: a brand new field of ideas which have not even been touched on by the medium's own practitioners, in which any small step breaks new ground. Since photography is presently permeating the art world, one can understand the easy acceptance of this delusion; it is, in Hemingway's words, "pretty to think so." It is also fallacious, a mirage whose only sustenance is wishful thinking and sufficient distance to make its insubstantiality difficult to verify.

My Camera in the Olive Grove:
Prolegomena to the Legitimization
of Photography by the Academy

The past decade has borne witness to a new and surprising phenomenon: a dramatic increase in the academic acceptance of photography as a serious field of creative and scholarly inquiry, and, as the inevitable corollary, the rise of a photographic academy whose structure, function, and attitudes are analogous (and, in most cases, essentially identical) to current versions of the more established academies within such media as painting and literature.

The prime symbol and crowning glory of this sudden ascension, at least on this side of the Atlantic, was the establishment in 1972 of the David Hunter McAlpin Professorship of the History of Photography and Modern Art at Princeton University. That segment of the photography community which is still caught up in the battle for photography's recognition as a "legitimate" art form has taken great satisfaction from this specific development and the larger iceberg it implies. Certainly, on a ritualistic level, it is a formal vindication of Alfred Stieglitz, his apostles and descendants, and their years of struggle to win a place for photography within the charmed inner circle of the "high" arts. (That the man for whom this $1-million chair was custom-built—Peter Bunnell, former curator of the Museum of Modern Art's Department of Photography—wrote his doctoral thesis on Stieglitz adds an appropriate symmetrical fillip.)

Such an unexpectedly warm welcome is naturally intoxicating. Yet, after more than a century of academic scorn as the illegitimate offspring of the sciences and the graphic arts, it might be wise—if only on principle—for the photography community to be somewhat less

Creative Camera International Year Book 1975.

eager and more cautious upon being clasped to the bosom of the aesthetic nuclear family.

To have "legitimacy" thus instantly conferred is at best a mixed blessing. For anyone who takes photography seriously, it is of course gratifying on one level to witness an increased attention to the medium from art critics, galleries, museums, collectors, and institutions of higher learning. On another level, however, acquiescence to the elevation of photography from the ranks of the "low" arts tacitly affirms the validity of a hierarchy among the arts.

This peerage is a hoary construct, deeply rooted in capitalistic premises. Its fundamental principle is an aristocratic one: that a medium's stature and significance are not to be gauged on internal qualities—i.e., the caliber of the work done by its exponents—nor on such work's effect upon the external world, but are instead proportional to that work's financial worth, inaccessibility, and lack of functional utility. The high arts, after all, have always been those which only the leisure class could afford to pursue.

For those of us who are seeking the elimination of this archaic, elitist concept of art, the reaffirmation of that aesthetic stratification, with its obvious allegiance to the class system, may understandably be viewed as counter-productive. Photography is inherently a democratic medium; anyone concerned with the cultural shortsightedness which has ensured the accuracy of Moholy-Nagy's frightening prediction of visual illiteracy cannot help but look askance at such priorities. In evaluating photography's newly conferred academic respectability, then, it is important to take note of the implicit premises thereof. Wrapping the mantle of scholarly approval around a medium which has received the cold shoulder from birth is surely a significant attempt at redefinition.

Simultaneously, we must look closely at the emerging photographic academy itself, in order to examine the implicit and explicit definitions of photography which it propounds. Photography is a unique medium in many ways, one of which is that it is enormously widespread and highly diversified in its utilitarian, communicative, and creative functions, yet young enough to have developed only a few centralized power blocs. These loci therefore exercise an ability to shape our definitions—and thus our culture's understanding of photography—which is quite disproportionate to their age and size.

The new photographic academy is certainly one of these. Paradoxically, to consider its influence at length is to risk extending that influence; yet we cannot afford to ignore it. It is unlikely that it will simply go away.

> *I think today you are seeing the beginnings of a very significant decline in the number of photographers who will be producing serious work for the simple, basic reason that their primary economic source is drying up, which is teaching. It's absolutely true. We have no monopoly on it, but we've got a very, very high percentage of our people who are fundamentally in the teaching profession as a vehicle to support what in fact is an art that is not being supported through any other vehicle.*
>
> PETER BUNNELL, 1973

Though it may be looser structurally, on a practical level an academy operates in patterns common to such kindred organizations as craft guilds and trade unions. One of the primary functions of such institutions is to promote the interests of their members by venerating and propagating standards of performance which, not coincidentally, reflect with considerable accuracy the capabilities, work habits, and taste patterns of those who belong to them.

A standard is a goal whose achievability has been proven beyond question. Within a guild/union context, standards proclaim what can be accomplished comfortably and decorously. No such organization has ever propounded standards which could not be met with relative ease by the lowest common denominator of its membership. No goldsmith's guild ever drums out all but the Cellinis. Standards embody the average competence of those who subscribe to and promulgate them. They are maintained by limiting the number of licensed practitioners and requiring that new licensees be trained by older ones. In guild and union situations, this takes place through the process of apprenticeship: learning to do something the way someone else does it.

Until quite recently, this transmission of craft competence was the sole thrust of formalized photography education. As a beginning, this was necessary. There were few textbooks—much less organized, coherent programs—dealing with the problems and issues of creative

(as opposed to commercial) photographic image-making. Conse-
quently, the best and often the only sources for relevant informa-
tion were those few individual master photographers who had pulled
together some coherent, communicable *modus operandi* from their
own experience and were willing to disseminate their personal know-
how in the classroom.

This was certainly better than no photography education at all, but
it had numerous flaws. One of these was the creation of a star system
under which a particular college, university, or art institute would be
considered photographically significant not because it had, say, an
intelligently structured and well-rounded program which gave stu-
dents a thorough grounding in the history of the medium and all the
diverse processes it encompasses, but rather because Harry or Aaron
or Minor or Ansel or Jerry was teaching there. To be sure, there's
nothing wrong with wanting to know how Harry or Aaron or Minor
or Ansel or Jerry "does it," but the leaking of one's trade secrets to
(and the infliction of one's taste patterns on) a group of students
hardly constitutes a formal educational methodology.

One central issue in photography education (and, for that matter,
in photography criticism) is the necessity for developing a useful,
comprehensive, non-sectarian vocabulary for discussing the expression
and communication of ideas, feelings, and perceptions through pho-
tographic imagery. The lack of such a vocabulary is among the cru-
cial problems in contemporary photography. It was surely perpetuated
by the star system, which encouraged students to mimic the dialect of
one or another individual image-maker, instead of evolving a mother
tongue for them all and encouraging proficiency therein. During this
period, students from different schools often had so little in common
that they could not even discuss their differences profitably. This
problem has been and continues to be compounded by inarticulate
photographer-teachers who delude students into the false belief that
verbal incompetence and illiteracy are a photographer's badges of
honor.

Nevertheless, one can also point out some highly beneficial results
of this apprenticeship system. The general level of craftsmanship
among students of creative photography rose markedly across the
board during that stage in the growth of photography education, and
it also spread much more widely than might have been expected, due

to an explosion of interest in studying photography which began in the early 1960s. This is not the place to trace the causes of that upsurge, which are multiple and complex, ranging as they do from increased affluence among the young to Michelangelo Antonioni's film *Blow-Up*. Suffice it to say that during that decade colleges, universities, and art institutes across North America added new photography departments and expanded extant ones. This in turn created a booming market for teachers of photography, fostering the illusion that anyone with a Master of Fine Arts in creative photography could always "fall back on teaching" to support him/herself.

When the economic bubble burst at the beginning of the 1970s, many of these young photographers found themselves redundant. The job market in teaching creative photography began to dry up, the competition became stiffer, and the ability to make personal images, even interesting ones, was no longer enough to guarantee one gainful employment in some school somewhere.

Those schools now hiring teachers of photography are in a position to pick and choose, so they are beginning to require credentials beyond a camera, a portfolio of prints, and a sheepskin. Generally, they are coming to expect applicants to be adept at all the various photographic processes, old and new, even if they don't employ such means in their own work. Increasingly, they expect candidates to have enough of a background in the history of photography to teach that subject as well. Often they require some training in teaching, which is a craft in itself. And, as a more interdisciplinary approach to photography education at last begins to flower, schools are starting to sift through the mass for those who are able to teach photography not only as a means of introspective self-expression but as a major language form—one whose communicative effectiveness can be of value to students from such diverse disciplines as sociology, history, and psychiatry.

Naturally, this puts the squeeze on those who are really only in it for the money, a fact which Peter Bunnell bemoans in the statement quoted above. I feel quite differently about it: the last thing photography needs, at this point or any other, is a generation of students whose instructors viewed teaching not as a calling but as a sinecure. Whichever of these attitudes one agrees with, the fact is that photography education is currently metamorphosing from the guild-derived

master-apprentice relationship to the professor-scholar symbiosis of the academy, and that this is occurring at a time when there is an unprecedented demand for photography education but an oversupply of would-be teachers.

Under such circumstances, any association whose imprimatur is convertible to heightened employability and/or job security is in a position of power. With such power comes politics.

> *Artists now not only admit to but are acutely aware of what they once only suspected and often avoided; that the central theme of their picture-making is imagery itself.*
>
> WILLIAM JENKINS, 1972

What differentiates an academy from a guild or union is that the academy concerns itself with transmitting not just craft competence but ideas as well. It is precisely in this regard that an academy always poses a threat to the medium it nominally represents. By definition, the purpose of an academy is to formalize the history of its medium by the analysis, annotation, and codification of that medium's traditions. But traditions, by definition, cannot be thus regimented and reduced to formulae. As John Szarkowski has written, artistic tradition "exists in the minds of artists and consists of their collective memory of what has been accomplished so far. Its function is to mark the starting point for each day's work. Occasionally it is decided that tradition should also define the work's end result. At this point the tradition dies."* Once an institution such as an academy becomes the source or reference point for the traditions of a medium, those traditions become fixed, immobile, and begin to lose their vitality. They cease to operate as traditions and instead are converted into conventions.

Conventions, like standards, are embodiments of competence. But creativity and competence are often incompatible with each other. This is not to say that incompetence is a virtue; but from a creative standpoint, a state of acompetence is often a necessity. Competence, after all, directs its possessor toward the duplication of what has already been done via the employment of time-tested, foolproof proce-

* *Looking at Photographs; 100 Pictures from the Collection of the Museum of Modern Art* (New York: Museum of Modern Art, 1973), p. 120.

dures. Creativity, on the other hand, is a form of acompetence aimed at generating that which has never before existed and which therefore has no pre-set rules to guide its making, no extant model by which its success or failure can be measured. Creative activity is essentially anarchic, incorporating accident, risk, innovation, abnormality, change.

An artistic academy is therefore almost always a contradiction in terms. Conservative by nature, devoted (like all institutions) to stability for the sake of self-preservation, an academy seeks to maintain the past in the present by molding the present in the shape of the past. Such an organism, which is predominantly entropic, is automatically at loggerheads with its medium's avant-garde. For it is always the latter who are disregarding and/or deliberately violating the medium's history and traditions, breaking through the boundaries on the academy's maps in order to keep the medium alive and growing. Historically, an academy's relationship to the living pioneers in its medium has usually been an antagonistic one, since academies are bastions of conventionalism while subversion of the established order—emotional, aesthetic, political, philosophical, and cultural—lies close to the heart of the creative impulse. Academies tend to be the mausoleums of tradition, as museums tend to be the graveyards of art.

Often there are positive benefits to be derived from the presence of an active academy within the larger context of a living medium. Some of these we are already beginning to reap. Among them are the spread of craft competence; the organization of an informational network, and a consequent increase in the rapidity of communication; the preservation of significant creative works and research materials; an increased attention to the medium's history and development; revitalization of still-viable methods and processes (such as the non-silver processes of the late nineteenth century, which will be newly useful in the silverless late twentieth century); and the power, respect, and money which accrue to academically established media as a rule.

These are unobjectionable in and of themselves, but there is a flip side to most of these coins, a price to pay. Over-emphasis on craft competence can deaden creativity. A short-circuited informational network of the sort William Jenkins waxes so enthusiastic over can rapidly become inbred and anemic (a demonstrated tendency of academicized creative activity). Western culture's obsession with perma-

nence and immortality manifests itself in our continual warehousing of the past. The scrutiny of art isolated from the personal and cultural contexts in which it grew leads to the dry, reductivist formalism of "photographs about photography." And too much time in the ivory tower can convince one that life imitates art—or, indeed, that art replaces life.

Those are some of the risks on the down side insofar as the existence of a photographic academy is concerned. Yet in considering that eventuality it is imperative to do more than merely strike some balance between these advantages and drawbacks. As noted previously, photography education is at a point of transition. The key problems facing us at this juncture are: the development of a non-sectarian vocabulary; the shaping of a methodology for teaching the fundamentals of visual communication with photography to workers in all disciplines, not only to "art photographers"; and the broadening of the base of photography education so that photography becomes a tool as basic as writing, taught from grade school on up to all members of our society.

These are not insoluble problems, but they are inarguable priorities. If the new academy can provide assistance in solving them in the most productively visionary fashion possible, then its presence will be a positive factor in the medium's evolution.

If, however, the photographic academy proves to be such dead weight as only a bastion of tradition can be, we might do well to remember that photography has already altered permanently the ways in which we experience our world and understand our experience. It has done so entirely without an academy of its own, and often over the active opposition of the larger academic community. Under such circumstances, it would not be ill-advised to retain the option of reverting to bastardy, should that involve losing nothing more than the dubious distinction of the good name of Art.

Because It Feels So Good When I Stop:
Concerning a Continuing Personal Encounter with Photography Criticism

I am not a photographer. I am a writer. And the impulse which has led me to spend the past six years writing about photography can best be characterized as paranoia.

Certain conjunctions which occurred in 1967—among them my reading of William Ivins' *Prints and Visual Communication* and Marshall McLuhan's *Understanding Media*—forced me, to the realization that photography was as omnipresent a mode of communication as my own chosen medium. The recognition that photography shaped me, my culture, my world, and my understanding of all three came as a considerable shock, particularly when accompanied by the admission that I paid it little conscious attention and had no comprehension of its *modus operandi*.

To alter the conditions of powerlessness generated by this ignorance, I began paying close attention to the medium in its various manifestations throughout my daily life. I also began educating myself, largely through books, in the history and evolution of photography as a mode of visual communication. The material I was ingesting along these lines was supplemented with exposure to as many monographs and exhibits of creative work as I could find; these imagemakers, the artist-photographers, were those searching for the means of controlling and personalizing this encoding system, and their explorations had obvious pertinence to my own.

In the course of this autodidactic activity, I came in contact with a diversity of contemporary writing about photography. Such of it as proved most useful to my researches tended, paradoxically, to come from outside the medium; most photography commentators seemed to be writing exclusively for photographers, rather than for a general au-

This is the text of a speech delivered at New York University on December 10, 1974, as part of N.Y.U.'s Fourth Annual Art-Critics-in-Residence Program, which is sponsored in part by a grant from the National Endowment for the Arts. A few minor revisions, additions, and updatings were made subsequently, but the statement stands essentially unaltered. It was published in the October 1975 issue of *Camera 35*.

dience. Then, as now, my interest in becoming a photographic image-maker was minimal. Such writing was therefore irrelevant to my needs. I came to feel that there might be others in my position, curious about the medium without being performers therein. I also came to feel that there might be some value to threshing out, in public and in print, some understandings of the medium's role in our lives. And undertaking an ongoing engagement with photography, from the specific and declared stance of a member of the audience, contained a challenge which I enjoyed taking up.

So, early in 1968, I began writing a weekly column from that perspective for the *Village Voice,* a weekly New York newspaper. (Titled "Latent Image," the column ran until the spring of 1973, when I resigned in a censorship dispute.) In 1969, I was invited to write for *Popular Photography* and subsequently, in 1970, for the *New York Times,* to which I contributed on a bi-weekly basis through October of 1974.

I am providing this information for several reasons. One is to give those who may well be unfamiliar with my writing some background data to indicate what I'm about and where I'm coming from. The other is to make it clear that I am not being coy, flippant, or refractory when I say that I have absolutely no formal training in photography or in being a photography critic and no fixed idea of what photography criticism is. I do have a working definition of my own activity: the intersecting of photographic images with words. Sometimes I feel I succeed at this; usually, by my own lights, to a greater or lesser degree I fail. It is the process of trying which engrosses me, and though I cannot explain adequately the impulse behind it, this continues to seem to me to be worth doing.

What follows is not the enunciation of a formal aesthetic; I do not have one. Nor is it a distilled methodology for evaluating photographs; from my standpoint, I merely look closely at and into all sorts of photographic images and attempt to pinpoint in words what they provoke me to feel and think and understand. This article, then, is simply one man's state-of-the-craft report, an account of what I have uncovered in a continuing investigation of what photography criticism may finally prove to be.

Among the most distressing problems of photography criticism is the serious shortage of people with whom to discuss them.

Photography criticism is by no means a crowded field. In New York City, which in terms of the number of gallery and museum exhibitions and book and magazine publishers is surely the photographic center of the world, the number of writers regularly responding in print to this flood of material can be counted on the fingers of one hand. Another way of illustrating the scarcity might be to indicate that there is currently a grand total of four books in print which are acts of photography criticism. These are the *Camera Work* anthology published by *Aperture,* Charles Caffin's *Photography as a Fine Art,* John Ward's *The Criticism of Photography as Art,* and Volume 1 of *The Photographic Notebooks of D. H. Moore.* The first two are collections of early-twentieth-century material; Ward's book is useful but the author is not and never has been a functioning critic in the public arena; Moore's book is self-published and hard to come by. All in all, hardly an abundant cornucopia with which to entice a potential audience or widen one's circle of peers.

In part, this situation may exist because, as an activity, photography criticism is problematic in itself. Though the vast majority of people in our culture may not engage regularly with criticism in such fields as literature, art, and music, and though these forms of cognitive inquiry may serve no valuable purpose in the context of their lives, the validity of the activity itself has long been established and goes largely unquestioned. We all know, or at least think we know, what an art critic or a music critic does, and share a widespread if somewhat vague faith in the ultimate usefulness of their labors.

In the minds of many, however, there seem to be vast doubts as to whether photography criticism is actually fit work for a grown man. With photography itself an only recently legitimized medium in the eyes of the taste-makers and the academicians, photography criticism is still viewed as something akin to an obscure form of perversion, worthy at best of nothing more than passing interest. As a creative medium and a major mode of communication, photography has attracted the brief attention of many commentators, from Charles Baudelaire to James Agee, but has evoked the enduring passion of very few. (Susan Sontag's recent articles in the *New York Review of Books* comprise a good case in point. Initially, it appears, Sontag felt that she could say everything worth saying about photography in two pieces, but subsequently felt impelled to flesh out her statement by adding a third, and now a fourth.)

A surprising number of people have written intelligently about photography in the past 135 years. Oliver Wendell Holmes, George Bernard Shaw, Walter Benjamin, Lincoln Kirstein, Roland Barthes (the uncredited source of several of Sontag's constructs), George P. Elliott, Marshall McLuhan—all are among those whom one could cite as authors of cogent writing about photography. But their contributions to the literature of the medium, however high in quality, are quantitatively scant. Shaw, with perhaps two dozen essays on the subject to his credit, is more prolific than most of the rest put together. However much one might cherish what these writers have had to say about photography, their interaction with the medium has not been extensive enough (Shaw being perhaps a borderline case, and his contemporary Sadakichi Hartmann as well) to qualify them specifically as photography critics rather than critics-at-large. They have nourished the literature considerably, but they are not central to its tradition.

There are other writers with a far less tangential relationship to photography. Both Minor White and Ralph Hattersley have published numerous invaluable essays on the "reading" or interpretation of photographs, and have returned to this subject again and again. White's approach is drawn largely from metaphysics, Hattersley's from psychology. Currently they appear to be finding a common ground of *Gestalt* mysticism which to my way of thinking is proving more obfuscatory than fruitful. Both of them, however, have been pioneers in demonstrating that photographs are not transcriptions but descriptions.

At the same time, it must be noted that both White and Hattersley are photographers and teachers, and that in their writing they speak from those positions. Only rarely has either of them brought his analytical/evaluative approach to bear on a publicly presented body of work to which the maker has, in Emmet Gowin's pregnant phrase, "given his consent." The imagery discussed by both has usually been student work, whose status is transitional and thereby protected.

Moving to another group, it must also be said that Beaumont and Nancy Newhall, John Szarkowski, Helmut and Alison Gernsheim, and Van Deren Coke have all written extensively about photography over a period not just of years but of decades, and that each of them has made large contributions to the literature of the medium. But their

stances have been those of curator and/or historian, positions which involve a tacit rather than an overt form of criticism.

This is not an insignificant distinction. Curators and historians do act as *de facto* critics; they select the imagery that the critics will write about and the audience will see. However, the writings of curators tend to be appreciations of work with whose presentation they are directly involved in their sponsorial role. Thus they rarely are obligated to come to terms, in print at least, with imagery to which they feel antagonistic or which does not fit comfortably into their aesthetic. Historians, on the other hand, concern themselves with the chronology (and ideally, though this stage of photography historianship is only beginning to be reached, with the *morphology*) of a medium's development. Consequently, the images and image-makers with whom historians must grapple are generally established ones whose fundamental significance does not need definition or defense, but rather elaboration and placement in context.

Historians and curators, therefore, write from privileged positions. The historian's privilege is the detachment and hindsight created by distance in time from the work's public birth; the curator's is the closeness and privity which accrues to those with the power of patronage. Neither of these privileges is available to the critic, and their absence distinguishes the critical function from the curatorial and historical.

Critics do, of course, sometimes write appreciations as well as exegeses, and often concern themselves with work from the past. The boundaries are not always clearly marked. For the purposes of this discussion, however, let us establish the following parameters:

A critic should be independent of the artists and institutions about which he/she writes. His/her writing should appear regularly in a magazine, newspaper, or other forum of opinion. The work considered within that writing should be publicly accessible, and at least in part should represent the output of the critic's contemporaries and/or younger, less established artists in all their diversity. And he/she should be willing to adopt openly that skeptic's posture which is necessary to serious criticism. (This last requirement includes, implicitly, a willingness to bear the resentments which are evoked by anyone adopting that posture. I use the word *skeptic* advisedly. Critical activity is not enmity, nor hostility. But the critic is not, and should not become, anyone's mouthpiece; and we must keep in mind the impor-

tant differences between constructive, affirmative criticism and the awarding of gold watches. The greatest abuses of a critic's role stem from the hunger for power and the need to be liked.)

Given the guidelines above, we can safely say that there are virtually no photography critics at work in this country outside of those individuals who write for a small handful of newspapers and photography magazines. No general-interest publication, no radio or TV station, and no major art periodical presents anything resembling running critical commentary devoted to photography.

A recent survey of the field, published as part of the book *Photography: Source & Resource* (Lewis, McQuaid, and Tait; Turnip Press, 1973), listed some thirty writers nationwide whose work could at least in part be defined—according to the survey's qualifications—as photography criticism. Many of these are columnists writing for a variety of regional newspapers, whose work I cannot evaluate because I am unfamiliar with it. Indeed, I had heard of and read work by less than one-third of those included. However valuable the writing of the others may be for their local readers, it is not part of a larger critical dialogue, for it is not even circulating among other critics.

That is a moot point, however, since there is in fact nothing yet approaching a true critical dialogue taking place within photography, even in the pages of the more widely disseminated publications. Few exhibits and books are discussed by more than one commentator, and it's a rare issue which is examined from more than one angle. In photography, we are at a stage best described as pre–critical mass, and though an explosion seems imminent it has not yet come to pass.

Thus it is impossible to discuss the "problems of photography criticism" as though they were clearly formulated and widely agreed-upon issues, consciously faced by a diversity of critics familiar with each other's relative positions, and known to an audience engaged in active observation of critical interactions and the concepts emerging therefrom. This is very far indeed from being the case. Excepting the recent "debate" between Minor White and myself in *Camera 35*, the last open controversy in print over photographic ideas and methodologies was the purist-pictorialist battle royal in the pages of *Camera Craft*, over three decades ago. That's a long time between rounds.

Therefore, rather than attempting to predict what some of the "problems of photography criticism" may turn out to be, it seems more

practical under the circumstances to address ourselves to the three interlocking hurdles which will have to be surmounted in order for a provocative critical dialogue in photography to begin.

To start with, there is the necessity for creating a network of appropriate forums for critical commentary.

Criticism, by its nature, is a public activity. Its purpose, as a process, is to establish, develop, and share a set of ideas and definitions intended to enable a group of disparate people—the critics, the audience, and the artists as well—to find in the work under discussion a common ground, a unifying metaphor for their mutual experiencing of the world and their understanding of that experience. This makes it virtually impossible to become a critic in private. The public role is inherent in the activity; the position does not become official (one might also say that the circuit is not complete) until the aspirant begins to publish and thus throws his/her hat into the ring.

Consequently, the existence of adequate training grounds is a prerequisite for the evolution of a generation of full-fledged critics. There simply must be places for beginning critics to cut their eyeteeth, work out their ideas, and test their attitudes regarding the medium. Most other media have well-established structures within which this maturation can take place: college and university workshops and publications in which to debut, "little magazines" in which to learn and grow, and thence to the larger critical journals or to more diversified, general-interest publications. Such systems not only permit critics to evolve and operate at their own organic pace but also encourage people to engage in critical activity.

No such system exists in photography at present. Even though formal photography education on the undergraduate and graduate levels has multiplied dramatically over the past decade, the number of schools whose photography departments and publications pay any attention whatsoever to photography criticism as a field of inquiry is miniscule. The rarity of "little magazines" is still noteworthy, and until quite recently those few extant devoted more space to reproductions of imagery than they provided for response to them. (Presently, one can point to *Aperture, Afterimage,* and *Exposure* as outlets for critical writing; there are few others at this level.)

There exist no "larger critical journals" in photography—nothing at all approximating *Artforum* or even *Art in America,* although a

few art magazines (including those two) do give periodic space to the medium. And, as noted before, no general-interest magazines and only a few newspapers devote space to writing which concerns imagery rather than hardware.

This brings us to a group of publications which I have not discussed so far because they are unique to photography and anomalous in the history of criticism. These are the large-circulation photography monthlies—*Popular Photography, Modern Photography, Camera 35, et al.*—and their various annual and semi-annual spinoffs. With the possible exception of writing, there is no other medium with as many amateur practitioners as photography can claim. And any comparison ends when one adds in the equipment involved in producing photographic images. Writing, painting, dance, music—none of these incorporate the acquisition of so much machinery and the consumption of so much material as does photography.

Like most hobbyists, amateur photographers get into the equipment at least as much as they involve themselves in image-making, if not more so. The primary function of the big photo magazines is to bring these hobbyists together with that technology—to marry the consumers and the products, or to be more blunt about it, to flog the goods unmercifully. Much of the writing they contain, consequently, is what we in the trade call "nuts and bolts" articles: equipment ratings, explanations of techniques, lists of tricks to assist in making something that looks meaningful, and the like.

Presumably these publications feel some slight obligation to inform their readership of developments in the medium of photography as a creative and communicative force. This presumption is based on the regular appearance within their pages of writing which considers exhibitions and book presentations of photographs. For what it's worth, these publications have provided more consistent coverage of such material than any others.

Unfortunately, it's not worth very much. The problem is not merely that these magazines, the major existing vehicles for photography criticism, are seriously if not entirely compromised by their absolute dependence on the billion-dollar photo-merchandising industry for ad revenue and thus for life. Intelligent, honest writing is often capable of redeeming the triviality of its vehicle. The deeper flaw is that much of what appears in those publications is at best a facsimile of criticism,

written primarily by photographers who too often fail to comprehend or acknowledge the significant distinction between meaningful criticism and the exercise of one's personal taste patterns.

One prominent writer/photographer, for example, gives over goodly portions of his book reviews to numerical counts of how many layouts fit into his categories of Good, Bad, and Indifferent. He never specifies which are which, nor has he ever presented an extended statement on layout which would make interpretation of his statistics possible. When he comes to speak more specifically of images, he tends to the other extreme of over-conciseness ("The photographs, which show wild areas near towns, are all sharp. For me, the one on page 73 is extremely beautiful").

Another babbles in embarrassing veneration of his idols or, alternately, concocts snappy two-word epithets (which might be paraphrased as "Dynamic Obsolescence vs. Morbid Introspection") which he attaches to large lists of photographers whose work often shares no ostensible similarity, neither of style nor of content. The intent of this labeling would seem to be the division of the photography community into armed and antagonistic camps. This writer uses his categories judgmentally, to separate those artists whose sensibilities he appreciates from those he dislikes. The latter are lumped together and dismissed *en masse,* without their individual crimes ever being specified— a form of aesthetic Stalinism.

That such taste-mongering passes for photography criticism is bad enough. Most of what is published under that guise deals even less extensively with the imagery and its messages, concentrating instead on the photographer's choices of equipment and materials, as though a photograph were a demonstration of the lens employed in its making rather than a description of its maker's vision of the world.

This is photography criticism's actual "tradition," its working definition of itself. The consequences of this genre of pseudo-criticism have been little short of disastrous. It has disseminated widely a totally counter-productive definition of photography criticism; the necessary contradiction thereof drains off time and energy which could be much better spent in other ways. It has discredited the large-circulation magazines as serious critical organs, and has rendered them almost entirely useless by establishing an atmosphere of inanity and irrelevance which absorbs almost any work presented in that context. And

it has grossly deluded and miseducated a large segment of the potential audience for serious photography and serious photography criticism by centering attention on equipment and technique rather than on image, idea, and content.

This misdirected audience is the second of the interlocking hurdles directly ahead. Most of its members are camera owners. Although possession of two hundred dollars' worth of toe shoes and leotards doesn't, as we all know, make you a dancer, these people have been propagandized by the hardware industry, by the photo magazines, and by our consumerist culture into believing that their ownership of cameras makes them photographers. And, although it has long been recognized in regard to the other media that the biases and jealousies endemic to being a performer within a medium tend to vitiate any performer's usefulness as a critic of his peers, these amateurs have been led to believe that no one outside the medium should say anything at all about photographs.

I find many indicators of this audience's vision of my role as critic in the correspondence I receive. I can count on a regular flow of letters asking me which single-lens reflex camera in the $300–$350 price range I would recommend. Others want my darkroom secrets, or the address of my favorite color-processing house. One gentleman actually named me his last hope in his search for a new case for a camera two decades old. His hope was dashed, needless to say, but you can be sure that Judith Crist and Clive Barnes and Barbara Rose receive no missives along equivalent lines, for there are no equivalent lines in their media.

It is evident from such correspondence that a sizable portion of my readership assumes me to be a practicing photographer, and one cognizant of and interested in all the latest hardware innovations. It is also evident that they feel entitled to demand that I function as a consumer guide to photographic merchandise—this despite the fact that in six years of writing I have given no indication whatsoever that this is an area of my critical concern or expertise.

That I am not a photographer is a fact which distresses another element of my readership. "Why don't you get a *photographer* to review photography" (italics theirs) is a complaint often received by my editors. I find it is elicited most dependably when I disregard a photographer's craft competence and instead discuss the mediocrity of

his/her imagery. For example, in a piece of mine on Yousuf Karsh which appeared recently in *Popular Photography*, two simple statements—that Karsh's work has evidenced no growth or change in several decades, and that his much-vaunted style appears to be a trap from which he is incapable of escaping even momentarily—generated a barrage of violently indignant letters. The main objections seemed to be that I was arguing with success and that, because I couldn't produce such work myself, I had no right to comment on its inadequacies. One correspondent informed me that I was unworthy to kiss the ground on which Karsh walks; another transcribed his anger onto toilet paper.

All this is comical, to be sure, and would be exclusively so if it represented what might be considered the lunatic fringe of the photography audience. Regrettably, however, it is instead emblematic of widely held beliefs and deeply cherished attitudes common to much of the audience for photography. Many people are simply not accustomed to considering photographs as anything other than craft exercises or displays of technical virtuosity; discussions of how or what a photograph communicates appear to discomfit them hugely.

That such a situation exists, and has existed for so long, is attributable primarily to the lack of a functional vocabulary for the criticism of photography. The language currently applied to photographs as distinct from other kinds of images is derived entirely from the jargon of technique; it is a form of shop talk which pertains to the manufacturing of photographs as objects rather than to their workings or effects as images. In essence, it deals not with the creative/intellectual problems of the photographer as artist and communicator, but with the practical difficulties faced by the photographer as craftsman. For any consideration of the former, one must fall back on the terminology of the other graphic arts or of traditional aesthetics, which is occasionally useful in approaching certain sorts of photographic imagery but bears absolutely no relationship to others and which fails to come to grips with some of the unique and essential qualities of any photograph, such as its factuality, its temporality, and its equivocal relation to what Edward Weston called "the thing itself."

The development of such a vocabulary is as necessary to the evolution of vital photography criticism as is the creation of forums for critical writing and the education/reeducation of what Minor White

calls a "creative audience." The sources for such a vocabulary will doubtless be diverse, including such disciplines as psychology, sociology, and structural linguistics. These, at any rate, are some of the areas in which I and others concerned with the absence of a vocabulary are currently nosing around for useful tools and constructs. Wherever the terminology eventually comes from, it must now be found, organized, and shared. Without a common language we all—photographic image-makers, critics, and audience alike—are doomed to remain strangers to each other, disconnected components of a generator with the capacity to enlighten us and illuminate our world.

1976

Where's the Money?

There are several ways of looking at the recent symposium, "Collecting the Photograph," which took place on September 20 under the sponsorship of *Art in America*. Its symbolic implications, its political ramifications, and its actual proceedings all merit consideration, and the viewpoints from which it might be studied include those of the collector of photographs, the scholar/historian/curator, and the photographer.

For obvious reasons, all of these aspects are going to receive short shrift in this account, but I hope to touch on a number of the important issues it raised from all those standpoints.

First, some basics. The symposium was, as noted, sponsored by *Art in America*, a widely read magazine which has paid very little serious attention to photography (much less than its closest rival, *Artforum*). Embarrassingly little attention, in fact; so this symposium was obviously an attempt to make a big plunge into the now-hot medium of photography before this failure of editorial judgment became any more ludicrous.

"Collecting the Photograph" was widely advertised. There were mailings from the magazine and ads in the *New York Times*; I even received a gratuitous announcement of the event from *Aperture*. This push was no doubt considered necessary because the tickets were priced at a hefty $50 apiece.

The symposium was not presented at any of the numerous educa-

Camera 35, January 1976.

tional institutions in the city, but at Alice Tully Hall in Lincoln Center—one of the poshest showcases in New York. Since nothing in the program necessitated that auditorium's excellent acoustics or lavish appointments (or exorbitant rental fee), it was obviously selected to apply the bourgeois veneer of high culture and wealth to the proceedings.

The participants in the panel were Peter Bunnell, now director of the Princeton University Art Museum; John Szarkowski, director of the Museum of Modern Art's Department of Photography; Nathan Lyons, director of the Visual Studies Workshop; Weston Naef, assistant curator of prints and photographs at the Metropolitan Museum of Art; E. John Bullard, director of the New Orleans Museum of Art; Harry Lunn of the Lunn Gallery in Washington, D.C.; and Sam Wagstaff, a private collector. The moderator was Eugenia Parry Janis, assistant professor of art at Wellesley College.

Breaking down the lineup, then, we have the overlapping imprimaturs of four major museums, two famous institutions of higher learning, the best-known independent photography workshop, a major art periodical, an active new gallery, and eight individuals of considerable (though varying) personal reputability stamped onto the notion of the collectibility of the photograph as a rare and precious object. (I will leave to the determination of others the question of whether or not it is self-serving or even unethical for representatives of museums —many of whom are also private collectors of photographs—to place their institutions' weight behind the marketing of photographs as art commodities.)

So, in terms of its ticket price, its publicity, and its participants, this event was self-evidently meant to promote and capitalize on the current surge of public awareness of photography as a "new" art form and the search by art collectors for something new in which to invest their money for fun and profit. (The very first paragraph of the press release issued by *Art in America* referred to photographs as "the hottest collectibles on the market" and waxed ecstatic about photographs which have brought "unheard-of-sums" and "skyrocketed in price.")

Now to the event. Against all odds, it was on every level (save the symbolic and political) boring and uninformative. It was also poorly planned and poorly run. The advertised schedule had the morning devoted to individual talks by the panelists, with the afternoon re-

served for an open forum. While that would have restricted the length of the speakers' prepared statements perhaps too severely (the morning session ran from 10:00 to 12:30), it would have made possible some discussion among the speakers and some active interchange between them and the audience during the afternoon session.

As it turned out, however, the prepared talks consumed virtually all the time of both sessions. The morning session started late, questions were not permitted at the end of the individual speeches, and by the time John Szarkowski finished it was 3:30, which left only half an hour for questions. Whether this was intentional or not I could not tell; it was certainly infuriating.

From the outset, it was obvious that little forethought and coordination had gone into the program. Weston Naef, the first speaker, had prepared a not overly elaborate presentation which simply required the simultaneous appearance of two slides (in different projectors) on the hall's large screen. This was apparently beyond the ability of the hall's projectionist, who was not only unable to synchronize most of the slides but could not even make them fit together on the screen. Nor, for that matter, had anyone had the forethought to provide the speakers with a remote control device with a reverse as well as a forward button, so that once they passed a slide it was gone for good.

Naef's talk depended on the visual referents he had brought, so much of what he had to say was incomprehensible. It was also mostly inaudible, since he tended to talk to the screen rather than to the audience and the microphone levels were not nearly high enough. (This also plagued Nathan Lyons during his talk.) Naef's main theme was the analogy between the various "states" of other graphic works, such as etchings and engravings, and the diverse forms in which a photograph might appear—a potentially useful analogy, regrettably lost in technical difficulties.

Lyons, looking and acting like a fish out of water, spoke about collecting photographs for visual research, as is being done at the Visual Studies Workshop. He was the only one present who indicated any discomfort with or distaste for the obviously money-oriented tone of the proceedings and their setting. He was also the only panelist who could be—and quite pointedly asked to be—considered as a photographer. He has a policy, which I admire and share, of willingness to talk to almost anybody anywhere about the things he believes in. Thus

he runs the risks of irrelevance and/or co-option for the chance—and frequently, as in this case, the off-chance—that someone will hear his message. Nonetheless, it was refreshing to hear someone talk about collecting without the acquisitive instinct being implicit in the concept. At the end of his speech a Visual Studies Workshop award—carried to the stage by Les Krims—was presented to Szarkowski for persuading the Museum of Modern Art to acquire the Eugene Atget archives from Berenice Abbott.

John Bullard's spot was devoted to the development of the New Orleans Museum's photography collection, which was begun in 1973. Bullard and his trustees felt that photography was an area where a museum could still build a major collection from scratch on a low budget, and they proceeded to do so. As he indicated in his text and slides, they have centered the collection around Louisiana artists (Laughlin, Bellocq) and photographers who have done some work in the state, such as Genthe and Hine. This regional core has been augmented with strong holdings in other American and European photographers—Sander, F. H. Evans, Doisneau, Weston, and Cunningham among them. The choices of images have been surprisingly intelligent and often unusual, as will probably be evident from the exhibit and catalogue the museum intends to publish next year. Bullard himself was an enthusiastic and engaging speaker who roused the audience somewhat from the lethargy (stupefaction would be more accurate) into which it had sunk.

After a lunch of bland sandwiches and mediocre wine, the second session began. Peter Bunnell energetically rattled off a collection of disconnected snippets having to do with his experiences at Princeton and elsewhere. My notes indicate that at one point he referred to the Princeton collection as "my collection." Two pertinent thoughts that he threw out but did not elaborate on sufficiently were (1) that the best way for a university to start its own photography collection is to locate and catalogue (and, ideally, centralize for preservation's sake) its own holdings, which are frequently extensive but often scattered and hidden away in the departments of architecture, history, archaeology, etc.; (2) that the real challenge to a museum director would be to start a collection dating from 1946 onward—post-war photography.

As Eugenia Janis said of the next speaker, Harry Lunn, "He brings us news of the market." Indeed he did. Lots of talk about people buy-

ing photographs for lots of money. Lunn, according to rumor, was the instigator of this symposium. Among the news and notes in his pep talk, I learned that AT & T has started buying photographs to decorate its offices. Whoopee, I'm sure.

John Szarkowski topped off the proceedings by defining briefly the various stances a curator can take toward a medium, dismissing most of them as beneath his consideration, and announcing that the highest and most rigorous form of curatorship was autocratic, elitist, and appropriately limited by the curator's own ideas and taste patterns, the narrower the better. As most every MOMA-watcher knows by now, this is a most accurate description of Szarkowski himself. There are, however, other equally legitimate approaches to curatorship. It is also worth noting that this perambulation was entirely irrelevant to Szarkowski's announced topic, "The Function of a Photographic Collection in an Art Museum."

There was little time left for questions, but the next half-hour was the most dynamic of the day. It was astonishing to find out how much anger this symposium had touched off in its audience. People strode up to the microphones to denounce *Art in America* for the exorbitant price of tickets (the hall, by the way, was no more than two-thirds full), the badly planned presentation, and the general irrelevance of many of the talks. No one from the magazine or the panel gave any answer. Dru Shipman of the Society for Photographic Education asked if there were not something antithetical to photography's nature as a democratic and reproducible image-making medium in the panelists' reverence for the photograph as a precious object. She got a most flippant and cavalier answer ("Sure!") from Szarkowski. Someone else asked why there had been no mention of work subsequent to the Photo-Secession. They got no answer at all. I asked Harry Lunn to state his position on the persistent rumors of cartels, price-fixing, and other such chicanery, practices which have been rampant among some dealers in vintage photographic material for quite a while now. Lunn would only say that such things happen. I also asked the panelists to enunciate some bare minimum ethics that photographers and photography collectors could expect from dealers and museums. Not one panelist was willing to do so.

In fact, none of the significant issues involved in "collecting the photograph" were explored, save by Nathan Lyons. There are many

questions which might have been addressed; these questions were not only unacknowledged and unanswered, but avoided by the panelists. The symposium did not live up to its own promises, and at $50 a ticket was in fact a blatant rip-off. *Art in America* must certainly be held accountable for this; some apology and explanation is owed by the magazine to the photography community.

But the anger which seethed in that hall was generated by more than the triviality and ineptitude of this particular fiasco. It was only a hint of the long-suppressed sense of outrage and injustice the photography community feels toward the art establishment, which has ignored photography for so many years and is now sniffing around the medium only because there's something to be had from it. It was grotesque to hear Janis, in her opening remarks, apply the terms "heroic" and "passionate" to collectors rather than to artists. It was painful to hear Peter Bunnell talk peevishly about the problems of preservation with which curators have to deal because photographers now frequently use unorthodox combinations of materials in their works. Janis apparently has no sense of proportion; Bunnell appears to be losing his.

There, I think, is the crux of the matter. Photography as a creative medium and a communicative vehicle is no more (or less) diverse, vital, and important than ever. Yet the medium's public image is going through a major transition, from bastardy to legitimacy. With legitimacy comes certain kinds of attention, prestige, money, and power. And so the photography community now has the chance to observe and make note of the art world's carpetbaggers, who are all too willing to forget their recent disdain for the medium. And the photography community also has a chance to discover who within its own ranks is truly committed to the medium and who can be bought. It already seems that, in too many cases, as George Bernard Shaw once said, all we are arguing about is the price.

The Indigenous Vision of Manuel Alvarez Bravo

Popular Art is the art of the People.

A popular painter is an artisan who, as in the Middle Ages, remains anonymous. His work needs no advertisement, as it is done for the people around him. The more pretentious artist craves to become famous, and it is characteristic of his work that it is bought for the name rather than for the work—a name that is built up by propaganda.

Before the Conquest all art was of the people, and popular art has never ceased to exist in Mexico. The art called Popular is quite fugitive in character, of sensitive and personal quality, with less of the impersonal and intellectual characteristics that are the essence of the art of the schools. It is the work of talent nourished by personal experience and by that of the community—rather than being taken from the experiences of other painters in other times and other cultures, which forms the intellectual chain of nonpopular art.

MANUEL ALVAREZ BRAVO

The resonance of credo is unmistakable. Coming from a photographer, these words* do not proclaim a personal achievement, but they do indicate his aspirations for photography. Yet Manuel Alvarez Bravo, still little known outside his native country and the professional world of photography, has in the past half-century forged a body of work precisely to meet such standards: fugitive, sensitive, personal, nourished by experience, deeply rooted in his culture and his people.

For an image-maker whose work has been known to and admired by Henri Cartier-Bresson, Edward Weston, Paul Strand, Diego Rivera, and André Breton, remaining obscure after fifty years of work in his chosen medium is no mean feat. One cannot help but suspect that to some extent this is self-imposed, born of a "fugitive" or reticent nature and a consistent avoidance of personal publicity. Insofar as it appears to be voluntary, I find myself loath to violate that privacy.

* From *Painted Walls of Mexico: From Prehistoric Times until Today*, text by Emily Edwards; photographs by Manuel Alvarez Bravo; foreword by Jean Charlot; Austin and London, 1968, p. 145.

Artforum, April 1976.

Yet there are other factors to consider. One of these is his remarkable absence from all the standard reference works on photographic history (except for Peter Pollack's *Picture History of Photography*, wherein he is mentioned only in passing and mis-indexed as "Alvarez-Bruno").* Some attention seems in order, if only to acknowledge what has been achieved. Additionally, his work assumes that photography is an explicitly demotic visual language, to whose fullest progressive range he is committed.

This is not to be understood as "socialist realism" in any sense. Alvarez Bravo's imagery does not deal in stereotypes; his awareness of and response to the ethos of Mexican culture is far too complex and multi-leveled to permit such over-simplification. There is a commitment to people on the lower social strata which is inherent in the persistent address of Alvarez Bravo's vision to their experience, and implicit in his uninterest in the middle and upper classes. Certainly this is intentional, and emblematic of his politics. But the work is free of slogans and generalities. Viewers of photographs may tend to generalize from them—sometimes at the photographer's instigation, often independently, and always at their own risk. But one of photography's unique functions is to describe particulars. That aspect of the medium is essential to Alvarez Bravo, for he uses photography as a probe, an incisive tool for uncovering the heart of a culture embodied in the individual people who form its base.

In referring to photography as a demotic language, then, I am not suggesting the establishment of some simplified, standardized politico-visual code and its imposition on all those who would communicate through photographs. Put it this way: there are many dialects at the disposal of the photographer; his/her choice thereof is also a choice of audience. With Alvarez Bravo, we have someone who—to extend the linguistic analogy—is fluent in both Mandarin and Cantonese, but chooses the latter to convey his messages.

That is an illuminating and instructive stance for a photographer to adopt. It merits scrutiny at this juncture because the definition of photography is currently being reshaped by a variety of cultural forces. One of those forces is the contemporary art world, whose relationship to photography at present might best be described as carpetbagging.

* Peter Pollack, *The Picture History of Photography: From the Earliest Beginnings to the Present Day*, New York, 1969, pp. 564, 702.

Something may be learned by assessing the art world's dominant theory, an essentially Mandarin formalism, in light of an approach to photography which is integral to that medium and at the same time directly contradicts the postulate that "in the last analysis the main subject matter of art is art."

That contradiction is quite explicit in the statement from Alvarez Bravo quoted at the beginning of this essay. We are face to face, not with a naif artist, but with an intentionally indigenous vision.

The distinction is significant. Like his craftsmanship, his sophistication conceals itself. Yet it is apparent—from images such as "Somewhat Gay and Graceful" and "Good Reputation Sleeping"—that he is adept in both the responsive mode, as in Cartier-Bresson, and the directorial mode of photography, as in Meatyard. Other images ("The Crouched Ones," "And By Night It Moaned," "Absent Portrait," for example) indicate his grasp of the medium's translative capacities—the exploitable differences between what is in front of the lens and what the combination of camera and film will or can be made to register. His sense of formal structure excited Edward Weston, most especially his "Boy Urinating." His recognition of the camera's versatility as a visual means for creating and describing symbolic relationships can be seen in photograph after photograph: "Sympathetic Nervous System," "Ladder of Ladders," "The Sign," "Another Sign." In works such as "Optic Parable" he demonstrates that he is fluent enough to create elegant, intricate puns—which James Joyce termed the highest form of language.

In short, his imagery displays highly conscious formal underpinnings, and he shows tectonic kinship with other workers in his medium. There are connections with Aaron Siskind and Brassaï to be found in his studies of walls. Weston, with whom he corresponded at Tina Modotti's instigation, surely affected him. He shares Clarence John Laughlin's fascination with graveyards. Paul Strand compared him to Eugene Atget in his love of place; the Czechoslovakian surrealist Josef Sudek is another parallel in that regard. To this list I would feel impelled to add Robert Doisneau, Brassaï again (though from a different angle), and most of all André Kertesz: all three have in common with Alvarez Bravo a responsiveness to nuances of human gesture and interaction.

Aside from his portraiture, Alvarez Bravo's images of people are

quite unlike the posed, stylized studies of a Bruce Davidson or a Paul Strand. Rather, they are swift, sharp glimpses of the physical manifestations of personal identity, outlined with clarity and without cynicism. Though sometimes ambiguous, as such manifestations can be, their duality is not exaggerated by the photographer. Like Doisneau, Brassaï, and Kertesz, Alvarez Bravo is able to make the viewer feel fully present at events by his attunement to other people's rhythms. Himself falling in step with the tempos of their lives in the process of making his images, he thereby allows the viewer to stand awhile in someone else's shoes, observant but unobserved. His concentration is on those instants when human beings—usually alone or in small groups—reveal through their bodies something distinctive about their relationship to the earth, to others, or to themselves.

Alvarez Bravo is anything but unaware of art forms outside his own. He is an authority on Mexican mural art (which he has photographed officially for many years). His peers are the modern masters, Rivera, Orozco, Siquieros, etc., who often posed for him. His work has long been known to the surrealists, and he has surely learned from them in turn. (Witness his use of titles that do not merely reiterate the image contents but instead specify and/or extend their metaphorical implications.)

Yet the major force which has shaped his imagery has not been art, but culture. The themes around which his work revolves are quintessentially Mexican, motifs so traditional as to be more unavoidable than chosen. What are his predilections? Dogs and dreams, ladders and walls, birds, people, earth and death.

It is difficult, given a body of work as extensive and interrelated as Alvarez Bravo's, to single out individual images for examination. Ideally, one should be able to refer the reader to a wide, representative cross-section. At this point, however, that is unfeasible; there is only one monograph on his work in print,* containing a scant thirty-three reproductions, published to accompany a small exhibition surveying his enormous output which toured this country briefly in 1971. A

* Fred R. Parker, *Manuel Alvarez Bravo,* Pasadena Art Museum, Pasadena, California, 1971. The only other extensive monograph on his work, generally unavailable at this point, is: *Manuel Alvarez Bravo: fotografías 1928–1968;* Instituto Nacional de Bellas Artes. Mexico, D.F.: Comité Organizador de Los Juegos de Las XIX Olimpiada, 1968. Text by Juan Garcia Ponce. Exhibition catalogue with 86 reproductions.

1975 exhibition at the Witkin Gallery in New York City contained a selection of new work along with more familiar images, but was unstructured and (through no fault of the gallery's, surely) hardly exhaustive. Let me, then, discuss a few images for what they might suggest of the whole.

I begin with one of a man lying face upward on the earth. From the sheer volume of blood which has poured out of his mouth and nose to spatter his clothing, pool under his head, and soak into the soil, I would assume that he is dead. However, the small sharp gleam of light in the corner of his left eye suggests in a most disconcerting way that his life continues. The cause of death is not apparent; it may have been external violence or internal hemorrhage. He seems at rest; his body is stretched out, his expression is not fearful or contorted. The photograph brings the viewer close to him, close enough to study his profile and note the details of his clothing—but not so close as to cut him off above the groin or to amputate his slightly curled left hand.

Aside from the man himself, his blood, and the earth, there are no other "contents" in the image, except for some dim folds of cloth in the background and the hint of another's hand or foot in the upper left corner. Instead of making his image at more of a distance (thus distancing the viewer equally from the event), or portraying the body in relation to other people at the scene (giving it more of a public quality), or looking down from above the body (with the overtones of superiority/triumph that would add), the photographer's choice of position places the viewer at the dead man's left side, the side closest to his heart, inches from his hand, crouching or kneeling—the place of a doctor, a friend or relative, a mourner.

I have always felt a powerful upward thrust in this image, as though the prone body were on the verge of rising horizontally from the ground. With the image turned on its side so that his head is at the top, the man seems quite alive and intent, his body rushing forward into space like Mercury's. Perhaps this response has to do with the counterpoised diagonals of the image's structure, or with the almost aerodynamic flow of his hair and blood.

So, by itself, the image suggests the unexpected death of a seemingly average young man, a death accepted with a certain equanimity; it indicates the cyclical inevitability of the body's return to the dust by depicting that quite literally; it accepts that cycle of the flesh stoically.

Yet the vitality of the figure and of the image itself implies some transcendence of the spirit. By itself, we might think of this image as a memorial.

But the image has a title: "Obrero en Huelga, Asesinado" ("Striking Worker, Assassinated"), 1934. The title is strictly—and, for Alvarez Bravo, rigorously—informational. The information it offers us could not be deduced from the image. We might have guessed that the man was a worker; we could not have known that he was on strike, nor surely that the cause of his death was political, not accidental. Yet this title does not contradict the impression of the image; instead, it elaborates it by providing the context in which to ponder this particular death, a context in which the symbolism of the image echoes, reverberates, expands. From the combination of the two—the visual data in the image, the verbal data of the caption—we are free to write out our own equations.

This is only one of many images by Alvarez Bravo in which death is the central issue. His work is full of tombs, cemeteries, coffins, the cadavers and skeletons of various creatures, and the religious/ceremonial artifacts with which mortality is celebra.ed in Mexico. If mortality—seen as the return to dust—is central to Alvarez Bravo's art, then this image is surely the epicenter, the one which brings him (and us) closest to the moment of transition from life to death. From it radiates outward much of his imagery: the diverse visions of death; people and animals lying on the ground, drawing sustenance from their soil in order to nourish it in turn; people laboring on or in the dirt, always in contact with it.

The photographer offers no escape from that connection. Walls pretend to divide and control the earth, but they continually crumble, reminding us of their earthy origin, or—as in "Mr. Municipal President," 1947—diminish the human protagonist. Ladders offer a way of climbing, but only for a time: they are always connected to the earth, often at more than one end, as is indicated in the ironic "Ladder of Ladders," 1931, in which a ladder leads upward to a child-sized coffin on a shelf. Only birds get to leave the earth, and even they are eventually snared by death (as in "Twilight Bird Swayed by the Wind," 1932), brought down at last.

If there is no escape, there is at least one release: dreaming. It is another recurrent motif in Alvarez Bravo's work: "Dreams Are For

Believing (Quevedo)," 1968, "Dogs Bark While Sleeping," 1966, "Good Reputation Sleeping," 1938, "The Nest," 1954, are a few of the images in which it figures. But we might use "The Dreamer," 1931,* as an exemplification, if only because it dovetails so precisely with "Striking Worker, Assassinated."

In this image also a man lies face upward on the earth. There is grass around his head and feet, but he appears to be on top of a ledge, or perhaps the uppermost of several stone steps. He is lying on his right side. In many ways he resembles the striking worker: for if he is unshaven and poor, he is also at rest, facing the sky, hair flowing back to touch the ground. They even look somewhat alike: about the same age and size.

Through the camera we are positioned on the same level as the dreamer—or, rather, he being at our eye level, somewhat below him. We are also somewhat further back from him than we were from the worker; the difference is no more than a foot or two, but it is enough to show him full length and also enough to insulate his reverie from the intrusion of camera and photographer.

Unlike the worker, who stares with open eyes into a harsh, flat light, the dreamer's eyes are closed and brushed, like much of his body, with a gentle, mellow glow of sun. Perhaps it warms him enough to make him dream of making love; perhaps that is why his left hand (again, unlike the worker's) is tucked between his closed legs, pressed against his sex. It is that possibility, at least, which Alvarez Bravo asks us to consider.

So they are different, the worker and the dreamer; and yet they are alike. I think it is important to recognize that Alvarez Bravo acknowledges both these realities in his work. Each person he portrays is an individual, and the photographer gives to each one his or her personal identity through his attunement to the subtleties of gesture, posture, and expression. Yet they resemble each other, bound together by their indigence and their share in an ancient culture.

The photographer's sense of the complexity of this issue is summed up in another image. It portrays two men at work on a beach. They stand face to face, the one on the left reaching for a basket of sand on

* This particular image has a historical forebear in O. J. Rejlander's "The Bachelor's Dream," and at least one offspring in the third image from the last in Ralph Gibson's *Deja-Vu*.

the head of the other. Were it not for that difference in gesture, they could be mirror images of each other: their hats, their short pants, their bodies, their stances are identical. One can imagine them as twin brothers, or children who grew up together as friends in the same community, under the same circumstances, and who have grown so like each other from being polished to an identical smoothness by the same shared experiences. It seems unlikely that they could come to differ radically from each other, that their lives could ever change. Yet they enact this eternal Sisyphean ritual with the assurance and grace of solo dancers. Alvarez Bravo names them "Los Mismos"— "The Same."

Immersed in culture, yet devoid of sentimentality, Alvarez Bravo requires that his work have emotional and intellectual accessibility as well as formal logic, continuity, and growth. His imagery may be fugitive, but it is not secretive.* Though he speaks in the vernacular with eloquence, his work makes no plea, sounds no alarms over transient plights, and polemicizes no issues. One cannot imagine him being so simplistic and humorless as to romanticize the Mexican people by analogizing them with the suffering Christ, as Paul Strand did in "The Mexican Portfolio." Perhaps only an American—from a culture merely four centuries old, built on stolen land—could be so naively ethnocentric.

The people of Manuel Alvarez Bravo's images bear as their birthright (often their only one) the knowledge that they will feed their native land with their toil and their flesh as their ancestors have done back into pre-history.† That is their burden, and their badge. Despite what economics may indicate, no matter what politicians and businessmen and the military may enforce, the land—and the culture—is theirs. Death is the equalizer.

But life is a dream.

* It seems pertinent to note, in this regard, that his style as a print-maker is neither bravura nor neutral. His prints as objects are carefully crafted, unassuming, and comfortable to be around. His images are never so dependent on the silver print as a vehicle that their poetry is lost in the translation into the more easily disseminated form of halftone reproductions.

† Alvarez Bravo's own connection with the same land pervades his images. He says of himself, "I was born in the city of Mexico, behind the Cathedral, in the place where the temples of the ancient Mexican gods must have been built, February fourth, 1902." (In Parker, p. 48.)

On Plagiarism

Plagiarize: to steal and pass off (the ideas or words of another) as one's own; use (a created production) without crediting the source: to commit literary theft; present as new and original an idea . . . derived from an existing source.

Webster's New Collegiate Dictionary

My first encounter with plagiarism took place during my junior year in high school. The institution in which I was incarcerated during my adolescence was one of New York City's science-oriented schools. Great stress was laid on grades and class standing, but English was considered nothing more than a necessary evil. Not surprisingly, one student, given the assignment of writing a short story (a task for which nothing in the curriculum had prepared him), copied one out of a magazine and handed it in to his English teacher.

She was so impressed by the story that, without asking his permission, she submitted it to the school literary magazine, which accepted it and published it. I read it there; it was unusually well-written—and also vaguely familiar. (As it turned out, I had come across it myself in the magazine from which he cribbed it.) I gave it no more thought, though. However, the literary magazine was excited enough by it to submit it to the city-wide high school fiction competition, and from there it went to the state-wide contest. Not until it reached the regional level, en route to the national finals, was the fraud discovered.

None of us (save, of course, the unfortunate student responsible) knew any of this until one winter morning. Our principal—a vicious little martinet unaffectionately known to all as "The Flea"—came on the loudspeaker to denounce the culprit, who was forced to confess and apologize to the entire school over the airwaves and then immediately expelled. The pledge of allegiance followed.

The incident remains vivid in my memory. Partly, I'm sure, because the punishment seemed unduly harsh: the student obviously had no intention of claiming credit for another's work, had merely tried to avoid an assignment, and had watched in horror as a minor and basically private deception grew into a major public one and an embarrassment for the school. But it also impressed me deeply with the

Published in two parts in *Camera 35*, April and May 1976.

seriousness with which the scientific community (of which we were all putative, pubescent members) took the issue of plagiarism.

Subsequently, in the course of studying English literature, I learned of countless other instances of plagiarism, and found that the literary community took it as seriously as did its scientific counterpart. I also came to understand more fully—through the process of doing research work on my own—the energy demanded by scholarly labor and the importance of a just claim to authorship as the rightful reward for that work.

Yet, at the same time, I was also learning to be a writer, and discovering that there were areas in which it was not so easy to draw those same lines. Certainly it would have been unthinkable to sign my name to anyone else's work, or to sign someone else's name to mine. But what was the difference between plagiarism and legitimate influence? Those of us in the advanced seminars on Lawrence or Hemingway or whomever inevitably produced mimetic fiction for at least a semester thereafter. There was a period when I wrote poetry like Browning, another when I wrote prose like Beckett. Participants in the writers' workshops even found bits and pieces of themselves cropping up in each other's work.

From that experience—and from subsequent time spent as a performing musician and photography critic—it has become clear to me that creative activity of any sort often involves a form of cannibalism. Aside from those few who grow and thrive in isolation, most artists have peers and teachers and influences, whom they devour, digest, and regurgitate. Sometimes this voracity decreases at the end of their "student" period, but frequently it continues for entire lifetimes. This seems a natural and inevitable process, a kind of creative recycling. It is possible to examine the work of, say, Ralph Gibson, and find bits and pieces of what he ate from Manuel Alvarez Bravo, Bill Brandt, Robert Frank, and André Kertesz; it is equally possible to look at the work of dozens of younger photographers and observe what they've consumed from Gibson.

Minor White's students tend to make sumptuous prints of large-format negatives of the natural landscape; Garry Winogrand's usually make neutral prints of small-camera snapshots; none of that is surprising. Influence and imitation being unavoidable, they are only to be criticized if and when they prove to be deliberately constructed

and/or inescapable traps. As Marvin Slobodkin says in his book *Inside Dope,* "If you have to sing your life in another man's style you will come to think there is only one way to sing."

Cannibalism is one thing; plagiarism is quite another. Creative cannibalism is organic and cyclical; plagiarism is parasitic and unilateral. I am not at all sure that there is such a thing as "the art community"; it is easy to talk about but hard to take a census of. If there does exist a sort of fraternal order composed of those engaged in serious creative activity, it seems to me there are two obligations to which its members are bound. Both are grounded in self-interest. One is to defend each other's work against censorship, at all costs; the other is to protect it from plagiarism.

I bring this up because this seems an appropriate time to begin grappling with an admittedly thorny but increasingly urgent question. Plagiarism in the visual arts has never been as clearly defined as it has in the literary world. What we have, in lieu of such definition, are the copyright statutes, which—in typically American fashion—deal with the legalities and avoid the creative and ethical ramifications. The optical/chemical relationship between photographic images and their contents* is such as to increase the pertinence of those issues, as the following incidents—all drawn, as they say, from real life—should make clear.

1. Someone designs an object for humble household use, and for mass production and commercial distribution. This does not prevent him from creating it with craft, intelligence, and artistry. The result is a combination of efficient function and elegant abstract form. A photographer takes that object, stands it on end, and photographs it against a flat black background. He does not bother to find out the name of that object's maker; he does not even bother to mention the name of the company whose craftsmen produced it. He simply signs his own name to it, presents that image for consideration (and sale) in a context which implicitly valorizes his activity rather than that of the object's maker.

2. A printmaker cuts a reproduction of a photograph from a magazine. He makes a silkscreen of it in which it is enlarged and repeated

* By "contents" I mean all the particular things included in an image, as distinguished from "content," which can be defined as the photographer's descriptions of the relationship(s) between those things.

four times in four different colors. He does not bother to find out the name of that image's maker.

3. A painter cuts a photograph from a magazine. He makes a transparency of it and projects it, much enlarged, on a canvas. Painstakingly he copies it in oils, line for line, tone for tone.

4. A photographer photographs another photographer's photograph. From his negative he makes solarized and flashed prints which are tonally different from the original and in which much detail is lost, but whose basic forms are still easily recognizable. He does this with anonymous, "found" images, which are fairly readily identifiable as such. He does it with the works of known dead photographers, in which case he identifies the photographers and titles his prints as "homages" to them. He does this with the work of living photographers, in which case he does not identify or accredit them at all.

5. A photographer photographs a group of photographs on exhibit at a major museum. He makes prints of his photographs of those photographs. He puts them into a limited-edition portfolio which he offers for consideration (and sale) in a context which valorizes his activity. He does not give the original image-maker explicit credit; instead, he incorporates onto his title page a cutesy pun on the name of the artist and the pseudonym of a famous colleague of his.

These are all actual instances in which artists have incorporated the work of other artists into their own images. Many more could be cited, but these seem typical of various stages along what might be thought of as a sliding scale. Consider (and, if you can, answer for yourself) these three questions about each of those instances:

1. How ethical has this image-maker been in relation to the maker of the original work which was used?
2. How creative has he/she been?
3. To how much of the final work can he/she lay claim?

The first image is Edward Weston's "Bed Pan, 1930." To make this image, Weston took a metal bed pan, stood it on end, placed it against a flat black background, lit it from the front, and photographed its profile. The result is, inarguably, a lovely image. The question I would ask is, to whom is its elegant lyricism attributable?

This photograph is not about the bed pan's relationship to anything else in the world. Its function is not described, and it is not placed in

a new context to give it symbolic definition. It is presented essentially without context, abstracted, a "discovered" form.

But "discovered" by whom? In fact, someone designed that bed pan intentionally. Of the many possible designs for it, on a functional level, he or she created one with remarkable grace and coherence. Unless we are to assume that this anonymous designer was either blind or ignorant, the linear rhythms which Weston employs to great effect in his image are the result of the conscious craft and creative energy of someone else.

Interestingly, Weston indicates in his *Daybooks* that he made this image shortly after seeing Brancusi's "Bird" for the first time. The kinship between the two forms is obvious, and Weston deserves credit for recognizing it. But what about the designer who had the genius to create a functional object with all the sweep and power of an abstract sculpture?

I think it is safe to say that if Weston had photographed Brancusi's "Bird" in the same way as he did the bed pan, he would not have shown it without giving credit to Brancusi, and indeed might not have presented it at all in exhibits of imagery for which he could take full and unequivocal credit. Many photographers have photographed sculpture: Charles Sheeler made superb studies of Greek, Roman, and Egyptian works as a staff member of the Metropolitan Museum, Brassaï documented Picasso's three-dimensional works, Hans Namuth has made fine images of much contemporary sculpture, and there are many others who could be cited. None of these image-makers has ever presented the results of these labors as anything more than collaborations, with their own contributions to the "laboring together" explicitly secondary to the original work and *ex post facto*.

So, when a photographer photographs someone else's work of art, it is considered appropriate for him or her to identify its maker, in acknowledgment that part of the resulting image's impact derives from the creative energy and intelligence embodied in the original work on which it is based. In this case, however, Weston made no such identification. He simply signed his name to the image, and proceeded for decades to present it and accept praise for "finding" beauty even in a "lowly" bed pan, discounting the designer who in fact put it there.

This is not an uncommon practice in the arts, and certainly not in photography. (One of the useful points Susan Sontag made in her

generally confused series of articles on photography is that the medium is often used for purposes which are essentially acquisitive rather than generative.) The usual justification for this among photographers is three-fold: (1) Anything and everything is legitimate grist for the image-mill. (2) Anything which is unsigned is anonymous and is up for grabs by anyone who wants to incorporate it into his/her work. (3) Anything which has a functional purpose is automatically deprived of any claim to status as art and thereby loses the protection to which it would be entitled as creative work.

All of these assumptions are open to question. The first eliminates the artist's ethical obligations to the world around him. The second is a catch-all generally used to cover laziness. (The bed pan, for example, is not anonymous, merely unsigned. Weston could have found out the name of the company which manufactured it and, through them, the name of the designer with whom he collaborated on the image. He preferred not to acknowledge the collaboration. Had he come across the Brancusi, unsigned, in a sculpture garden, would he have been entitled to treat it the same way?) And the third is ridiculously elitist, especially coming from a photographer.

The photograph has long been considered a functional and anonymous image/object. After many years of struggle, this attitude on the part of artists, academicians, and the general public is at last being altered. As Paul Byers says, "Cameras don't take pictures." Photographs are made by human beings, and are naturally invested with whatever craft, intelligence, and creativity their makers can muster.

It used to be taken for granted that any artist—a collagist, a printmaker, a painter—was free to use any photograph he/she found anywhere* in any fashion whatsoever, not only as food for thought, but as an element within a work, as the actual imagistic basis of the work, or both.

Many artists have done so over the years; the second and third instances above would fit a number of cases. Recently, however, photographers have begun to object to this practice, strenuously and sometimes legally. It appears that they have a solid leg to stand on in this regard. According to report and rumor, both Robert Rauschenberg (who makes prints involving collaged photographs "found" in

* Except when presented as an "art object"—signed and hung in a gallery.

magazines) and Andy Warhol (who makes screen prints and paintings based on the repetition of "found" photographs from newspapers) have chosen to settle out of court with photographers whose images they've employed in their works without permission and/or recompense. A number of Photo-Realist painters have run into the same problem, with the significant result that most of them now copy their own photographs in oils.

But photographers cannot have their cake and eat it too. If they seek support for the creative and economic autonomy of their work, it is incumbent on them to grant that same respect to work in other media, without hierarchical excuses. And, of course, they should grant that respect to work in their own medium—because autonomy, like charity, begins at home.

The problem is particularly acute in photography because the medium makes it possible to appropriate not only the idea(s) in another's creative work but even its actual physical appearance as an image/object. As a copying device, the photograph is unexcelled among the graphic arts, and nowhere is its illusion more effective than in photographic copies of photographs. Ironically, the photograph is perhaps the most easily forged image form around.

For as long as there have been photographs, there have been photographs of photographs by famous and even little-known photographers. Positives and negatives are continually being copied and reprinted: we could turn to Ansel Adams' prints from Jacob Riis's plates, Cole Weston's prints from his father's negatives, George Tice's faithful platinum versions of Frederick H. Evans' lantern slides, Lee Friedlander's luminous contact prints of E. J. Bellocq's Storyville images, and the Library of Congress' prints of images by Mathew Brady, Russell Lee, Walker Evans, Ben Shahn, and Dorothea Lange as examples.

The intent, in most of these cases, is not the generation of new works but the restoration and preservation of physically deteriorating imagery, usually with increased accessibility and thus the widening of its audience as a corollary motive. The photographers who prepare these facsimiles and revisions tend—appropriately—to be quite modest in assessing their own contributions to the resulting imagery, since their act is essentially a tribute of craftsmanship paid to the creative longevity of another's already realized work.

In a related but somewhat different vein, there are photographers involved in rescuing, reviving, and reinterpreting (often drastically) images made by photographers who are anonymous and/or dead. Everything from old glass-plate negatives dug up in attics to what's on top of the discard bins in modern processing concessions is being investigated and recycled by contemporary photographic image-makers. This seems to me to be legitimate. There are vast amounts of photographic imagery to which there is no way of establishing authorship and/or no one to lay claim. Photographs which are lost or forgotten become part of the midden heap of potential "found" imagery, which should be open for rummaging to all. (Assuming, of course, that the right to privacy of the original photographer and his/her subjects is respected.) There are hundreds of image-makers poking around among these visual potsherds at present; Bobbi Carrey, Robert Heinecken, and Alisa Wells are only a random sampling of artists who have exhibited and published work of this sort.

But I have come across two photographers who incorporate other photographers' images into their own in ways which exceed the limits described above to an extent which I find disturbing.

The first of these is Van Deren Coke. For years now, Coke has been making "flashed" and solarized prints of other photographers' images. Initially, the material he worked from was truly "found": old glass-plate negatives, ambrotypes of his family, and the like. Then began a series of "homages," unique prints made from copy negatives of images by well-known photographers who are no longer living; I recall having seen solarized Eakins, Weston, and Meatyard images, among others, in various exhibits of Coke's work. Usually, Coke has titled these prints of his after the makers of the original images.

But I have also seen Coke's name on solarized copy prints of photographs by living artists—Emmet Gowin and Les Krims come to mind— without any credit given. Though it may be old-fashioned of me, I find this a questionable practice. The solarization alters the image dramatically, destroying information and shifting the tonal relationships, but the primary forms out of which the image is constructed remain and are recognizable. In images based on original photographs dating from well before the interpreter's era, there are usually signals (such as technical or informational anachronisms) to indicate the mixed sources of the new image. In images based on well-known works, the viewer's familiarity with the original makes the borrowing obvious.

But when a less familiar image by a young photographer is thus reinterpreted, it is not inconceivable that the imitation of his/her image will reach the audience before the original.

The second, related act is that of L. R. John, who created his "Series Man Rose" by photographing Man Ray's photographs on the walls of the Museum of Modern Art during an exhibit and making a group of prints which he exhibits and sells in limited-edition portfolios. John's prints are of course different to some extent from Man Ray's, by necessity: they are muddier tonally, much detail has been lost, they include faint reflections from the glass frames and are often slightly distorted as a result of shooting from an angle to the picture plane. Additionally, in his own imagery John affects a grainy printing style which he has applied here as well. The result is not, to my eyes, a significant reinterpretation of someone else's imagery even to the extent that Coke's might claim to be; from one standpoint, they could be quite adequately described as mediocre forgeries.

From another standpoint—Larry John's—"Their intention is not to defile or blaspheme but to restate a man in his spirit, humor, and above all freedom, with joy in a/an (seemingly) impious act, that which is Man Ray." That's a very self-serving statement, by the way. Defilement, blasphemy, and impiety are powerful acts requiring strength and courage; copying someone's work off the wall of a museum is . . . copying someone's work off the wall of a museum.

The question to ask here is where John has lived up to his own announced intention. Does the work "restate a man in his spirit, humor, and above all freedom, with joy"? Not in any meaningful way that I can see. Instead, it attempts unsuccessfully to align L. R. John with Man Ray, and fails to validate its presumptuousness.

Coke's work (according to the introduction to his monograph by Gerald Nordland, director of the San Francisco Museum of Art) has a similar rationalization. "Coke's use of another artist's photograph," writes Nordland, "has overtones of Duchamp's *readymade* esthetic in which the artist confers on an existing work the status of art by his recognition of its unique expressive properties. . . ." Is it not equally presumptuous for Coke to treat imagery by Thomas Eakins, Edward Weston, Emmet Gowin, and Les Krims as though it could not attain "the status of art" until Coke recognized its unique expressive properties?

Not too long ago, an artist wishing to express something altered a

Picasso on display at a museum. His defense was that he was "collaborating" with Picasso as a fellow artist. A number of other fellow artists made a public declaration that it was the right of every artist to be free from the threat of unilateral "collaboration" or "joining." That, I think, is the issue here. Involuntary collaboration is another way of saying slave labor. I believe that collaboration should be voluntary, and that some debt—both annotative and economic—is owed to a living photographer (or a dead one's estate) when his/her imagery is knowingly incorporated into other works or obviously used as the basis for same—especially if the "new" work is for sale. Imitation may be the sincerest form of flattery, but the merchandising of imitations of other people's work is parasitic. I'm sure Larry John and Van Deren Coke would disagree with that term. I'm sure they would prefer to call it symbiosis. But if this is symbiosis, what have Ray, Gowin, Krims, Meatyard, Weston, and Eakins gained in the exchange?

As I hope I've made clear, this is a troublesome issue, and one which I have not fully resolved. I would be interested in hearing from anyone—including the photographers cited—with strong opinions in either direction.

"Violated" Instants: Lucas Samaras and Les Krims

The most provocative work that I've seen done with the SX-70 camera has come from Leslie Krims and Lucas Samaras, both of whom have recently published books of their imagery produced via this medium-within-a-medium.

The SX-70 as an image-making device is uniquely challenging precisely because it is so restrictive. It is as foolproof a system as possible, intentionally devised to produce acceptable photographic prints every time. The camera's operator has a minimum of creative control over the appearance of the prints which the camera spits out, and no choice over the format: it's a 3¼-inch square every time. Thus it poses a unique test to image-makers, viz., how can its integrity be violated?

Most of the options available for over-riding the camera's built-in controls—exposure and focus being the most obvious—are not particu-

Camera 35, July 1976.

larly useful from a creative standpoint; tricking the system by over- or under-exposure, or by misfocusing, simply results in unreadable and inept images. The format, too, is inviolable: one cannot crop or dodge, tone, or enlarge. The image is not accessible to traditional photographic craftsmanship. In a sense, the SX-70 image is an arena, an enclosed space within which one human intelligence can choose to do battle with a rigidly structured photographic process.

What is intriguing about the recent work in this medium by Krims and Samaras is that they have come to it from radically disparate concerns as image-makers, and have produced unique and very different bodies of imagery.

In fact, aside from the camera itself they share only two things. One is a commitment to the directorial mode of photographic image-making; both of these artists stage events for the camera.

The other is a technique for the manual alteration of the SX-70 print. Both Krims and Samaras have discovered that the pigmented chemical batter sandwiched between the plastic surface of the SX-70 print and the opaque back remains soft and workable for almost twenty-four hours after exposure. By pressing on the print with a stylus (blunt-tipped so it won't pierce the transparent surface), these pigments can be moved and mixed, manipulated in a variety of ways. Irrelevant details and unnecessary information can be scrambled and eliminated; elements in the original image which belie desired illusions can be removed; lines and forms can be altered in fantastic and grotesque ways without destroying the appearance of photographic verisimilitude. The print as an artifact retains its technical virginity, and thus the presumption of photographic innocence; the image, as idea, plays against that presumption. The subversion of expectations is central to all the contemporary arts, photography among them.

That is what Samaras and Krims have in common. What separates them fills two books.

As I indicated in a brief previous discussion of Samaras ("Autobiography in Photography," November 1975), he is nominally an artist, not a photographer. However, he has consistently used photographs in such works as boxes, sculptures, films, and constructions, and by now has built up a considerable body of strictly photographic imagery through the exclusive use of the Polaroid system. The subject matter is always himself and his personae; all his photographs are self-portraits

in a quite literal sense. They are narcissistic, self-mocking, introverted, and flamboyant.

There are forty of his "Photo-Transformations" included in the book, in full color; they are reproduced one to a page, considerably enlarged (roughly 9 x 9 inches). The book also contains twenty smaller black-and-white illustrations of related works by the artist, several essays on his work in this form, and a chronology. Thus, though the book is essentially the catalogue of a traveling exhibit organized by the California State University, Long Beach, it is also a monograph on his SX-70 work and a companion piece to the previously published *Samaras Album,* created with the earlier Polaroid system. (The book, titled *Photo-Transformations,* was published by E. P. Dutton in 1975.)

His approach to the SX-70 differs markedly from the methodology he evolved for his first work with Polaroid. Aside from the manual alteration of the emulsion, Samaras now makes extensive use of a group of home-made filters (red and green mylar, a piece of broken blue glass—shades of Norman Rothschild!) to produce a lurid, hallucinatory color palette which he employs in a painterly fashion. Most of the images are close-up portraits, with his head filling the frame; usually, all but one feature—the ear, the nose, the eye, or the mouth—has been modified or obliterated. The results are almost uniformly horrific: screaming mouths suspended in a primal ooze, yolky eyes staring balefully. Often his body seems to be dissolving as you watch.

The mood of these new images seems grimmer to me; though they are no less inventive and virtuosic, they are not so playful as their predecessors. Their irony now shades into pain. Yet the most recent of these images, which appears on the cover, is almost joyful, suggesting a recent transformation within Samaras himself. It will be instructive to see where he goes from here.

Les Krims's *Fictcryptokrimsographs* (Humpy Press, 1975) is a logical outgrowth of his work over the past decade, but also a fairly radical departure therefrom. Until he began using the SX-70 in 1973, he had never publicly presented any work in color; all his prints were made on Kodalith paper (which he continues to use on other projects). In addition, his images—though based on situations, often elaborate, either set up by Krims or selected for their weirdness—were purely photographic, in that they were straight prints of unmanipulated single negatives.

So the work has a much different physical appearance from what preceded it. At the same time, the evolution of Krims's ideas has been consistent. He is a black humorist, obsessed with the anomalous and the perverse. Among his principal tools for exploring these phenomena are juxtapositional incongruity and the suspension of disbelief generated by the credibility generally granted to photographs. In this book—which, unlike his other publications, is a collection of single images rather than a sequence or suite—people are attacked by watermelons and bananas, women remove their breasts, milk is poured from the carcass of a chicken . . . all of it inexplicable but authoritative. The question to ask is not whether he's coherent, for he surely is, but rather, what language is he speaking with such fluency?

Krims's images have very rarely made "sense" to me; they are difficult to describe because their subject matter is usually their own precise absurdity. At the same time, they are quite pointed—not reducible to a single meaning, yet meaningful. The photographer has chosen to title almost all these new images (another departure from his standard practice to date), yet the titles do not direct us to literal interpretations, nor do the images rely on them. In an odd way they remind me of the titles used by Manuel Alvarez Bravo, the Mexican photographer. Though this is surely their only point of resemblance, Krims and Alvarez Bravo create titles to extend and amplify their imagery, not to explain it. A sampling of Krims's: "I Get a Headache from Listening to German Sounds," "The Affect of Kosher Pickles on a Gentile Woman," "Miniature Dining Room Double Breast Ensemble."

So I will not attempt to explicate these images further. They are perhaps best approached directly; almost all the writing I've seen about them has been oblique including my own and even the introduction to this book by Hollis Frampton, which is too thorny to be excerptible but which rewards the attention it requires. Like Frampton, I hope "to introduce strangers already favorably disposed to one another. . . ." That holds true for Samaras as well.

The SX-70 reduces its users to two essentials: thinking and seeing. What these books offer is the opportunity to watch two diverse and rigorous intelligences adapt an almost inflexible tool to their own visual ends. Strangely, I find myself thinking of Stieglitz's cloud photographs, made to demonstrate that his work did not depend on its subject matter for its power. Decades later, Krims was to state this in

another way: "The greatest potential source of photographic imagery is the human mind." Stieglitz might well disown Krims and Samaras as his inheritors if he were alive, and they in turn might not acknowledge him as a forebear, but the family resemblance is unmistakable.

Novel Pictures: The Photofiction of Wright Morris

The following essay was written in 1968, the year in which Wright Morris completed his photofictional trilogy by publishing *God's Country and My People*. The essay was submitted—by request—to one of photography's "little" magazines, where it apparently disappeared in their files, as it did in my own. Recently a carbon copy of it resurfaced, coinciding happily with a widespread renewal of interest in Morris' photographic activity.

This new attention being paid to Morris as an image-maker includes a presentation by Peter Bunnell and Jim Alinder at the national Society for Photographic Education meeting in Minneapolis this past spring; a 200-print retrospective exhibit of Morris' photographs, organized by the Sheldon Memorial Art Gallery at the University of Nebraska; and a fine catalogue of that exhibit, *Wright Morris: Structures and Artifacts, Photographs 1933–1954* (University of Nebraska Press, 1975), which contains almost one hundred reproductions, an extensive interview with Morris by Alinder, and other biographical information.

To date, the concentration in this re-evaluation has been on Morris as a photographer. Certainly he merits that, for his images are distinctive, powerful, and intelligent (though Alinder's assertion in the catalogue that Morris' photographs of the 1940s "will rank as the best of that decade" seems unnecessarily and indefensibly sweeping).

However, I believe now—as I did when I first wrote this essay—that the most unique and important aspect of Morris' accomplishment was its successful combination of photographs and words in ways never previously attempted, its exploration and re-exploration of his photographs as metaphors for his history and his experience. The trilogy which resulted is unparalleled in both literature and photography; it calls for consideration as a new form with its own integrity, rather than as a collection of photographs with incidental texts.

Camera 35, August–September 1976.

That was the intent of this essay, and since no one in the interven-
ing years has attempted such an assessment it seems perhaps even
more pertinent now than when it was first written. Aside from elimi-
nating one anachronism (*The Inhabitants* was not yet back in print),
I have not altered it significantly.

The steady rise of Wright Morris to popular and critical recognition
as one of America's finest contemporary novelists has effectively ob-
scured his early accomplishments in another medium: photography.
Also overshadowed, consequently, have been his pioneering efforts in
a visual-literary form best described as photofiction.

The simultaneous appearance of his two masterworks in this hybrid
form should do much to reawaken widespread interest in this sadly
neglected aspect of Morris' creative output. The newly published
God's Country and My People (Harper & Row) is his latest venture
into the (save by himself) unexplored territory of photofiction; *The
Home Place*, finally back in print after a hiatus of almost twenty
years (University of Nebraska Press, 1968), is, in a strange sense, less
its forefather than its younger brother. Together with *The Inhabitants*
(1946; reprint edition, Da Capo Press, 1973), his first photo-text,
these volumes compose a powerful triptych. Taken as a single, unified
statement—which, in effect, is what emerges from their interaction—
they unfold three successive stages in the evolution of one man's rela-
tionship to his roots, his land, and himself, as they are affected by the
photographic image.

Coming to terms with one's past is hardly an original literary
theme, serving as it does as the basis for a sizable percentage of all
writing. Morris began his own process of reconciliation quite simply
in *The Inhabitants*, a young man's vision of the Midwest, and specifi-
cally of Nebraska, where he was born and raised. In the text, he de-
scribed Nebraska less as a state than as a state of mind, shared con-
currently by all who have ever lived there (hence the title). It was
this psychological region, teeming with ghosts and ghosts-to-be, which
Morris sought to map in his prose and capture in his photographs.

In the formal sense, *The Inhabitants* was not an uncommon sort of
book (though an excellent sample of its genre), and its uniqueness
lay principally in the fact that its moving text and haunted photo-
graphs were the work of one and the same man. Though, in retro-
spect, it can be seen as a necessary prelude to what was soon to come,

no one could have predicted that, concentrating on the same theme—the continuity between and, moreover, the coexistence of past and present—and utilizing some of the same pictures, the author would move from psychic travelogue to novel.

Yet, though published only two years later, *The Home Place* is radically different, in both method and intent, from *The Inhabitants*. From the somewhat generalized, impersonal viewpoint of the latter, Morris shifted abruptly into the first person for *The Home Place*, abandoning the relatively dispassionate abstractions of his earlier work in order to focus with more narrow intensity on a single inner landscape—that of novelist Clyde Muncy (drawn semi-autobiographically), whose brief visit to his "home place" in mythical Lone Tree, Nebraska, teaches him the lesson of Thomas Wolfe's half-truth: you really can't go home again. (The other half, which Morris had yet to understand fully, is that you can never truly leave home either.)

The novel—for, despite numerous autobiographical overtones, *The Home Place* is a work of fiction—is illustrated with a vast number of superb photographs. This in itself was a major innovation; never before had an author presented his readers with an objective correlative—in the form of photographic documentation—of his fictional world. But Morris went even further, developing this experimental technique beyond its most obvious application. The photographs are not employed prosaically—that is, they are only infrequently tied to specific events in the narrative. Instead, they are used to epiphanize, by directly visual means, those subtly changing moods at which the narrator hints only obliquely. The initial result of this startling device is the gradual erasing of the thin, firm line between art and life. Then this combination of photographs and text, visual fact and verbal fancy, produces an eerie tension, as life and art struggle to dominate each other.

From the heat of that conflict Morris forged a marvelous and wholly *sui generis* work. No other author has since attempted such a feat—not, I suspect, because it is a creative dead end (far from it), but because no one so equally gifted in these two disparate media has yet appeared. Photofiction as a form therefore lay fallow until, with *God's Country and My People*, Morris himself returned to harvest a new crop from that fecund soil.

Taking up the same set of pictures with which he illustrated his

first two photo-texts (reproduced more handsomely in this volume than ever before), Morris contemplates them anew after an interval of twenty years' duration. Like talismans whose secret powers have lain too long dormant, the photographs disclose fresh wonders under the skillfully necromantic probing of Morris' eye and pen.

But there is a difference now in the way he looks at and into these fine pictures, a fundamental transformation in his attitude toward them; for now they are all that remains of the real past from which he carved his fictions. All else is vanished, the people moved or dead or changed, changed utterly. In tangible terms, only the photographs endure to prove that any of it was more than a dream; thus they take on an awesome significance, like a handful of scattered potsherds at an archaeological site. They are the sole clues from which to reconstruct what was and to surmise what might have been; the associations they now evoke from Morris' memory are the distillations of what his past has taught him.

Morris is not unaware of this, and uses it subliminally, in a manner reminiscent of André Breton's in his surrealist classic *Nadja*—defining a life by those events which occur, in Breton's phrase, "apart from its organic plan." Speaking at last in his own voice, Morris revisits Nebraska, his past, himself—but each of these "home places" is a disturbing blend of reality and fiction. Familiar characters (real or imagined? it is no longer possible, nor for that matter necessary, to distinguish) reappear briefly; gaps in the historiography of Lone Tree are filled in; autobiographical fragments provide tenuous connecting links between the author's life and his work.

Morris is not simply playing cat-and-mouse, however; there is method in his madness. It is the measure of his talent that not only has he new things to say about his photographs, but that his insight into himself, his understanding of life's influence on art (and vice versa) has deepened and matured into wisdom, making *God's Country and My People* the crowning achievement of his photofictional canon.

In the last analysis, what Morris has given us in his trilogy is a lucid description of the ways in which photographs of people and places we have known (or, to put it another way, static images of our past) affect us over the course of a lifetime; the way they grow away from us, and we from them, in time; the way in which they challenge,

support, and—in a sense—even determine our ever-changing self-portraits. This psychological phenomenon is of great importance in our relationships to our own worlds. We are indebted to Wright Morris for offering his own life and art as a first case history.

The Directorial Mode:
Notes Toward a Definition

Within the century and a half of photography's history, two recurrent controversies have had strong influence on its evolution into a graphic medium with a full range of expressive potential. These conflicts, centering around issues which have masqueraded as debates over style and even technique, are, in fact, philosophical clashes. The first—which for all intents and purposes is finally over—was the fight to legitimize photographic imagery *per se* as a suitable vehicle for meaningful creative activity.

The initial stage of this fight had more to do with the art establishment's defensive antagonism toward photography than with the practitioners' attitudes toward the medium, or the public's. The general public has always been interested in looking at photographs, even (perhaps especially) at photographs which were not certified as Art. The problem has never been the lack of an audience, but rather the withholding of certain kinds of incentives: prestige, power, and money.

The morphology of photography would have been vastly different had photographers resisted the urge to acquire the credentials of aesthetic respectability for their medium, and instead simply pursued it as a way of producing evidence of intelligent life on earth. However, photographers—some of them, at least—have chosen to enter the "artistic" arena. So, there have been cyclical confrontations between the dominant public definitions of art at various times and photography's concurrent definitions of itself.

Though he was neither the first nor the last to take up these cudgels, the key figure in our century was that decidedly bourgeois gentleman with aristocratic tendencies, Alfred Stieglitz. Stieglitz de-

sired—*noblesse oblige*—to lead a crusade; his was for the acceptance of photography as High (Salon) Art. At the time he embarked on his quest, the most rampant forms of High Art were recognizable via adherence to conventions of subject matter and style, among them livestock in rural settings, sturdy peasants, fuzziness, and orientalia.

Initially, it appears, what Stieglitz meant by Art Photography was imagery resembling Whistler prints or genre paintings, or both—at least to judge by his own early work and the photographs by others which he presented in *Camera Notes* and *Camera Work,* the major critical organs which he edited (and, in the case of the latter, published). He and his cohorts successfully addressed these accepted themes and evoked the requisite mannerisms from their medium, which is, in fact, adaptable enough to almost any end to make even that possible. The final result, however, was an attenuated school of photography based on imitation of the surface qualities of a nostalgic, enervated school of painting.

That this definition of both High Art and High Art Photography was a creative dead end eventually became apparent. (Indeed, it becomes increasingly apparent that the battle for the acceptance of photography as Art was not only counter-productive but counter-revolutionary. The most important photography is most emphatically not Art.) And whereas Stieglitz began by advocating and sponsoring a brand of photography which still exists in the antiquated and slightly debased form of camera-club pictorialism, he subsequently became aware of—and, to his credit, embraced—that ferment in which post-impressionist seeing and camera vision commingled to generate radical new forms of visual expression. So he ended up proselytizing for a way of working in photography which was diametrically opposed to what he had initially propounded; the last issues of *Camera Work* were devoted to the blunt, harsh, Cubist-influenced early images of the young Paul Strand.

Strand and others, both here and abroad, were persuaded that different media were much like sects, to whose dogma practitioners should hew closely, and that a medium was best defined by its inherent and unique characteristics—those aspects which were shared by no other. Curiously, they did not consider photography's almost infinite adaptability to any style of expression as such a characteristic, but settled instead on the related (though not identical) qualities of sharp-

ness of focus and realism. And, as purists tend to do, they made of these qualities not merely stylistic choices but moral imperatives.

This was an approach to photography which found corollaries in many art and design movements around the world; its connections with no-frills utilitarianism, form-following-function theories, and the general mechanophile tendencies in literature and the arts are self-evident. Coincidentally, it also happened that at the same time photographic historiography was beginning to evolve from the purely technical to the chronological and aesthetic. (The next stage, the morphological, is only now beginning to be reached.)

Photography, being a hybrid medium, looked at askance by the art establishment almost everywhere except the Bauhaus, received remarkably little attention as a field of scholarly and critical inquiry, a situation which persisted until the beginning of this decade. So, incredible as it seems in retrospect, during the 1930s the historiography of the most radical innovation in communication since the invention of the printing press and the most democratically accessible image-making tool since the pencil was vested in a mere handful of people—somewhere between six and twelve, depending on how and whom you count.

Inevitably infected with the aesthetic *Zeitgeist,* these historians were understandably anxious to prove that their medium was distinct from its predecessors in the graphic arts and yet directed toward the same field of ideas as was the vanguard of the arts in general at that point. Naturally, then, they explicated the development of photography as apostles of realism. The rest, one might say, is history—though what they wrote, in most cases, more nearly approaches theology.

People believe photographs.

Whatever their response may be to sculptures, etchings, oil paintings, or wood-block prints, and regardless of the level of sophistication they bring to encounters with such works, people do not think them credible in the way they do photographs.

Their credence is based on many factors. These are a few:

1. Photography institutionalizes Renaissance perspective, reifying scientifically and mechanistically that acquired way of perceiving which William Ivins called "the rationalization of sight." Thus photography reassures us constantly that our often arbitrary procedures

for making intellectual sense out of the chaos of visual experience "work."

2. Although in its physical form the photographic print is nothing more than a thin deposit of (most commonly) silver particles on paper, the image composed thereby does encode a unique optical/chemical relationship with a specific instant of "reality." Remote and equivocal it may be, but undeniable. A certain lack of aesthetic distance is virtually built into the medium.

3. The mechanical, non-manual aspects of the process combine with the verisimilitude of the rendering to create the illusion of the medium's transparency, or, as Ivins put it, its lack of "syntax."

After all, infants, lower primates, and even servo-mechanisms can take photographs which display the qualities just cited. Photographing appears to be nothing more than concretized seeing, and seeing is believing.

These and other factors have, from its inception, created an atmosphere around photography within which the medium's credibility is not to be questioned—not lightly, at any rate. The assumption has been that the photograph is, and should properly remain, an accurate, reliable transcription. This, of course, is restrictive and inhibiting to some image-makers, who have refused to accept love-it-or-leave-it dicta from the medium's purists. So photography's second major struggle has been to free itself from the imperative of realism.

Viewing this crucial philosophical relationship to photography (and, implicitly, to reality) in terms of a continuum, we can say that at one end there is a branch of photography concerned with justifying the medium's credibility. It operates as an essentially religious discourse between image-maker and viewer. It involves an act of faith on both parts, requiring as it does the conviction that the image-maker has not significantly intervened in the translation of event into image. In responding, the viewer is not supposed to consider the image-maker's identity, but only the original event depicted in the image. The photographer's choice as to which (and what sort of) events to address is the only personal, subjective evaluation permitted in this mode. All other aspects of presentation are supposed to be neutral; a high degree of technical bravura is acceptable in some circles, but anathema in others.

We have long attached to images in this mode—and must now la-

boriously disengage from them—two misleading labels: *documentary* and *straight/pure*. The former is generally applied to images depicting human social situations, the latter to formal, studied images of traditional graphic-arts subject matter—nudes, still lifes, landscapes, portraits. I would tentatively suggest that we consider the terms *informational* and *contemplative/representational*, respectively, as somewhat more accurate replacements.

In its relationship to the photograph's credibility, this latter mode might be described as theistic. Another, an agnostic one, permits a more active intermediation between the *Ding an sich* and the image. Here there is no great leap of faith required; the image-maker openly interprets the objects, beings, and events in front of the lens. The subjectivity of these perceptions is a given, as is their fleetingness. A certain amount of chance and accident is also accepted in this method, sometimes even courted; for photographers, like politicians, tend to take credit for anything praiseworthy that happens during their administrations.

The viewer's engagement with these images usually involves a conscious interaction with the photographer's sensibility. However, the photographer is still presumed not to interfere with the actual event going on, though in some situations—especially if the event in question is taking place within the photographer's personal/private life, rather than in the "outside world"—that line is hard to draw. In theory, such a photographer is simply free to impose his/her understandings of—and feelings about—the "real" event onto the image thereof; the viewer is made equally aware of both.

We have no labels specifically attached to this mode; its practitioners have been categorized according to other systems. Among them I would include Robert Frank, Dave Heath, Brassaï, André Kertesz, Manuel Alvarez Bravo, Henri Cartier-Bresson, Sid Grossman, W. Eugene Smith—quite a mixed lot in terms of subject matter and style, but attitudinally related. William Messer has proposed the use of the term "responsive" to define this mode.

A third, atheistic branch of photography stands at the far end of this continuum. Here the photographer consciously and intentionally *creates* events for the express purpose of making images thereof. This may be achieved by intervening in ongoing "real" events or by staging tableaux—in either case, by causing something to take place which would not have occurred had the photographer not made it happen.

Here the "authenticity" of the original event is not an issue, nor the photographer's fidelity to it, and the viewer would be expected to raise those questions only ironically. Such images use photography's overt veracity against the viewer, exploiting that initial assumption of credibility by evoking it for events and relationships generated by the photographer's deliberate structuring of what takes place in front of the lens as well as of the resulting image. There is an inherent ambiguity at work in such images, for even though what they purport to describe as "slices of life" would not have occurred except for the photographer's instigation, nonetheless those events (or a reasonable facsimile thereof) did actually take place, as the photographs demonstrate.

Such falsified "documents" may at first glance evoke the same act of faith as those at the opposite end of this scale, but they don't require the permanent sustaining of it; all they ask for is the suspension of disbelief. This mode I would define as the *directorial*.

There is an extensive tradition of directorial photography as such. But directorial activity also plays a part in other modes as well. I would suggest that the arranging of objects and/or people in front of the lens is essentially directorial. Thus I would include most studio work, still lifes, and posed nudes, as well as formal portraiture, among the varieties of photographic imagery which contain directorial elements. Edward Weston was not functioning directorially when he photographed a dead pelican in the tidepools of Point Lobos, but he surely was when he placed a green pepper inside a tin funnel in his studio; and he was doing so consciously when he made his wartime satires (such as "Dynamic Symmetry") or the 1931 image which he felt it necessary to title "Shell and Rock (Arrangement)."

When—as evidence from other photographs indicates—Alexander Gardner moved the body of a Confederate soldier for compositional effect to make his famous image "Home of a Rebel Sharpshooter," he was functioning directorially. So was Arthur Rothstein when, by his own testimony, he told the little boy in his classic Dust Bowl photograph to drop back behind his father. So was the late Paul Strand when—according to reports—he "cast" his book on an Italian village, *Un Paese*, by having the mayor of the town line up the residents and picking from them those he considered most picturesque.

The substantial distinction, then, is between treating the external world as a given, to be altered only through photographic means (point of view, framing, printing, etc.) en route to the final image, or

rather as raw material, to be itself manipulated as much as desired prior to the exposure of the negative.

It should be obvious from the above examples—and many more could be cited—that directorial elements have entered the work of a vast number of photographic image-makers, including many who have been taken for or represented themselves as champions of documentary/straight/pure photography. Things are not always as they seem; as Buckminster Fuller says, "Seeing-is-believing is a blind spot in man's vision."

The problematic aspect of straight photography's relationship to directorial activity is not the viability of either stance; both are equal in the length of their traditions and the population densities of their pantheons. Rather, it is the presumption of moral righteousness which has accrued to purism, above and beyond its obvious legitimacy as a creative choice. This posture is not only irrelevant and—as the above examples indicate—often hypocritical, but baseless. Even if all purists adhered strictly to the tenet that any tampering with reality taints their imagery's innocence and saps its vital bodily fluids, the difference between that passive approach and a more aggressive, initiatory participation in the *mise en image* is—though highly significant within the medium—still only one of degree. We must recognize that the interruption of a fluidly and ceaselessly moving three-dimensional *Gestalt* and its reduction to a static two-dimensional abstraction is a tampering with reality of such magnitude that the only virginity one could claim for any instance of it would be strictly technical at best.

> *I am not a Historian, I create History. These images are anti-decisive movement. It is possible to create any image one thinks of; this possibility, of course, is contingent on being able to think and create. The greatest potential source of photographic imagery is the mind.*

This statement was made by Les Krims in 1969.* Krims has been working in the directorial mode (he refers to his works as "fictions") for over a decade. He has explored it thoroughly and prolifically, enough so that the above quotation could serve as a succinct credo for all those who use the camera in this fashion.

* In a letter published in *Camera Mainichi/8* (Japan), 1970.

Krims is by no means the first photographer to take this position, nor is he the only one of his generation to do so. Yet it is apparent that, both inside and outside photographic circles, there is little recognition that there does exist a tradition of directorial photography. Certainly you would not know it from reading any of the existing histories of the medium. This widespread unawareness is traceable to two sources: the biases and politics of photographic historiography to date, and the ignorance about photography of most of the art critics who have dealt with the medium. The consequences have been that photographers with a predilection for this approach to image-making have had to undertake it in the face of outright hostility from a purist-oriented photography establishment, with no sense of precedent to sustain their endeavors; and that the current crop of conceptual artists employing photography directorially are on the whole even less informed in this regard than their contemporaries in photography, and thus have no concern about and no accountability for the frequency with which they duplicate and plagiarize previous achievements in this mode.

Perhaps the first large-scale flowering of directorial photography—the point at which such work entered the average Western home and became an intrinsic part of our cultural experience of the medium—came with the introduction of the stereopticon viewer and the stereographic image, circa 1850. Stereo photographs of all kinds, mass produced by the millions, became a commonplace form of entertainment and education during the next three decades, and survived as such well into the twentieth century. Among the standard genres of stereo imagery was the staged tableau, often presented sequentially and narratively; the scenarios ranged from Biblical episodes and classics of literature to domestic comedies and schoolboy pranks.

Through the stereograph, Western culture received its first wide exposure to fictionalized photographs. This initial experience has been followed by many others: erotic, fashion, and advertising photography are only a few of the forms which have been, by and large, explicitly directorial from their inception. Most of these, however, are not considered "serious" usages of the medium; their commercial function and/or popular appeal presumably render them insignificant, even though they reach and influence a vast audience. (As I noted before, the public has never been unwilling to look at photographs.)

Within the more self-conscious arena of Art Photography, whose audience has always been comparatively scant, the advent of directorial photography as an active mode and an acknowledged alternative to realism dates back to the same period—the 1850s—and the work of two men: O. G. Rejlander and Henry Peach Robinson.* Both staged events for the purpose of making images thereof—mostly genre scenes and religious allegories; both used the process of combination printing, involving the superimposition of one negative on another, which fictionalized the resulting print even further. Their work was the subject of heated debate from all sources—photographers, artists, art critics, and the public as well. Until recently, the sentimentality of the most popular of their images (Rejlander's "Two Ways of Life" and Robinson's "Fading Away") was used by photo-historians as a basis for dismissing their entire *œuvres* and their way of working as well. (Re-examination of their output turns up some astonishing, little-seen imagery; in Rejlander's case, for instance, "The Dream," "The Juggler," and "Woman Holding a Pair of Feet.")

Beginning in 1864, the Victorian photographer Julia Margaret Cameron also produced an extended body of directorial work in which she blended, for better or worse, current literary themes and attitudes with the visual conventions of Pre-Raphaelite painting. Some of her images were studio portraits of famous artists and *literati;* others were enactments of scenes from literature. Also sentimental, for which they too have been often dismissed, they are nonetheless powerful images whose illusions are effective despite—and perhaps even because of—the viewer's knowledge of what was "really happening" at the time.

Subsequently, there rose and flourished the photographic movement generally known as *pictorialism*. That word itself is problematic, even though the dictionary definition is non-judgmental. (Certainly as a term it is less absolute, and therefore less enticing to true believers, than its ostensible opposite in photography, *purism*.)

At different times *pictorialism* has had different meanings and implications in photography. Presently it is employed to describe bland, pretty, technically expert executions of such clichés as peasants tilling

* Strangely, in 1888 a public controversy between Robinson and Peter Henry Emerson began over these same issues. Emerson advocated a purist approach to the medium: no interference with the external event, no multiple negatives, no retouching (though, inconsistently, he allowed for the "burning in" of fake clouds, since the real ones would not register on the slow films of the day). Emerson's position was called "naturalism"; Robinson's was called *realism!*

the fields, fisherfolk mending nets, and sailboats in the sunset, still being cranked out by mentally superannuated hobbyists. As such, it is essentially derogatory. Initially, however, it had quite a different import; it indicated adherence to a set of conventions—prescribing styles and subject matter—which were thought to be essential to any work of fine art, not just art photographs.

That it became trapped within those conventions is regrettable, though doubtless inevitable. However, an attitude toward the medium of photography underlay the pictorial impulse, and that attitude is of great importance. It could be summarized thus: photography is only a means. Whatever tools or methods are required for the full realization of the image as conceived should be at the disposal of the image-maker, and should not be withheld on the basis of abstract principle. Man Ray said much the same thing: "A certain amount of contempt for the material employed to express an idea is indispensable to the purest realization of this idea."

Pictorialism, then, was the first photographic movement to oppose the imposition of realism as a moral imperative. The pictorialists felt free to exercise full control over the appearance of the final image/object and, equally, over the event it described. Practitioners staged events—often elaborate ones—for their cameras, and resorted to every device from specially made soft-focus lenses to handwork on the negative in order to produce a final print that matched their vision. Much of the imagery they created was, and is, extremely silly; much of it was, and is still, beautiful and strong. For all their excesses, Anne Brigman, Clarence White, F. Holland Day, Gertrude Käsebier, and many others produced some remarkable and durable work.

Creatively, the kind of photography we now call pictorialism reached its peak during and shortly after the Photo-Secession era—from the turn of the century through the early 1920s. Then it began to come up against the purist attitude. The clash between these two opposing camps came to a head in the pages of Camera Craft, a West Coast magazine, in the early thirties, in the form of a heated exchange of letters between various members and sympathizers of the f/64 movement (among them Ansel Adams and Willard Van Dyke) and William Mortensen.

Mortensen was a practitioner of and articulate spokesman for pictorialism, though by the time he achieved recognition the form was already in decline. In the minds of most, the purist-pictorialist schism

was simplistically conceptualized as hard sharp prints on glossy paper versus soft blurry prints on matte paper. The actual issue at stake was far more complex: it concerned the right of the image-maker to generate every aspect of a photographic image, even to create a "false" reality if required. (Mortensen himself worked almost entirely in the studio, creating elaborate symbolist allegories filled with demons, grotesques, and women both ravishing and ravaged.)

The debate was a draw, at least in restrospect, but second-stage Hegelianism won the day: the aesthetic pendulum swung to purism, and pictorialism fell into disrepute. Mortensen—who, in addition to this debate, was widely published in photography magazines and authored a series of how-to books which are to pictorialism what Ansel Adams's instructional volumes are to purism—was actually purged from the history of photography in what seems a deliberate attempt to break the movement's back.*

For the next three decades—until the late 1960s, in fact—there were commercial outlets for certain kinds of directorial images, but any photographers working directorially in a non-commercial context did so over the vociferous opposition of most of their peers and of the aesthetic-economic establishment which controls the medium's access to the public and to money. Still, some persevered: Clarence John Laughlin, making his Southern Gothic image-text pieces in New Orleans; Edmund Teske, pouring out his passionate homoerotic lyrics in Los Angeles; Ralph Eugene Meatyard photographing the ghoulish masked charades of his family and friends in Lexington, Kentucky; Jerry Uelsmann resurrecting lost techniques in Florida. There were others too, hoeing that hard row.

The 1960s were a time of ferment in photography, as in most other media. Old attitudes and assumptions were put to the test. Purism, it was found by a sizable new generation of photographers, was still

* From the first one in 1937 to the most recent of 1964, no edition of Beaumont Newhall's *The History of Photography: From 1839 to the Present Day*—the standard reference in the field—so much as mentions the name of William Mortensen. It will be instructive to see whether the forthcoming edition—a major revision supported by the Guggenheim Foundation—rectifies this omission.

In fact, none of the books on the history of twentieth-century photography refers to Mortensen. If this could be considered even an oversight, the only questions it would raise would concern standards of scholarship. Since it cannot be construed as anything less than a conscious choice, however, the issue is not only competence but professional ethicality.

viable as a chosen approach but restrictive as an absolute. Even so, old attitudes die hard, and these younger photographers found themselves facing an establishment and a public that was so accustomed to equating creative photography with purism that it was (and still is) considerably perplexed by anything else.

But they too have persevered. It would be difficult to compile a complete list of those working in this mode at this time—there are a great many, and the number is increasing rapidly. Les Krims and Duane Michals must certainly be counted among the pioneers of their generation in this form; both are prolific, both have published and exhibited widely, both are reference points for the current generation of younger photographers and are obvious sources for much of the mediocre directorial photography which passes for "conceptual art" nowadays.

John Pfahl, Ken Josephson, and Joseph Jachna have all produced extended series in which they enter into or visibly alter the landscape, with related hermeneutic inquiries into the illusionism of the medium. Lee Friedlander (in *Self-Portrait*), Lucas Samaras, and the late Pierre Molinier have all used the camera as a dramatic device, in front of which their fantasies and obsessions are acted out. Eikoh Hosoe, Richard Kirstel, Arthur Tress, Adal Maldonado, Ed Sievers, Doug Stewart, Paul Diamond, Ralph Gibson, Irina Ionesco, Mike Mandel, Ed Ruscha, William Wegman, Robert Cumming, and Bruce Nauman (among others) also have things in common.

This article was conceived as an examination of those connections, with a historical prologue to set current ideas in their full context. The prologue has grown to engulf the main text and is still too summary. But, to conclude: willingly or no, whether or not they consider themselves "photographers" or "artists" or whatever, these individuals and many others are exploring the same field of ideas. That field of ideas is built into and springs from the medium of photography itself; it has a history and tradition of its own which is operative on many levels of our culture. There is no direct equation between ignorance of history and originality. Disclaiming one's ancestry does not eliminate it. It is regrettable that in most cases these creative intelligences are not aware of their lineage; it seems foolish that in many cases they attempt to deny it. The moment would seem to be ripe for them to acknowledge their common sources and mutual concerns; their real differences will make themselves apparent in due time.

1977

Humanizing History: Michael Lesy's *Real Life*

> *The facts, sir, are nothing without their nuances.*
> NORMAN MAILER, TESTIFYING AT THE TRIAL OF THE CHICAGO 7

Michael Lesy's second book, *Real Life: Louisville in the Twenties*, contains an implicit imperative: it is time to reconsider our understanding of what we call "history." This same imperative could also be found in Lesy's previous book, *Wisconsin Death Trip*, a similarly structured work. Both books have aroused considerable controversy, centering around Lesy's stance and methodology.

Because Lesy is a social historian with a dark, even grim vision of the American experience, his books are disturbing to the many people with fantasies about the "good old days," especially those who live in the specific geographical areas from which his material is drawn.

As one of the first historians to undertake a serious exploration of photographic images as primary data, Lesy has also inevitably come into conflict with more traditional historians, who have ignored the challenges of photographic research and interpretation (to an extent which scandalizes the name of scholarship), but who accuse Lesy of unorthodoxy in utilizing photographs to make some of his points.

Last but not least, many photographers—predominantly those at the "creative/art" end of the spectrum—argue fiercely with the temporal social and political implications Lesy extracts from images which they would prefer to see treated on a "purely visual" basis.

So Lesy catches it from all sides. To my knowledge, though, no one

Photogram, March 1977.

has claimed that his books are either boring or ineffectual. Obviously, the very heat of the arguments they generate demonstrates that these books are provocative and effective; so the appropriate questions would seem to be, what do they provoke and how do they generate their effects?

Lesy creates his books by using a deceptively simple collage technique. He brings photographs of the people and places of a particular time and geographical region together with fragmentary texts drawn predominantly from original source material. Occasionally he retells certain tales in his own voice, but generally he lets people speak for themselves. To find the voices which echo in his pages, he combs through civil and criminal court records, police ledgers, the files of mental institutions, newspaper archives, and the taped or transcribed reminiscences of local residents. He has the ear of a gifted writer for the telling figure of speech, turn of phrase, and precise detail which can bring such accounts alive.

The photographs which are combined with these excerpts in both Lesy's books are not random assortments, but are drawn from homogeneous and indigenous collections. In the case of *Real Life,* they are selections from the archives of the University of Louisville's Caufield and Shook Collection, a unique and important resource comprising thousands of images made over many decades by a local commercial photographic firm. It should also be said that Lesy has an eye for poignant, evocative, and surreal imagery.

Since all the raw material is essentially unimpeachable—because it's verifiable, and because it's rarely if ever overtly interpreted by the author—what is it that's so disturbing about these books?

To state it simply, they lead the reader to unpleasant conclusions by means other than logical argument and statistical "proof." The conclusions could be summed up thus: life in America—insofar as Louisville typified America—during the Roaring Twenties was not what we picture it to be. Insanity, suffering, violence, greed, cruelty, sexism, racism, the abuse of alcohol and narcotics, and political corruption were then, as now, so commonplace as to be taken for granted.

That is hardly a new conclusion. Lesy guides us to it efficiently, via a carefully edited blend of documentation in which the persuasive power of personal testimony (often autobiographical) and the pathos of now-dead people enacting their rituals for the camera are juxtaposed

to generate a poignant despair. Perhaps that is part of what bothers those who engage with these books: it becomes readily apparent that Lesy's method could be applied to virtually any locale in any era in order to create similar statements leading to identical conclusions.

They are truisms, these works. But they're truisms we're reluctant to face. One of the most wondrous of human abilities is our capacity to romanticize the past, even that which we experienced directly, by remembering the good parts and forgetting the bad. It keeps us going, that very human tendency to rewrite our individual and collective memory as we go along. Witness, for example, our current mythologizing of one of the more dismal epochs of our brief history, the Great Depression, which—if we're to believe such fictions as "The Waltons" —did us all good by helping to draw families together through adversity.

The assumption lurking behind Lesy's books and within his method is that the quality of life for most people has always been dismal. That's a pessimistic, even a jaundiced, attitude, though not an illegitimate one. But it is one we do not allow to historians; it is permitted only for writers and artists.

That, I think, is the crux of the matter. If Lesy were a novelist—a black humorist, say, like Céline, Beckett, Burroughs, or Heller—the bleakness of his vision would not be challenged. Which is peculiar, when you come to think about it: that a man who supports his vision with documentation should be more suspect than one who invents it entirely. It suggests that we accept certain attitudes from artists because we can always dismiss them as fiction.

Lesy's work stands at a border line—hence this confusion. His chosen subject is the quality of life in the past, and although he approaches it as a social historian what emerges is nothing resembling what we think of as "history." "History," as we have come to know it, is not concerned with the individual lives of common people; its themes are patterns, cycles, landmark events and the public lives of those few who wield power. It is statistical and sequential. Most of all, unlike reality, history makes sense.

A significant distinction must be made here. "History" and "the past" are not identical. "The past"—that totality of all events which have occurred prior to any given moment—simply *is*; history is what we make of it. As José Arguelles writes in *The Transformative Vision*:

In the ashes of a disintegrated mythic consciousness, art is invented; from the forehead of art, history springs into being. Quite simply, the death of myth is the birth of history. Through its midwife, art, history becomes the illusion of culture—but only for those who have the power to make history. And this is the tragedy, the terror, of history.

Much of our behavior in the present, collective and individual, is conditioned by our shared definitions of the past, our mutual belief in "history." Thus we tend to reject any radical redefinitions of history, since they force us to question our present attitudes. We much prefer to think of "history" as objective, unchallengeable, immutable.

But of course it is not. History is an interpretation of the past; historians are channels, human filters, fictioneers in their own right, full of built-in assumptions, biases, and blind spots. The scholarly discipline of historiography is a process which generalizes from events by severing their causes and their consequences from the experience of the people who lived through them. That, I think, is the very point of Lesy's approach. History generalizes; photography and eye-witness accounts particularize. Lesy seeks to restore to historiography its connection with human experience—the "real life" of his title. His emphasis on the more desolate end of the scale of human experience certainly reflects his own bias, but we must remember that both historiography and the psychology of memory are prone to neglecting that end of the scale. Lesy is simply attempting to right that balance by reminding us that history is an abstraction—real life is what we live.

Visual Recycling:
Irving Penn's "Street Material"

Anything purporting to be a full discussion of Irving Penn's "Street Material"—an exhibit of twenty-eight photographs at the Metropolitan Museum of Art—must consider the event from at least two different perspectives.

The first is close up, face to face with the images themselves. They

are platinum-palladium prints* on Rives and Arches paper, a combination which makes them into precious objects not only aesthetically but literally. These large, handsome, eminently decorative works are full of delicate nuances of tone and rich in detail. When examined at intimate distance, they engage the eye with surface: the mellow, muted patina of rare and costly metal melded with the subtle creaminess and tooth of handmade all-rag paper. Move a half dozen steps backward and their forms—massive dark areas centered on pure white backgrounds—dominate the attention, as their subject matter asserts itself: crushed tin cans, discarded cigarette packs, and workmen's gloves—urban detritus, junk.

Penn's visual recycling of this debris is amusing, and there is some irony (considerably attenuated, however) in his creating larger-than-life icons from it (shades of Claes Oldenburg) and manufacturing them in multiples so lavishly. The "found object" is hardly new to photography, of course. Indeed, within the medium's history the *objet trouvé* predates, anticipates, and to a considerable extent even engenders the surrealists' "invention" of that concept. But Penn has created a pleasant variation on that theme, mixing it with equal parts of pop art and *nostalgie de la boue*. His renderings of these artifacts are so elegant and refined, though, that it is difficult to imagine them shocking or even provoking anyone, as Henry Geldzahler predicts in his introduction to the exhibit. Whatever their aspirations in that regard, their achievements do not extend beyond titillation.

Imagistically, these works are a direct extension of Penn's decades of involvement in studio photography. Penn has always preferred to

* Platinum, like silver today, was once used in commercially manufactured photographic paper; it was favored by many creative photographers for the exquisite delicacy of tonal gradation it made possible in printmaking. Drastic rises in the cost of platinum early in this century ended commercial production of such paper, and silver became the principal metal for the interpretation of photographic negatives. (Silver paper is now entering the same cycle of scarcity and eventual disappearance.)

Since the early 1930s, photographers wishing to print in platinum have had to make their own printing paper. A number have done so: Laura Gilpin has manufactured platinum paper for her own use for some sixty years, and roughly a decade ago George Tice began a series of experiments which have led to a widespread revival of interest in platinum printing. Penn has evolved his own formulae and techniques, about which he is highly secretive. Because it is obviously more tedious, difficult, and costly to make such prints, they are usually fewer and invariably more expensive than silver prints of the same images.

function directorially, keeping all aspects of the photographic event under his control as fully as possible. The only variable for him, the sole element of chance, has been his subjects. So it is a small step from bringing people and/or products into the controlled environment of his studio to doing the same with random objects.

To be sure, these images also represent a number of minor departures for Penn. The change in materials from his usual silver print manifests a different involvement in craft as process. The shift in scale is noteworthy: while the average print size of his studio portraits is no smaller than these, the former do miniaturize by presenting their subjects smaller than life, whereas these enlargements monumentalize. And, in addition to the slight ironic resonance generated by the disparity between subject matter and presentation, there is some more to be found in the decision of a master craftsman specializing in images of the famous, the wealthy, and the expensive to turn to plebeian consumer goods in a state of terminal disintegration.

All of this is moderately interesting, perhaps even to a wide audience. Certainly it would be quite sufficient to justify and sustain a one-person gallery show, if only as evidence that an established stylist was still willing to experiment and inquire. But this is hardly just another solo exhibit. It is being presented in the Metropolitan Museum's Special Exhibitions Galleries by the Met's Department of Twentieth-Century Art (and not, significantly, by its Department of Prints and Photographs). The Met's curator of twentieth-century art, Henry Geldzahler, is considered one of the more powerful middlemen in the world of contemporary art. This is the first exhibition of photographs which has originated in that department—and, indeed, the first that Geldzahler has sponsored anywhere.

That is the second perspective from which this exhibit must be observed. It should also be pointed out that this work is not finally finding its home in the museum, but rather making its public debut there. These images have never been seen before, although a related series (platinum prints of images of cigarette butts) was similarly introduced last year at the Museum of Modern Art under the aegis of John Szarkowski, curator of MOMA's photography department.

I can understand the temptation to display one's work in such prestigious surroundings, especially with a renowned curator's imprimatur certifying it as *de facto* museum-worthy at birth. But I believe that

Penn has done his work a grave disservice by succumbing to those lures. Regardless of whether one enjoys, respects, or even admires these images, they cannot bear the weight inherent in that context.

Penn's crafting of these images is, arguably, virtuosic, but one could hardly call them seminal; their basic ideas are even more venerable in photography than in the rest of modern art, and Penn certainly has not amplified or extended them significantly. Because this is their first appearance, no plausible argument for the value of these images as influential works, either inside or outside the nominal parameters of photography, can be made; and of course no claim for their historical importance can be substantiated at this time.

Thus, when viewed as part of what might be described as a presentational collaboration between Penn and Geldzahler, this body of work fails itself and collapses. These images are not exemplary. They are not even so unique in and of themselves as to demand or sustain prolonged attention. I doubt very much that they would be on the Met's walls if their maker were a lesser-known photographer than Penn.

In many ways, therefore, the appearance of these images in this particular place at this time is not only an individual and aesthetic statement but an institutional and political one as well. In my opinion, the propriety of employing a major national repository as a cotillion ball for untested work is highly questionable. This is not a unique instance of such practices at the Metropolitan; the museum is currently merchandizing under its own imprint a portfolio of original color photographic prints by Stephen Shore, who had not yet reached the ripe old age of thirty when the portfolio was published last year. Surely there is no curator at either the Met or at MOMA who is so naïve as to be ignorant of the value of such patronage in political and economic terms.

But that is another whole argument in itself, concerning a situation which Penn's show is not responsible for but merely exemplifies. Sticking to the instance at hand, it must be said that Geldzahler's effulgent wall label indicates that he is profoundly ignorant of the history, evolution, materials, and potentials of the photographic medium. It must also be said that in its relationship to the continuum of contemporary photography Geldzahler's choice of this particular œuvre as the vehicle for his entry into photographic curatorship is a fundamentally reactionary one. Photography is an inherently demo-

cratic and accessible image-making medium, much of whose importance in all its forms resides in the inexpensive and almost infinite repeatability of its imagery. Geldzahler's selection of Penn asserts, to an international audience, that in the context of twentieth-century art as a whole he finds the most meaningful images by a living photographer to be those made in limited editions by a court artist working in an archaic process requiring precious papers and metals.

That is, to say the least, misguided. It is misguided on such a vast scale that it will seriously mislead large segments of the viewing public. Consequently, it can only be described as curatorially irresponsible.

Lament for the Walking Wounded

Last spring I witnessed an occurrence which so epiphanized the current state of photography's transformation into high culture that it's haunted me since. It happened at a major conclave of people involved in making, learning how to make, and teaching others how to make what we loosely call "serious" or "creative" photographs. This group—perhaps half a thousand strong—was being addressed by one of the nation's most prominent art critics. His talk, the keynote speech for this gathering, was something of an embarrassment. Not only was the man a poor public speaker, but his comments failed to match the energy potential of the occasion and generally went well under the heads of his audience.

Given the range of approaches he could have chosen, the speaker selected the most innocuous—and also the most trivial: chatty, informal reminiscence. Entertainment, in short. Most of his time was given over to unnecessarily elaborate recountings of the comparatively infrequent occasions on which he had deigned to direct his attention to photography. Considering the major creative and technical developments which have taken place within the medium in the last twenty-five years—the period his critical career spans—his relationship to photography could hardly be called prophetic, nor indeed even attentive. In fact, a good claim could be made that he missed the boat entirely.

Nonetheless, there he was, making the best of what little he had to work with. As the skimpiness of his material became painfully clear,

he did what many mediocre entertainers do—he started looking for laughs and for sympathy. His way of obtaining them was to hold a particular photographer up to ridicule on the basis of his personality, regaling the audience with anecdotes about this obstreperous individual.

I happen to know this photographer, fairly well though hardly intimately. We have corresponded and talked at length on the phone and met numerous times and dined together. He is certainly, on one level, a remarkable and picturesque character, colorful enough that Tennessee Williams wrote him into his newest play, *Vieux Carré*. The man is an incessant talker, cantankerous, obsessive, constantly defending the premises of his own imagery and that of others who work in similar ways. He operates out of a sense of contest so ingrained that he can no longer let down his guard; indeed, he is so habituated to fighting a lonely battle that he can barely recognize or acknowledge his allies.

But this hardly makes him a buffoon, which is how the speaker was portraying him. He is a dedicated seventy-two-year-old image-maker who has devoted forty years to photography. He has created an enormous body of work with a number of distinct but related branchings—an *œuvre* so large that there is probably no one beside himself who knows all its corridors. I think much of his imagery is seminal, though that is arguable. Certainly it is unique, personal, inventive, historically significant within photography and informationally invaluable in several other fields. He has created this work under conditions of adversity, both physical and economic; he has supported himself as a free-lancer, and until very recently had received virtually no institutional recognition or backing of any kind. In addition to the neglect of the larger visual arts community—which all but a handful of his generation of photographers experienced—he also suffered from the less than benign neglect of the photography community. This may be due in part to his difficult and intransigent nature, but certainly has much to do with his work, a large segment of which has been done in a style which was critically, curatorially, and historically unfashionable thirty, twenty, and even ten years ago. (At this point, he looks more and more like a pioneer.) Certainly he is one of those photographers deliberately ostracized by the photohistorical establishment (whose intensely political machinations merit more study than they've received). He's

not mentioned in Newhall, mentioned only in passing by Pollack, and receives a brief one-paragraph biography in Gernsheim's *Creative Photography;* his work is not illustrated in any of those tomes. So he's worked in the boonies, without recognition, throughout his career, almost entirely self-sustaining economically, physically, and psychologically.

In short, he's a good example of what I've come to think of as the walking wounded of photography. I have met dozens of them in the past ten years; I know of dozens more. They are men and women, over fifty years old, who never got their due and are beginning to realize that they may never get it. In some cases the oversight has been accidental, the conspiracy of circumstance. In others, it has been intentional. Some of the stories would curl your hair. But that's another can of worms. What I'm trying to say is that there are hundreds of them out there—in California and Indiana, in Louisiana and in Massachusetts, in Chicago and New York, in London and in Paris. They see a smattering of their peers finding some belated recognition and, through the sale of their archives, even some long-awaited economic security and protection for their life's work. They see dozens of young photographers fresh out of school snapping up the grants and the museum shows and the stalls for photographers in the stables of suddenly interested art galleries. And, after three or four or five decades of work, they begin to wonder if, in the current public feasting on photography, there are any scraps for them.

Bitter? I hope to tell you. And angry. And frustrated. And suspicious. And with ample reason. Bad enough that the above-mentioned critic, who was still wet behind the ears when the photographer in question was twenty years into his life's work, should make jokes about such an artist behind his back in public. Bad enough that this should happen at a time when the photographer was discovering that he faced not only continued economic adversity and great difficulty in preserving his life's work, but major medical problems as well. Bad enough that the person making the jokes was a representative of that group whose offhanded disregard for photography is partly responsible for bending this photographer (and many of the others) into the very shape that was being mocked.

But worse than this critic being so tasteless as to make those jokes, worse by far, was the audience's laughing at them. Not politely, or

reservedly, but wholeheartedly—so overjoyed at being tacitly included in this critic's sphere of influence that they were ready and willing to cut one of their own adrift. It was shocking to discover how cheaply we could be bought. What advanced stage of corruption have we reached in these last five or six fast years that such a moment could come to pass? How could a room full of hundreds of people who claim a deep commitment to photography permit a man who's demonstrated none at all to treat one of their fellow toilers in the vineyard as a clown? Why did no one in that room denounce the insolence?

That critic owes the photographer he insulted an apology. That roomful of photographers and photography teachers and photography students owes him an apology. And I owe him an apology—because I was there, and did not speak out against this indignity. I even laughed, along with the rest, though I felt ashamed in doing so and have felt so since. It is easier to laugh at him, and at the many others like him, than to confront their pain. Such laughter is a dismissal, a disavowal. Stepping away from such people is simpler than identifying with them, or (heaven forbid) joining them, sharing their suffering and their anger.

My laughter told me that I was on the verge of losing something I once held very precious, which I can only call tribal pride. When I first became involved in photography, back in the late 1960s, part of my attraction to the medium was to the growing sense of deep community among its practitioners—a feeling that, regardless of stylistic persuasion, they were all members of a maligned and embattled caste. But things are changing rapidly. Academic and art world absorption is quickly leaching away that community's sense of identity and uniqueness. Greed and growth are contributing their share to its dissolution. That tribe is evolving into a herd.

I am not sure what, if anything, is being gained in the transformation. But the price that's being paid becomes increasingly clear, and perhaps the rush should be stopped long enough to ask ourselves if the cost is not too high. Must we jettison our wounded? Must we embrace the sources of their injuries? Must we blind ourselves to what they experienced as "a life in photography"?

One basic gauge of human behavior is how any given group honors its dead and cares for its wounded. Of the two tasks, honoring the dead is surely the less demanding; not coincidentally, it's the only one

the art world is willing (even eager) to take over from us. Caring for our wounded will be a harder chore to perform; it's much more tedious, messy, and indefinite.

But perhaps it would teach us something worth learning. It might even restore to us something infinitely valuable. At any rate, it's something to which all of us in what used to be called "the photography community" might give some thought, young and old alike. Because the alternatives, in that community as in any other, are clear: close ranks around your wounded and nurse them with the same tenderness you'd like shown to you, or abandon them—and expect the same in turn.

No Future for You?
Speculations on the Next Decade
in Photography Education

In the past decade, the membership of the Society for Photographic
Education has increased dramatically: from a small handful to a list
of hundreds, enough to fill a sizable directory. No doubt this organ-
ization will continue to grow, that being in the nature of such bodies.
Paralleling this numerical growth is the expansion of this organiza-
tion's sphere of influence: it is safe to say that much of what we
loosely refer to as "photography education" is promulgated by mem-
bers of this society, and will be increasingly so transmitted as time
goes on.

Collectively, then, we form the main channel through which many
of the photographers-to-be of the near future—and most of the best-
educated ones—will have to pass. *Channel,* of course, is only one of
several possible metaphors describing our functioning. *Funnel* is an-
other; so is *filter;* so is *bottleneck.* Our shaping of the future will
determine which of these possible self-descriptions is most appropriate.

A look at that future seems a fitting way to open this conference,
particularly since it may provide some contrast to the lap of luxury in
which we're sitting at the moment. Let us consider the ten years
ahead of us and what they are likely to bring. After all, at the end of
that decade we will be four years past 1984, and only twelve years
from the millenium. What we achieve between now and then, there-
fore, will be our groundwork for the year 2000.

At present we are witnessing a unique confluence of events in the
evolution of photography. The medium has won a number of its

Keynote Address to the National Conference of the Society for Photographic Educa-
tion, Asilomar Conference Center, Pacific Grove, California, March 22, 1978; pub-
lished in *Exposure,* Summer 1978.

battles along various fronts simultaneously. It has pervaded the field of visual communication so thoroughly that its elimination is unthinkable. It has proved itself, on a virtually global level, to be the most democratically accessible tool for personal expression of all the visual media. And, in less than a century and a half, it has effectively achieved the status of a "high" art while forcing all the other visual arts to redefine themselves radically. Indeed, it is even engendering a fundamental re-examination of the prevalent aesthetic hierarchy.

These are not overnight developments; they are the cumulative result of the medium's maturing and the consequent manifestation of its inherent nature. What is significantly new is not the existence of these phenomena *per se*, but the comparatively sudden, concurrent, and widespread recognition of them.

To a considerable extent, that recognition can be traced to the efforts of the members of the Society for Photographic Education. Certainly, in the past decade, we have done much to develop public awareness of the medium's history and its influence on our culture. Photography teachers across the country have also successfully established and elevated those standards of craft which are the gauges for all who work in the medium. Nor have those been our only accomplishments. We have entrenched ourselves firmly—perhaps irrevocably—in the groves of academe. And we have, in record time, glutted the market for career art photographers and for teachers of art photography.

This suggests, to me at least, that we have been a mixed blessing in relation to our medium and our culture. Is this the true flowering of photography education? Is this where all our efforts were leading? To the establishment of photography as yet another academic discipline? To the self-perpetuation of art photography? To the creation of a caste of visual idiot-savants monitored by a professional elite tightly controlling the outlets and the sinecures? To an ever more massive annual rendezvous at some posh hotel or chic spa?

Is this where we were heading all along? If so, why? And if not, what are we doing here?

Let us consider the next decade through a series of speculations. These projections are based on actual events and current data, not on extra-sensory perception. They are not prophecies; they are safe predictions.

The medium of photography is in the midst of a technological up-

heaval unmatched since the fruits of World War II military research were declassified and made available to the post-war public.

We are witnessing the rapid disappearance of silver as the primary vehicle for photographic imagery. The current generation of students is probably the last which will take the availability of silver-based materials for granted. Since much of the tradition of photography—in educational, historical, and critical terms—is based upon the silver negative and the silver print, extensive revision of our premises in these regards will be necessary, as will the development of comparable understandings of such likely replacements as magnetic and/or electronic films and papers.

Such a change will leave those involved with two-dimensional non-electronic or non-magnetic imagery even more at the mercy of the major photographic manufacturing corporations, which already are far too influential in determining which materials shall be made available to photographers. Thus it might be advisable for us to take steps toward creating a generation of students educated to be alert consumers of photographic materials, trained to make active and effective demands on the suppliers of those materials.

We are also on the verge of major breakthroughs in three-dimensional imagery, with holography by far the most likely candidate for the dominant process in that area. The introduction of holographic equipment and materials which are economically and technically accessible to the popular market may well take place during this coming decade. I see no reason not to believe that such a process will replace two-dimensional imagery as the primary vernacular photographic medium as surely as color replaced black and white in that same field.

This will have the inevitable result of rapidly rendering two-dimensional imagery—especially in black and white, and most particularly in silver—obsolescent and archaic. In the minds of many, that will automatically make such imagery more "artistic" by rendering it non-functional in the everyday traffic of visual communication. It will certainly create a schism among photography students in their attempts to determine which of these major branchings merits their personal and/or professional commitment. It will probably create a similar schism among photography educators, and even those who manage to develop an educational methodology encompassing both forms had best be prepared for the divisiveness this evolution will generate.

There is another aspect of this technological upheaval which merits our serious attention. As I have noted previously, we have already entered an era in which the forgery of photographically credible imagery is eminently feasible. I am not speaking here of the expressively oriented work of such image-makers as Jerry Uelsmann or Clarence John Laughlin, though their techniques are readily adaptable to the production of imagery with other intentions. Rather, I am speaking of recent developments in the technology of image generation.

It is now possible, by a computerized process developed for police use, to reconstruct from even the blurriest film or still photograph a sharper, more focused image of anything depicted therein. This is achieved by the application of statistical probability factors to the various possible resolutions of such out-of-focus images. It is also possible, by another computerized technique, to take a still image of anything—including such an artificially resolved photograph as described above—and from it generate still or kinetic video images in which the subject of the original image can be made to perform any desired action realistically in convincingly dimensional space. What this means is that our visual communications hardware has reached the point where photographically credible imagery, both still and motion, can be manufactured with little or no recourse to actual photographs.

The existence of such technology within a culture which has been convinced for almost one hundred and fifty years of the scientific accuracy and evidentiary unimpeachability of photographs as documents should be cause for alarm. The visual technology for population surveillance and for the manipulation of news, fact, and history which buttresses the totalitarian futures projected in Aldous Huxley's *Brave New World*, Ray Bradbury's *Fahrenheit 451*, and George Orwell's *1984* is all in existence at this moment. Certainly as photography educators we must begin to work toward increasing the sophistication of the citizenry at large in the interpretation of photographic imagery and its manipulative potential; we must also work toward the establishment of professional codes of ethics, effective detection methods, and legislative controls to counteract that potential.

Let us now turn our attention to "the academy," that hypothetical construct within one or another of whose physical manifestations most of us transmit such knowledge and (*o vanitas!*) wisdom as we have managed to acquire.

I think it not unreasonable to assume that for most of those in this organization—except for the present student membership—the coming of age of their relationship to photography and photography education occurred during the moneyed 1960s and early 1970s. That was a time of wondrous—or, from another standpoint, ghastly—innocence for all those involved in so-called creative photography. At least for a time, it was possible to believe that colleges, universities, and art institutes would never cease to open and expand departments of photography, thus providing an endless source of teaching positions to degreed young photographers trained only in personal self-expression. It was possible to believe that the government-run and privately subsidized foundations would continue to pump ever-increasing numbers of grants into the veins of art photography, that we could nurse at that teat forever without fear of it drying up and without preparing to be weaned. It was possible to believe that museum and gallery exhibition spaces would continue to open up, that more and more photography books would be published and photography magazines founded—that, in short, it would be possible for a virtually infinite number of career art photographers to live reasonably well merely by "doing their own work" and, if absolutely necessary, supplementing that by teaching others to do the same.

In the past few years we have learned—to the dismay of many though hardly unpredictably—that our culture's need for career art photographers is limited and that we may well have over-supplied the demand for the remainder of this century. As the population of career art photographers swells, the ratio of available grants, teaching positions, traditional exhibition spaces, and publishing outlets necessarily diminishes. This basic mathematical formulation is a piece of hard news which it is our task to break to the current generation of photography students. It is also our responsibility to make ourselves accountable to their immediate predecessors, those whom—in our foolishness and naiveté—we deluded into thinking otherwise. I am speaking of those lost souls one encounters in increasing numbers, wandering the corridors of such meat markets as the College Art Association and SPE gatherings, desperate for someone, anyone, to look at their portfolios and take their resumes. They are competing frantically for a pitiful handful of jobs teaching others to make art photographs—since, at best, that is all they have been trained to teach —and the ratio of these applicants to available positions is unspeakable.

Those educators who brought them to this pass owe them much, much more than an apology.

Declining enrollments in many degree-granting photography programs whose emphasis is entirely on self-expressive imagery bear out the suspicion that fewer and fewer students are willing to commit themselves to being career artists in photography. We have seen the end of the era of the open pocketbook among the institutions housing photography departments; I believe we are now seeing the end of that era among the students who enter such departments. More and more, we will be facing a demand for the economic self-justification of all courses of study, photography among them. Profiles of the current generation of college students show them to be far more conservative in choosing their field of specialization, and more deeply concerned with the relationship between their education and their future in the job market, than were the students of ten years ago—among whom many of those present could no doubt number themselves. We must confront in ourselves that clash of attitudes. We will do these students a profound disservice by failing to alert them to the imperatives of their times and instead substituting our charming but outdated assumptions for the realistic assessments they require of us.

Such realistic assessments, even when we learn to make and provide them for our students, will hardly serve as adequate alternatives to meaningful goals within the medium. Nor will it be anything more than a stopgap measure to divert the energies of the more practical among them to such related areas as curatorship, historiography, criticism, and conservation, since those are ultimately no less self-limiting as employable skills than the professional exploration of one's own visual psyche.

I would suggest that we can direct these students along either of two broad courses. Those who wish to photograph along purely self-expressive lines should be clearly informed of the severe limitations of career options in that field, and should be urged to develop other means of economic self-support. They should also receive extensive instruction in those skills which are essential to professional art photography—exhibition design, book layout and production, and teaching. And they should be prodded into the exploration of alternatives to the museum/gallery/monograph circuit in which so much art photography is presently trapped.

Those who wish to earn their living through their craft should be

urged to develop an involvement with and expertise in one or more other fields of study in which photography plays a significant role. I am speaking here—as I have elsewhere—of the concept of interdisciplinary studies. It is a concept which appears to threaten many of those involved in photography education. I say this because I have seen precious little dialogue on this subject over the past ten years despite the fact that an increasing number of other disciplines—sociology, anthropology, psychology, and history among them—are becoming increasingly aware of their involvement with and frequent dependence on photography.

I presume the resistance to this concept arises because it undermines the widely held and much-cherished assumption that elevation to the rank of Art Photographer relieves one of any obligation to develop and broaden one's world view, renders unnecessary any demonstrable connection between one's images and other modes of understanding or communicating, and entirely eliminates the tedious necessity of reading. I assume further that the concept is maligned because fewer and fewer of those in photography seem to know much about anything other than photography, yet take it for granted that that is all they need to know. When such conceptual blinders are added to an already monocular vision, the doors of perception begin to close.

Facing up to the challenge of interdisciplinary studies in photography will require much painstaking reassessment of our educational assumptions, priorities, and methodologies. It will also require drastic, even brutal, upgrading of the minimal and mediocre standards of research, preparation, thinking, and articulation to which students of photography are presently held. No part of that process will make anyone involved in it happy. But there is no way of avoiding that challenge without becoming irrelevant to the medium's future.

Concurrently, an increase in what is called "leisure time" is beginning to take place. This is happening partly as the result of a frozen job market in which there is not enough full-time work to go around, and partly as the result of voluntary changes in our national work patterns. The consequence will be that more people than ever before will be turning to the creative/expressive/communicative media as outlets for their energies. Photography will certainly be among these.

A dramatic increase in coherent and effective adult-education pro-

graming in photography will be needed to match this surge of interest and its remarkable potential. I see that potential as at least twofold. It will accelerate the breakdown of the traditional distinction between amateur and serious photographers—a we-they construct which unproductively pits plebes against elitists. The distinction between well-educated amateur photographers and well-educated career art photographers will become an increasingly narrow one, probably no wider than the ersatz sheepskin on which the latter's diplomas are printed. This change may also enable us to influence a constantly growing core of people from all walks of life and assist them in becoming active rather than passive in their relation to visual communication. We can do this by teaching them photography as a means of self-expression, as a tool with which to probe into their world and into the nature of vision itself. This, in turn, is likely to lead to an increased interest in integrating photography into the educational process at progressively earlier stages, which will bring with it the need for trained teachers with a solid grounding in visual education from childhood through adolescence.

In such a context, photography education is likely to find itself serving purposes linked quite directly to the medium's inherent nature as a democratic tool for expression and communication. We should keep in mind that any true democratizing of creativity does not necessitate the equalizing of all creative activity and its reduction to the level of mediocrity of the lowest common denominator. It does involve offering each and every individual the opportunity to have his or her creative abilities respected, nourished, and amplified as an ongoing function within the larger structures of life.

That is a difficult path to tread. It involves fundamental reformulations of our concepts of creativity and education, and requires the abandonment of our stereotypes as to what being an artist is all about. So far, we have tended to take the easier road—and have thereby created an already over-crowded class of specialists in self-expression who feed on sinecures in the profession of teaching, to which they have no commitment and in which they have no training; who feed on patronage from the privileged wealthy with their institutional fronts; who feed on public grant monies extracted from other human beings whom our culture has turned into worker drones.

Are those the unique understandings to be drawn from the medium

of photography? Is it possible that we have subverted that medium by ignoring its essences and conforming it to the shape of the "high" arts? What meaningful structures can we truly expect to erect upon such decadent and self-defeating premises? Have we been building toward the future, or away from it?

Finally, let me say—as, again, I have said on many previous occasions—that there is little purpose in encouraging people to express articulately their emotions, perceptions, and understandings through photography if their ability to do so is societally and/or governmentally restricted. The right to what I have elsewhere termed "freedom of vision" has never been legally established as an accepted corollary to freedom of speech, and even the latter freedom is all too often embattled. Currently there are a considerable number of lawsuits and other incidents which revolve around the right to make, publish, and disseminate photographic imagery of various kinds.

The issue is censorship, in one form or another. As a rule, these incidents are directly traceable to the Burger Supreme Court's decision which established "local community standards" as the basis for obscenity prosecution. As I predicted on the occasion of that decision, it has begun to have its inhibiting effect not only on literature but on photography as well. I believe that the situation will get worse, not better.

So I suggest that it would be in the best interests of this organization and its constituency to establish a task force centered around the issue of freedom of vision. This task force should be charged with studying existing statutes pertinent to freedom of vision; with compiling a history of censorship cases which bear on photography and the other visual media; with keeping track of present-day incidents and reporting on them regularly to the membership; with recommending appropriate legislation to protect the right of image-makers to make and present their work without political or legal repression, and legislation to protect the right of the public to freely view and purchase such work; and with recommending specific test cases in which the SPE might take on the role of *amicus curiae*.

In short, I am proposing that we become the most effective possible lobby for freedom of vision. I suggest further that, as educators in a visual medium, we accept as part of our responsibility to our students

and our medium the inculcation of that right. The delusion that photography—or, at least, "pure" photography—was somehow exempt and disconnected from politics should have been cast aside when the Nazis stopped August Sander from completing his life's work and directed him instead toward landscape photography. Indeed, that delusion should never have arisen. It is time to dispel it, and it is both natural and appropriate that the task falls to us.

Surely these are not the only problems ahead for those involved with education in photography. No doubt there are others already visible, and still more which have yet to surface. But I believe that these will be among the central issues of the next decade for all of us.

I did not come here with ready-made solutions to these problems—this speech is not a test. But the decade ahead certainly is. The answers to it, right or wrong, lie within us and the courses of action we choose. I hope that what I have said here tonight provokes some discussion of these issues among us. And I hope that in 1988 I will be able to read over these words and discover that they were not entirely irrelevant to the decade they anticipate.

Index